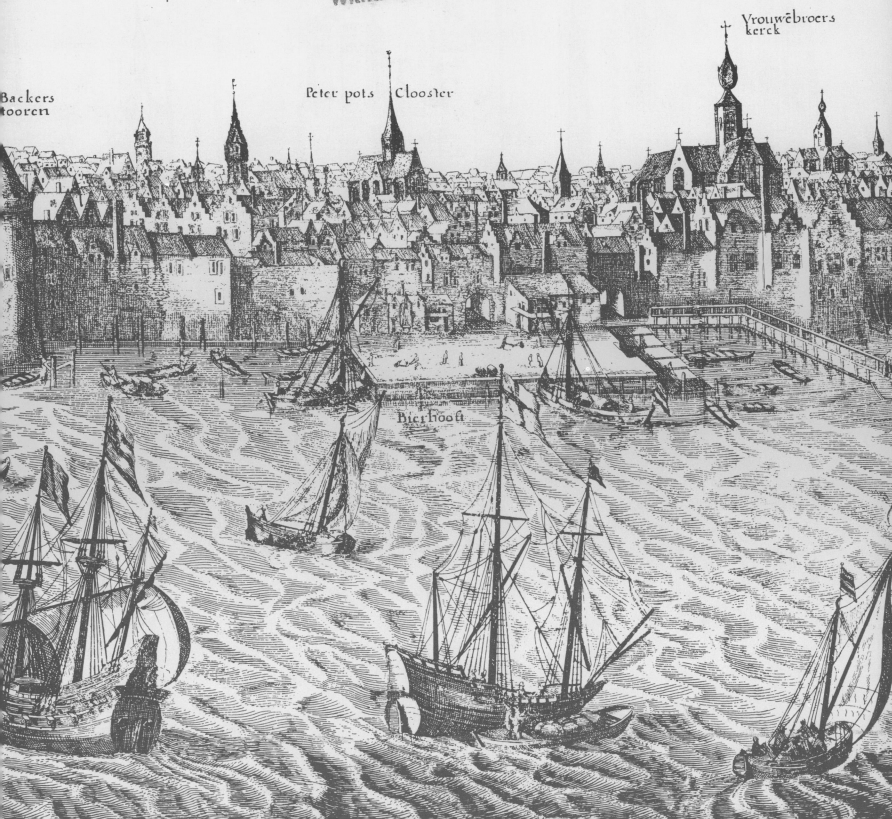

Backers
tooren

Peter pots Clooster

Vrouwebroers
kerck

Bierhooft

Jacob Jordaens

Jacob Jordaens

R.-A. d'HULST

translated from the Dutch by P.S. Falla

Cornell University Press
Ithaca, New York

First published 1982 by Cornell University Press.

Designed and produced for Cornell University Press, New York
and Sotheby Publications, London, by Philip Wilson Publishers
Limited, Russell Chambers, Covent Garden, London WC2E 8AA.

International Standard Book Number 0-8014-1519-5.

The publishers extend their thanks to H.A.L. Fisher for permission to reproduce
the extracts on pp 11 and 13 from his *A History of Europe* (1976).

Picture research by Linda Proud and Diane Rich.
Designed by Gillian Greenwood.
Set in Monophoto Plantin Light by Jolly & Barber Ltd, Rugby, England.
Printed and bound in Spain by Heraclio Fournier S.A.

Contents

In memory of my dear friend
Professor Dr J.G.van Gelder

Preface

The present volume describing the life and work of Jacob Jordaens is one of the fruits of more than twenty years' study of the great Flemish master. Although during that period I have also been active in other fields, my interest in Jordaens and my study of his work have never ceased. My original intention to make a complete *catalogue raisonné* has been carried out only in respect to his drawings (*Jordaens Drawings*, 4 volumes, 1974); as regards his other works, the task has proved too great and must be taken over by younger scholars. The paintings produced in different versions by his studio assistants, and the later copies, are too numerous for me to list and describe with any approach to completeness. Moreover, the poor quality of many of these works has in a sense discouraged me from efforts which would, I believe, have been out of proportion to the value of the result.

As is often the case with artists who directed a large studio, such as Floris and Rubens in the Netherlands, Jordaens's output is still confused by an almost unlimited number of works falsely attributed to him. One of the main purposes of this book is to separate the wheat from the chaff and to demonstrate the high standard of Jordaens's own works, which have made him famous for over 300 years. It is by no means insignificant that such different artists as Velázquez, Vermeer and Watteau expressed their admiration by including one or another of his works as a 'picture within a picture' in compositions of their own.

Except for a few works discussed for special reasons, all those listed in the present volume are, in my opinion, entirely by Jordaens's own hand. Although I have not attempted absolute thoroughness, I trust that nothing of real importance has been overlooked.

Where known, each work is documented with medium, size and present location. Major museums are listed by city alone and in the case of possible ambiguity and in all captions, the institute's complete title is provided.

The many paintings and drawings that Jordaens produced during his long career are distinguished not only by their different purposes and subject-matter but also by variations in style. I have taken particular care to show how Jordaens's style evolved in the course of time. This chronological evolution is described in the text as accurately as possible and is illustrated accordingly. Only portraits have been moved to their own chapter.

In this monograph I have unavoidably repeated portions of my early publications on Jordaens. In many places such material has been adapted to the needs of the present volume, and in some cases it has been reproduced more or less verbatim, as in the chapter on drawings. The account of political, economic,

social and cultural conditions in Antwerp at the end of the sixteenth and in the seventeenth century is largely based on the writings of H. A. L. Fisher and L. Voet, and in discussing Jordaens's place in contemporary art I have made use of A. Stubbe's essay *Jacob Jordaens en de Barok*, with which I am largely in agreement.

In *De tekeningen van Jacob Jordaens* (1956), I gave a full account of the literature up to that date. The only monograph on Jordaens which has since appeared is my own *Jordaens Drawings* (1974); this contains a supplementary bibliography of works published since 1956, such as essays in periodicals and exhibition catalogues. I should mention here three extensive reviews of *Jordaens Drawings*: Oliver Millar, 'A Master of the Baroque' in *Apollo*, October 1975, (pp 299–300); Gregory Martin, 'A True Son of Antwerp' in *The Times Literary Supplement*, 28 November 1975; and J. S. Held in *The Art Bulletin*, December 1978, no 4, pp 717–32, together with the catalogues of two exhibitions held at Antwerp in 1978 to commemorate the tercentenary of the master's death. The first of these, *Jordaens in Belgisch bezit*, was devoted to paintings and took place from 24 June to 24 September in the Museum of Fine Arts; the catalogue was by Marc Vandenven. The second exhibition, *Jacob Jordaens, tekeningen en grafiek*, was held at the Plantin-Moretus Museum from 17 June to 17 September; I was responsible for the choice of works and for the catalogue.

This book would never have been compiled without the help and cooperation of many. Thanks are due in the first place to the numerous curators and private persons who allowed me access to their collections, and to the archivists and librarians who assisted my research with information or suggestions. I am also indebted to my collaborators in the Nationaal Centrum voor de Plastische Kunsten van de 16de en 17de eeuw, who in many ways helped to make this publication possible; to Mr P. S. Falla for the care he has bestowed on the English translation from Dutch; to my wife for her tireless and meticulous checking, proofreading and indexing; and finally to the publishers for the accuracy with which their task has been performed.

I

Antwerp at the end of the sixteenth and in the seventeenth century

Few artists have been so closely associated with their native city as Jacob Jordaens. He was born, married and died at Antwerp, and apart from a few short visits to other parts of the Southern and Northern Netherlands he spent the whole of his long life there, sharing fully in the good and ill fortune that befell the city in those troubled times. At the time of his birth in 1593, after a long period of armed struggle the separation between the southern and northern provinces was already complete, practically although not officially. This did not, however, mean the end of political and religious antagonisms and consequent bloodshed, although Antwerp itself was spared the latter from then onwards. The Eighty Years' War (1566–1648), which still continued, and the re-assertion of Habsburg supremacy left deep traces and determined the fate of the Spanish Netherlands for many generations. Citizens who, like Jordaens, openly declared themselves to be Protestants did not always have an easy time under a government which incited its subjects to militant Catholicism and was by no means inclined to forget the events of the recent past.

In the great European conflict occasioned by the Protestant Reformation, Spain was marked out to be the foremost champion of the Catholic cause. While one species of Protestantism had established itself in northern Germany, and another was battling for its life in France, Spain behind her stiff, mountainous barrier was Catholic to the marrow. Here, as nowhere else in Europe, the defence and expansion of the Catholic faith were identified with the growth and glory of the nation. Philip II was a devout and dutiful Catholic ruler, who conceived it to be his principal mission in life to uproot heresy from his dominions and to support the faith of his fathers throughout the world.

The strength of Spain consisted in its standing army. During the second half of the sixteenth century the best officers in Europe were probably to be found serving under the Spanish king. Some, like Alva, were Spanish noblemen. But others were Italians, including the greatest general of the century, Alexander Farnese, duke of Parma. On the sea Spain was, for several reasons, less formidable. She was partly a Mediterranean, partly an Atlantic, power,

and her tactics were unsuited to fighting in the ocean and the English Channel.

The emancipation of the Dutch republic was greatly assisted by the fact that the rebels were left in undisputed command of the sea.

But the root of Spanish weakness lay in finance. No European government in the sixteenth century was financially strong: but Spain is a conspicuous instance of a country owning a vast surface of the globe, both in the old world and in the new, and having immediate access to the richest mineral resources then known to exist, which

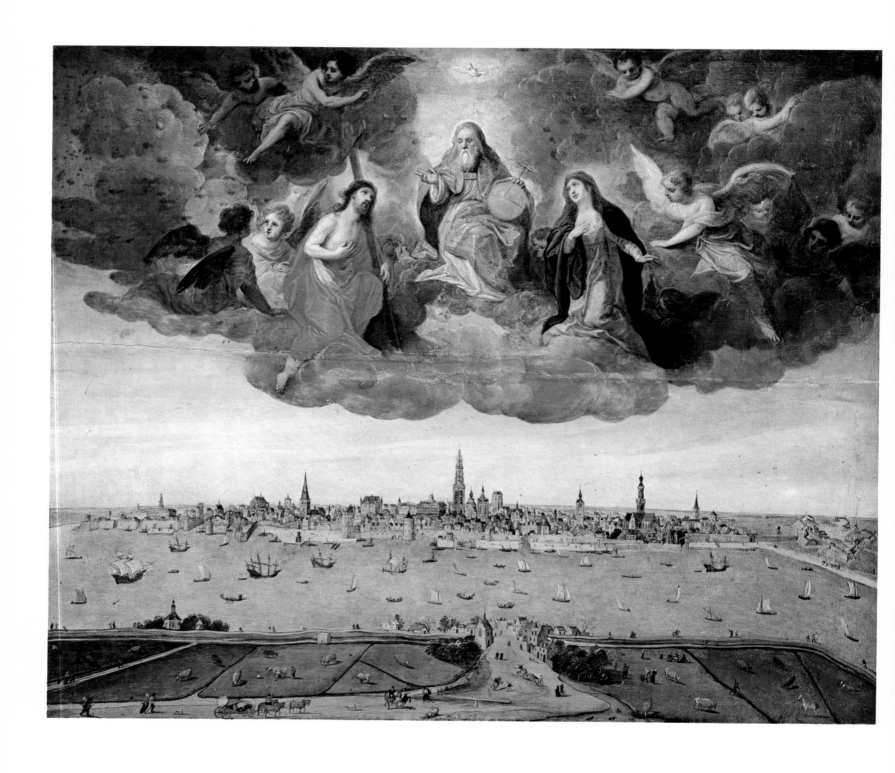

1 ABEL GRIMMER and HENDRIK VAN BALEN
Antwerp at the River Scheldt
circa 1600
panel, 37 × 44cm
Antwerp, Koninklijk Museum voor Schone Kunsten

was nevertheless in perpetual straits for money, and often unable by reason of sheer penury to perform the most elementary tasks of government. The reasons for this paradox are to be found partly in an unintelligent general policy, partly in an ignorance of economic laws and a vicious system of taxation, and not least in the absence of any effective check on peculation and extravagance. The king could raise but little money from Spain itself,

and still less could be expected from his Italian conquests.

It followed that the most elastic source of material revenue was to be found in the Netherlands.

At the beginning of the sixteenth century

Antwerp was one of the wealthiest trading cities in the world. She was unhampered by guild restrictions. She had become a great centre of international dealings, easily distancing Bruges and Ghent in the wealth and freedom of her communications, and, owing to the development of oceanic trade, possessing an advantage over Flanders as a banking centre. And fast rising into prominence was the Hanseatic city of Amsterdam, whose prosperity, originally founded on the herring fishery, was now augmented by the growing wealth of all those European states which were situated near the Atlantic littoral.[1]

Under Philip II's father, Charles V, born at Ghent in 1500, the Netherlands were the heart of the Holy Roman Empire: they provided numerous advisers and, more important still, the chief financial resources which enabled the emperor to maintain his government and wage wars. On the whole they had not much to complain of in the way they were governed under Charles, but his reign was already disturbed by troubles arising from the Reformation. The first Protestant movement by supporters of Luther was suppressed without difficulty thanks to the emperor's strong measures. The Anabaptists of the 1530s, whose activity had marked social overtones, were detested by all parties, and their execution at the stake did not arouse much sympathy. But when, around 1540, a new species of militant Protestantism began to gain ground in the form of Calvinism, it drew its followers from all classes and had powerful champions among the nobility. The Calvinist movement, moreover, was much more political in character. Philip II, who succeeded his father in 1555, was a Spaniard first and foremost; his treatment of the Netherlands provoked violent opposition, and the higher nobility, both Catholic and Protestant, began to agitate for greater independence.

Calvinist activities and anti-royalist propaganda combined to produce the iconoclastic outbreak of 1566. The rebellion was put down in the same year, but in his fury Philip II sent the duke of Alva and his army to keep the Netherlands under firmer control. This soon created tension and led to the revolt of Holland and Zeeland in 1572, followed by the other provinces in 1576. However, the bitter quarrels between Catholics and Protestants enabled Philip's skilful governor, Alexander Farnese, to regain the Southern Netherlands for Spain and Catholicism (1579–85). The North, however, held its ground and became independent as the Calvinist republic of the United Provinces.

The city of Antwerp was involved in the first phase of this bitter struggle, known as the Eighty Years' War. Many of its inhabitants were Calvinist, and in August 1566 its churches and monasteries were laid waste by the iconoclasts. The duke of Alva erected a citadel to the south of the town, and for some years the population remained quiet under the threat of Spanish arms. However, on Sunday 4 November 1576 a force of mutineers left the citadel to storm and

plunder the city. After this disastrous outbreak, known as the 'Spanish fury', the soldiers withdrew, but the vengeful citizens proclaimed a rebellion and opened their gates to the Calvinists. Antwerp and Ghent were now the chief Calvinist strongholds in the South, and Antwerp was the last fortified city to surrender to Alexander Farnese in August 1585, after a heroic struggle and a siege lasting over a year.[2]

At the time of Jordaens's birth the cities of the Southern Netherlands had a long experience of sieges and 'furies' behind them, and the countryside had been ravaged and plundered. The flower of the population had perished in the war or emigrated to the North for religious reasons, the whole administration was in chaos, the finances were in ruins and socio-economic conditions were disastrous. The cities were bleeding to death: the population of Antwerp fell from 100,000 in 1560 to 42,000 in 1589, and remained at about 53,000 for most of the seventeenth century. Although still uncontestably the most important city of the Southern Netherlands, it was by then only the shadow of what it had been in the previous century. With its silent streets and many houses emptied by the exodus of Protestants, it presented the sad appearance of a city from which the life had largely ebbed away.

After 1585, although the war still continued, the South enjoyed relative peace and quiet as compared with the previous twenty years. The Twelve Years' Truce from 1609 to 1621 brought a welcome respite, and the Spanish Netherlands did not suffer unduly in the second phase of the war, which was ended by the Treaty of Münster in 1648. An important part was played by the archduke Albert and his consort Isabella, who governed the Spanish Netherlands from 1598: they showed a strong sense of reality, which had hitherto been lacking in Spanish policies, and a keen interest in relieving the country's distress. Antwerp, whose energy had not been broken and which now enjoyed a breathing-space, gradually began to revive, and the cessation of political and religious strife made it possible to set about healing economic wounds. Although the mouth of the Scheldt river was held by the United Provinces, which levied a toll on traffic to Antwerp, the city managed to recover a good deal of ground. It had lost its function as an international centre of exchange, but it remained, as in its heyday, the chief distribution centre for the import and export trade of the reviving Southern Netherlands. However, the increasing competition of Amsterdam prevented Antwerp from wholly recovering its former glory.

No time was lost in restoring Antwerp to the Catholic faith. Jesuits, Dominicans and Augustinians set busily to work, with the secular clergy not far behind. In a single generation the city was transformed from a Calvinist stronghold into the chief centre of militant Catholicism in the Southern Netherlands. This rapid and complete return to the old religion is not so surprising, as many had abandoned it only for political reasons. But the Protestants did not all give in at once. After the fall of the city they were, as a special concession, given four years to decide whether to leave the country or revert to Catholicism. Those who rejected both alternatives knew that Charles V's edicts were still in force and that they ran the risk of being executed. However, the days of burning at the stake were past, as the authorities in the South knew that if they treated dissidents too harshly the same treatment would be meted out to Catholics living under the rule of the United Provinces. Consequently, throughout the seventeenth century Protestants in the Southern Netherlands were able to practise their religion as long as they did not do so openly. From time to time they were threatened with persecution, but in general a blind eye was turned.

None the less, they had to pay occasional fines and were subjected to various hardships. It must be remembered that the seventeenth century, and especially the first half of it, was the period of the Counter-Reformation. The Catholic church had recovered itself, regrouped its forces and taken the offensive. All-powerful in the Southern Netherlands, it sought to regain what it had recently lost, and every year brought it some new triumph. Under its influence, the whole of cultural life and much of the pattern of scientific inquiry was determined by religious criteria. In these circumstances it was still dangerous, in the 'most pious of Christian lands', to separate oneself from this powerful and vigilant institution.

In the first half of the seventeenth century the one field in which Antwerp still retained a predominance over its Northern rival was artistic life, which had been concentrated there since the previous century. The need to make good the ravages of war and iconoclasm meant, especially under the rule of Albert and Isabella, that painters, sculptors and artists of all kinds enjoyed a ready market for their products, and the best of them also exported their works on a large scale. A vast number of works of art were produced: the general level was extremely high, culminating in the work of such masters as Rubens, Van Dyck and Jordaens. Owing chiefly to its painters, Antwerp acquired an artistic reputation higher than it had ever enjoyed, even at the peak of its European fame in the sixteenth century. The period was also one of great intellectual activity, as a result of the colleges founded after the capitulation by the regular clergy to provide the new generation with a thorough humanistic education. Antwerp printers and publishers made known the works of their fellow-townsfolk throughout the Catholic world, and the city's importance as a Counter-Reformation centre thus spread far beyond the national frontiers.

After about 1650, however, the situation deteriorated. Competition with the United Provinces was undermined by the latter's economic ascendancy and the artistic and intellectual development that went with it. The wars of Louis XIV led to further decline, as the Southern Netherlands were once again ravaged and Antwerp's hinterland destroyed. On the artistic and intellectual level the creative spirit seems to have been extinguished: art lost its style, and for the most part intellectual stimulus came from abroad. Antwerp declined into a regional centre: the brilliance of its second flowering was over.[3]

II

The life of Jacob Jordaens

The circumstances in which some artists functioned had such a direct influence on their output that their work itself seems to be a commentary on their lives. Frequently, as for instance with Adriaan Brouwer, these circumstances were the immediate cause of what they produced. To understand the work of such artists it is necessary to be familiar with their lives. In contrast, the work of other artists seems to have developed quite independently of their private lives: the links between the two exist, but cannot be directly identified. Even with artists of this type, however, it is essential to know their biography: for both material and psychological events may have affected their work, although sometimes more by reaction than by direct influence. Many creative spirits aspiring to an ideal, have consciously reacted against their own social environment. Most Antwerp painters of the seventeenth century, including Jacob Jordaens, can be placed somewhere between these two extremes: they did not disavow their origins, but their whole effort was directed to creating a world of their own, from the point of view both of content and form.

Jacob Jordaens was born in Antwerp and spent his whole life there, apart from a few short journeys in the Southern Netherlands and the United Provinces. The baptismal register of the cathedral shows him to have been christened there on 20 May 1593.[1] The house in which he was born, then called 'Het Paradijs', stood near by in the Hoogstraat at what is now no 13: it was the home and business premises of the artist's father, also called Jacob, who was a linen merchant [4]. The Hoogstraat, then the centre of the cloth trade, leads from the Grote Markt to the Oever, both elegant squares and commercial centres. The location of the house shows that the family belonged to the well-to-do bourgeoisie, which is confirmed by the prosperous situation of many of the artist's relatives.

The Jordaens family were true natives of Antwerp. As far as can be traced from official documents, they had always been residents of the city. The name Jordaens was not uncommon there in earlier times, and the Lists (*Liggeren*) of St Luke's guild show that in the sixteenth and seventeenth centuries it was borne by numerous artists. These, however, were not necessarily related to Jacob and his direct forebears, who had traditionally lived by trade.[2]

On 2 September 1590 the artist's father married Barbara van Wolschaten at the cathedral.[3] After Jacob, the first child, eight daughters and two more sons were born. Not much is known about them, except that one of the daughters became a nun, two others entered the *béguine* community, and one of the sons

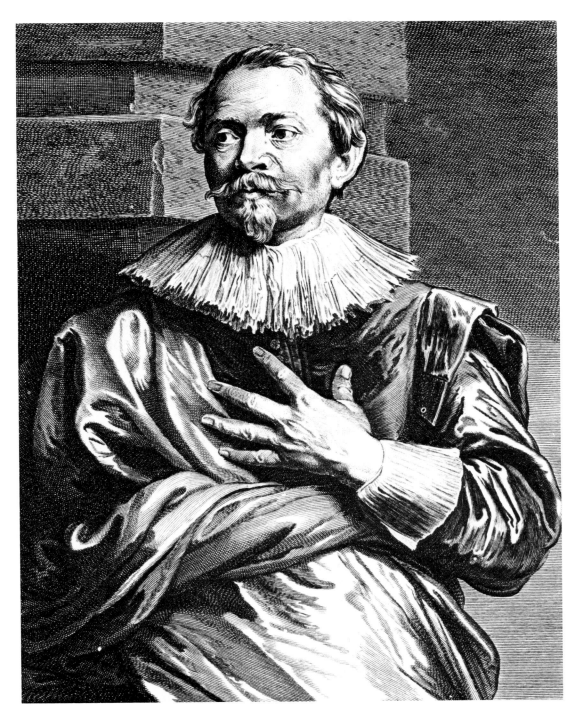

2 VAN DYCK, engraved by PETRUS I or PETRUS II DE JODE
Portrait of Jordaens
248 × 176mm
Antwerp, Stedelijk Prentenkabinet

became an Augustinian.[4] Little is known of Jacob's childhood. In 1607 he was apprenticed to Adam van Noort,[5] whose daughter he later married. He was then fourteen, the usual age in those days for beginning an artist's career. It is not known where he had been to school, but no doubt he received the customary education of a boy of good family. He wrote a clear and elegant hand, could compose a good letter and knew French quite well, as is shown by documents written by him in that language. His work shows considerable knowledge of mythology, probably derived from such moralising works as Carel van Mander's *Uytlegghingh op den Metamorphosis Pub. Ovidij Nasonis*, first published in 1604. He had a better than average knowledge of scripture, noticeable particularly in works dating from after his conversion to the Reformed faith.

Adam van Noort is known to have been Jordaens's only teacher. Although not a great painter himself he must have been particularly able in this respect, as the Register shows that he taught more than thirty-five apprentices.[6] He is known principally on account of the subsequent fame of two of them, Rubens and Jordaens. Jordaens must have thought highly of his teacher: he spent a great deal of his life in the same house as Van Noort and made many drawings and paintings of his fine head with its grey hairs, in a style showing both affection and veneration. Adam van Noort was a careful and industrious man who, by dint of hard work, raised himself from a lowly to a high position in society. He amassed a considerable fortune which he bequeathed to his children and which for the most part came into Jordaens's possession. His father, Lambrecht van Noort, was a painter from Amersfoort near Utrecht. He became a member of St Luke's guild in Antwerp in 1549 and a burgher of the city on 30 April 1550, but was an unsuccessful man and a poor artist.[7] Adam, who had endured all kinds of hardship as a child, was a better painter than his father. When he became a master in the guild in 1587 he was already married to Elizabeth Nuyts, the daughter of Jan and Katelijne de Moy, one of the most respected families in Antwerp. Adam and Elizabeth van Noort had three sons and three daughters: Catharina married Jordaens, while Anna and Elizabeth remained unmarried. Of the three sons, Jan died at Madrid in 1626 and Adam died young. Martin was baptised on 11 March 1601 and is referred to as a merchant in a document of 1643 concerning an agreement with his sisters about the distribution of their parents' estate.[8]

The Nuyts family was very well-to-do, and in 1589 Elizabeth inherited money from her parents together with a share in two houses, 'Den gulden Engel' ('The Golden Angel') and 'Het gulden Schaap' ('The 'Golden Sheep'), both in the Hofstraat;[9] she became sole owner of these in 1595.[10] Adam van Noort is referred to as living at the 'Golden Angel' in a deed of 1597 whereby the city magistrature conferred on him the office of dean of St Luke's guild.[11] There is no doubt that his prosperity was largely based on his wife's fortune as well as his artistic ability. When he died in 1641 or 1642 he left no fewer than eight houses in addition to considerable personal property. These houses eventually became Jordaens's[12] and were thus added to the wealth he had inherited from his own parents. Jordaens in fact lived all his life in a state of material comfort, and was one of the richest and the most respected citizens of Antwerp.

In 1615, at the age of twenty-two, Jordaens was admitted as a master in the guild of St Luke: the lists describe him as a watercolour-painter (*waterscilder*) and state that the dean of the guild was Francoys Francken the Younger, his deputy being 'Joannes Moretus, bookseller'. The accounts refer to him as a painter and draper's son and record that he paid 23 guilders and 4 stivers as a 'full master' and 9 guilders of 'wine money'.[13] In 1616–17 he became a member

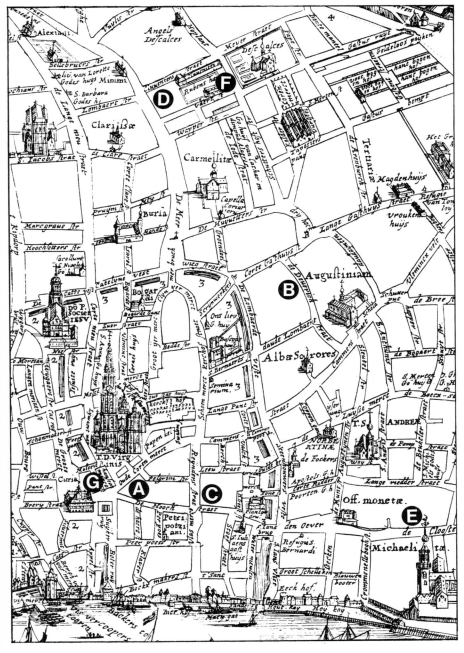

3 P. VERBIEST
Map of Antwerp (overleaf, detail above)
circa 1650
A 'Het Paradijs', Hoogstraat, Jordaens's birthplace
B Adam van Noort's house, Deurickstraat (now Everdijstraat)
C Jordaens's house, Hoogstraat
D St Arnoldus, where Rubens lived with his mother before 1600
E St Michielsstraat (now Kloosterstraat) where Rubens lived
 after his return from Italy in 1608
F Rubens's house from 1617 until his death
G 'De Berendans', Grote Markt, Van Dyck's birthplace

4 'Het Paradijs' (house in centre), Jordaens's birthplace,
Hoogstraat (now no 13), Antwerp

3 P. VERBIEST
Map of Antwerp
circa 1650

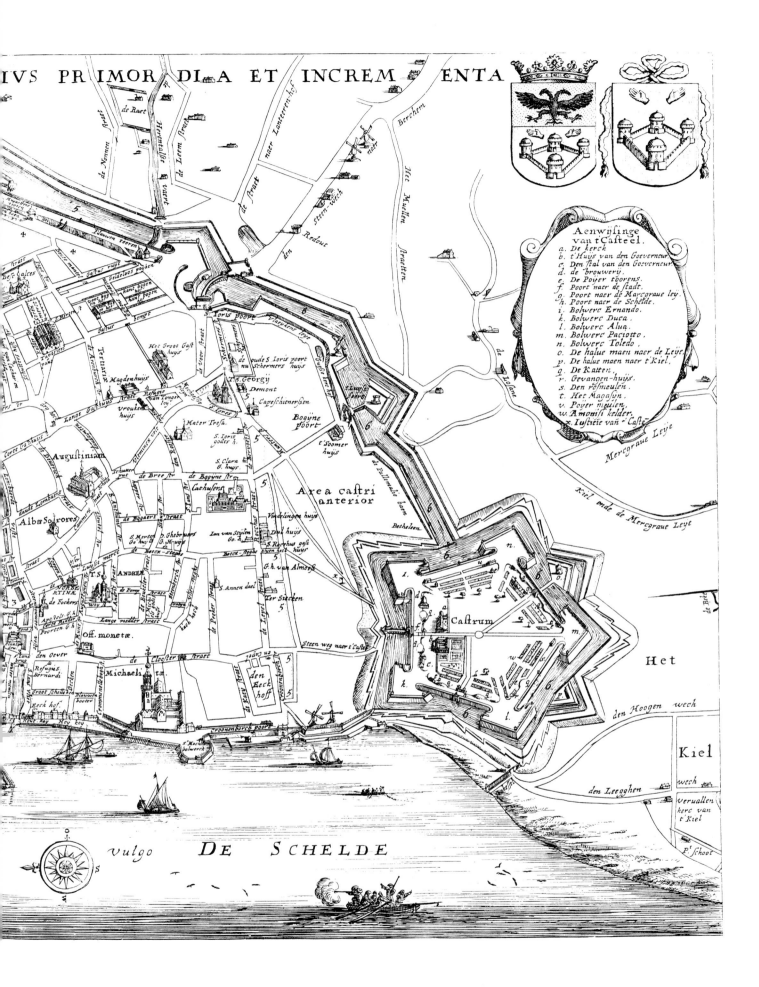

of the guild's relief fund, which aided artists who fell sick and helped to pay their burial expenses.[14]

Jordaens's appearance at the end of his apprenticeship can be judged from two group portraits which he painted in about 1615–16 and which are now in the Hermitage at Leningrad [232] and the Kassel museum [233]. Both portraits show him with a lute on his knee; in one of them he is with his parents, brothers and sisters, and in the other the Van Noort family.

During Jordaens's apprenticeship with Van Noort the latter was living in a house in the Everdijstraat (Deurickstraat) that he had bought in 1598,[15] together with his wife and six children.[16] The young Jordaens evidently enjoyed the family atmosphere, and the master–pupil relationship was reinforced by feelings of friendship and eventually by Jordaens's marriage to Van Noort's eldest daughter. Their wedding was celebrated in the cathedral on 15 May 1616,[17] a few days before the bridegroom's twenty-third birthday. Catharina, who was baptised on 21 August 1589, was nearly four years older than her husband.

The three children of the marriage—Elizabeth, Jacob and Anna Catharina—were all baptised in the cathedral, like their parents before them. Anna Catharina married Johan II Wierts, a native of Antwerp who had studied law at Louvain and afterwards went to The Hague as a member of the Council of Brabant, of which he later became president. Elizabeth never married and lived all her life in her father's house, including the period of his widowhood. Young Jacob became a painter like his father, although his name is not mentioned in the Lists of St Luke's guild or any other document. However, there is in the Amiens museum a *Noli me tangere*, signed *J. Jor. Junior 1650*, a painted version in more academic style of a composition found in a drawing by Jordaens senior which is now in the Institut Néerlandais in Paris.[18]

After their marriage Jacob and Catharina lived in the Everdijstraat. The record of the burial of Jan Moretus, who died on 11 March 1618, lists the relatives and friends who were informed of his death, including 'Adam van Noort and his son-in-law in the Everdijstraat'.[19] Van Noort owned two houses in that street, both bought in 1598, and as he had only one son-in-law it is clear that Jordaens is meant. On 15 January 1618 the young couple bought a home of their own in the Hoogstraat, the same street as that in which Jacob had been born: it consisted of a rear building, approached by way of a gate and a small inner narrow courtyard.[20] To assist them in the purchase, on 3 March of that year their respective parents each took a mortgage of 1,000 guilders on the premises.[21] Jordaens and his wife probably moved in shortly afterwards. Van Noort subsequently went to live with them there: this must have been before 4 June 1634, as on that date he is mentioned in the funeral record of Melchior Moretus as living with his son-in-law in the Hoogstraat.[22]

The young painter's life showed a normal pattern of good and bad fortune. His first child, Elizabeth, was born on 26 June 1617,[23] while his father died on 5 August 1618.[24] He was already extremely active as an artist, and many of his works from this period are known. In 1620–21 he took on his first pupil, Charles du Val,[25] followed by Pierre de Moulijn in 1621–22[26] and Jan Kersgiter and Mattijs Peetersen in 1623–24.[27] Early success made Jordaens self-confident, as may be seen from his proud, dignified expression in a family portrait, painted by him in about 1621–22, now in the Prado at Madrid [234].

By a special decision of the magistrature Jordaens was appointed on 28 September 1621 to the high office of dean of St Luke's guild for the administrative year running from October 1621 to October 1622.[28] At that time the

guild was in a difficult financial position. When the chamber of rhetoric known as 'The Gillyflower' (*De Violier*), which was associated with the guild, was revived in 1618, the guild proceeded to lease the imposing premises on the main square known as 'The Old Crossbow'. By this and other expenses the deans had so overburdened the guild's finances that it was soon unable to meet its annual expenditure. The city fathers must have thought highly of the twenty-eight-year-old artist to expect him to be able to rescue the guild from its difficulties. It was an ambiguous honour to be offered the decanate in such circumstances; Jordaens at first refused, but on 30 September the magistrates ordered him, on pain of a fine, to take the oath at the city hall within twenty-four hours.[29] He replied that he was prepared to accept the office of dean and the expenses that went with it, but begged to be excused from paying his predecessors' debts. On 1 October the mayor and council appointed alderman Jan Happart to examine and report on Jordaens's petition, while ordering him to take the oath pending their further decision.[30] It is not known exactly what happened after that. Records show, however, that by a municipal order of 10 September 1622 Anthoni Goetkint was appointed dean of the guild and Abraham Goyvarts his deputy,[31] so that Jordaens cannot have exercised the office for longer than a year.

Jordaens's family grew on 2 July 1625 with the birth of a son, named Jacob after his father,[32] and on 23 October 1629 with a daughter, Anna Catharina.[33] The artist's mother died a few years later, on 11 February 1633.[34] Her property was divided between her sons Jacob and Izaak, and her daughters Anna (the wife of Zacharias de Vreese), Magdalena and Elizabeth (both *béguines*), under an agreement dated 16 June 1633.[35] On 18 March 1634 a further agreement was signed concerning real estate.[36]

Jordaens's parents had eleven children, of whom eight were still alive at the time of the Leningrad family portrait of about 1615–16 [232]; by 1633 the number had fallen to five. Since the family were well off, the inheritance divided among them was no doubt considerable. The painter's share included the house 'Het Paradijs' in which he was born, and when, on 10 March 1635, he bought two houses on the Verwersrui[37] this was probably with the aid of funds from the same inheritance.

Professionally his affairs were going well. His activity was expanding and he played an increasingly prominent part in the artistic life of Antwerp. He received important commissions, including large altarpieces ordered by the clergy, and designed some sets of tapestries. In 1634 he agreed to a request by the Antwerp magistrates to work under Rubens's direction on the decorations for the 'Joyous Entry' of the Cardinal Infante Ferdinand of Austria, the new governor of the Spanish Netherlands.[38] In 1637–38, when Rubens's health and energy were declining sharply, Jordaens worked with him on the paintings for the Torre de la Parada, Philip IV's hunting lodge near Madrid.[39] All this activity called for numerous assistants, and Jordaens's studio gradually increased in size. From this time on the names of new pupils appear regularly in the Lists: Rogiers de Cuyper in 1633–34,[40] Hendrick Willemsen in 1636–37,[41] Hendrik Rockso in 1640–41,[42] Gilliam de Vries in 1644–45,[43] Orliens de Meyer, Jean Goulincx, Andries Snijders, Conraet Hansens, Adriaen de Munckninck and Pauwels Goetvelt in 1646–47,[44] Arnoldus Joerdaens in 1652–53,[45] and Mercelis Librechts in 1666–67.[46] Altogether the Lists record sixteen pupils during Jordaens's career, including the four previously mentioned. There is evidence, however, that there were more than these. For instance, a notarial declaration was made on 12 August 1641 by Johannes de Bruyn, Hendrik

Wildens, Daniel Verbraken, Johannes-Baptista van den Broeck, Hendrik Ker-
stens and Johannes-Baptista Huybrechts: all of these stated that they were or had
been pupils of Jordaens, but none of them is mentioned in the Lists.[47]

Jordaens was becoming increasingly prosperous and, following Rubens's
example, he built himself a splendid dwelling appropriate to his status and to his
extensive activity. Adjoining his home in the Hoogstraat was a house belonging
to the merchant Nicolaas Bacx. This included a rear building and went by the
name of 'De halle van Lier' ('Lier Hall') or 'De Turnhoutse halle' ('Turnhout
Hall'), because at the beginning of the fifteenth century the magistrates of Lier
(Lierre) erected a cloth hall there for their fellow-townsmen, and the hall was
probably later also used by the cloth-dressers and dealers of Turnhout. On 11
October 1639 Jordaens succeeded in buying this house.[48] He must have set
about building his new home soon after, for at least one of the two façades that
still exist was completed in 1641. Whether De halle van Lier was demolished
outright or only by degrees, is a question unlikely to be answered, as the
contemporary plans and records only indicate the situation of the house and say
nothing about its construction, elevation or appearance. It is known that in the
course of the work Jordaens had trouble with neighbouring owners: disputes
over lights and party walls can be followed in documents from 1641 to 1649.[49] It
may be noted that the buildings of the new complex never occupied more than
three sides of the still extant courtyard. Jordaens had access to this courtyard
either through what had been De halle van Lier or by way of the passage leading
from the Hoogstraat to the rear building purchased in 1618.[50]

Apart from the façade of the front building [5], which bears the date *1641*,
and that of the studio [6], both of which look on to the courtyard, little of the
structure added by Jordaens has remained except for the studio cross-beams.
After his death the complex had several owners. In 1770, when it became the
property of Laurentius Petrus Solvijns, it was unchanged from the state in
which Jordaens left it. In 1787 Solvijns also acquired 'De halle van Weert' in the
Hoogstraat, next door to the former Halle van Lier, and in 1792 he bought the
house called 'Stad Weert' which is now no 10 Reyndersstraat. In this way all
the buildings around the courtyard on to which Jordaens's property faced were
brought under the ownership of a single man. From then on Jordaens's house
was accessible from the Reyndersstraat, and the major alterations were begun
which have led to its present condition. Nothing remains of the internal
architecture of Jordaens's front building, and the façade of his house today looks
no different from other commonplace parts of the Hoogstraat. In the two
frontages that still remain, the Baroque ornamentation in full relief is confined
to the projecting central portion including the entrance and balcony. The
entrance to the studio is particularly interesting: here are the first instances of
the exuberant Baroque forms that were so popular in secular architecture at
Antwerp during the second half of the seventeenth century.[51] Both frontages are
impressively solid and handsomely proportioned.

The new home in which Jordaens spent the rest of his life, and in which his
wife and daughter died as well as himself, must undoubtedly have been built
entirely to his own taste. Although the building was altered by subsequent
owners, it is clear that he painted pictures to adorn the ceilings and probably also
the walls of certain rooms. The ceiling of the large hall overlooking the street
was decorated with a series of twelve *Signs of the zodiac* [154–156],[52] and eight
scenes of *The story of Psyche* [204–206, 213] were painted for a parlour in the old
rear building.[53] Apart from this our information is derived from sales of the

5 Façade of Jordaens's house,
Hoogstraat, Antwerp, completed
in 1641; seen from the courtyard

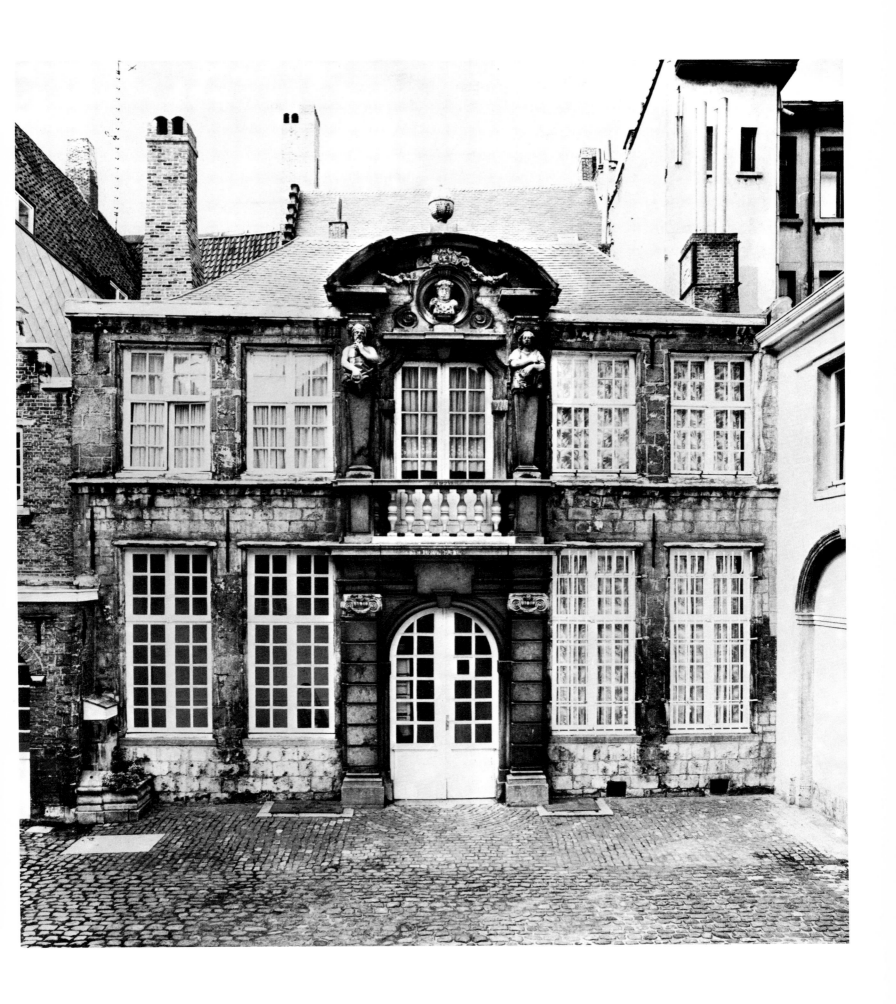

furnishings after his death. The first of these, at which his best paintings were sold, took place on 18 June 1685 at Anthoni Schaerders's house on the Vrijdag-markt, but no list or catalogue is known to exist.[54] For the second sale, held at The Hague on 22 March 1734, the catalogue comprises no fewer than 109 items, including many paintings by Jordaens himself but also works by lesser Dutch and Flemish masters; Rubens and Van Dyck are not mentioned.[55]

The building and furnishing of his fine new home must have taken up much of Jordaens's time in the early 1640s, but this did not prevent him from being extremely active in other directions. He was in the prime of life and in excellent health, and his boundless energy enabled him to accept and carry out the commissions which poured in at this time from various patrons. Rubens died in 1640, and Van Dyck, who had been in England for several years, died in 1641 at an early age. Jordaens thus became the most eminent Flemish painter, and from then on he received requests from parish councils in larger and smaller cities to paint altarpieces for them. At the same time he was in demand in more exalted quarters and even received commissions from crowned heads. This was the more remarkable since, by temperament and conviction, he was not a court painter like Rubens and Van Dyck but rather belonged to the bourgeoisie: his natural affinity was not with the rulers but with the ruled.

In 1639–40 he was asked to paint twenty-two scenes of *The story of Psyche* to decorate the walls and ceiling of the queen's closet at Greenwich Palace, built by Inigo Jones. The commission was enveloped in mystery and caused Jordaens much anxiety. Sir Balthazar Gerbier, the agent in Brussels of Charles I of England, received orders to commission the work from Jordaens as Rubens was too dear. Gerbier made use of the services of Cesare Alessandro Scaglia,[56] an abbé and diplomat then living at Antwerp, who seemed to him the best inter-mediary with the artist but was not supposed to know for whom the work was actually required. During the negotiations Gerbier tried to persuade the English court that Rubens, a close friend of his, was better suited to carry it out. Failing this, he argued that at least the ceiling paintings should be entrusted to Rubens, whom he thought better at foreshortening, and that Jordaens should do the wall decorations. Rubens's death on 30 May 1640 put an end to these plans, and Jordaens was entrusted with the whole work. It was never completed, however: eight wall paintings, and no others, were delivered to Scaglia and reached the English court. Scaglia died suddenly on 21 May 1641, and a lawsuit with his heirs ensued over the payment for seven pieces which Jordaens had delivered a month before. In addition, Jordaens claimed compensation for the work he had put in on seven further paintings then in his studio, three of which were for the walls and four for the ceilings. In order to escape payment the heirs declared that Scaglia had never ordered any paintings from Jordaens but had only acted as a friend in recommending him to Gerbier. The court's decision in this mysterious affair is unknown.[57]

Substantial though the king's order was, it did not fully occupy Jordaens's studio, where work continued on paintings for private customers and municipal and church authorities. Jordaens's prominence among Antwerp artists and the appreciation shown for his art are further illustrated by the fact that soon after Rubens's death in 1640 the latter's heirs asked him to complete two paintings that had been commissioned by Philip IV.[58] Jordaens was obviously on good terms with the family of his great predecessor.

Despite all the documents that have survived, it is not easy to form an idea of daily life in Jordaens's home and studio or his relations with family, friends,

6 Façade of Jordaens's studio, Hoogstraat, Antwerp, completed *circa* 1641; seen from the courtyard

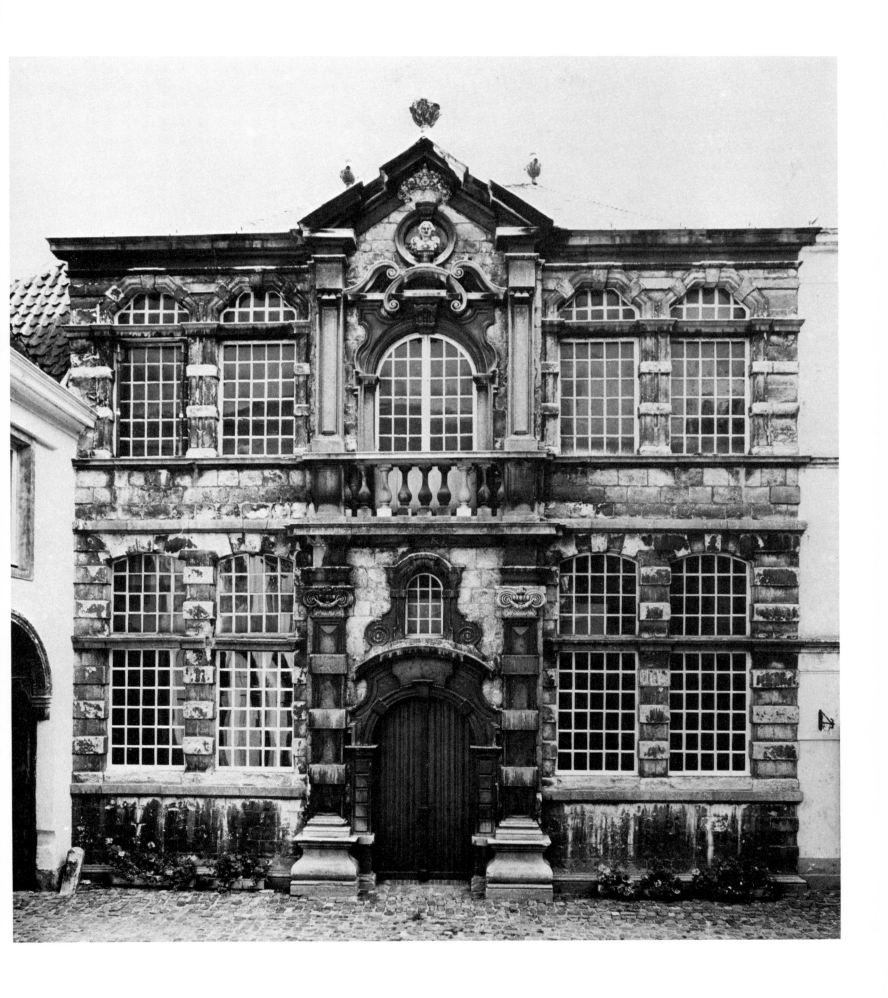

neighbours and fellow-artists. Not much of this can be derived from matter-of-fact records of births, marriages and deaths, the purchase of real property or contracts with clients. Letters written by or to Jordaens are nearly all concerned with his work and are as a rule impersonal. It is pleasant for a change to come across a document which, although referring to a rather trivial occurrence, does throw some light on the artist's personal relationships. Dated 30 July 1642,[59] it shows that Jordaens and his household had enemies as well as friends. Apparently the wife of a silversmith named Van Mael had a violent grudge against them, although the Jordaens family declared that they 'did not know Van Mael or his wife and had never had any words with them, good or bad'. Nevertheless, on the evening of 28 July, having previously uttered threats, the Van Maels and some male accomplices set upon Catharina Jordaens and her daughter as they sat chatting, according to custom at that time of year, outside their house in the Hoogstraat. Mevrouw van Mael drew a knife and pursued Catharina and her daughter indoors; when eventually obliged to withdraw she threatened to return. Perhaps the cause of this behaviour was some religious antagonism. Jordaens complained to the magistrate, who referred the matter to the bailiff for investigation, after which no more is heard of it.

Among the major commissions that Jordaens received during nearly the whole of his career were those for designing sets of tapestries. The earliest document concerning this activity dates from 22 September 1644.[60] It relates to a contract with the Brussels tapestry-weavers Frans van Cotthem, Jan Cordys and Boudewijn van Beveren whereby Jordaens was to supply cartoons for a 'chamber tapestry' series representing *Proverbs* [174, 176]. A set of eight such tapestries was bought in 1647 by Leopold William, governor of the Spanish Netherlands from 1646 to 1656, who took them back to Vienna along with his rich collection of paintings and other works of art. An inventory of the archduke's possessions drawn up at his death in 1662 shows that he owned two series of tapestries with *Proverbs*, one of them interwoven with gold thread.[61]

Although Jordaens was registered in the guild in 1615 as a *waterscilder*, ie maker of a kind of ersatz tapestry on paper (*see* Chapter IX), he also painted in oils from the beginning. His first dated oil painting, an *Adoration of the shepherds* [38], belongs to the year 1616, but stylistic examination shows that others were earlier still. Jordaens's talent developed at an early age, and in view of his success he probably soon gave up painting with watercolours on canvas and devoted himself entirely to the more profitable activity of painting in oils. Afterwards, however, he also used watercolour to design cartoons for tapestries in the proper sense. It is hard to say exactly when he began to do so; the earliest sets known to have been woven after his cartoons, *The story of Odysseus* [107, 110] and *The history of Alexander the Great* [114], can be dated on stylistic grounds *circa* 1630 and *circa* 1630–35 respectively. After these came *Scenes from country life* [124, 127], *circa* 1635.

The *Proverbs* series [174, 176] is not only the earliest known from documents but also the first for which cartoons have survived: these two are exhibited in the Musée des Arts décoratifs in Paris. In the seventeenth century, cartoons for tapestries were painted both on canvas and on paper. Those for Rubens's *Eucharist* series, for example, are on canvas; however, all those by Jordaens that are now known are on paper. He also used paper for the sketches for his tapestries, executed in watercolour and bodycolour, whereas Rubens generally used oils on panel. No doubt Jordaens's preference originated in his training as a *waterscilder*.

By this time Jordaens's fame had spread to foreign countries, and young artists came from abroad to train under him. Shortly after 1642 he had in his studio the Pole Alexander Jan Tricius, who had worked under Poussin in Paris from 1640 to 1642; after leaving Antwerp he studied under Weiner at Danzig, and afterwards settled at Cracow. He excelled in portraiture and worked for, among others, the Polish kings John II Casimir and John III Sobieski.[62]

In the first half of the seventeenth century many pupils sought admission to the studios of the great Antwerp masters, and those who were successful regarded it as a great favour. Rubens wrote on 11 May 1611 to Jacob de Bie,[63] who had approached him on behalf of a protégé, that he had no room in his studio for any more pupils and that some young men had to study for years with other masters before he could take them on. The impression that the great Antwerp painters made on the young generation is given in a letter to Rubens of 28 August 1614 from Justus Rycquius,[64] begging the master to accept his nephew Stadius as a pupil. Rycquius wrote that the young man 'would regard it as a supreme good fortune to see Rubens, to be able to greet him and enjoy a little of his society'. Jordaens must have exercised a similar attraction, as is seen, for instance, from instructions given by Queen Christina of Sweden on 19 August 1645 to Harald Appelbom, her agent at Amsterdam, concerning her protégé Joris Waldou, the son of her head cook. Appelbom was to see that the young Waldou, who had received some artistic training in Holland, made his way to Antwerp, 'where there are excellent painters, for example Jordaens'. He was to become Jordaens's apprentice for two or three years,

to practise the art of painting and to be well instructed in all in which he still falls short concerning the principles of art, and to get a thorough training in great, small and average-sized narrative pictures, landscapes and all other necessary things. But, seeing that art is also very well learned by good and truly original pictures, an arrangement must be made with Jordaens as to how much he will require to instruct him thoroughly in the art of painting. You will also make arrangements as regards all he may need for living—for his lodgings and all the rest, as well as his studies, and what he may require to live with Jordaens at Antwerp. The works which he makes under his master's guidance can be sent here in due course.

Ironically Christina, who was to abdicate in 1654 and become a Catholic shortly afterwards, added the injunction to impress on Waldou 'to be on his guard against the Popish religion, as well as other evils which might be pernicious to him'.[65]

Jordaens's reputation at the Swedish court also brought him important commissions. Thus Houbraken writes[66] that he painted a *Passion* series of twelve pieces for King Charles X Gustavus, who reigned from 1654 to 1660; however, nothing more of this is known. More important, in any case, was a previous commission from Queen Christina, whose agent Johan-Philips Silver-croon on 21 April 1648 ordered from him a series of thirty-five paintings, the subjects to be determined later.[67] The agreement, concluded before an Antwerp notary, stated that the paintings were to be 'foreshortened': they were intended to decorate the ceiling of the Hall of Estates in the castle at Uppsala. The whole series had to be delivered at The Hague not later than 1 May 1649. On 30 October 1648 Peter Spiering, the queen's agent at The Hague, requested permission from the States-General to transport 'ten of the 35 pictures that are being painted at Antwerp to decorate one or more of Her Majesty's apartments,'[68] and permission was duly granted on 4 November.[69] On 27 May 1649 Spiering put in a further request for the transport of a consignment including three cases

containing seventeen paintings.[70] It is not clear whether the commission was executed in full or how many pictures actually reached Sweden. One of the few clues is a report of 1717 by the architect Nicodemus Tessin the Younger, who, referring to the fire which took place at the old castle of Stockholm in May 1697, wrote: 'It is a great pity that in this last fire 36 pictures were completely destroyed, all of them by Giordano'.[71] One can only guess whether these included any of the paintings executed for the castle at Uppsala.

Among the paintings which were in Jordaens's house at his death and were sold by his heirs on 22 March 1734 was no 78: 'A large square piece with four large oblique pieces, serving as a ceiling of a large chamber, representing the story of Psyche, painted by Jordaens for Queen Christina of Sweden, in all 24 feet by 22 feet'.[72] These may have been an undelivered part of the 1648 order, or perhaps separately commissioned. It may be noted in passing that the scenes ordered in 1639–40 for the queen's closet at Greenwich Palace were also to depict the story of Psyche, and Jordaens later chose the same theme for the decoration of his own house.

It is no small matter to paint thirty-five large canvases in the course of a year, however ingenious and skilled the artist may be. It is not surprising therefore that Jordaens enlisted the help of his studio, and to avoid any dispute this was expressly provided for in the agreement with Silvercroon. Jordaens undertook that the scenes would be 'well and ingeniously painted, partly by himself and partly by others, as it shall suit the said Jordaens. And whatever is painted by others he shall repaint in such a way that it shall pass as his, Signor Jordaens', own work, upon which he is to put his name and signature.'[73] Such written provisions as these were useful for the protection of both client and artist. Like Rubens, Jordaens occasionally had his assistants copy his sketches, enlarging them to their final size, after which he would add a few touches that stamped the work as his own. More may be gleaned from a declaration made by Jordaens before a notary on 25 August 1648 in reply to a customer's complaint. In this he stated that out of five pictures sold two years previously to Martinus van Langenhoven three were 'entirely painted, retouched or altered by his own hand'. He agreed that he had treated the same subjects in the past, but said that he had repeated them because they pleased him. For this purpose his assistants had made copies which he worked up afterwards. In this way the three pictures were 'repainted and altered by his own hand, so that he regarded them as original and no less good than his other ordinary works'.[74]

This may show sufficiently in what different ways Jordaens's paintings were produced from the point of view of actual execution, but the studio's method of work was also determined by other factors. If, for instance, a programme was prescribed laying down exactly what was to be depicted, the master was obliged to take a greater part in the creative process. This was the case with an important commission for Amalia van Solms, widow of Prince Frederick Henry of Orange. Before the prince's death in 1647 the couple had planned to build a country retreat in the Haagse Bos, which was to be Amalia's property and wholly designed in accordance with her taste. The plans were made by Pieter Poot with the assistance of Jacob van Campen, architect and painter; they were completed in 1645, and the first stone was laid in September of that year. However, the building was still unfinished at the time of Frederick Henry's death. His widow then decided to decorate the main hall with a series of paintings that would perpetuate the memory of her husband, a noted statesman and art-lover. Van Campen was given the task of converting the space to its new purpose. The hall

7 Autograph letter from Jordaens to Constantijn Huygens
concerning the decoration of the Grand Hall in Huis ten Bosch,
near The Hague
Dated Antwerp, 14 October 1649
Mariemont, Belgium, Musée

was built in the form of a Greek cross, and the plan was to depict the prince surrounded by members of his family and scenes of the principal events of his stadholdership. These, in accordance with contemporary taste, were to be given a symbolic character so as to produce a more noble and distinguished effect. Amalia and her advisers took as their model Rubens's celebrated series of paintings for Marie de Médicis in the Palais du Luxembourg and those for Charles I in the Banqueting House at Whitehall; and, since Rubens was an Antwerp master, it was natural for them to turn to a fellow-townsman of his, at all events for the main part of the work.

Amalia van Solms and Jacob van Campen were already well acquainted with Flemish artists, and so was Constantijn Huygens, the late prince's faithful counsellor, who acted as agent in several negotiations. Frederick Henry had bought various pictures by Rubens; he and his consort had had their portraits painted by Van Dyck; he possessed other works by the latter artist, and had shown much interest in Antwerp painters whose style resembled that of the two great masters. Jacob van Campen, who designed the Amsterdam town hall, commissioned the fine sculptures that adorn it from an Antwerp artist, Artus Quellinus the Elder. Besides Jordaens, several artists from the Northern as well as the Southern Netherlands were invited to collaborate in the decoration of the Huis ten Bosch. Among them were the Flemings Gonzales Coques[75] and Thomas Willeboirts Bosschaert, the Dutchmen Cesar Boëtius van Everdingen, Salomon de Bray, Jan Lievens, Christiaen van Couwenbergh and Gerard Honthorst, and some other Dutch masters who owed much to the Antwerp school: these included Theodoor van Thulden and Pieter Soutman, who had worked with Rubens, and Pieter Fransz de Grebber.[76]

Jordaens's letters discuss his work for the Huis ten Bosch, which included two paintings. The first commission was for the less important of these, *The triumph of Time*: this appears from a letter he wrote to Huygens on 14 October 1649,[77] which also indicates that Gonzales Coques had a part in the negotiations. At that time Jordaens had already visited Amalia van Solms at Turnhout, where the princes of Orange had a country seat with a hunting-ground, and had submitted a sketch that pleased her. The picture was most probably completed in 1650. The second work commissioned for the Huis ten Bosch, *The triumph of Frederick Henry* [203], was the largest canvas in the hall and the centre-piece of its iconographical system. The first report of it is in a letter of 23 April 1651 from Jordaens to Huygens,[78] from which it appears that the latter as intermediary commissioned the work in writing together with a sketch by Jacob van Campen and an explanation of what was proposed. Jordaens did not care for the sketch, and in his long letter suggested various amendments in respect to both composition and iconography: to illustrate these he proposed to send four or five sketches of his own to Her Highness and to Huygens. In a subsequent letter to Huygens of 8 November 1651[79] he once more expressed vexation at Van Campen's interference and indicated some further changes. He added that he had been the victim of an accident, having fallen off a step-ladder which collapsed and injured his shin, 'so that I was in great pain throughout the month of October, being unable to stand or walk on that leg and afraid that gangrene would set in'. The same letter gives an idea of the difficulties involved in painting such an enormous canvas: 'The full-size execution is a harder task than I had expected: the main trouble is that I cannot spread out the whole work in my own house, so that I have to work on it by bearing the design in mind rather than actually seeing it'. However, Jordaens seems to have overcome these difficulties

THE LIFE OF JACOB JORDAENS

and setbacks fairly quickly, as he completed the work in the following year, 1652.

Doubtless the Dutch court for whom the picture was intended had no difficulty in grasping its symbolism, in broad terms at any rate. This was certainly true of Amalia van Solms, who had not only loved her late consort but had admired him and shared his experience as a statesman. But even she must have needed some help in following the detailed significance of the dozens of symbolic figures in the enormous canvas. Recognising this, Jordaens sent her a long exposition in French entitled 'Explication du grand tableau triumphal du feu très illustre prince Frédéricq Henry de Nassau, prince d'Orange, de louable mémoire, pour madame Son Altesse la princesse douairière'.[80]

These large-scale commissions and numerous others from lay and ecclesiastical patrons did not prevent Jordaens from continuing to work at the decoration of his own house in the Hoogstraat. It was at this period that he painted the eight ceiling pictures for a room in the rear building, depicting *The story of Psyche*. These are now in the possession of the descendants of a previous owner of the house, who had them removed to his own home; one bears the date *1652*, which is probably the year in which the series was completed.

Jordaens was nearly sixty, but he was still robust and enjoyed good health, as can be seen from a *Self-portrait* at Munich [250], showing him dressed in an ample robe and holding a document. Although marked by the years, he gazes at the spectator with a resolute and self-confident expression. This painting dates from the end of the 1640s: an engraving after it by Pieter II de Jode[81] was published in 1649 in Johannes Meyssens's *Images d'hommes d'esprit sublime, qui, par leur art et science, devroient vivre éternellement et dont la louange et renommée fait étonner le monde*.

Some documents of the early 1650s show Jordaens as a designer of cartoons for a particular sort of tapestries, the subjects of which are referred to as 'Horses in Action' or ' Large Horses'. The Antwerp dealer Frans de Smit possessed two such cartoons on 5 July 1651;[82] on 21 November 1651 another Antwerp merchant, Carlos Vincque, placed an order with the Brussels weavers Everaert Leyniers and Hendrik Rydams for a set of seven tapestries;[83] and on 18 November 1654 a third Antwerp merchant, Jan de Backer, commissioned the firm to repeat the same series.[84] A similar set of tapestries of horses, entitled *The riding-school*, is in the Kunsthistorisches Museum in Vienna.

While most documents relate to Jordaens's work as an artist, some throw light on his religious convictions; in particular, they make it clear that in later life he belonged to the Reformed church. As early as 1649 he was the object of grave suspicion in official quarters on account of a journey to Brussels with his son in May of that year. Summoned to explain his conduct, on 23 July 1649 he swore 'by God and his saints' that the only purpose of the journey was to pay some legal costs in respect of a suit against one Frans Rijssels.[85] Some years later, between 1651 and 1658, a much more serious incident took place, according to a document in the national archives in Brussels, in which the bailiff of Antwerp, Nicolaes van Varick, recorded his official receipts and expenditure from 1 January 1651 to the end of June 1658 and also the penal sentences pronounced during that period.[86] Under this last heading can be read: 'The painter Jordaens, on account of certain scandalous writings, has given satisfaction in the amount of £240'. There can be no doubt that this large fine was exacted on account of Protestant writings, as the term 'scandalous' was then used to describe any action or publication that in any way attacked the Catholic church.

At the end of 1660 Jordaens, giving evidence in a lawsuit, took the oath 'by God' without adding 'and his saints' as Catholic regulations required.[87] In 1671, when he was seventy-eight, he and his daughter and maidservants were admitted to the communion of the Reformed congregation of Antwerp known as 'The Mount of Olives under the Cross'.[88] The Lord's supper was celebrated at intervals in the homes of different members of the community, and as far as is known it first took place in Jordaens's house on 24 December 1674. Subsequently the persecuted Calvinists assembled there on several occasions: on 18 March, 21 July and 28 December 1675, on 12 April and 25 December 1676, on 20 March and 25 December 1677, and finally on 9 March and 16 June 1678.[89] Jordaens and his daughter Elizabeth, who lived with him, died on the night of 18 October 1678, and were buried under a single tombstone in the Protestant cemetery at Putte, a village just over the Dutch frontier.[90] They rest beside Jordaens's wife Catharina, who died on 17 April 1659 and was buried there also.[91] It may be added that a number of works from Jordaens's later period, especially drawings, are connected with Protestant and especially Calvinist writings.[92] Granted that the subjects may have been imposed on him by patrons, at least they bear witness to the good relations he maintained with Protestant circles.

Although it is clear that he belonged to the Reformed church at least from 1650 until his death, the reasons for his change of faith or the exact time and circumstances are not known. It has been suggested that his parents were Protestant, but there is no evidence for this and every reason to suppose the contrary. His father's funeral took place at the cathedral in 1618, as did his mother's in 1633; his brother Abraham entered the order of the Hermits of St Augustine, while his sister Catharina was a Franciscan tertiary; two other sisters were *béguines*, Magdalena at Antwerp and Elizabeth at Breda.

Jordaens's religious convictions may have been strongly influenced by his relations with Adam van Noort. It will be remembered that he was inscribed in the Register of St Luke's guild as Van Noort's pupil, that he married his master's eldest daughter and that the two artists spent a great part of their lives together. It is known from a documentary source, that Van Noort was himself a Lutheran. When Alexander Farnese conquered the Calvinist stronghold of Antwerp in 1585 he naturally regarded the existing civic militia with great suspicion. In order to purge it of Protestant elements he had a list of its members to be drawn up by districts,[93] from which it appeared that, as might have been expected, many of them had left the Catholic church: as far as artists were concerned, those who had done so were in a large majority. One such was 'Adam van Oort', resident in the first district, whose name is marked in the list with the sign denoting a Lutheran. Among other prominent artists who were marked as Protestants were 'Meerten de vos' (Lutheran) and 'henrick de Clerck' (Calvinist).

Although there is no firm evidence that Adam van Noort's pupil and son-in-law imbibed something of his religious views, there is equally no ground for disbelieving it. It is not conclusive, for instance, that Jordaens married Catharina van Noort in Antwerp cathedral. Catholic priests alone were empowered by law to celebrate a marriage and register it officially, and accordingly Protestants married in Catholic churches and had their children baptised there. The Catholic clergy winked at this practice, while the Protestants saw it as a mere formality and a justifiable means of avoiding the difficulties they would otherwise encounter in civil life. It seems a fair assumption that Jordaens was from a Catholic family and that he adopted the Reformed faith, probably owing in part

to the influence of his Protestant teacher and father-in-law; as to the date of his conversion one can only guess.

Although Jordaens's great reputation was no doubt the main reason for the important commissions he received from foreign courts during the second half of his career, it is probable that his adherence to Calvinism also played a part, especially as regards commissions from the United Provinces. Among the painters who, together with Jordaens, were invited to decorate the Orange Hall in the Huis ten Bosch was the Brussels court painter Gaspar de Crayer. He was to have executed the equestrian portraits of Princes Frederick Henry and Maurice of Orange-Nassau on their way to the battle of Nieuwpoort. These portraits, however, were never painted, for reasons given in a letter of 16 August 1649 from Constantijn Huygens to Amalia van Solms. Huygens stated that De Crayer had advanced all sorts of excuses in order to avoid carrying out the commission, but in Huygens's opinion his real reasons were religious and political, as the subject was 'trop Huguenot et Orangois pour estre exécuté dans Bruxelles'.[94] On the other hand, Catholic painters such as Theodoor van Thulden and Thomas Willeboirts Bosschaert made no difficulty about contributing to the decoration of the Orange Hall. In the same way, the Protestant Jordaens did not hesitate to paint altarpieces for Catholic churches, although he may have preferred in general to work for his fellow-Protestants.

The other official commissions that he carried out towards the end of his life were also from the Protestant North: he helped to decorate the new town hall at Amsterdam and the fireplace of the courtroom in the Landhuis at Hulst. The Amsterdam town hall, now the Paleis op de Dam, was inaugurated on 19 July 1655: however, the building was still far from complete, either inside or out, and it was many years before the decoration was finished. For the ceilings and chimney-pieces and for the first-floor gallery, a broad passage leading to the various municipal offices, recourse was chiefly had to artists from the Northern Netherlands, including Rembrandt, but Jordaens was also invited to take part in the work. On 13 January 1661 the clerk of the treasury noted that agreement had been reached between the city fathers on the one hand, and Jan Lievens and Jordaens, on the other, that each of them would paint a picture of Claudius Civilis for the ovals in the gallery for the sum of 1,200 guilders, 'without claiming any further amount by way of agreement or otherwise'.[95] Apparently the first work supplied by Jordaens met with such approval that other commissions followed: on 13 June 1662 the treasurers made arrangements to pay him for three pictures, including the Claudius Civilis already delivered 'for the niches in the large gallery of the town hall of this city'.[96] As a special mark of appreciation the city fathers presented Jordaens on 28 April 1662 with a gold medal 'struck to commemorate the peace with Spain'.[97] Nor was this the only sign of their esteem. On 27 November 1664 it was decided that 'in the next five years, beginning with the year 1665, no paintings shall be commissioned or bought for any part of the town hall, but that all such expense shall be eschewed for the aforesaid time'; but fourteen days later, on 12 December, a special exception was made in Jordaens's favour. 'It is agreed that the place in the gallery that has been made ready for a picture shall be occupied by a painting by Jordaens to complete the series he has already begun, since the aforesaid master is of such an age that he is unlikely to be able to execute works of art in five years' time; however, the resolution adopted yesterday on the same subject shall remain in force.' The clerk noted in the margin: 'Jordaens to supply a painting of David and Goliath'.[98]

In addition to this *David and Goliath* Jordaens had painted another biblical scene, *Samson routing the Philistines*, which formed a pendant to it in the eastern gallery. Besides classical and biblical scenes the burgomasters of Amsterdam had allotted considerable space to a patriotic subject, the insurrection against Rome of the Batavians led by Gaius Julius Civilis, an event associated symbolically with the struggle of the house of Orange against Spain. The Batavian series consisted of eight paintings, two each in the spandrels of the four corners of the gallery. Two were entrusted to Jordaens: *Gaius Julius Civilis attacking the Roman camp by night* and *The peace between Gaius Julius Civilis and the Roman leader Cerialis*.[99]

Jordaens's work for the Landhuis at Hulst—a small Zeeland town that changed owners several times during the Eighty Years' War and was finally conquered for the North by Prince Frederick Henry in 1645—was somewhat limited, consisting of three pictures painted in 1663 to decorate the large courtroom where they are still to be seen.[100] Placed around three sides of the chimney-piece, these represent the glorification of *Justice*.

It was also in 1663 that the Antwerp Academy was founded, at the request of St Luke's guild and, as King Philip IV's charter declared, 'after the model of Rome and Paris'. In 1664 the city gave the guild temporary permission to use the eastern part of the gallery above the Exchange building for its meetings and for the Academy's educational purposes. A stage was erected in this 'Schilderskamer' for the use of rhetoricians. The chamber of rhetoric known as 'The Gillyflower' had been associated with St Luke's guild since 1480, and in 1660 a second chamber, 'The Olive Branch', had followed suit. This union of the fine arts with literature and drama should not cause any surprise: from the mid-sixteenth to the mid-eighteenth century treatises on art and literature almost invariably identify the close relation between painting and poetry, emphasising that although the 'sister arts' differed in the manner and means of expression, they were identical in their fundamental nature, purpose and content. The saying ascribed by Plutarch to Simonides, that pictures are silent poetry and poetry is the voice of painting, was constantly quoted with approval, as was Horace's dictum that poetry is a kind of pictorial art: *ut pictura poesis*.

Many artists offered works of their own to decorate the Schilderskamer. In 1664 Artus Quellinus presented a life-size bust of the Marquis of Caracena, governor-general of the Spanish Netherlands, who had done much to bring about the foundation of the Academy; in 1665 Theodoor Boeyermans painted a ceiling-piece representing *Antwerp, nurse of painters*; in 1666 Dirck van Delen adorned the Schilderskamer with an allegorical scene of *The union of St Luke's guild and the Gillyflower*, in which the figures were painted by Boeyermans. For some time to come, artists offered works to decorate the Schilderskamer on all sorts of occasions. One of the earliest to do so was Jordaens, who in 1665 presented three large canvases. One of these, entitled *Justice* or *Human law founded on the divine*, with the inscription *Arti Pictoriae Iacobus Iordaens Donabat*, was used as a wall decoration; the other two, which jointly formed an *Homage to the poet*, embellished the ceiling together with Boeyermans's work already mentioned, thus again emphasising the close relationship between poetry and painting.

The guild showed its gratitude to Jordaens by presenting him with a chased silver ewer accompanied by complimentary verses. Taking into account the grandiloquence of the time, this rather lame panegyric nevertheless testifies to the respect and veneration in which Jordaens was held.[101] At the time when he

received this honour he was already over seventy, but was still in good health and full of energy. The Hamburg painter Mathias Schuyts, who called on him in 1669, noted on the fly-leaf of his copy of Carel van Mander's *Schilder-Boeck*: 'I found him still painting industriously when I visited him at Antwerp: he was very kind and polite and took me all over his house, showing me the many works of art in his possession, both by himself and others'.[102] Joachim von Sandrart, who had also known him personally and was his first biographer, wrote that in his seventy-eighth year, *ie* in 1671, Jordaens was still vigorous and living comfortably at Antwerp, and had become very well off and much respected.[103] However, the years had taken their toll and the master's life was nearing its end. When the Prince of Orange, accompanied by Constantijn Huygens, visited him on 7 June 1677, he found him seated in a chair in which he was carried about; Huygens noted in his diary 'Il disoit avoir 86 ans et radottoit parlant mal à propos de temps en temps'.[104]

Jordaens and his daughter Elizabeth, who lived with him till the end, both died on the night of 18 October 1678.[105] There is little doubt that they fell victim to the 'Antwerp plague', a disease that raged for three months of that year, sparing no household and wiping out nearly a third of the city's population. No will by Jordaens is known to exist, but he probably made one, for in 1679 his son-in-law Johan II Wierts, councillor at The Hague, presented the Maagdenhuis (home for orphan girls) at Antwerp with the sum of twenty-five pounds Flemish and a picture of *The washing and anointing of the body of Christ* [57] 'on account of the kindness which the late Jacq. Jordaens felt towards the poor'.[106]

III

Formative years

to *circa* 1618

In 1608, seven years before Jordaens became a master in St Luke's guild, Rubens (1577–1640) returned to Antwerp after a long stay in Italy. The city was full of activity, and Rubens, like other painters, eagerly seized the opportunities offered to artists as a result of the Twelve Years' Truce (1609–21). A few months after his return he had received a commission from the city magistrates to paint an *Adoration of the Magi* for the chamber of estates in the town hall, where negotiations for the Truce were to be conducted. Probably about the same time he painted *The glorification of the Eucharist* for the Brotherhood of the Holy Sacrament in the Dominican church, now St Paul's, and also, for an unknown patron, an *Adoration of the shepherds* for the same church. Still more important was the commission in 1610 for a *Raising of the cross* by the churchwardens of St Walburga's [8], while in 1611 the Arquebusiers' guild commissioned a *Descent from the cross* for their altar in the cathedral. In the first few years after his return, Rubens also painted various works for guildhalls and the residences of wealthy Antwerp magistrates and merchants, such as a *Samson and Delilah* for the home of Nicolaas Rockox.[1] Rubens soon became celebrated and much sought-after, and his paintings made a great impression on Jordaens and other young artists.

Apart from Rubens, the most important figure painter then working in Antwerp was Abraham Janssens (1575–1632). His *Allegory of the Scheldt and Antwerp* [9], commissioned by the aldermen in 1609 and completed in the following year, is scarcely inferior in composition and colour to Rubens's *Adoration of the Magi*, near to which it was hung in the council hall. Janssens's mastery of tonal values enabled him in a number of works to achieve a harmonious balance of strong local colours. This effect, which would not have been lost on the young Jordaens, combined with broad, vivid drawing and cool lighting in the style of Caravaggio, gave an especially decorative character to some of Janssens's works. The sculptural and monumental aspect of his figures is sometimes pushed to the point of rigidity, but this very lack of inward animation serves to emphasise the firm, stylised composition which entitles him to a place, albeit a more modest one, in Rubens's company.[2]

Otto van Veen (1556–1629) was one of the most admired painters in Antwerp until the appearance of his gifted pupil Rubens, whom he influenced considerably in the latter's pre-Italian days. Van Veen's work gives an impression of strength, monumentality and seriousness of purpose. His close-knit compositions, the models for which were taken from Italian art, always included a limited number of figures in close-fitting garments, depicted organically and

8 RUBENS
The raising of the cross
circa 1610–11
panel, 462 × 341cm (wings 462 × 150cm)
Antwerp, Cathedral

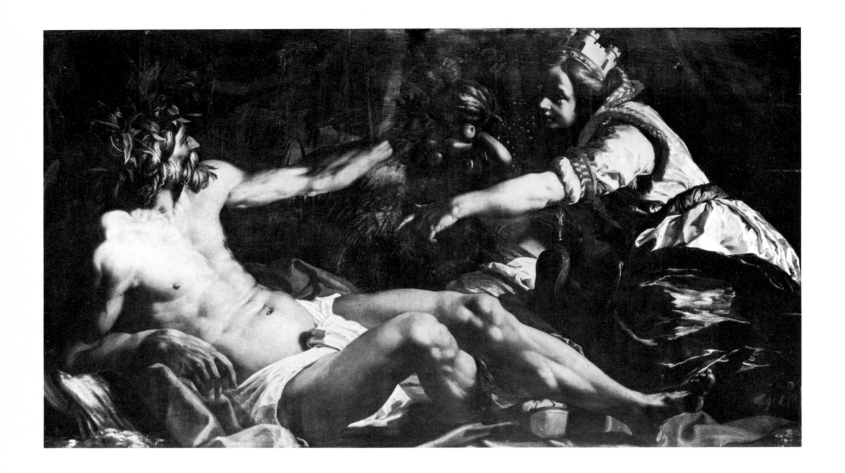

9 ABRAHAM JANSSENS
*Allegory of the Scheldt and
Antwerp*
1609–1610
panel, 174 × 308cm
Antwerp, Koninklijk Museum
voor Schone Kunsten

giving a sense of weight to the scene [10]. His art in fact belongs to what Walther Friedländer called the pre-Baroque style.[3] There is no sign that Van Veen influenced Jordaens directly in any way, but he may have done so indirectly in that his style can be detected in some of Rubens's early works.

Of Rubens's three masters, Van Veen was the only one to influence his pupil, in whose painting is virtually no trace of Adam van Noort or the landscape painter Tobias Verhaeght. Adam van Noort (1562–1641) was also Jordaens's teacher and would be important for that reason, were it not that his surviving work [11] shows him to have been a rather weak personality who, in consequence, did not influence Jordaens to any lasting extent. He is described in the Antwerp Register as a 'conterfeyter' or 'Pictor iconum', but no portrait by him has yet been discovered. Most of his compositions are reminiscent of Frans Floris; some point to sympathy with certain trends of Dutch Late Mannerism or Classicism, while his latest work even shows the influence of his more gifted pupil Jordaens. It is possible, however, that a certain affinity of mind between Jordaens and his father-in-law led them both to prefer subjects with Calvinist associations, such as *Christ blessing children* or *Paul and Barnabas at Lystra*.

10 OTTO VAN VEEN
The calling of St Matthew
panel, 269 × 162cm
Antwerp, Koninklijk Museum
voor Schone Kunsten

11 ADAM VAN NOORT
Christ blessing children
panel, 87 × 195cm
Brussels, Musées royaux des
Beaux-Arts

12 MAARTEN DE VOS
Marriage-feast at Cana
1596–97
panel, 268 × 235cm
Antwerp, Cathedral

Works by artists of the preceding generation were also well known to aspiring artists in Antwerp around 1615. Within a year of the iconoclastic riots of 1566, work began on repairing the damage and replacing destroyed pictures and statues. Altars were again plundered and many works of art removed during the less violent wave of iconoclasm in 1581, which meant that several churches were refurnished after the return to Catholicism in 1585. Many new altarpieces were commissioned in the years following 1566 and 1585, and a study of those that have survived suggests that most of them were the work of Maarten de Vos (1532–1603), who dominated church decoration until the late 1590s, thus ensuring the continuity of traditional artistry in Antwerp at a time of political and economic transformation. A follower of Frans Floris, De Vos went to Italy in the 1550s and, according to Carel van Mander, visited both Rome and Venice. After his return he enriched Antwerp with animated figure paintings against a sharply receding background reminiscent of Tintoretto [12]. After Floris's death some of his pupils, including the brothers Ambrosius and Frans I Francken, were attracted by De Vos's art and became followers of his, as is shown by various paintings of theirs in Antwerp and provincial churches. The Floris school split into a conservative group which continued in the style of the master's middle and late period, and a group of Late Mannerists influenced by De Vos. The first group included Adam van Noort and Crispijn van den Broeck, while among De Vos's followers were Hendrik de Clerck, who worked

chiefly in Brussels, and Maerten Pepijn. There is little or no sign that the young Jordaens paid much attention to the work of any of these artists. None the less his use of large figures functionally involved in the composition, their remarkable immediacy and strongly plastic character are features constantly found in the figure painting of the sons of Quentin Metsys, in Floris and in the followers of De Vos in his late period.

The young Jordaens must have been extremely productive, as quite recent research has shown. As regards the dating of works produced shortly after he became a free master in 1615 the only firm evidence consists of three signed and dated pictures: an *Adoration of the shepherds*, 1616 (New York) [38], *The daughters of Cecrops finding the child Erichthonius*, 1617 (Antwerp) [49], and *The adoration of the shepherds*, 1618 (Stockholm) [55]. After these there is not a single dated or datable picture for the next ten years,[4] the next reliable indication being *The martyrdom of St Apollonia* [94] painted in 1628 for the Augustinians of Antwerp.

Jordaens was twenty-two years old when he became a free master in 1615, and the question arises whether he did not already have some works to his credit. He entered Adam van Noort's studio in 1607, at the age of fourteen, and in view of his gifts it seems fair to suppose that he painted works of his own from about 1612 onwards.[5]

The identification of a painter's earliest works is a delicate task. A precocious and talented artist like Jordaens, confronted with traditional models from the past and with the works of his contemporaries, will be eager to adapt them to his own personality and draw useful lessons from them for his own development, and this means that his output will be variable in character. He will experiment, choose from various sources, adopt the palette or composition scheme of one or another artist, and thus to some extent remain caught up in the work of his contemporaries or predecessors. It is not surprising, therefore, if his earliest works on the one hand show unexpected limitations, while on the other they display a creative, individual quality as the borrowed elements are translated into a new, personal language. This antinomy of tradition and personal style would make it impossible to distinguish Jordaens's earliest pictures from commonplace copies if the mature fruits of his developed talent were unknown. An experienced artist who became so powerful and self-assured must have developed along the same lines as those he adopted as a young painter, and some indication of what was to come must be discernible in his earliest works.[6]

This paradox where the formation of an individual style excludes and replaces tradition and yet at the same time reaches out to it and is nourished by it, is visible in a copy by Jordaens, now in the National Museum of Western Art at Tokyo [13],[7] after Rubens's *Lot and his family fleeing from Sodom, circa* 1613–15, now at Sarasota, Florida. The copy must have been painted very soon after the original, and it is clear that Jordaens tried to follow his model closely both in composition and in detail. Yet he saw it, so to speak, through the prism of his own temperament: the figures are shorter and less graceful, the contours are markedly undulating and dynamic, and the individuality of the copy is accentuated by the artist's boldness of touch and a bright yet cool colour-scheme in which heliotrope, lilac, sharp yellow and virulent green play an important part. Many of these features continued to characterise Jordaens's work for years to come; in some respects this painting shows in embryo tendencies that prevailed throughout his life, such as a predilection for robust, healthy, powerful forms and the expressive use of brushwork.

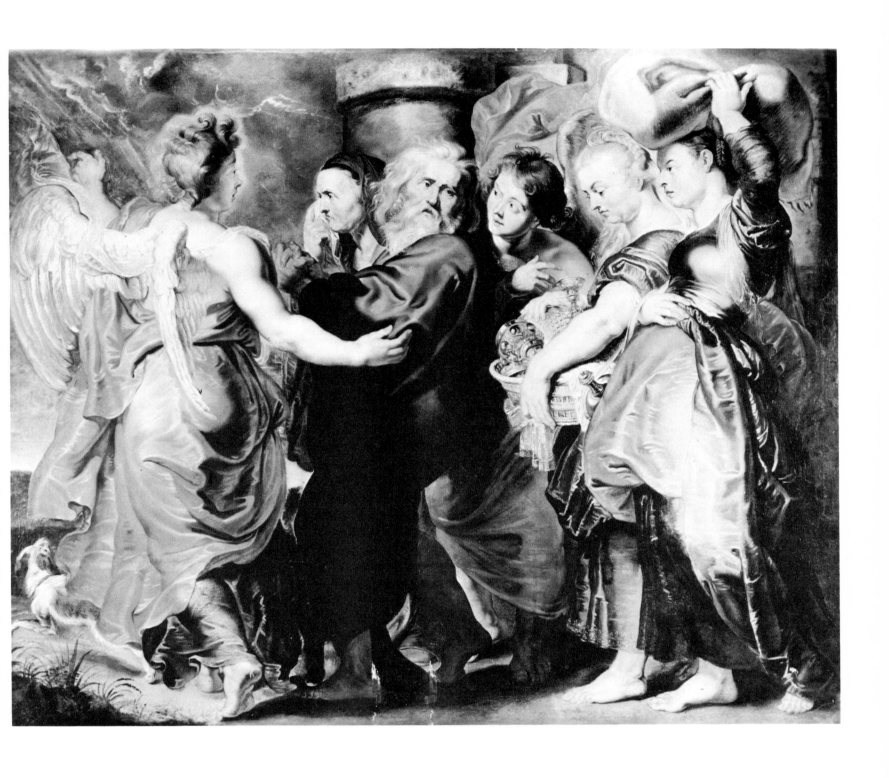

13 *Lot and his family fleeing from Sodom*
circa 1613–15
canvas, 169.5 × 198.5cm
Tokyo, National Museum of Western Art

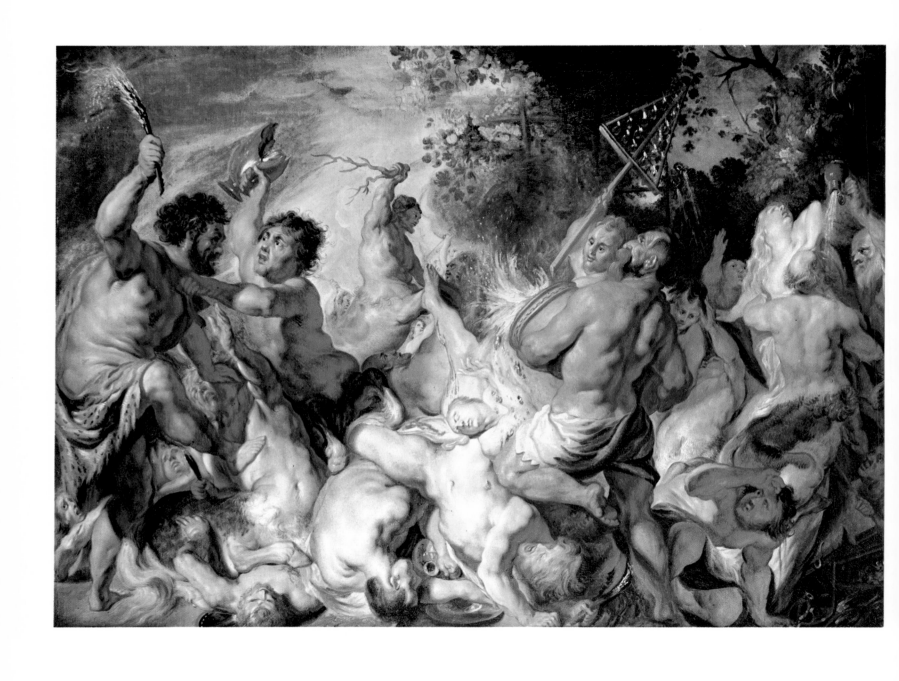

14 *The battle of the Lapiths and Centaurs*
circa 1615
canvas, 77 × 105cm
London, Agnew's (1975)

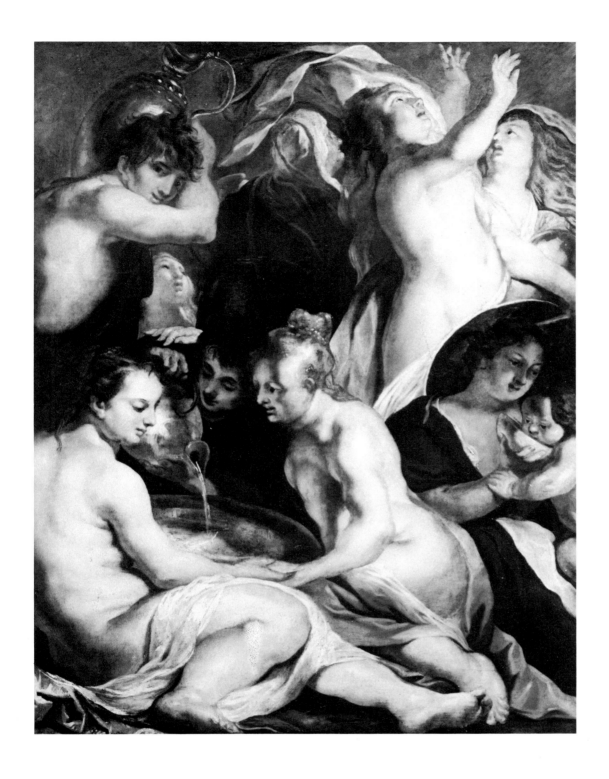

15 *Moses striking water from the rock*
circa 1615
panel (fragment), 107 × 82cm
Ghent, private collection

The fact that Jordaens copied Rubens points to a lasting interest in his work, which remained one of Jordaens's chief sources of inspiration throughout his career. It can be said without exaggeration that his artistic development followed close behind Rubens's at all times, but especially during the earliest years of his activity, when a number of important compositions by the older master aroused an immediate reaction and stimulated him to paint his own versions of them. Thus Rubens's *Return of the Holy Family from Egypt, circa* 1615, at Hartford, Connecticut [25], inspired a work of the same title by Jordaens, now at Providence, Rhode Island [24].[8] The rendering of the landscape and the grouping of the three main figures leave no doubt as to the relationship. Three angels who accompany the travellers and strew flowers on them from above are reminiscent of similar heavenly personages in other works by Rubens such as *The rout of Sennacherib, circa* 1612–14, at Munich. The overcrowded and decentralised composition and the bright, shimmering colour-scheme show clearly that at this time Jordaens's art was still dominated by Late Mannerism.

Similar traits can be found in *The baptism of Christ*, one of Jordaens's earliest known works [26]; in a private collection at Düsseldorf in 1930, it has since disappeared.[9] Its composition goes back to the numerous Late Manneristic cabinet-pieces that Hendrik van Balen (*circa* 1575–1632) painted for the Antwerp bourgeoisie during the first two decades of the century. This 'little master', a teacher of Van Dyck, was of some importance in Antwerp at the beginning of Jordaens's career. Although rooted in the Flemish tradition, his art escaped the ossification of traditional forms. Models from Venice, reaching him chiefly through the German Hans Rottenhammer, caused him for a time at least to strike out on a path independent of Rubens.[10] Noteworthy among his cabinet-pieces are the graceful, witty, mythological scenes showing attractive figures against a rapidly receding background. The general resemblance can easily be seen by comparing Jordaens's *Baptism of Christ* with a decorative piece such as *Diana and Actaeon, circa* 1605–1608, at Kassel [27]. Still more noticeable is the resemblance to Van Balen's own *Baptism of Christ* in the Vanderkelen-Mertens Museum at Louvain,[11] where the figures of Christ and John are similarly posed in the foreground. Both pictures show a seated woman on the left with a child on her lap, and the landscape is conceived in the same general way. It is typical of Jordaens, however, that he omits the angels watching the event from the air or from the ground, thus diminishing the idealistic aspect and presenting it as a down-to-earth incident among solid human beings. The way in which the figures' complexions are varied according to age and sex is generally Manneristic, but the sinuous dividing line between light and shadow on the exposed parts of their bodies is peculiar to Jordaens. His young, forceful personality is chiefly seen, however, in the strength and plasticity of the figures; while the almost obtrusive soles of the feet reflect realist tendencies which announce a Caravaggesque technique.

Spurred on by an irresistible creative impulse, around 1615 Jordaens designed a number of compositions which have various features in common with *The baptism of Christ*: the earliest of these appear to be *Moses striking water from the rock*, *The battle of the Lapiths and Centaurs* and *The rape of Europa*. The picture of Moses was subsequently cut down on both sides; only a fragment now remains, in a private collection at Ghent [15].[12] This shows the Israelites quenching their thirst after the miracle has taken place. Moses cannot be seen, but the attitudes of the figures show that he must have been on the right. *The battle of the Lapiths and Centaurs* [14][13], exhibited London, Agnew's, 1975,

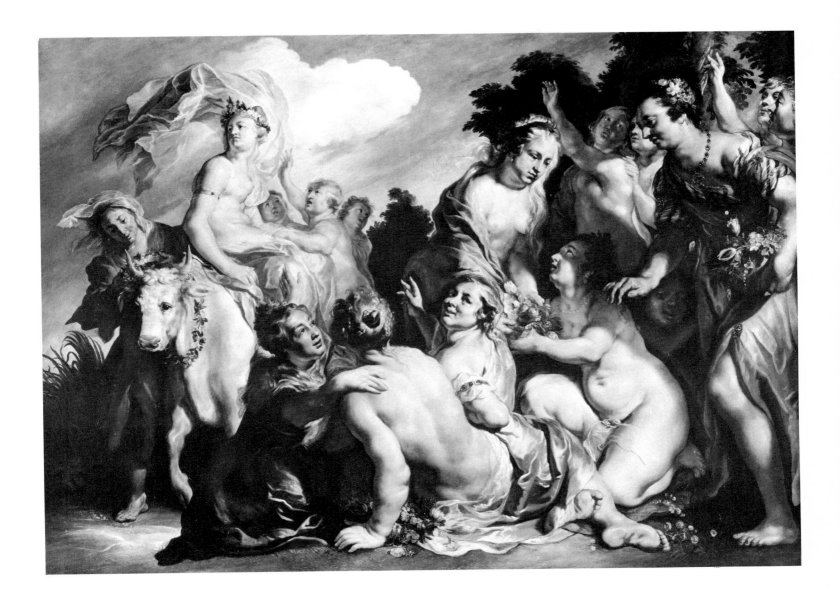

depicts a Homeric struggle between two mythical races, in which it is hard to distinguish friend from foe. Invited to the wedding of Hippodameia and Peiri-thous, king of the Lapiths, the neighbouring Centaurs, heated by wine, at-tempted to carry off the bride; a fight ensued in which the Lapiths were victorious. A tumultuous and imaginative composition of this sort is unthink-able without the example of such works from Rubens's studio as *The rout of Sennacherib, circa* 1612–14, at Munich, or *The conversion of St Paul, circa* 1615, formerly in Count A. Seilern's collection in London – both subjects lending themselves to a predilection for scenes of violent movement. Jordaens's habit of filling the composition with figures to produce, as it were, a monumental and plastic bas-relief is particularly striking and was to be visible in his work for many years to come. The monumental quality of the scene is enhanced by its being shown from below, in a manner characteristic of Rubens during the first years after his return from Italy. Better structured and hence easier to take in as a whole is *The rape of Europa*,[14] formerly in the collection of Colonel H. E. Pateshall, Allensmore Court, Hereford [16]. The subject is taken from Ovid's

16 *The rape of Europa*
circa 1615
canvas, 173 × 235cm
Whereabouts unknown
(formerly in the collection of
Col. H. E. Pateshall, Allensmore
Court, Hereford)

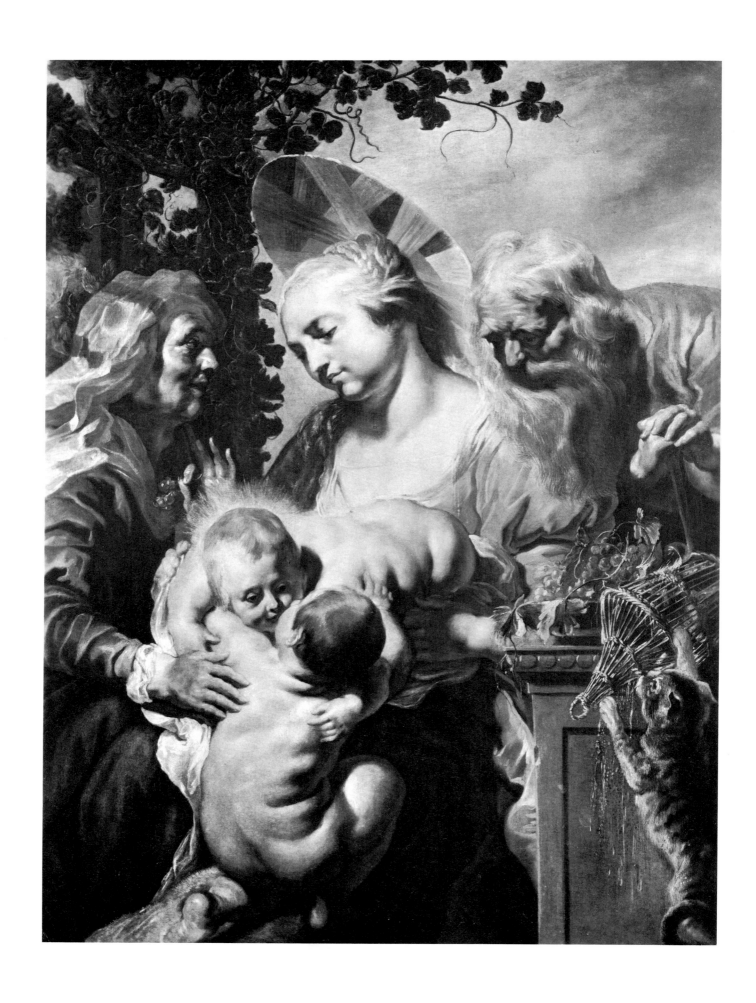

17 *The Holy Family with St Elizabeth and the infant St John*
circa 1615
canvas, 155 × 113cm
Brussels, Musées royaux des Beaux-Arts

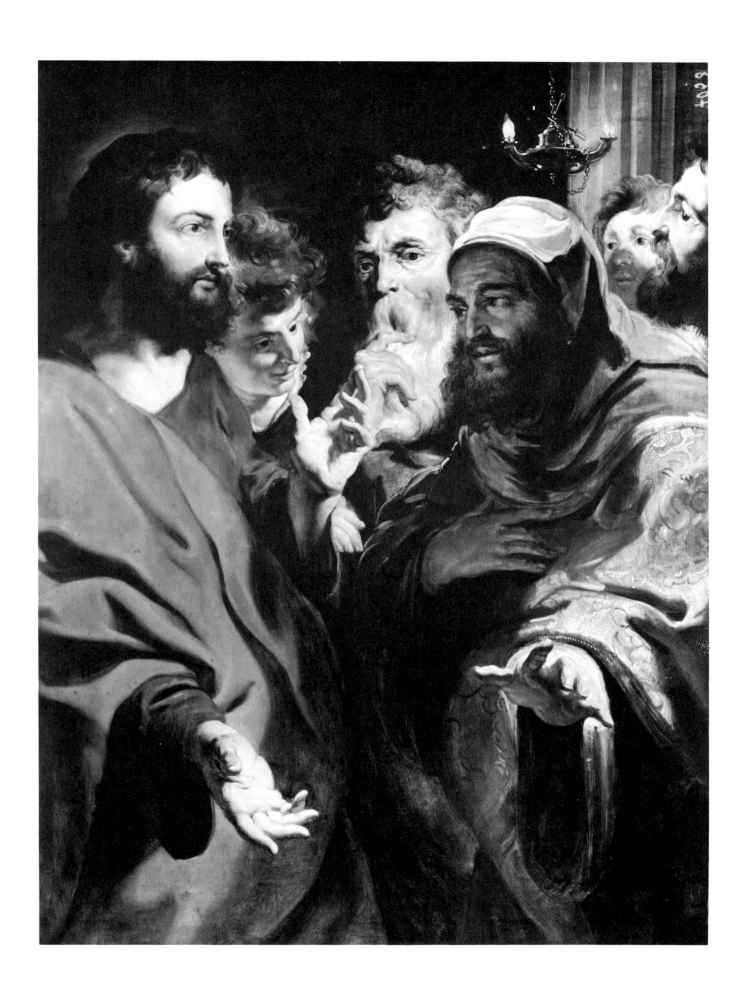

18 *Christ instructing Nicodemus*
circa 1615
panel, 112 × 83cm
Brussels, Musées royaux des Beaux-Arts

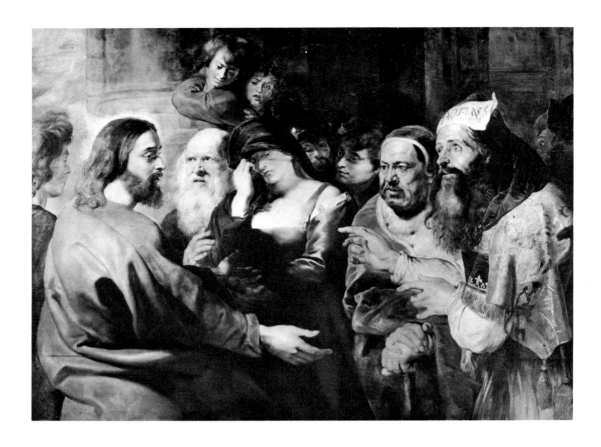

19 RUBENS
The woman taken in adultery
circa 1612–13
panel, 122 × 198cm
Brussels, Musées royaux des
Beaux-Arts

Metamorphoses (II, 833–75), the painters' bible of profane themes, and shows
Jupiter as a white bull plunging into the sea with the daughter of the Phoenician
king Agenor on his back. Another small *Rape of Europa* sold at Sotheby's,
London, 16 July 1980 [20],[15] shows a later point in the story: the sea voyage
from Phoenicia to Crete, accompanied by Neptune and his attendant naiads.
Here are all sorts of motifs, poses and gestures from Rubens's compositions, *eg*
The birth of Venus at Sans-Souci, or *Neptune and Amphitrite* formerly at Berlin,
both from *circa* 1614–16.

Mythological scenes like *The battle of the Lapiths and Centaurs, The rape of
Europa* and many others were of course not painted for church purposes but to
adorn official buildings, guildhalls and luxurious upper-class homes. None the
less it is surprising at first sight that such paintings of 'pagan' themes were
commissioned by the Catholic élite of the Southern Netherlands. A look at the
church's adaptation of classical iconography will elucidate this seeming para-
dox. The fourth-century Fathers were confronted by an antique culture which,
while contrary to their own faith, enjoyed enormous prestige and had played a
part in their own upbringing. They had no choice but to adopt what they could
neither do away with nor replace. Hence the pagan inheritance was absorbed
into the tradition of the church. This did not take place without resistance:
throughout the Middle Ages many theologians and rulers uttered warnings and
protests against those who kept alive the memory of the heathen gods. With the
Renaissance, the culture of antiquity was virtually glorified, in the face of
growing opposition. In Italy and the countries under its influence, the sixteenth

century witnessed the domination of classical mythology in both art and literature. It might have been expected that the Counter-Reformation would be a period of stricter and more systematic opposition, and that the Council of Trent would enforce a regime of austerity in the realm of art, with the heathen gods as its first victims. This was not so, however, as the culture of the clergy was subject to the same conflict as it had been in early Christian times. Nurtured on Greek and Roman literature, even the most pious of them could not shake off their classical attainments and habits of thought: as humanists they continued to admire what they condemned, or ought to have condemned, as theologians. Thus they reconciled the irreconcilable, and assigned a role to the heathen deities by making them incarnate ideas and moral principles. Gods and goddesses could by their actions inspire love of good and hatred of evil, provided their deeds were interpreted symbolically, and thus allegory became a moral antidote to mythology. The Jesuit programme of education showed what good use could be made of such a delicate and flexible instrument as allegory, and mythology assumed a place of honour in the integration of heathen literature with Christian upbringing. It is no wonder that the teaching of pagan fables, justified not only on literary but on moral grounds, left deep traces in the minds of the upper classes, whose education was mainly in Jesuit hands, and that they had no scruples about decorating their homes with mythological scenes.

20 *The rape of Europa*
circa 1615–16
panel, 55.5 × 92.5cm (heavily restored)
Whereabouts unknown; sold at Sotheby's, London, 16 July 1980 (lot 61)

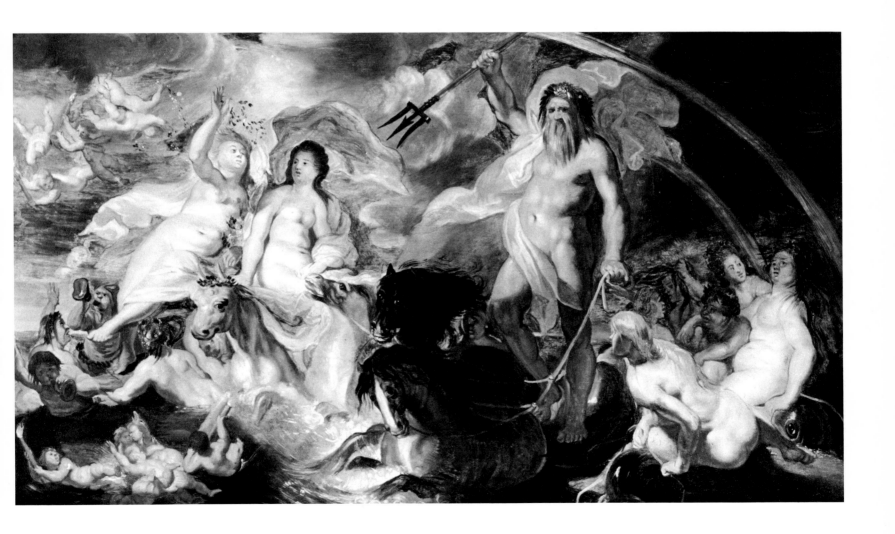

The church itself took a more cautious view, realising the dangers that lay concealed in classical allegory, which indeed was often a fraudulent device to confer respectability on improper stories. Moralised versions of Ovid's *Metamorphoses* were placed on the Index by the Council of Trent, evidently so that erotic tales should not be presented under a pious disguise.[16] This, however, had little effect on artists and their clients: the *Metamorphoses* remained a popular source of inspiration, and the many pictures based on them gave satisfaction to the paradoxical feelings of Christian humanists. One of the most important publications in this connection was Carel van Mander's *Uytlegghingh op den Metamorphosis Pub. Ovidij Nasonis*, which appeared at Haarlem in 1604. The author was a man of liberal views for his day, and a glance at his work shows how, for instance, the tales of Jupiter's licentious amours could be made to reconcile profane learning with deep Christian faith. *The rape of Europa*, as represented in Jordaens's painting sold at Sotheby's [20], is interpreted by Van Mander as follows. After recounting the fable and quoting Plato and other

21 *Bacchanal*
circa 1615–16
panel, 78 × 110cm (all four sides subsequently enlarged to 93 × 130cm)
Whereabouts unknown; sold in Paris from the Nardus Collection, 1953

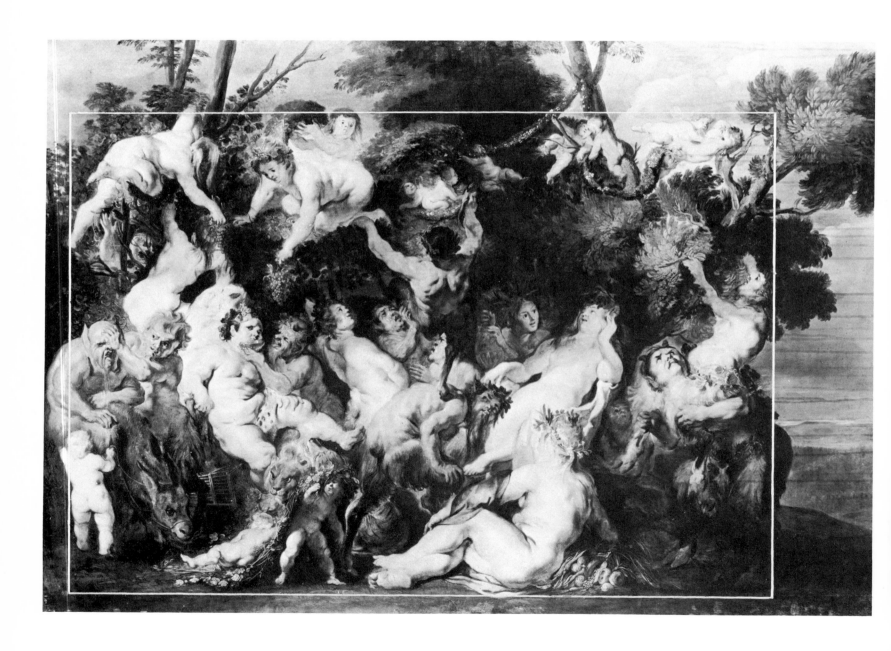

authors, he explains that: 'Europa, seated on the bull's back, and gazing back towards land as she is carried out to sea, signifies the soul of man, which is carried by the body through the sea of this world's troubles; and she gazes fervently from afar towards the shore from which she came, that is to say God her creator'.[17]

After a period during which the antique deities were taken less and less seriously and gradually declined into mere objects of erudition, they underwent an unexpected revival in the seventeenth century. Poussin represented them in dream-like fashion as symbols of the lost Golden Age. Artists like Rubens and Jordaens, on the other hand, evoked them in their original, crude reality: well-fed and flushed with wine, they lost part of their majesty but gained in animal vigour. Jordaens's *Battle of the Lapiths and Centaurs*, his *Bacchanal*, formerly with L. Nardus in Paris [21],[18] and *Nymphs and satyrs* (*Allegory of fruitfulness*), formerly at Oldenburg [22][19] show the gods and goddesses in all their primitive reality as flesh-and-blood creatures subject to human impulses.

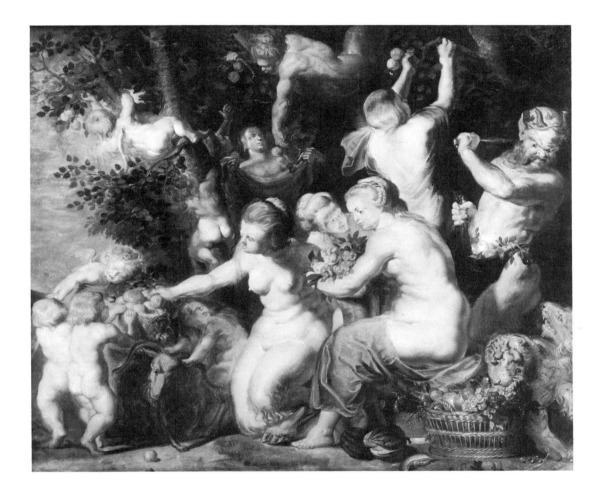

22 *Nymphs and satyrs* (*Allegory of fruitfulness*)
circa 1615–16
panel, 64 × 75cm
Whereabouts unknown (formerly in the Oldenburg Museum)

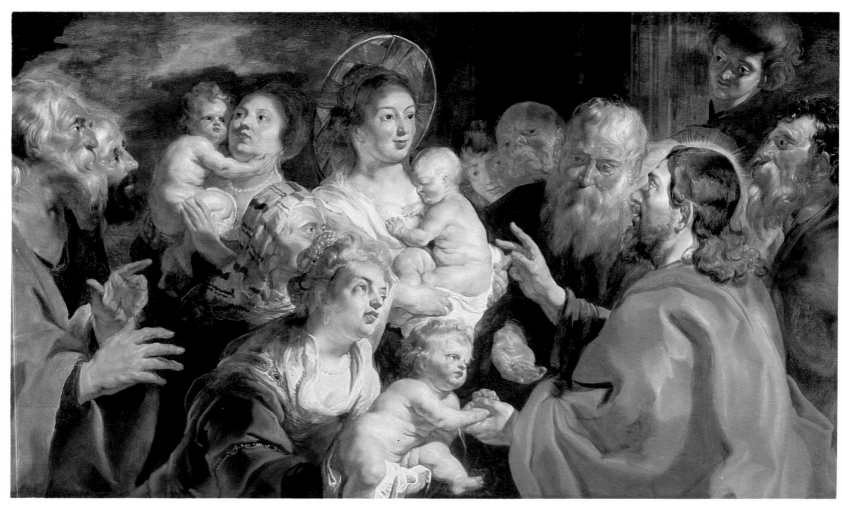

23 *Christ blessing children*
circa 1615
panel, 104 × 170cm
St Louis, Missouri, Museum

24 *The return of the Holy Family from Egypt*
circa 1615–16
canvas, 75 × 55cm
Providence, Rhode Island, Museum of Art, Rhode Island School
of Design

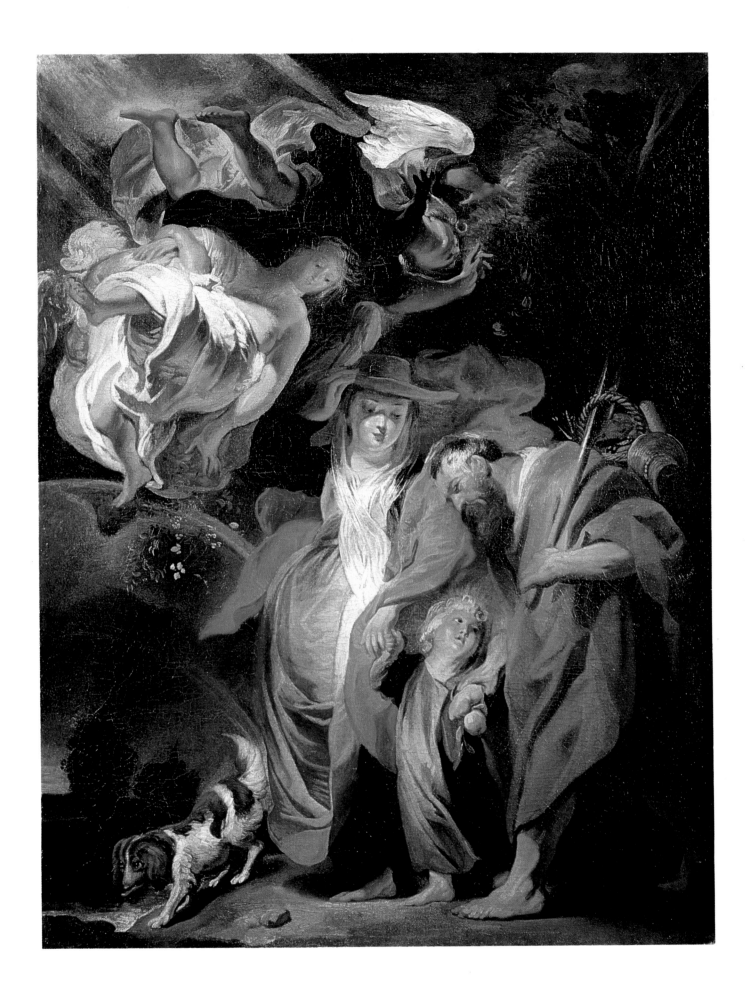

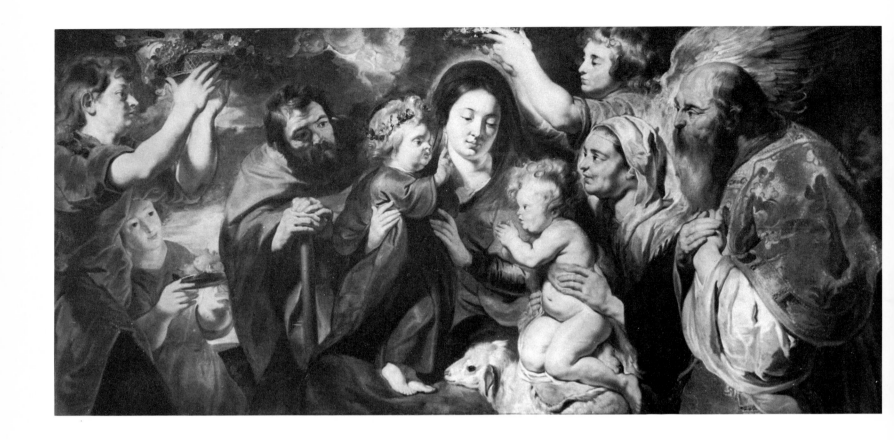

37 *The Holy Family with St John, his parents and angels* signed *I. Iordaens Inventor et Depingebat, circa* 1616
panel, 106 × 122cm (cut off at top and bottom)
Warsaw, National Museum

36 *Christ's charge to Peter (detail)*

Antwerp [40][37] respectively. Jordaens frequently painted the Holy Family, or the Virgin and Child, together with the infant St John and sometimes the latter's mother Elizabeth or both his parents. The idea that Jesus and St John the Baptist knew each other as children has no foundation in the Gospels, but Pseudo-Bonaventura relates in his *Meditationes* (XI) how the Holy Family met the little St John on their way home from Egypt: John offered wild fruit to Jesus, and the two afterwards played in the house of John's father Zacharias. This is the source of the many scenes, so popular in the seventeenth century, of the two children in each other's company.[38] Another tradition was that the Holy Family was accompanied by one or more angels on their way to and from Egypt:[39] this explains why in Jordaens's painting at Warsaw it is they who offer fruit to Jesus. In that painting the group of the Holy Family, John and Elizabeth shows a striking resemblance to the same group in Rubens's *Holy Family with St Elizabeth and the infant St John, circa* 1614, in the Wallace Collection, London. Even more noticeable is Rubens's influence on the Grenoble *Adoration of the shepherds, circa* 1617 [41].[40] Jordaens must have had very early access to the two compositions of the same title which Rubens had just executed: the

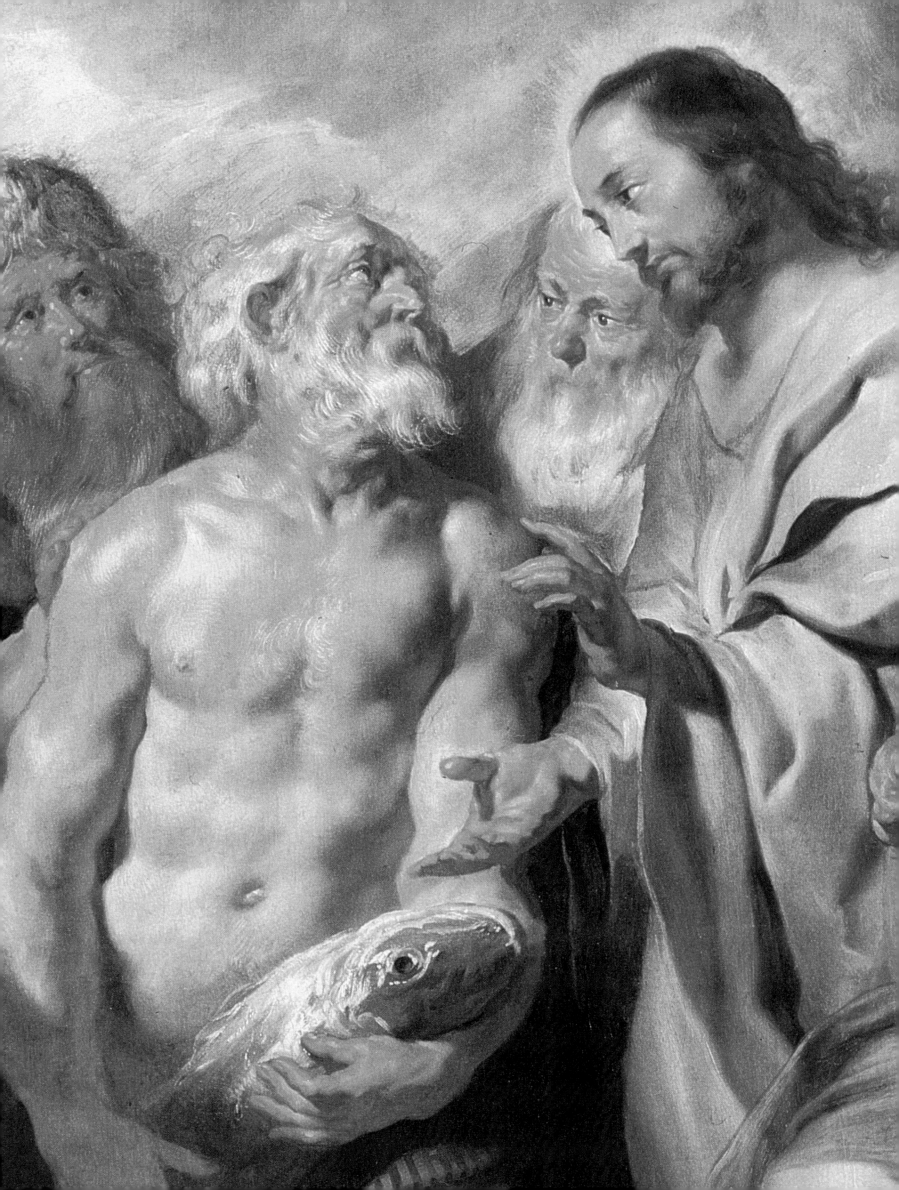

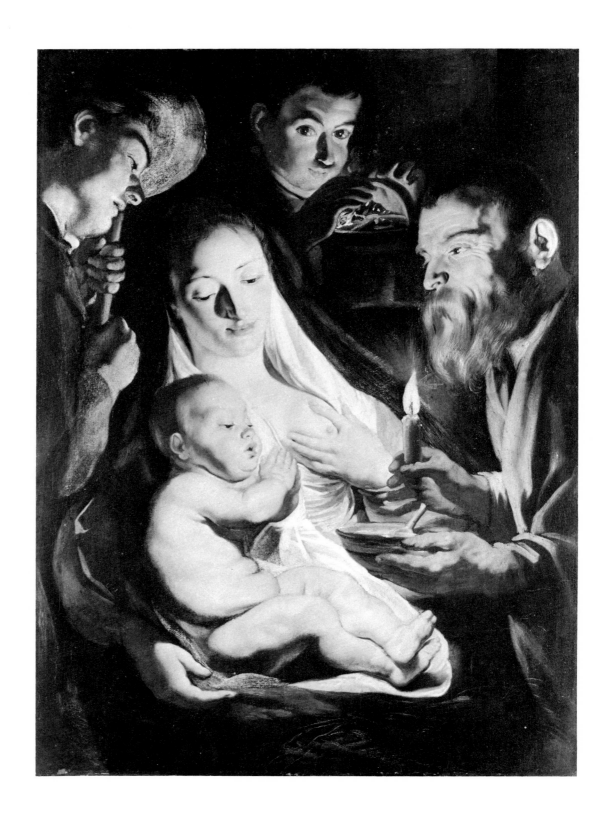

38 *The adoration of the
shepherds*
signed and dated *J. Jor 1616*
canvas, 113 × 81cm
New York, Metropolitan
Museum of Art

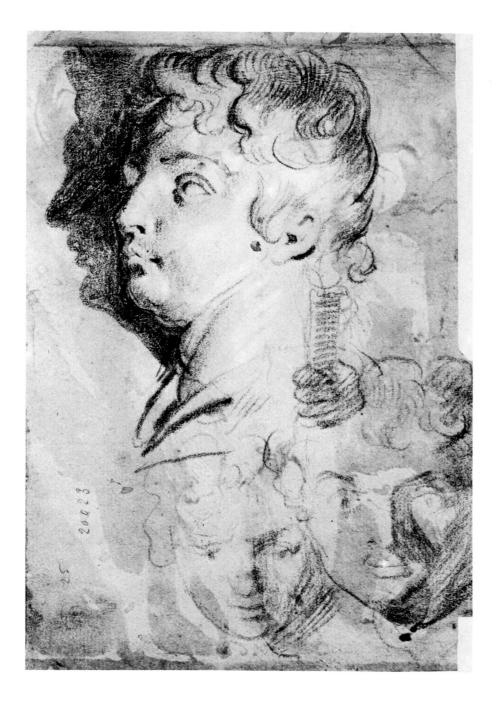

39 *Three studies of a sculpted
head and a study of a hand
holding a candle*
circa 1616–17
drawing, 227 × 152mm
Paris, Musée du Louvre

general design, the compact group of figures and the lighting all point to the oil
sketch in the Rubenshuis,[41] while on the other hand some particular motifs are
borrowed from the *predella* of Rubens's triptych in St John's church at Mech-
lin.[42] Nevertheless, both the painting at Grenoble and that at Antwerp are fully
in line with the development of Jordaens's individual vision: as in *The adoration
of the shepherds* in New York [38], the atmosphere is dominated by a sense of
peace, recollection and grateful admiration of the newly born Child Jesus.

Jordaens was always attracted by secular allegory, which inspired numerous
paintings including some of his best. Subjects of this kind enabled him to bring
together his careful observations of things and people and unite them into a
harmonious whole, while gratifying the taste of a society where such scenes were
immensely popular. He did not at once succeed in the genre, however, as may be

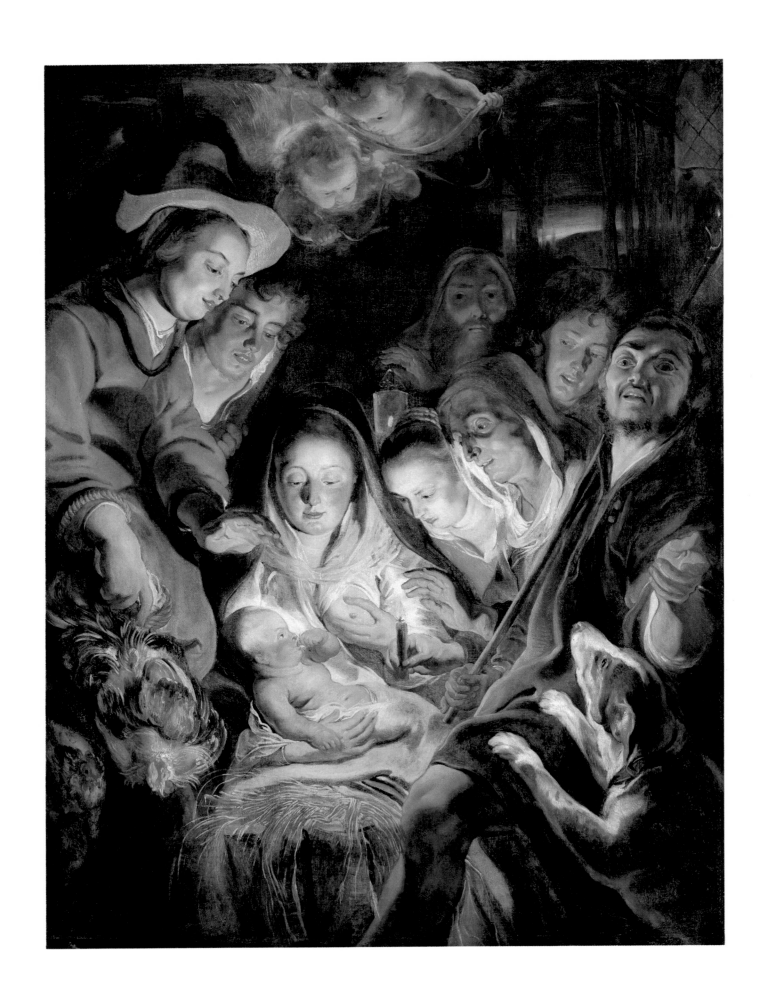

40 *The adoration of the shepherds*
circa 1617
canvas, 158 × 117cm
Antwerp, Koninklijk Museum voor Schone Kunsten

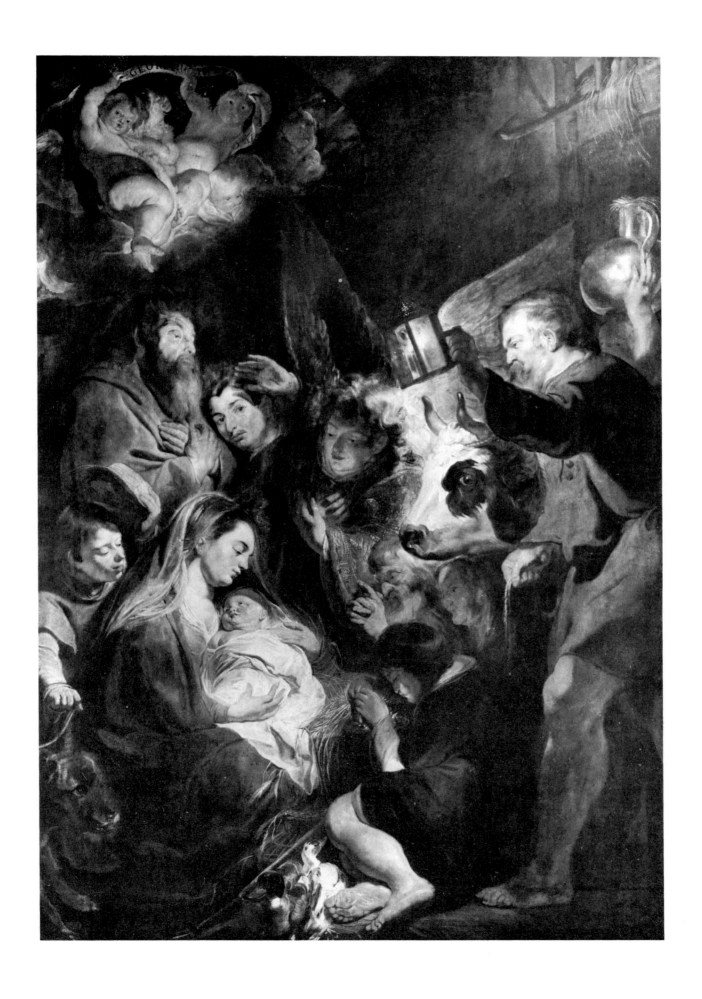

41 *The adoration of the shepherds*
signed *J. Jordaens Fecit, circa* 1617
canvas, 255 × 175cm
Grenoble, Musée des Beaux-Arts

73

seen from the *Allegory of knowledge*, which was with the Berlin art dealers Van Diemen in 1931 and is now lost [42].[43] Knowledge, personified by a greybeard leaning over a terrestrial globe and holding a pair of compasses (geometry), is protected by Minerva against Slander, in the semblance of a fury, and Ignorance, a naked man lying on the ground, while the glory of Knowledge is proclaimed by Fame with a trumpet. Knowledge promotes navigation, symbolised by Neptune seated in his chariot, and so brings prosperity, represented by the naked goddess of Fortune scattering coins. This striking work by the impetuous young artist is clearly inspired by such models as Rubens's *Triumph of the conqueror*. But Jordaens did not yet possess Rubens's ability to accentuate the principal figures and thus make the picture easy to take in: the figures are distributed in an unrhythmical and somewhat arbitrary fashion and the general effect is by no means one of clarity.

42 *Allegory of knowledge*
circa 1617
canvas, 117 × 168cm
Whereabouts unknown
(formerly with the art dealers
Van Diemen, Berlin, 1931)

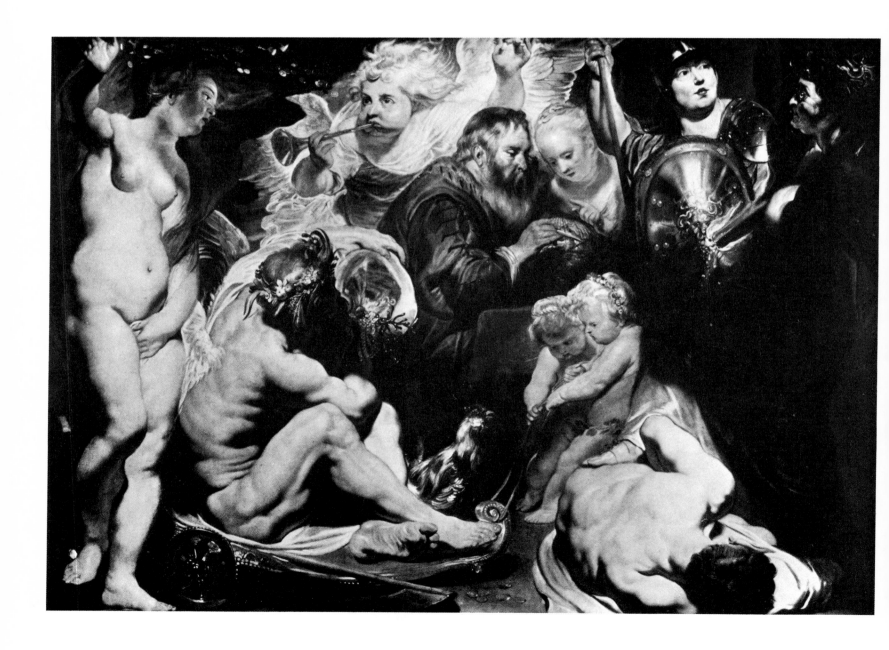

74

The *Allegory of fruitfulness* in Munich [44],[44] which is both clearer and more grandiose, is not the first of the long series of Jordaens's paintings on this theme, but is certainly one of the most important. Compared with the Oldenburg version [22], in which the figures are static after the classical manner of Rubens's early art, the Munich painting is conspicuous by its exuberance. Vigorous nymphs and satyrs surround the symbolic female figure of Fertility, to whom they have just presented an armful of fruit, while others are busy plucking fruit from the trees. Once again Jordaens owes a great debt to Rubens. The theme of this picture would not be conceivable without such works as Rubens's *Bacchanal* at Leningrad, and some figures are borrowed almost literally from different paintings of his: for instance the standing nymph in contrapposto, and the nymph crouching on the ground, can be found respectively in *Neptune and Amphitrite* formerly in Berlin and *Venus frigida* at Antwerp. But these borrowed

43 *The apotheosis of Aeneas circa* 1617
canvas, 258 × 295cm (originally 210 × 236cm)
Copenhagen, Statens Museum for Kunst

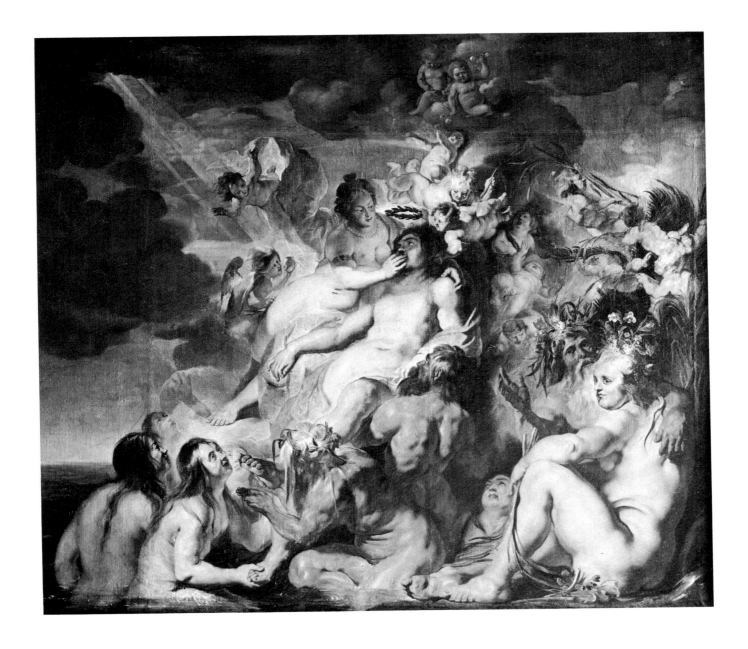

elements are transformed by Jordaens's vision in the same way as Rubens himself transformed traditional Flemish, antique or Italian models. While the *Allegory of fruitfulness* contains numerous features reminiscent of earlier works, in other respects it points to the future. The young artist, who never really goes beyond a flat surface or makes any use of perspective, nevertheless permits a small glimpse of landscape to show that the scene is set in an actual space. Later on he was to resort to this practice more and more.

Around 1617 Jordaens painted three scenes from Ovid's *Metamorphoses*. One of these, *The daughters of Cecrops finding the child Erichthonius*, bears the date 1617; *The apotheosis of Aeneas* and *Meleager and Atalanta* resemble it in style. *The apotheosis of Aeneas* at Copenhagen [43][45] is probably the earliest of the three. Subsequently enlarged, its original format was similar to that of the *Allegory of fruitfulness* at Munich; both canvases are large and almost square; in both of them the composition is developed around a central element, centripetally in the first and centrifugally in the second. The apotheosis of Aeneas (*Met.* XIV, 597–608) is a somewhat rare theme in seventeenth-century Flemish painting. Ovid relates that Venus, having made her father Jupiter promise that her son Aeneas would be deified, commanded the river Numicius to wash him clean of all earthly defilement. When this was done, the hero's mother touched his lips with nectar and ambrosia and transformed him into a god: this is the moment shown by Jordaens. The same technique of choosing a crucial moment to awaken the spectator's recollection of a whole story is used in *The daughters of Cecrops finding the child Erichthonius* in Antwerp (1617) [49].[46] From Ovid's account (*Met.* II, 522–61) Jordaens selects only the point at which, despite Athene's prohibition, Aglauros opens the basket in which the baby lies: nothing is shown of what preceded this moment, or of its consequences. For the composition and figures he based himself on Rubens's painting of the same subject, dated *circa* 1615–17, in the Liechtenstein Collection at Vaduz [50]; but whereas the latter emphasises the dramatic character of the discovery, Jordaens concentrates on the luxuriant beauty of the female nudes. Like *The daughters of Cecrops . . .*, *Meleager and Atalanta* at Antwerp [51][47] may be regarded as directly inspired by a composition by Rubens, this time his painting of the same title, *circa* 1615, at New York.[48] With the aid of five half-length figures Jordaens illustrates the climax of Ovid's story (*Met.* VIII, 260–545) of the hunting of the huge boar which Diana sent to ravage Calydon as a punishment for her neglected sacrifice. Assisted by a band of heroes including the huntress Atalanta, Meleager succeeded in killing the animal and offered Atalanta the spoils. The other huntsmen were angry and jealous and attempted to seize the booty, whereupon Meleager slew two of them (the brothers of his mother Althaea). The picture shows him about to draw his sword, and the colour-scheme contributes vividly to the atmosphere of impending murder. Atalanta's garment and that of the man in the foreground are of a passionate crimson colour; Meleager's loincloth is of an ominous glassy green, and the deep shadows are impenetrably sinister; in contrast the forms of Meleager and Atalanta stand out like angels of light, prepared ruthlessly to crush the forces of darkness.

From the same period, about 1617, are two paintings of scenes from Christ's childhood: an *Adoration of the shepherds* at Athens[49] and *The Virgin and Child with St Elizabeth, St Zacharias and an angel*, formerly in the collection of Mrs J. H. Dent-Brocklehurst.[50] Of the first of these, only the central part belongs to this period: it was later retouched, probably in the studio, and enlarged on both sides, thus turning it from a vertical into a horizontal format. Of the second work

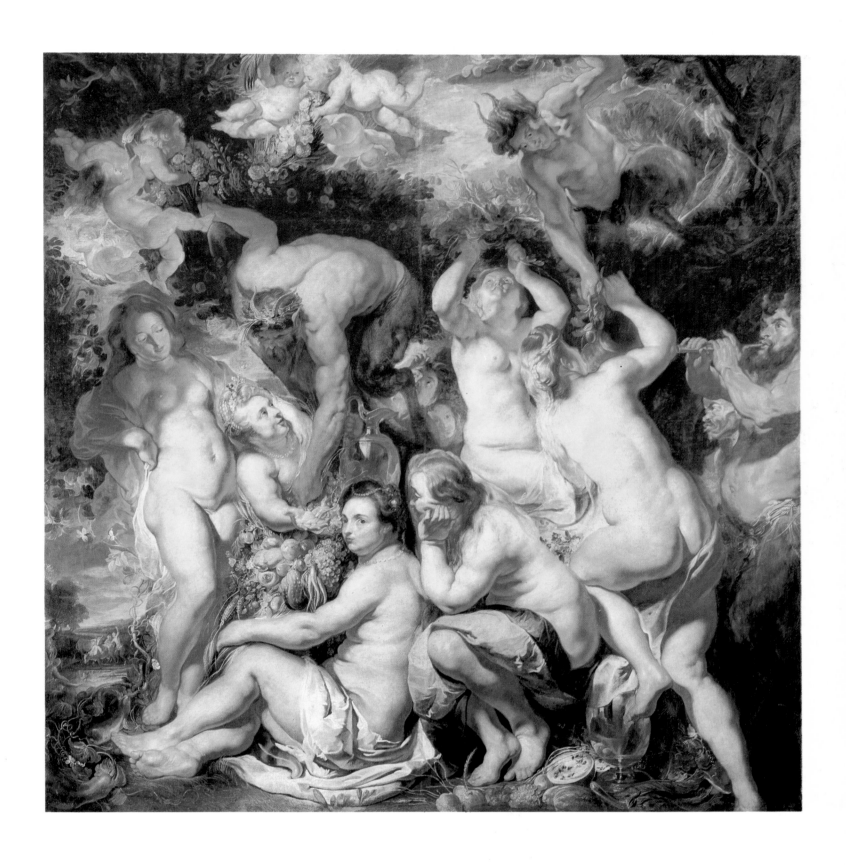

44 *Allegory of fruitfulness*
signed *IOR FECIT, circa* 1617
canvas, 250 × 240cm
Munich, Alte Pinakothek

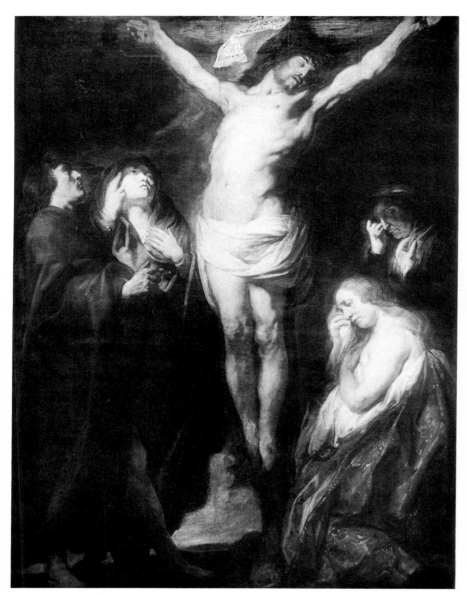

45 *Christ on the cross*
circa 1617
canvas, 242 × 185cm
Antwerp, St Paul's church

46 *The descent from the cross*
circa 1617
drawing, 195 × 123mm
Lille, Musée des Beaux-Arts

only a fragment has survived: the more extended composition of which it was part is known from two copies in which St Joseph also appears, seated on the ground and reading a book.[51]

In St Paul's, the former Dominican church at Antwerp, there is in the left side-aisle a series of fifteen paintings of the Mysteries of the Rosary, including a *Scourging of Christ* by Rubens, *Christ carrying the cross* by Van Dyck and *Christ on the cross* by Jordaens [45].[52] There appear to be no documents of the period indicating when they were painted. However, a later inscription on the panels of *The scourging of Christ* states that it was painted in 1617, and while this is not proof in itself it seems acceptable, being corroborated by the style of Jordaens's *Christ on the cross* and of the other paintings. It also appears from a document in the records of St Paul's that Jordaens's picture was presented to the church by 'Joffr. Magdalena Lewierter',[53] the mother of Rogier Le Witer, grand almoner of the city of Antwerp, whose portrait Jordaens was to paint in 1635 [236].

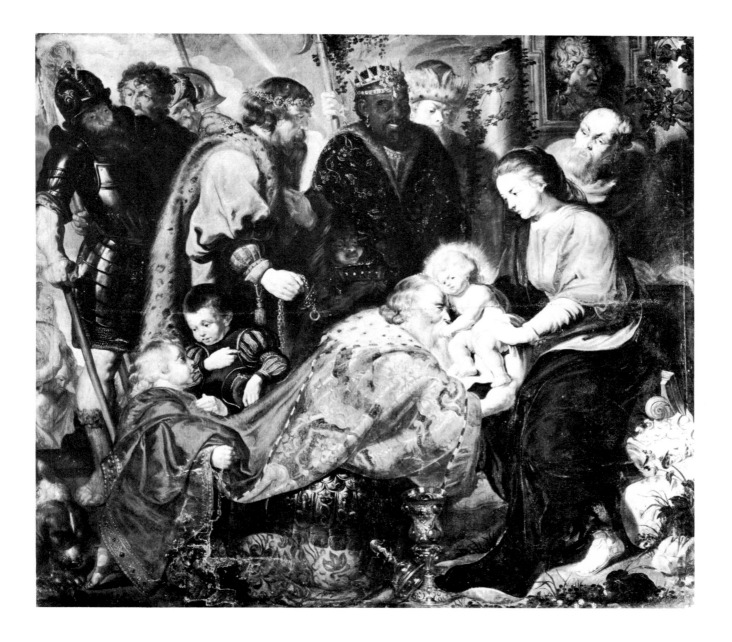

Rubens's influence is strongly visible in this dramatic scene of the Passion, especially in the noble pathos of Christ's majestic body, which appears unscathed notwithstanding his torments. At the foot of the cross, in vivid tones and strongly illuminated, the tall forms of John and the holy women are seen against the low horizon inflamed by the setting sun.

Rubens's influence is equally visible in a recently discovered *Adoration of the Magi* in the church at Skalbmierz, Poland [47].[54] The large canvas of the same title which Rubens painted for the Antwerp city hall soon after his return from Italy, as well as his later *Adorations of the Magi*, for instance that painted for St John's church at Mechlin, clearly affected Jordaens's composition and choice of figures. However, the presentation of the figures, the dog in the foreground and not least the architecture – consisting of two pillars and a niche with a statue, as in *The daughters of Cecrops* [49] – bear witness to the growing intensity of Jordaens's individual vision.

47 *The adoration of the Magi*
circa 1617
canvas, 176 × 200cm
Skalbmierz, Poland, church

49 *The daughters of Cecrops finding the child Erichthonius*
signed and dated *I. Iordaens Fecit. 1617*
canvas, 170 × 280cm
Antwerp, Koninklijk Museum voor Schone Kunsten

48 *Head of an old woman*
circa 1617
drawing, 360 × 270mm
Antwerp, Stedelijk Prentenkabinet

50 RUBENS
The daughters of Cecrops finding the child Erichthonius
circa 1615–17
canvas, 218 × 318cm
Vaduz, Liechtenstein Collection

51 *Meleager and Atalanta*
circa 1617–18
canvas, 152 × 120cm
Antwerp, Koninklijk Museum voor Schone Kunsten

83

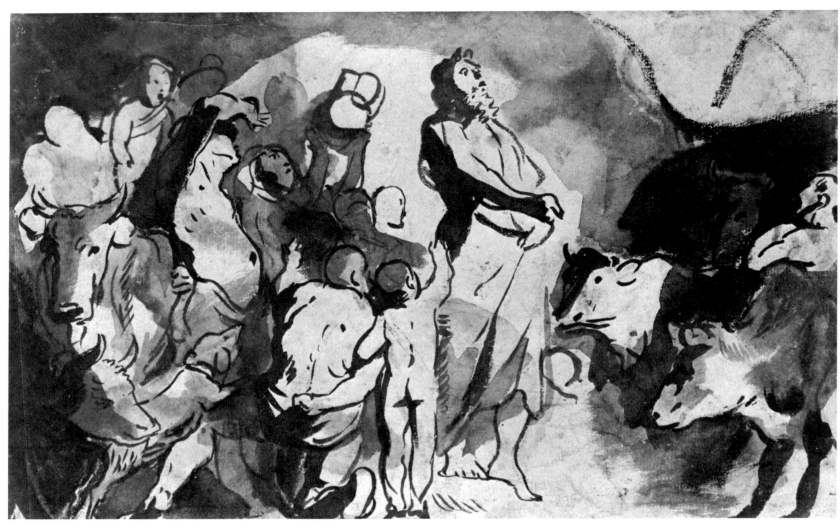

52 *Moses striking water from the rock*
circa 1618
drawing, 202 × 322mm
Antwerp, Stedelijk Prentenkabinet

53 *Moses striking water from the rock*
circa 1618
panel, 208 × 180cm
Karlsruhe, Staatliche Kunsthalle

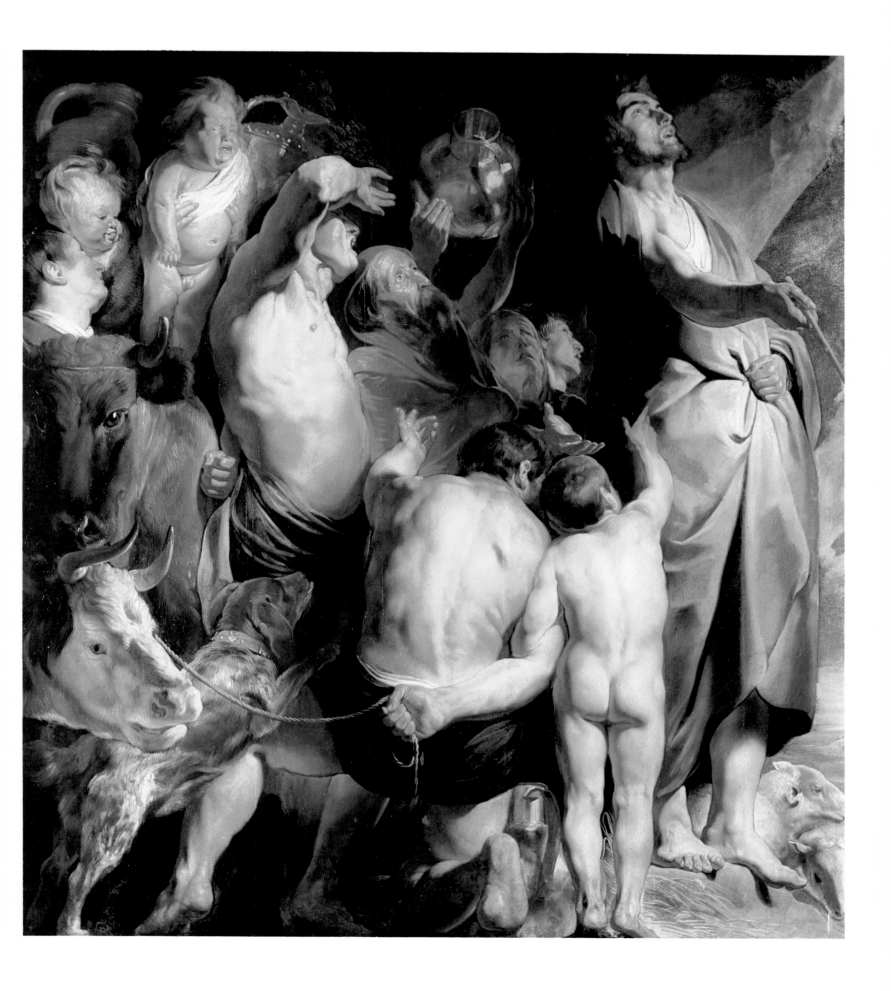

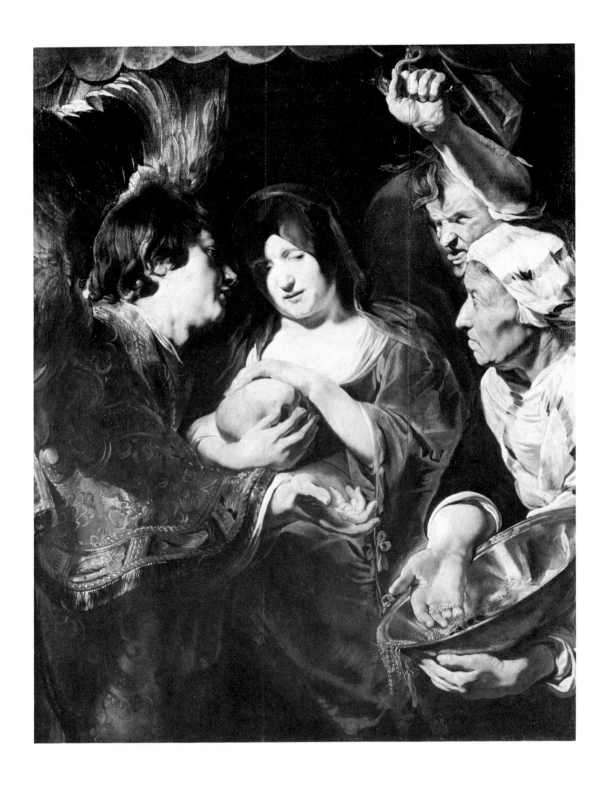

54 *Allegorical scene* (*Penitent
Magdalene*)
circa 1618
panel, 125 × 97cm
Lille, Musée des Beaux-Arts

In *The adoration of the shepherds*, signed and dated *1618*, at Stockholm [55][55] Jordaens shows at the age of twenty-five that, following Caravaggio, he has completely mastered the artistic expression of realism. The Virgin and Child are shown in rustic simplicity with no attempt at idealisation, and the shepherds are nothing more than types of the Flemish people that might compare with some of Bassano's country folk. Caravaggio's influence is best seen in the lighting. Here for the first time the strong light and deep shadows play a fundamental part in the composition. The individual forms are thrown into higher relief as the light, absorbing the half-shadows, brings out the plastic expressiveness of the more important parts, while those that are less essential are cast into deeper shadow. The local colours are no longer bright and shrill but have a mellower quality, and are distributed with an eye to contrast which does not diminish their vibrancy. The flesh tints – golden-brown in the light and almost black in the shadows – are entirely Caravaggesque and completely different from the Manneristic type of palette.[56]

This *Adoration of the shepherds* was preceded by an *Allegorical scene* at Lille,[57] also known as a *Penitent Magdalene*, which resembles it in many aspects including the central composition and the way the figures are cut off by the frame [54]. A woman with a chastened expression is seen grasping a skull: meditating on life and death, she is being tempted by Vice in the person of a repulsive debauchee with a brood of snakes in his hand, and by an importunate old woman offering jewels as a symbol of Vanity. An angel with a gentle, winning countenance stands by her in the shape of a robust peasant youth dressed in gold brocade. Powerfully modelled by the light, the figures stand out boldly against a staid, neutral background. The woman's blissful, imperturbable calm, a mind at peace in a luxuriant body, can be seen again in *The adoration of the shepherds*, where it is suffused by the joy of motherhood. Here the light pours down abundantly from the blue summer sky, enveloping and penetrating everything it encounters. From now on, Jordaens successfully depicts the way in which light caresses flesh, how it imparts vibrancy to garments and objects and evokes the warmth of close human contact. His bold, confident brushwork has acquired a quality, directness and rhythm which will enable him to accomplish his finest works.

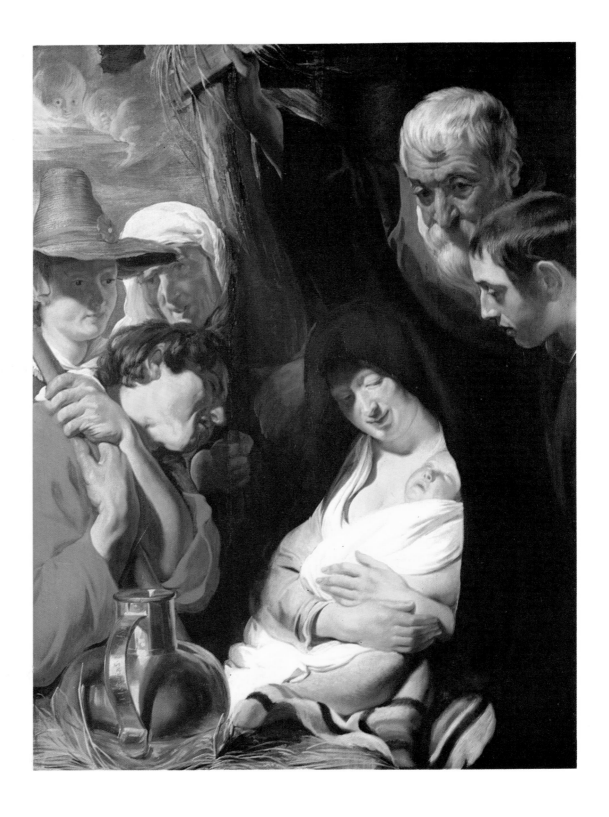

55 *The adoration of the shepherds*
signed and dated *I. Iordaens Fecit 1618*
canvas, 124 × 93cm
Stockholm, Nationalmuseum

IV

The rich unfurling

circa 1619–27

The adoration of the shepherds (1618) marks the end of the formative years of Jordaens's style and the beginning of the period of his finest work, which continued until about 1628, when he painted the great altarpiece of *The martyrdom of St Apollonia* commissioned by the Augustinians at Antwerp [94]. Of the pictures and preliminary sketches and drawings executed during these ten years, none bears an actual date. A chronology must therefore be established by stylistic analysis and by details found in archives concerning the painter's life and that of his family. Since Jordaens frequently used members of his family as models, their presence in one work or another furnishes a number of clues that are not without value. Caution is necessary, however, as some studies from life were kept in the studio for years and used repeatedly.

It has not been possible to ascertain that Jordaens depicted himself in paintings of this period, but his wife Catharina van Noort and at least one of his children occur in them more than once. Of the three children of the marriage, two are a main concern: Elizabeth, christened in 1617, and her brother Jacob, who was to become a painter like his father and was baptised in 1625. The young couple and their first child are seen with a serving-maid in a group portrait in the Prado at Madrid [234]: here Elizabeth seems to be four or five years old, so the picture must have been painted in about 1621–22. From this portrait it is possible to identify the three members of the family in other paintings. Catharina's typical countenance with the prominent nose, narrow slit eyes and pendulous lower lip can easily be recognised in the young peasant woman in *Satyr and peasant* at Göteborg or the painting of the same subject at Munich [63].[1] The roguish features of the child Elizabeth are also distinctive enough to be recognised in some works of this period. The presence of Catharina or her daughter is of course not in itself sufficient evidence on which to date a painting, but together with stylistic analysis it may be possible. The small boy who also occurs frequently is a less certain indication. It is tempting to identify him with the painter's son Jacob, but there is no authentic portrait of the latter. However, given Jordaens's fondness for painting members of his family (*see* Chapter VIII) it would be surprising if he had made an exception in his son's case.[2] His predilection for using members of his own circle as models extended to some who were not related to him: for instance, he painted several oil sketches of Grapheus, the old messenger of St Luke's guild at Antwerp, and used them in various scenes (*see* p 107). In the case of other, unidentified individuals who appear repeatedly in his paintings it may be safely assumed that he sketched

them in various poses in his studio. On the other hand there are oil sketches of his which, by reason of their style, must date from the 1620s, yet the persons depicted in them cannot be found in any finished work of that time. Among these are the *Three musicians* in Madrid [73][3] and *Four studies of a man* in the Bernard Houthakker Gallery in Amsterdam[4] (one of these studies represents the model as a shepherd in an adoration scene).

The appearance of such oil sketches in this period is not unrelated to the development of Jordaens's studio. Given the high quality and the spontaneous and rhythmic brushwork of the paintings discussed so far, there is no reason to suppose that they were not entirely Jordaens's own work. A young artist on the threshold of his career would not be expected to have assistants or pupils, and none are heard of in Jordaens's case. But the fact that he was appointed dean of St Luke's guild by the city fathers in 1621, when he was only twenty-eight years old, shows how early his merits were appreciated, and between 1620 and 1624 he took four pupils into his studio. It is not known whether he also had assistants at that time, but it is as well to take account of the possibility that some change occurred in the studio's method of output, and that studies of heads gradually took on increased importance. It may also be that the existence of two almost identical versions of the same painting, like the *Satyr and peasant* at Göteborg and Brussels [62], is a sign that Jordaens's activity was supplemented by studio help.

A number of religious paintings belong more or less to the first half of the period 1619–27: no member of Jordaens's family can be recognised in them with any certainty, and hence they cannot be dated by reference to the age of a particular individual. Four are of large size: *Moses striking water from the rock*; *The washing and anointing of the body of Christ*; *The Holy Family with St Anne, St John, his parents and an angel*; and *Christ on the cross*.[5]

56 *Nymphs and satyrs*
(*Allegory of fruitfulness*)
circa 1618–20
drawing, 206 × 325mm
Chicago, Illinois, Art Institute
(Leonora Hall Gurley Memorial)

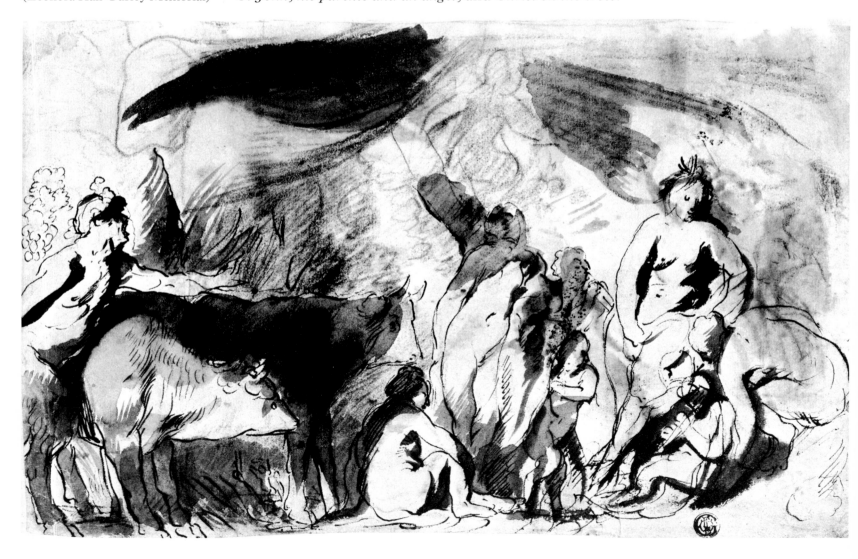

57 *The washing and anointing of
the body of Christ*
central section, *circa* 1620–23;
extensions, after 1650
canvas, 212 × 257cm (originally
120 × 205cm)
Antwerp, Openbaar Centrum
voor Maatschappelijk Welzijn

In pre-Christian times, miracles were already regarded as a sign of divine power and favour. In the history of Israel this occurs from Moses onwards: he and the prophets after him performed wonderful acts in order to manifest God's power and the authority of their mission. One of these, Moses striking water from the rock, was a favourite subject of Jordaens's. An early treatment of the theme dating from *circa* 1615 has already been mentioned [15]. A somewhat later one, probably of *circa* 1618, is in the Karlsruhe museum [53].[6] In it are found various traces of Caravaggio's influence, which first came to full expression in *The adoration of the shepherds* at Stockholm, including the use of realistic popular types and the effect of strong modelling light which also produces dark cast shadows. Another feature found here as in some works by Caravaggio, especially his *Entombment* in the Vatican, is that of several figures all gazing in the same direction: they are staring in amazement at the miracle, which is outside the compositional field and therefore invisible to the spectator. The same effect is seen later in Jordaens's *Disciples at Christ's tomb* in Dresden [85], where the sepulchre itself is withdrawn from the spectator's gaze. The *bel homme* figure of Christ as he appears in *Christ's charge to Peter* in St James's church at Antwerp [36] is here seen in the figure of Moses striking the rock, but there is no other resemblance between the two paintings: the modelling has become much more sensitive, and rich impasto brushwork can be seen intermittently.

The washing and anointing of the body of Christ was bequeathed by Jordaens to the home for female orphans in Antwerp, in token of his concern for the poor; it is now in the Museum of the Social Welfare Centre in that city [57].[7] It was in the painter's home at his death, but this does not mean that it was one of his last

works. On the contrary, the central portion was painted in about 1620–23, though the picture was enlarged on all four sides by Jordaens or his studio after 1650. Such modifications of format, which were also customary in Rubens's studio, were frequent with Jordaens. The additions in this case are of inferior value and contrast strongly with the central portion, which is monumental and charged with emotion. In many respects this portion is reminiscent of Caravaggio's *Death of the Virgin* in Paris: the harsh realism of Christ's outstretched body, the contrast between pathetic and genre-like features – on the one hand the profound grief of Mary and the disciples, on the other the coquettish Magdalene showing off her headgear and gracefully curved neck – and, finally, the concentrated lighting and sharp delineation of shadows. All these features, as well as the rich brushwork, contribute to the high quality of the picture.

To the same period belongs *The Holy Family with St Anne, St John, his parents and an angel* in New York:[8] like *The washing and anointing of the body of Christ*, this picture was subsequently reworked. Only the four figures on the right belong to the original portion: the boy St John and the lamb probably also belonged to it but were partly overpainted, while Elizabeth, Zacharias and the angel, as well as the cartouche with the inscription *Radix Santa et Rami. Rom. 11.16*, are clearly recognisable as additions. Another painting reworked by Jordaens's own hand is *The disciples at Christ's tomb* in Dresden, *circa* 1625 [85],[9] where the rich, angular folds of Mary Magdalene's shot-coloured mantle exhibit the style of the 1630s. This work again illustrates Jordaens's interest in Caravaggio, especially his *Entombment* in the Vatican, which Jordaens most probably knew through Rubens's copy now in Ottawa.

Christ on the cross is a large canvas which originally hung over the grave of two sisters, Marie de Hester and Clara de Moy, in the *Béguine* church at Antwerp; it was removed by the French in 1794 and afterwards placed in the museum at Rennes, where it still is [58].[10] Like Jordaens's earlier version of the subject in St Paul's church at Antwerp, it is inspired by a Rubens painting: the figure of Christ would be unthinkable without Rubens's *Coup de lance*, completed in 1620, thus providing a *terminus post quem* for Jordaens's work.

Series of apostles, both painted and sculpted, were part of the traditional furniture of churches in the seventeenth century. Among sculptors the names that immediately come to mind are Duquesnoy, Faid'herbe and Van Mildert. As regards painting, Rubens introduced the custom of representing Christ and the twelve apostles half-length. In a letter written in Italian in 1618 he offered Sir Dudley Carleton, among other works, a series of this kind in return for some antique sculpture; the apostles had been copied by his assistants from originals which were now in the possession of the duke of Lerma, but he was prepared to retouch them.[11] Evidently Van Dyck and Jordaens knew of these works by Rubens and felt challenged to produce similar ones. Much has been written about Van Dyck's work in this line, but less attention has been paid to that of Jordaens. In the only complete series now known he adopted the rather unusual plan of grouping the apostles in four paintings of three each. J. B. Descamps[12] saw them in 1769 in St Saviour's church at Lille, whence they were later transferred to the museum there. They were painted with studio help, certainly not before the 1630s. In addition several earlier documents mention paintings of individual apostles,[13] and some of St Peter and St Paul have actually survived. It is uncertain, however, whether they ever formed part of a series in Rubens's manner: very possibly, especially in the case of Sts Peter and Paul, they were merely executed in pairs. The Counter-Reformation assigned a special place to

58 *Christ on the cross*
early 1620s
panel, 237 × 171cm
Rennes, Musée des Beaux-Arts

59 *Satyr and peasant*
circa 1620
canvas, 172 × 194cm
Kassel, Staatliche Gemäldegalerie

60 *Pan and Syrinx*
circa 1620
canvas, 173 × 136cm
Brussels, Musées royaux des Beaux-Arts

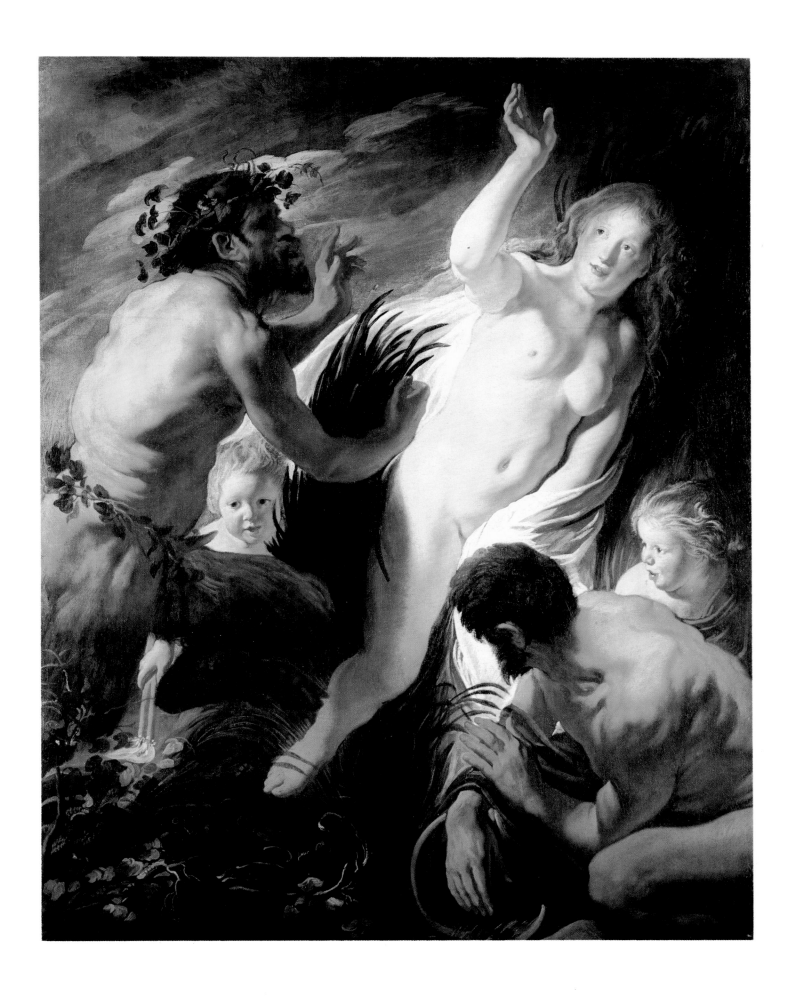

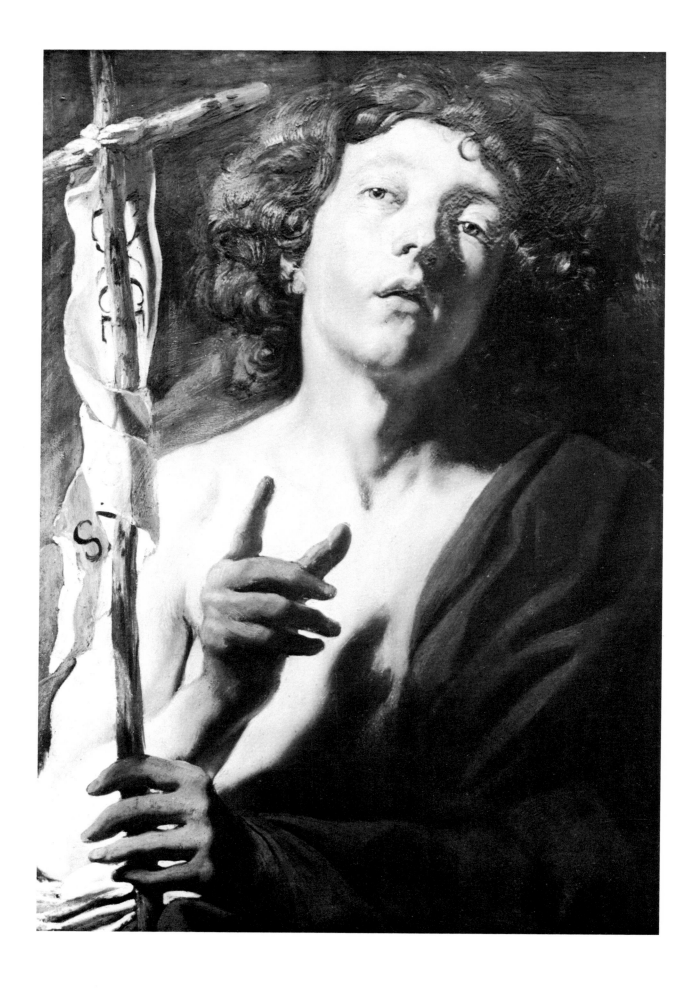

these two apostles, whom tradition regarded as the two main pillars of the church: Peter, the enemy of heretics, and Paul, the light of the gentiles, were associated and generally portrayed together. Descamps[14] mentions a *St Peter and St Paul* by Jordaens's hand at Mechlin, in the church of the sisters known as *Van Leliendael*. Among the individual apostles that have survived are two from the first half of the 1620s: a *St Paul* of *circa* 1620 in Mrs Edith Ullstein-Glaser's collection at Durham, North Carolina,[15] and a *St Peter* at Munich[16] which must have been painted soon afterwards. A *St Paul* in the H. Shickman Gallery, New York (1969)[17] is of later date.

Besides apostles, Jordaens made half-length paintings of other saints. The Groningen museum has a *St John the Baptist* [61] depicted as a boy, and there is a picture of the same saint in more mature years at Columbus, Ohio.[18] In addition to these two works dating from *circa* 1620, there is a *St Jerome*[19] and a *St Mark*,[20] both painted *circa* 1623 and now in a château at Slavkov (Austerlitz), Moravia, and a later *St Jerome*[21] in the H. Shickman Gallery, New York (1969). Probably there are other saints among the anonymous figures executed in the early 1620s, mostly in the form of sketches, but the absence of attributes makes it impossible to identify them.[22]

Jordaens's non-religious subjects in the period 1619–27 included fable, mythology and allegory. A *Satyr and peasant*, as previously noted, was among his very first works; this fable of Aesop's attracted him throughout his life, and at this time he produced some of his best versions of it. Among these are the painting at Kassel [59][23] and the one at Göteborg,[24] which must have been painted soon after and of which there is a replica of equal value at Brussels [62].[25] In these three works he used the same grizzled head as a model for the satyr,[26] while for the composition he relied indirectly on Caravaggio, *eg The pilgrims to Emmaus*. By this time he had fully adapted the Lombard artist's technique to his own personality, as, for example, in the treatment of chiaroscuro. While Caravaggio seeks to produce a dramatic atmosphere by strong contrasts of light and dark, Jordaens's scenes are flooded with bright sunshine which gives full effect to the rich colours and helps to create a human, intimate atmosphere. Like Caravaggio, and to a still greater extent, he uses popular types for his figures. The peasants' simple clothing, the grimy soles of their feet, their scanty food and the faithful animals all give the impression of a primitive but healthy way of life. In the *Satyr and peasant* at Göteborg and Brussels it is Jordaens's wife Catharina as the young woman behind the table, with her little daughter Elizabeth by her side. As the child appears to be three or four years old, this picture probably dates from *circa* 1620–21.

The *Satyr and peasant* at Munich [63][27] is an extended version of that at Göteborg. The peasant, the old woman [70], the child and the young wife are seen in almost the same poses, but a younger model has been used for the satyr, and the maid with a milk-jug has been replaced by a farm lad and a cow. Almost everything else is the same: the wicker chair with the cock proudly perched on it, the shaggy dog in the foreground and the earthenware bowl on the table. But, while the figures and composition are only slightly modified, a considerable evolution has taken place in the colour-scheme. The scene is no longer out of doors but in the closed space of an interior warmed by a glowing fire. The light, which in previous versions streamed down from a pure, sunlit sky, is subdued: it is strong enough to cast shadows, but does not bring out the colours in their full value. These are soft and mellow like the fruit that the young woman is putting on the table, but are well adapted to a cosy, domestic atmosphere.

61 *St John the Baptist*
circa 1620
panel, 67 × 48cm
Groningen, Groninger Museum
voor Stad en Land

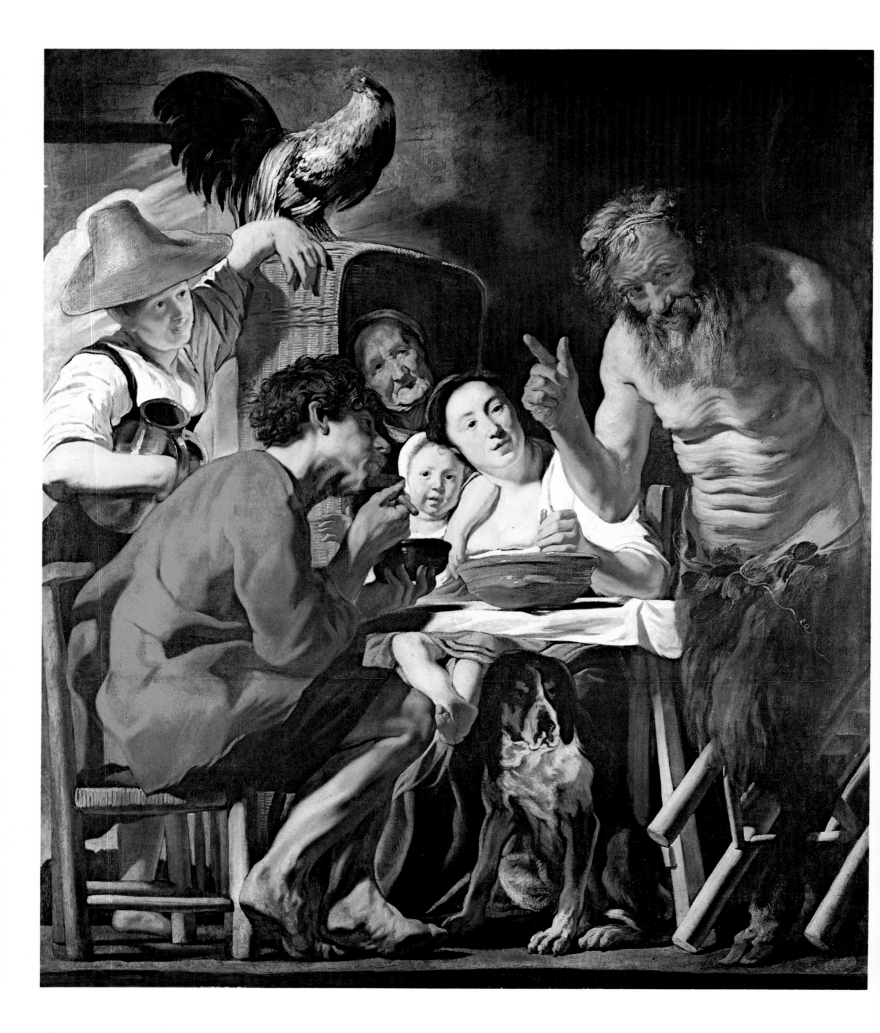

98

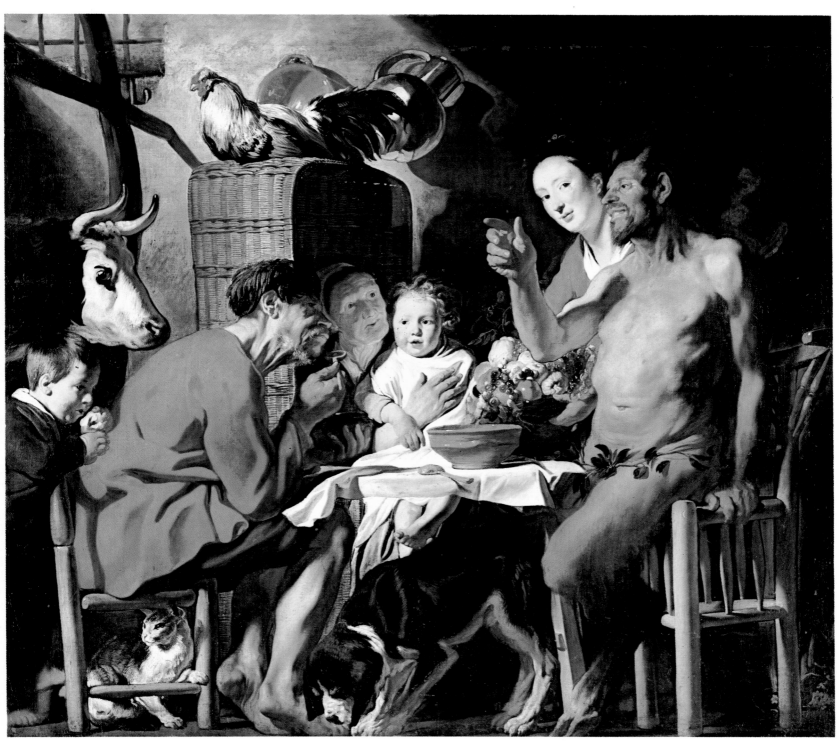

63 *Satyr and peasant*
circa 1620–21
canvas, 174 × 205cm
Munich, Alte Pinakothek

62 *Satyr and peasant*
circa 1620–21
canvas, 188.5 × 168cm
Brussels, Musées royaux des Beaux-Arts

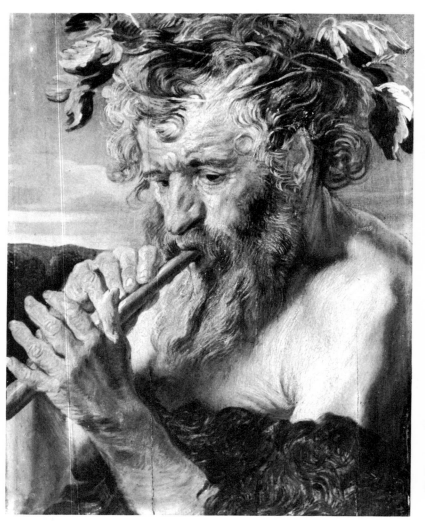

64 *Satyr playing the flute*
circa 1620
panel, 65 × 49.5cm
Warsaw, National Museum

65 *Satyr and peasant*
circa 1620–21
drawing, 253 × 210mm
Paris, École Nationale
Supérieure des Beaux-Arts

66 *Satyr and peasant*
1620–21
drawing, 159 × 181mm
Sacramento, California,
E. B. Crocker Art Gallery

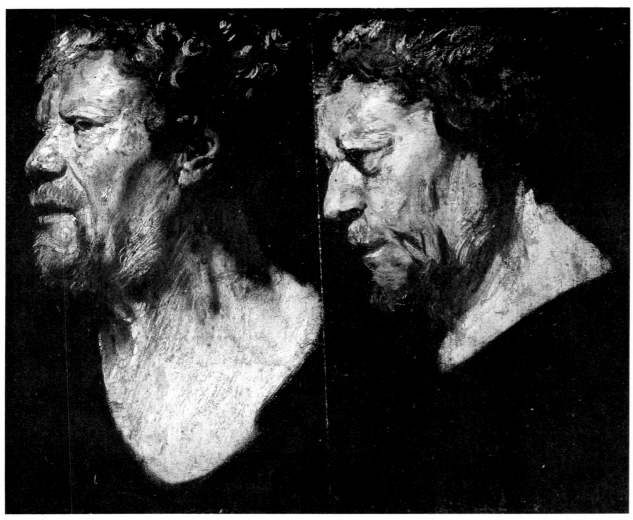

67 *Two studies of the head of*
Abraham Grapheus
circa 1620–21
oil on paper, mounted on panel,
45 × 52cm
Ghent, Museum voor Schone
Kunsten

68 *Study of the head of*
Abraham Grapheus
circa 1620–21
panel, 66 × 50cm
Detroit, Michigan, Detroit
Institute of Arts

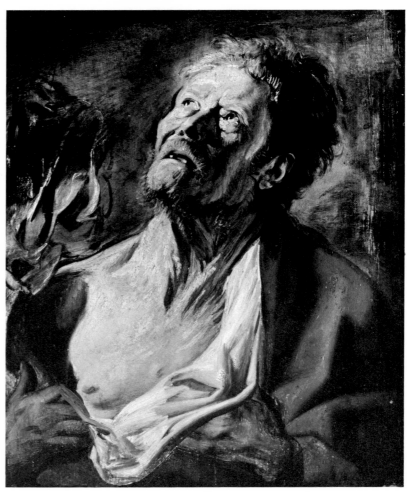

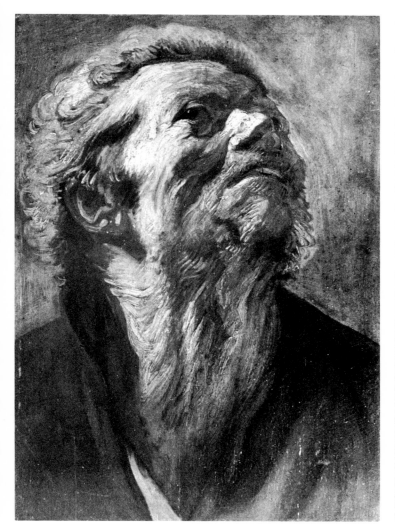

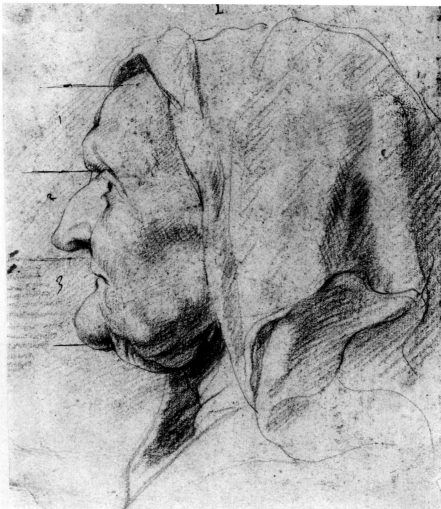

Mythological subjects treated at this period are *Meleager and Atalanta, Mercury and Argus, Pan and Syrinx* and *Apollo flaying Marsyas*. The *Meleager and Atalanta* at Madrid[28] is composed of two easily distinguishable parts, executed at different times [71]. The right-hand half belongs to the early 1620s, while the other was added by Jordaens himself in about the 1640s. The picture has an atmosphere of pathos and almost feminine refinement which has so far been unusual in his work. Atalanta's tender gesture as she seeks to restrain her protector, and her moving expression as she addresses him, show a completely new type of feeling which is visually reflected in the variegated modelling, the graceful linking of the gestures and the soft colouring. Paintings of such subjects answered to the Christian beliefs of Jordaens's patrons as well as their secular erudition. Familiar as they were with the moralised Ovid in book form, they found no difficulty in recognising the symbolic meaning below the surface. Remembering the death that awaited Meleager as a punishment for killing his uncles, they learnt how harmful it was to be swayed by angry passions. The picture also led them to meditate on the ever-present danger of sudden death, with which Providence is apt to visit malefactors.[29]

69 *Study of the head of Abraham Grapheus*
circa 1620–21
canvas, 43 × 31 cm
Douai, Musée des Beaux-Arts

70 *Head of an old woman, in left profile*
early 1620s
drawing, 212 × 172 mm
Copenhagen, Statens Museum for Kunst

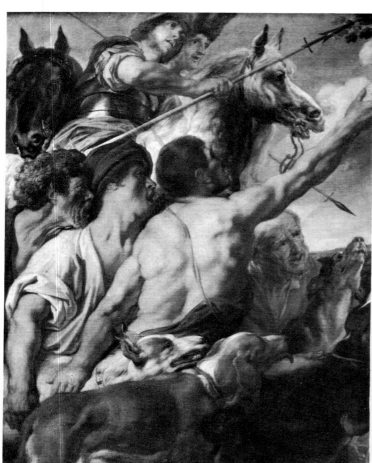
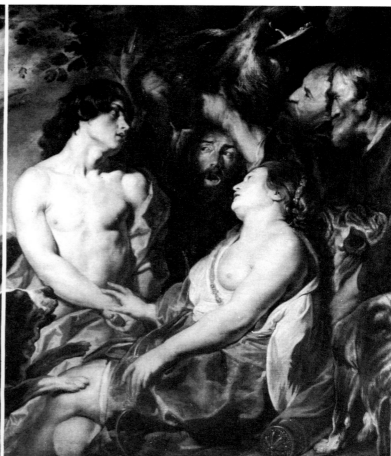

71 *Meleager and Atalanta*
right side, early 1620s; left side,
circa 1640–50
canvas, 151 × 241cm
Madrid, Prado

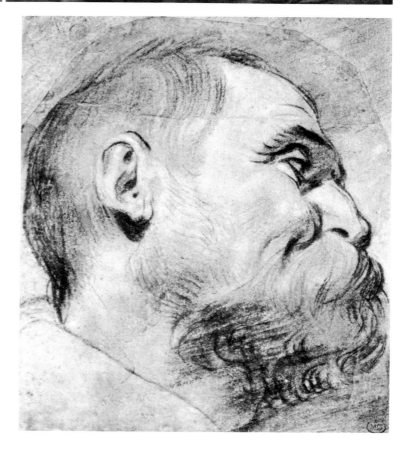

72 *Head of a man, facing right*
circa 1620–23
drawing, 148 × 128mm
Dijon, Musée des Beaux-Arts

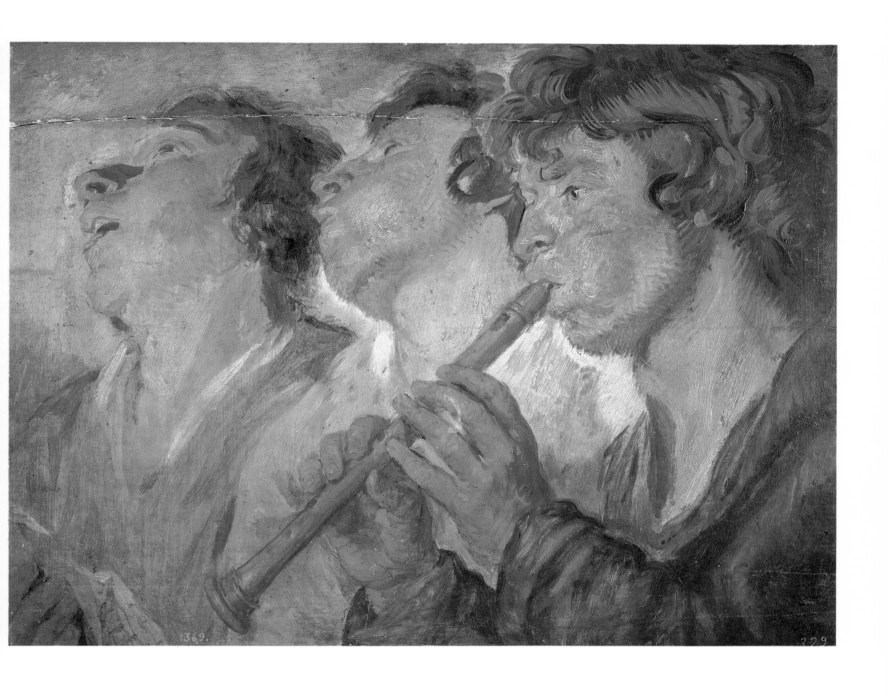

73 *Three musicians*
circa 1620–23
panel, 49 × 64cm
Madrid, Prado

The subject of *Mercury and Argus* at Lyons [74][30] was similarly 'moralised' by Jordaens's contemporaries. Again the scene is from Ovid's *Metamorphoses*: Mercury, having lulled the herdsman Argus to sleep with his flute, is about to cut off his head and release Io, transformed by Jupiter into a white heifer. It takes some imagination to read into this, as Carel van Mander does,[31] the moral that sensual delight weakens the reason and incites to idleness and neglect of duty, but people of the time did not shrink from such forced interpretations. In this fine picture, executed in rich impasto and with a broad, confident touch, the blue, white and red garments give a sense of exultation. Local colouring in these three hues is also the basis of other works of this period, especially various versions of *Satyr and peasant*. From the compositional point of view the group formed by Mercury, Argus and the herd of cattle must have satisfied both Jordaens and his patrons, as it was several times repeated by the studio.[32] Jordaens himself reproduced it literally in the 1640s, in a more extensive landscape reflecting his new concept of space.

The important part played by the cows in the Lyons picture points to another characteristic of Jordaens's work: the herd entrusted to Argus of course is part of the story, but it also testifies to Jordaens's great fondness for painting animals. Cows and horses abound in his work; goats, sheep and lambs often feature; dogs and cats are brought in at every turn; farmyard animals and poultry make an appearance in one place or another; and in many scenes a single parrot is perched in a conspicuous place. Above all Jordaens shows an interest in cows, the peaceful denizens of luxuriant Flemish meadows. In both versions of *The rape of Europa*, in *Paul and Barnabas at Lystra*, in *The adoration of the shepherds* at Grenoble, in *Moses striking water from the rock*, and now in *Mercury and Argus*, bulls and cows play an increasingly prominent part, and they figure in many of his later works as well. He must have made many studies of them from life, but the only known examples are an oil sketch at Lille[33] dating from the early 1620s [75], and a few drawings.[34]

In Ovid's tale there is a passage where Argus, already half asleep, asks Mercury how the flute came to be invented. In reply Mercury tells him of the nymph Syrinx who, chased by the amorous Pan, fled to a sandy river-bank, where she was changed into a reed and thus escaped her pursuer. Charmed by the musical sound of the wind in the reeds, Pan fashioned out of them the instrument known as Pan-pipes (*Met.* I, 689–712). The moment at which Pan is about to seize the nymph is the subject of a painting by Jordaens at Brussels [60].[35] To the two main characters he has added three others: a crouching naked man leaning on a pitcher, symbolising the river Ladon to which Syrinx fled, and two small children, one with a lighted torch.[36] The composition may have been based on Hendrik van Balen's picture of the same subject of 1605–1608.[37] Joachim von Sandrart, who knew Jordaens, wrote that he had once completed a *Pan and Syrinx* with life-size figures in six days,[38] but does not say when this was. Some authors have pointed out that a play of this title was performed at Antwerp in 1619 by the 'Gillyflower' group of rhetoricians associated with St Luke's guild.[39] Possibly these are two pieces of evidence relating to the Brussels picture, but it is impossible to be certain.

In *Apollo flaying Marsyas*, now in Huis Osterrieth at Antwerp [76],[40] Jordaens sought to achieve a graceful effect despite the harsh, realistic nature of the theme. The picture shows the Phrygian satyr and flute-player Marsyas being flayed alive by Apollo, the tutelary deity of music, whom he had impudently challenged to a trial of skill (*Met.* VI, 382–97). Bound to a tree, with his hands

behind his back, Marsyas screams in pain; his blood, pouring into a basin, is greedily lapped up by a dog. A dark-skinned satyr, accompanied by a young faun who is weeping with compassion, vainly begs Apollo to show mercy. Here again is the subject of a typical interpretation by Christian humanists. The moral in this case was that man should not be led by pride to defy God's will,[41] and the episode also illustrated the Stoic principle of mind overcoming matter.

Besides scenes from fable and mythology, in the first half of the 1620s Jordaens painted two *Allegories of fruitfulness*: *Homage to Pomona* and *Homage to Ceres*. The activities of country folk in their lush meadows or convivial farmsteads, together with the world of rural deities, satyrs and nymphs, were a favourite source of inspiration which Jordaens used again and again to produce paintings full of light and air and of healthy, quasi-animal life. The *Allegories of fruitfulness* are perhaps the clearest illustrations of this preference. True symbols of Jordaens's spiritual and artistic nature, they are admirably suited to convey his exuberant sense of earthly pleasures, his love of things in full bloom, his delight in voluptuous female forms and in the profusion of nature's bounty in fields, gardens and orchards. This theme attracted him from the beginning of his career, and he continued to celebrate it throughout his life. The early versions at Oldenburg [22] and Munich [44] have been noted above, but its most perfect expression is in the Brussels *Homage to Pomona* [79][42] – Pomona, the glorious nymph who was wooed by all the gods of field and forest for her beauty and skill in gardening and fruit-growing. Jordaens does not take much trouble to depict her attributes, which Rubens would on no account have omitted. He confines himself to placing a few bunches of grapes in her arms, but her form and her whole attitude radiates such an impression of fertility that no symbols are needed to convey his meaning. Nymphs, satyrs and a countrywoman surround her, filling the scene with a wealth of imagery. In this wonderful picture, all the elements of which are bound together in perfect harmony, Jordaens made use of several borrowed features. The work owes much to the many mythological and allegorical scenes in which Rubens introduced nymphs and satyrs to evoke a similar though more exalted world. But still more direct is the link between Jordaens and Elsheimer, whose inspiration is seen in the composition even though he worked in Rome and Jordaens never went south of the Alps. It would not be surprising if Rubens was the intermediary here, as he was between Jordaens and Caravaggio. Rubens's admiration for Elsheimer is well known, and at his death he possessed four of the latter's works.[43] Most noteworthy in *Homage to Pomona* is the solemnity of its atmosphere. The woodland deities have come among men as genial, affectionate friends, who at the same time confer dignity on everyday human affairs. This is shown in the monumental nude standing erect like a slender pillar; the young nymph in the foreground, resting her head on her hand, with a musing expression as if she were pursuing an elusive dream; and the elderly satyrs following the ritual of homage with a devout and serious air.

In the features of the satyr with the boy on his shoulders is seen for the first time a representation of Abraham Grapheus. This official of St Luke's guild at Antwerp had an extremely fine head, and many of the guild's members painted his portrait or used him as a model.[44] He is depicted as early as 1602 as a colour-grinder in *St Luke painting the Virgin* by Maarten de Vos.[45] Having entered the guild as an apprentice in 1572, he would then have been about forty-five years old. He is best known, however, from the splendid portrait painted in 1620 by Cornelis de Vos,[46] one of Antwerp's greatest portrait-painters, in the costume

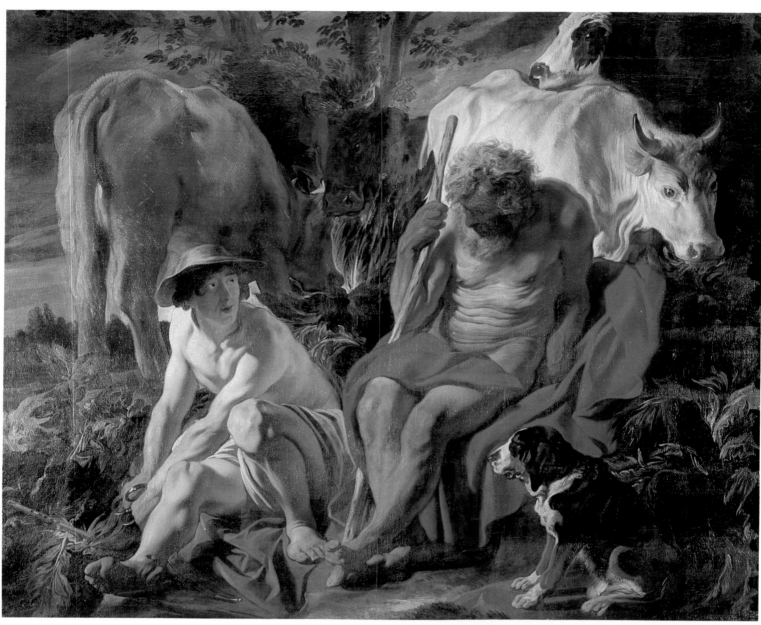

74 *Mercury and Argus*
early 1620s
canvas, 196 × 235cm
Lyons, Musée des Beaux-Arts

75 *Five studies of cows*
early 1620s
canvas, 59 × 72cm (enlarged by
another hand to 66 × 82cm)
Lille, Musée des Beaux-Arts

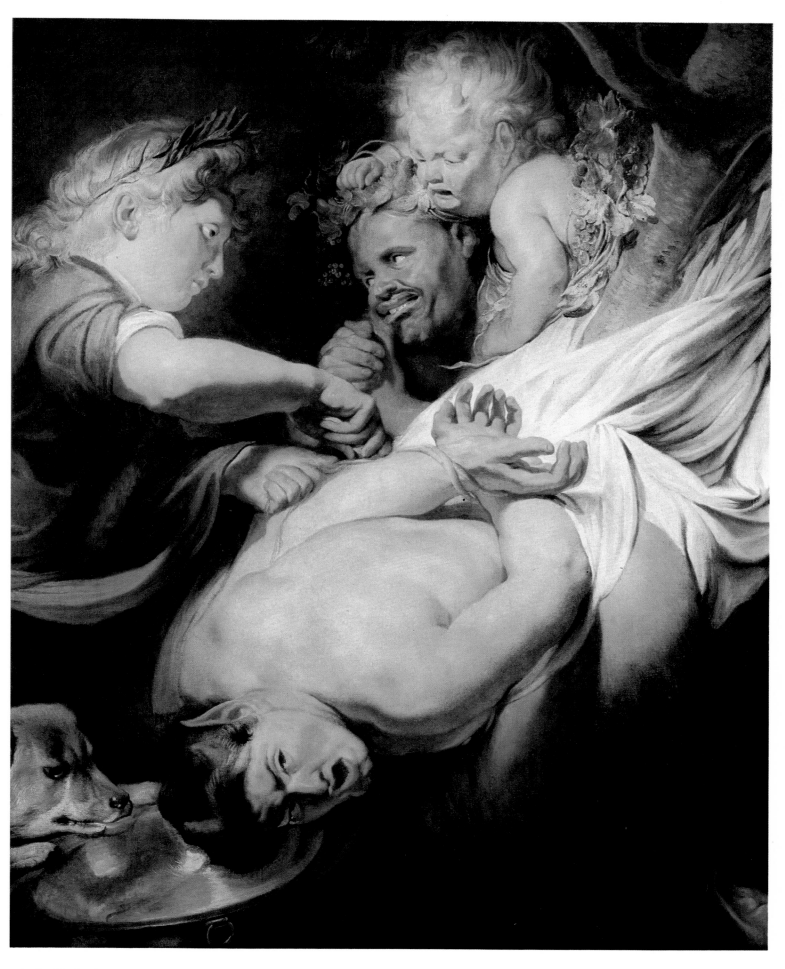

76 *Apollo flaying Marsyas*
early 1620s
canvas, 146 × 117cm
Antwerp, Huis Osterrieth

and with the attributes of a *knaap* (assistant), which was an office of some dignity in the guild. Grapheus, who died in 1624, was painted several times by Van Dyck, but it was Jordaens above all who admired his fine appearance and repeatedly sketched it from life. Some studies of Grapheus by Van Dyck and Jordaens respectively are so similar in composition and technique that the two artists must have sat side by side to depict him *in paragone*. Judging from the boldness of touch and the soft impasto which gives the paint a velvety texture, Jordaens's studies must have been executed shortly before the end of 1621, when Van Dyck left for a six years' sojourn in Italy. Following Rubens's example, he kept them in the studio and used them from time to time for new compositions. The finest that have survived are in the museums of Ghent [67],[47] Brussels,[48] Detroit [68],[49] Prague,[50] Caen[51] and Douai [69]. The painting at Ghent comprises two studies,[52] one of which was used for the satyr's head in *Homage to Pomona*. At that time Jordaens must have had other similar studies of heads in the studio, for instance that of the young Moor looking up at the bunch of grapes that is being offered to Pomona. He has already featured in *Allegory of fruitfulness* at Munich [44] and *Apollo flaying Marsyas* at Antwerp [76], and he recurs several times in later works.[53] Both Rubens and Van Dyck also introduced variety into their early work by including a striking Moorish countenance of this kind. Dark-skinned natives of the Maghreb cannot have been very numerous in Antwerp at that time, and it may be that all three masters used the same model. The profiled head of the old satyr offering an armful of fruit is probably also based on a study: he is repeated identically in *St Peter finding the tribute money in the fish's mouth* [82].

77 *Homage to Pomona* (*Allegory of fruitfulness*)
circa 1623
drawing, 190 × 260mm
Brussels, Musées royaux des Beaux-Arts

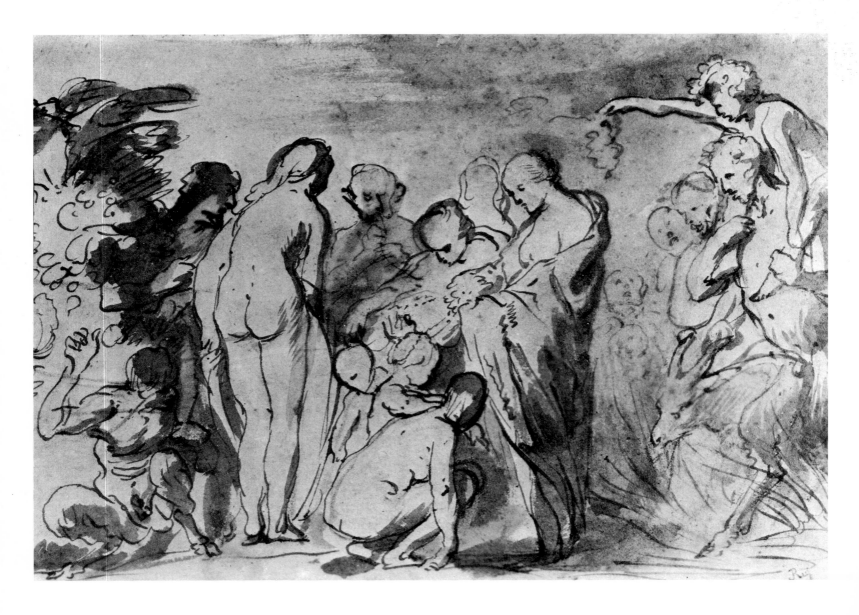

Ceres, an ancient Roman or Italian goddess of vegetation and especially corn, was venerated in antiquity chiefly by the common people. In *Homage to Ceres* at Madrid [84][54] she is depicted with ears of corn in her hair and a cornucopia of fruit in her arms, surrounded by a grateful company of those who have enjoyed her bounty. This homage symbolises the full circle of earthly existence: thanks to Ceres the seed grows, plants and animals thrive and become food for man- kind; finally man at the end of his life is committed to the ground and fertilises fresh growth. The composition of this work is not unlike that of Titian's *Homage to Venus*, also at Madrid.[55] It lacks the solemn, religious atmosphere of *Homage to Pomona*: instead of a timeless scene here is an incident of daily life. This is due not so much to the choice of the rustic types as to the somewhat confused way in which they are disposed and above all the fact that three of them are looking at the spectator, thus disturbing the psychological unity. At least two figures are already familiar from other works: the woman represented as Ceres was the wife in *Satyr and peasant* at Munich [63], while the child looking up from under the horse's neck appeared in that painting and also in *Pan and Syrinx* [60]. No studies of the woman are known, though they probably existed; as regards the child, there is a panel at Leningrad[56] on which Jordaens sketched the same mischievous head in three different poses. A third figure, the old shepherd seen in profile, may be the same model as Joseph of Arimathea in *The disciples at Christ's tomb* at Dresden [85]. Another shepherd, in the background, was painted after a study now at Douai [69] for which Grapheus posed, looking upwards, while the mother with the child in her lap is based on one of the studies in *Three women and a child* at Bucharest [80].[57]

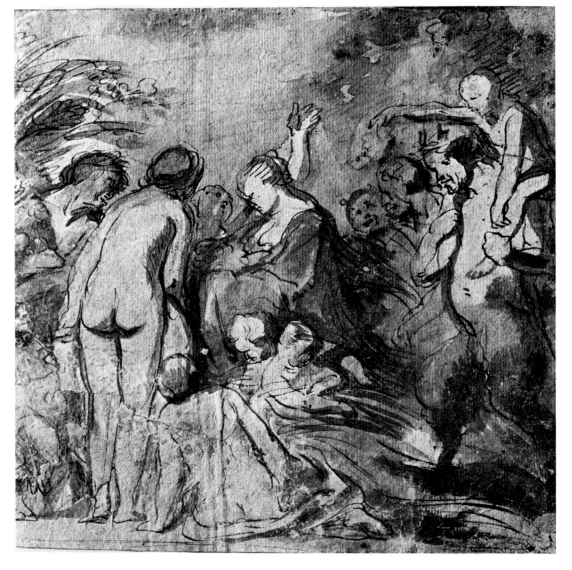

78 *Homage to Pomona* (*Allegory of fruitfulness*)
circa 1623
drawing, 240 × 230mm
Copenhagen, Statens Museum for Kunst

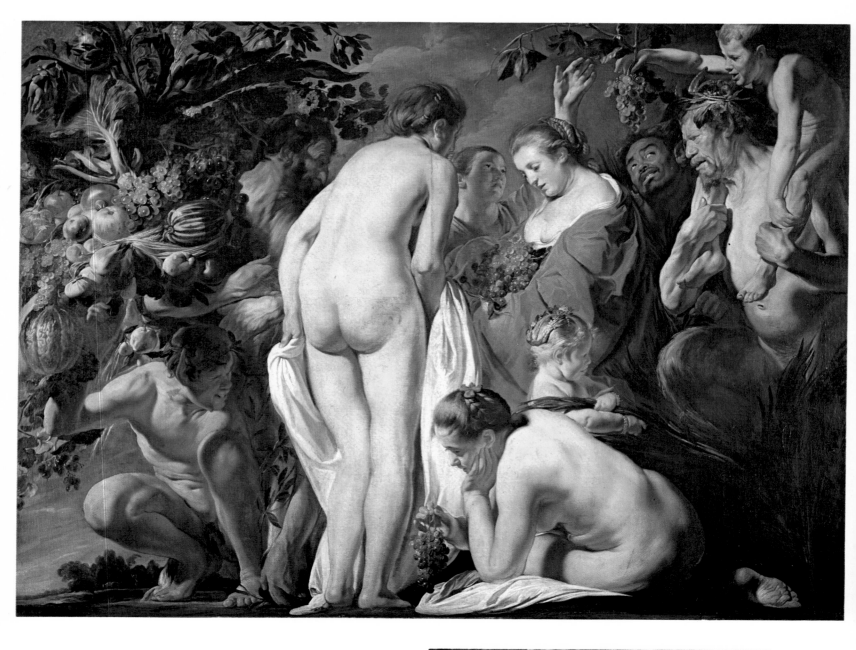

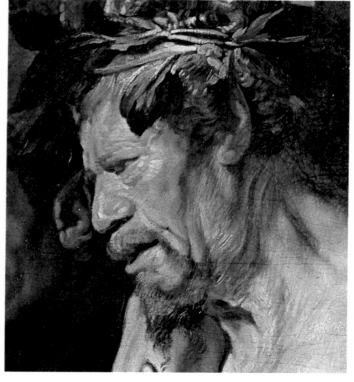

79 *Homage to Pomona* (*Allegory of fruitfulness*)
signed *.ORDA . . . FECI., circa* 1623
canvas, 180 × 241 cm (height reduced when recanvassed)
Brussels, Musées royaux des Beaux-Arts
(*details opposite*)

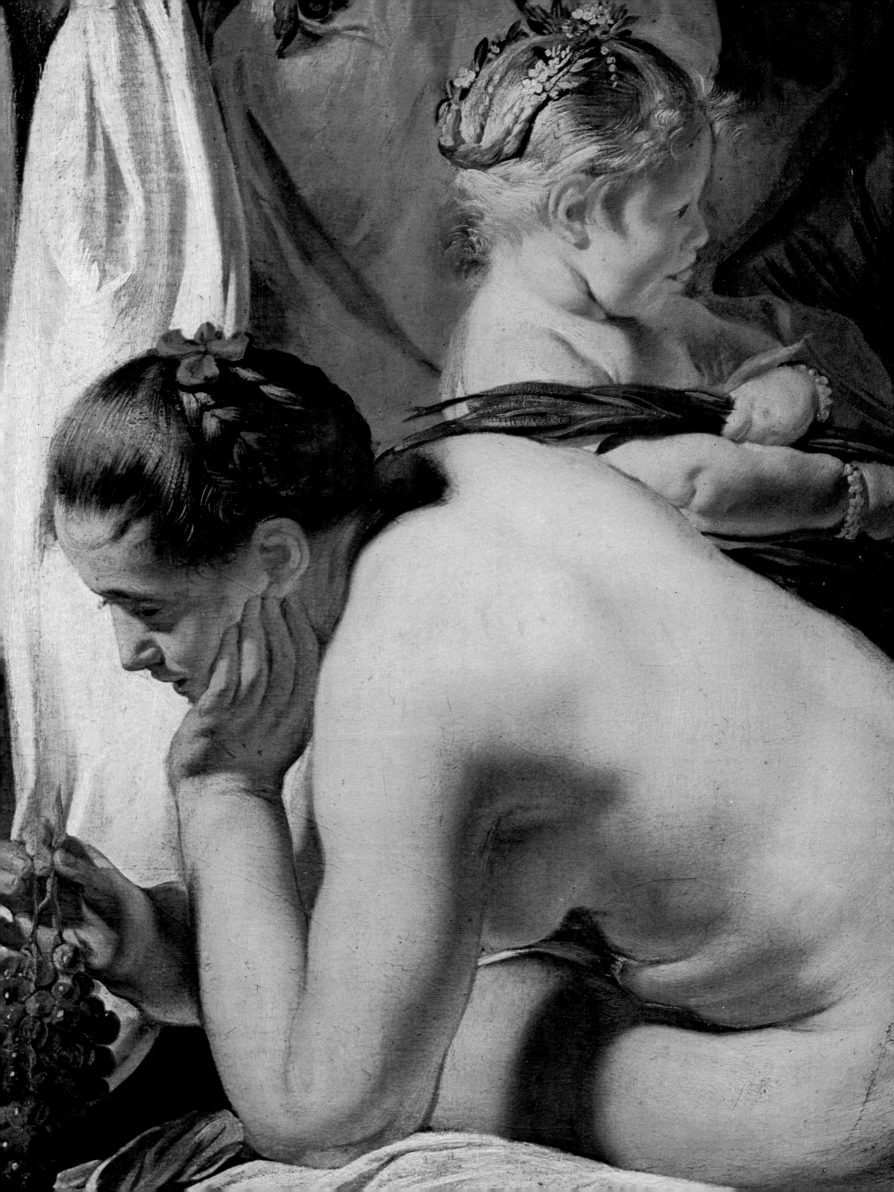

St Peter finding the tribute money at Copenhagen,[58] a masterpiece which at first sight looks like a genre painting, impresses by its huge size (281 × 468cm) and above all the profusion of figures it contains [82]. Jordaens's contemporaries must also have been struck by it. His first biographer, Joachim von Sandrart, writes admiringly: 'So he has also reproduced, along the length of a long hall, the large ferry boat of Antwerp in an incomparably fine way: in which are to be seen all kinds of animals and people working according to their trade'.[59] Curiously, this description does not mention the actual subject of the work. This is probably because Peter is not in the ferry boat which occupies the centre of the composition but is crouching on the landing stage at the extreme right with the fish in one hand and a coin in the other, while four other apostles look on intently from behind (Matthew 17:24–27). It is also the case that these biblical figures are in no way physically differentiated from the motley company in the boat. Jordaens was evidently fascinated by the noisy and colourful scenes he must have often witnessed on the banks of the Scheldt at Antwerp, so that he placed the biblical story among a company of boatmen and their passengers. The ferry, crowded to the gunwales, is setting out on to the turbulent waters of the river: sailors are pushing it out from shore, and the half-hoisted sail is beginning to catch the stiff breeze. Bright sunlight streams down on to the people and animals from between scudding clouds that threaten squalls of rain, and imparts a warm glow to the colours it touches; some passengers are bathed in sunshine, others enveloped in deep shadow. The huge composition derives its animation from the uneven distribution of light and the imaginative disorder of the crowded forms. For whom it was painted is not known.

No painting by Jordaens illustrates better the significant use he made of studies of heads. So many can be recognised that it can almost be concluded that at this period he never painted a head on a canvas without using a model, whether a study in oils or a drawing. In the present work there is first the connection with the already mentioned oil sketch of *Three women and a child* at Bucharest [80], three studies from which appear in the painting: at the prow of the boat a woman with her child, and next to the mast another woman, bare-breasted and shielding her eyes against the sun.[60] There must have been a study for the old boatman at the forward end, as his head also appears in *Satyr and peasant* at Kassel [59] and *Mercury and Argus* at Lyons [74]. The youth in profile next to him is seen – also in profile, but in reverse image and together with a study of Grapheus – on a panel at Hamburg,[61] while the old woman, also next to the boatman, is a literal repetition of the grandmother in *Satyr and peasant* at Munich [63], which again points to the existence of a study. Among characters noted before are the Moorish youth who appears in the same pose in *Homage to Pomona* [79] and the upward-looking greybeard next to him, painted after the study of Grapheus at Douai [69]. The weeping child, seen between the legs of the boatman hoisting the sail, appeared in *Apollo flaying Marsyas* [76] as the young satyr lamenting Marsyas's unhappy lot. The man with the white beard, to the right of the mast, is seen later in a different pose in *St Martin healing a possessed man*, 1630 [97]; the bald, slightly built old man beside him is from a study formerly in the Adler Collection at Asch [81],[62] while the heavily bearded man in profile somewhat further to the right appeared as a satyr bearing an armful of fruit in *Homage to Pomona* [79]. Of the five apostles on the landing stage only one (in the centre at the back) is seen elsewhere, in a sketch-like *Old man with raised finger*, formerly in the collection of Michel van Gelder, Uccle, Brussels [83].[63] An example of Jordaens's habit of using more than one study of

80 *Three women and a child*
circa 1623
paper, transferred to panel,
32 × 62cm
Bucharest, Muzeul de Artá

81 *Study of an old man*
circa 1623
canvas, 49 × 43cm
Whereabouts unknown
(formerly in the Adler
Collection, Asch)

115

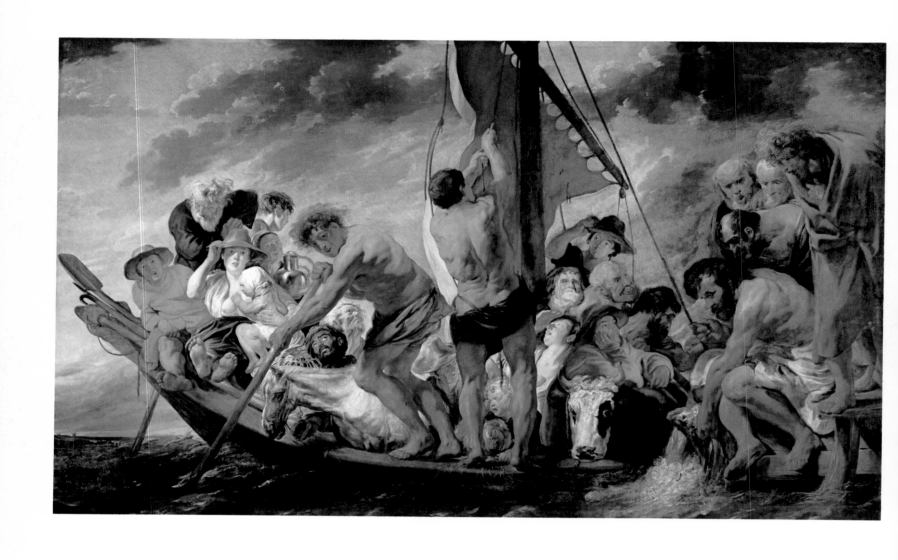

82 *St Peter finding the tribute money in the fish's mouth*
circa 1623
canvas, 281 × 468cm
Copenhagen, Statens Museum for Kunst
(details opposite and page 120)

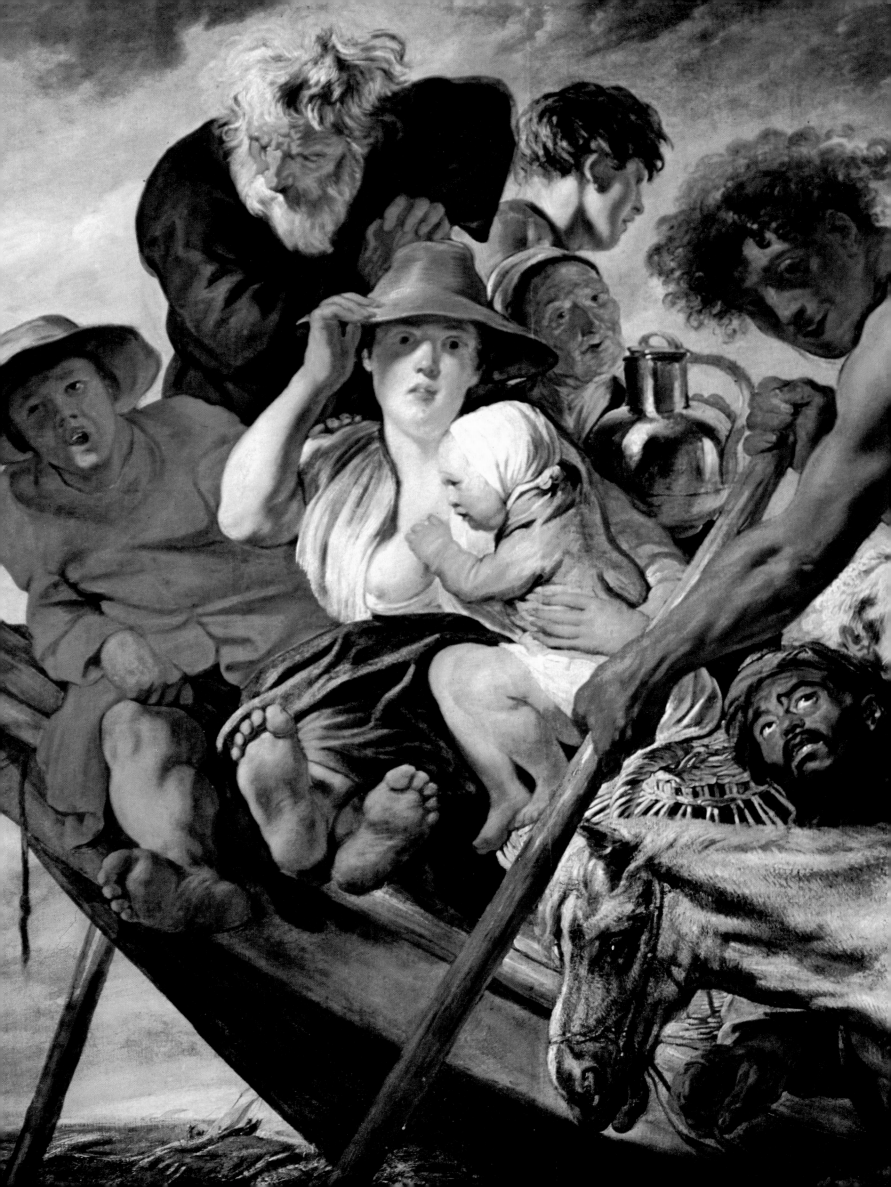

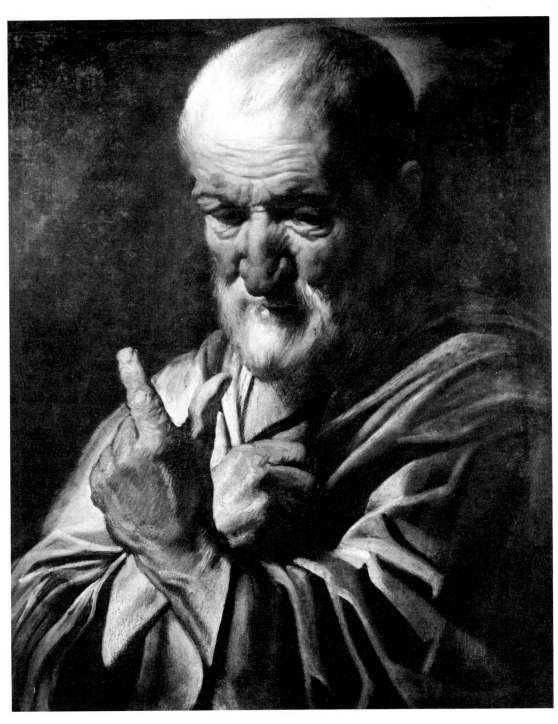

83 *Old man with raised finger*
circa 1623
panel, 68 × 52cm
Whereabouts unknown
(formerly in the collection of
Michel van Gelder, Uccle,
Brussels)

the same model in a painting is afforded by the curly haired apostle behind Peter
and the naked man pushing the boat off. What has been said of the studies of
people also applies to animals: the white horse is seen in an identical pose in
Homage to Ceres [84], and the ox with black markings on its face, looking full at
the spectator, is also present in a drawing of *The adoration of the shepherds* at
Dresden.[64] This enumeration is somewhat lengthy, but the picture presents a
unique opportunity to illustrate how extensively Jordaens made use of studies in
the 1620s, so that his works of this period are related not only by their style but by
the ever-recurring human and animal types based on studies kept in the studio. In
later years these studies tended to be drawings rather than oil paintings.

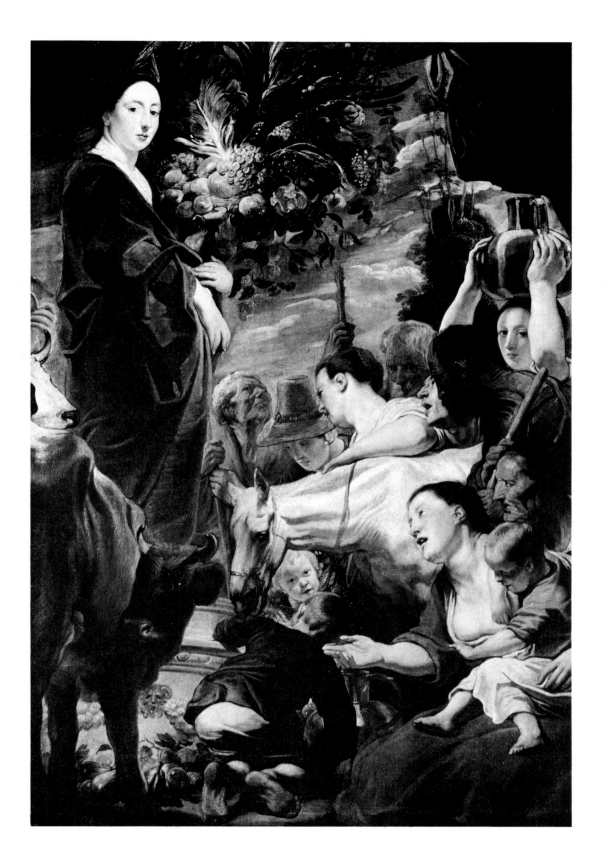

84 *Homage to Ceres*
circa 1623–25
canvas, 165 × 112cm (perhaps cut down on left and top)
Madrid, Prado

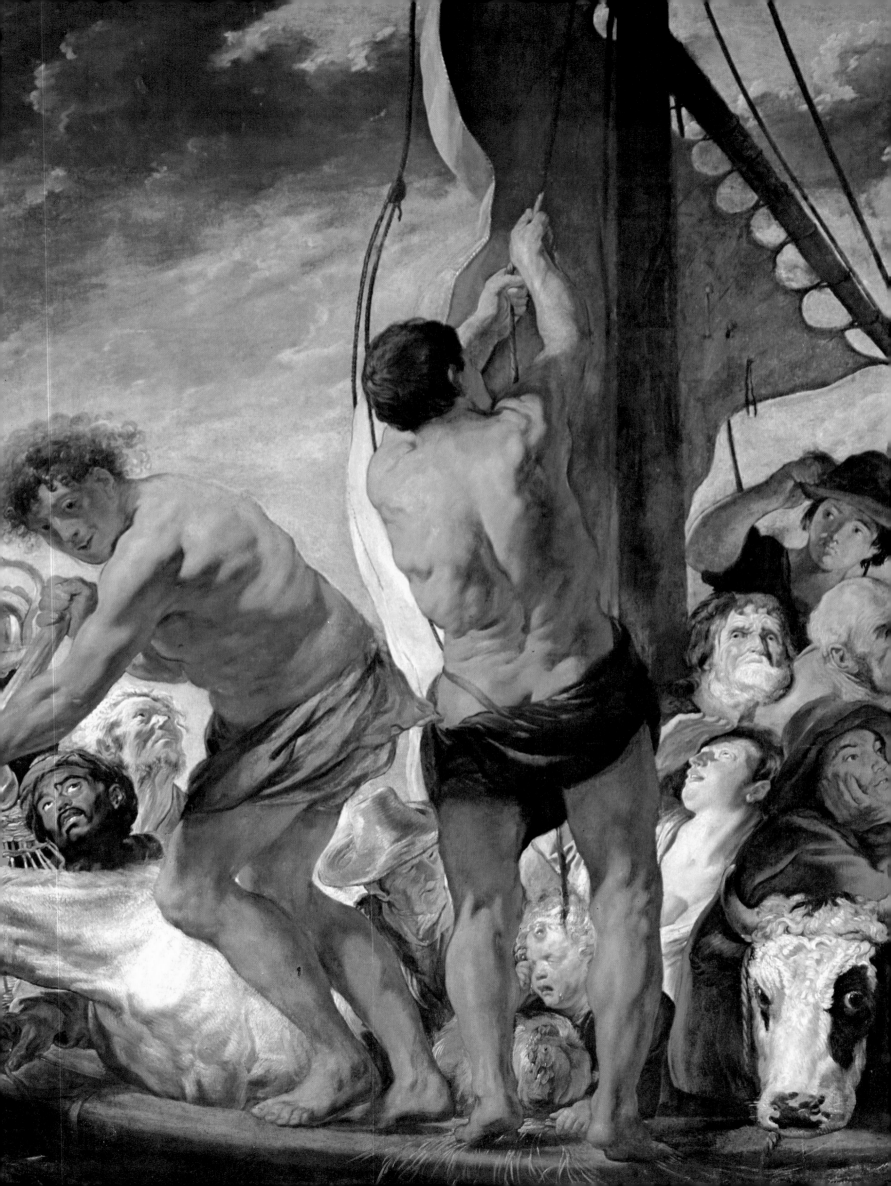

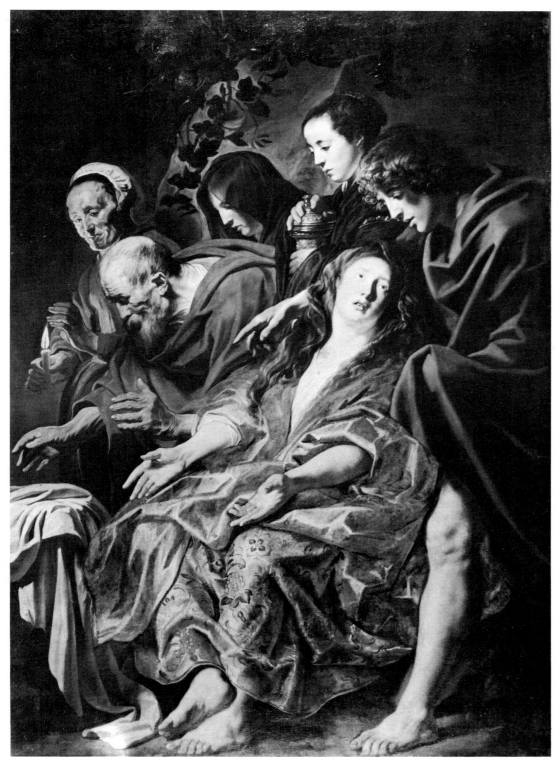

85 *The disciples at Christ's tomb*
circa 1625; reworked by the artist 1630s
canvas, 215 × 146cm
Dresden, Gemäldegalerie

82 *St Peter finding the tribute*
money in the fish's mouth
(detail)

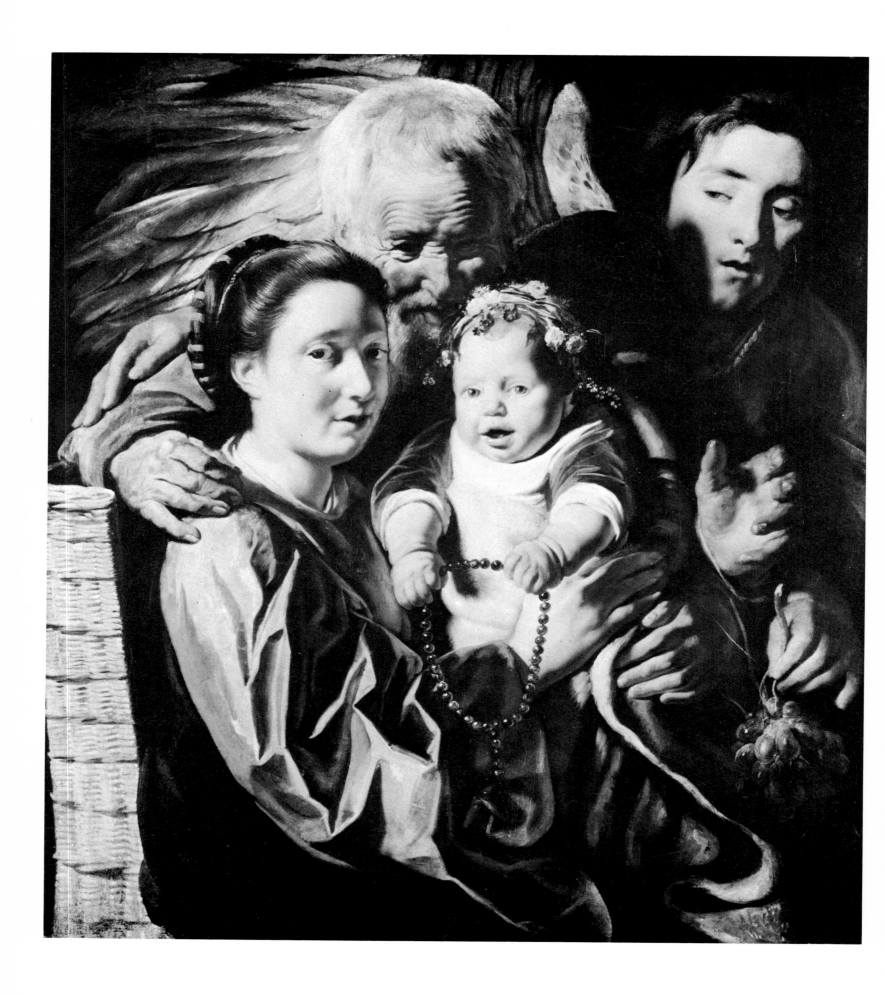

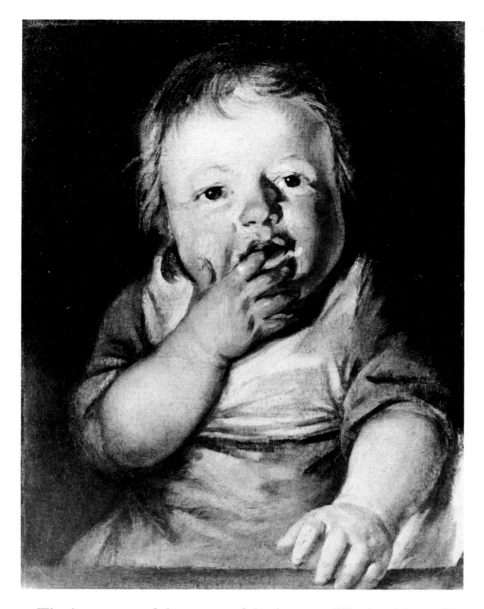

The inventory of the estate of Anthonette Wiael, widow of Jan van Haecht, drawn up at Antwerp on 5–7 July 1627, includes two pictures of which no trace has yet been found: an 'Assumption of Our Lady with ten angels, by Geert Snellincx and Jordaens', and 'Two pendants by Tobias van Haecht with figures by Jordaens'.[65] It appears from this that the master collaborated with other painters from an early stage, and also, as might be expected, that many pictures painted before the date of this inventory have been lost. Among those that have survived and were probably painted about 1625 or between then and 1630 are a number of religious scenes.

Probably the earliest of these is a *Holy Family with an angel* in the collection of August Carl von Joest at Wesseling near Bonn [86]:[66] a domestic scene in which Mary with the Child on her lap is embraced by Joseph, while the angel lays one hand on Joseph's shoulder and in the other holds a bunch of grapes symbolising the Passion. The Child Jesus, holding a rosary in token of his saving mission, is not unlike the *Small child* in the Pomeranian Museum at Gdańsk, Poland [87];[67] it has been suggested that this represents Jordaens's son born in 1625, and there is nothing in the style to contradict this.

87 *Small child*
circa 1625
canvas, 38 × 29cm
Gdańsk, Poland, Pomeranian Museum

86 *The Holy Family with an angel*
circa 1625
canvas, 87 × 77cm
Wesseling near Bonn, August Carl von Joest Collection

The *Child Jesus with St John* at Madrid[68] shows the two boys standing beside a fountain [88]. John, who is to recognise Jesus as the Messiah and baptise him as a sign that the kingdom of God is at hand, is dressed in penitential garb, holds up a banner with the words *Ecce Agnus Dei*, and points to the lamb beside him; Jesus is recognised by his halo. The fountain symbolises Jesus as 'fountain of life', and perhaps also alludes to his baptism. Neither the attitude nor the expression of the two children suggests the role that history has in store for them: healthy and well formed, they simply take pleasure in each other's company. In *The Holy Family with a maid-servant* at Stockholm[69] Jordaens reverts to his older practice of using an artificial source of light to create a cosy indoor atmosphere [89]. As in *The adoration of the shepherds* of 1616 [38] the candle is supplemented as a source of light, in this case by the open fire at which Joseph is warming his hands. With motherly pride Mary exhibits the young Child that can scarcely stand upright, a motif perhaps borrowed from Caravaggio's *Madonna of the rosary*, then in the Dominican church at Antwerp. As in some other *Holy Families* of the period, the spectator is brought into close

88 *The Child Jesus with St John*
circa 1625
panel, 130 × 74cm
Madrid, Prado

89 *The Holy Family with a maid-servant*
circa 1625–30
panel, 122 × 92cm
Stockholm, Nationalmuseum

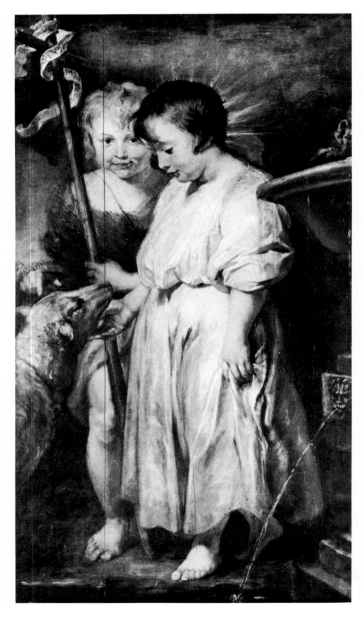

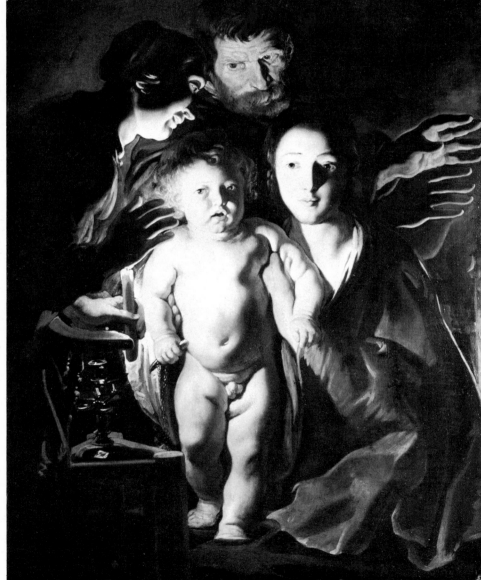

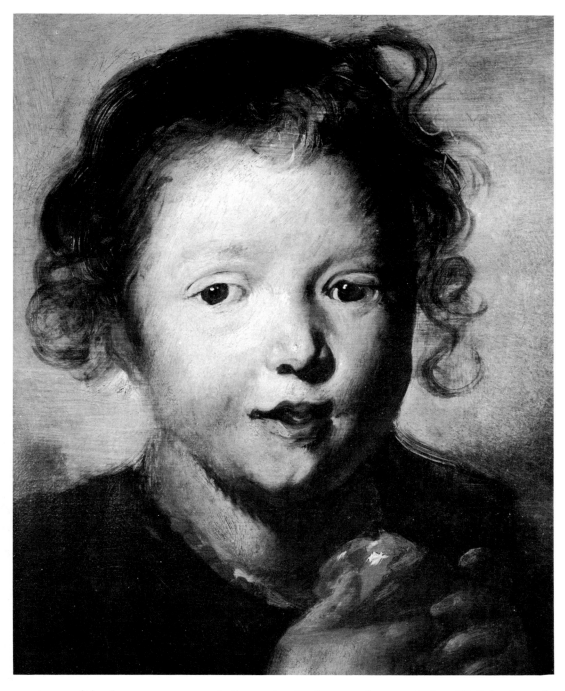

contact with the scene, especially as both the mother and the Child, though somewhat dazzled by the candle-light, are looking in his direction. The nocturnal atmosphere and the glowing fire place the genre-like scene in the heart of winter, the season at which Christ was born. The motif of the Child standing and supported by its mother is also found in a *Holy Family with St John* in London, probably of somewhat later date, *circa* 1630.[70] In *The Holy Family with St John and two maids* at Bucharest,[71] another night piece, the figures are lit by two candles and the Child is again displayed by his proud mother. *The Holy Family* at Southampton[72] comprises only the Child, Mary and Joseph, all three gazing at the spectator as if inviting him to join them. The Child Jesus, who underlines the invitation with a friendly gesture, is a somewhat idealised version of a study in the possession of Mr John Nieuwenhuys at Brussels [90].[73] This

90 *Study of a child*
circa 1628
panel, 36 × 29cm
Brussels, John Nieuwenhuys
Collection

125

study very probably represents Jordaens's son Jacob, born in 1625; the apparent age of the child in the picture suggests that it may have been painted in about 1628, so that the painting at Southampton cannot be previous to that date.

The inventory, drawn up on 7 July 1632, of the estate of Rembrandt's teacher Pieter Lastman includes a picture of *The four evangelists* by Jordaens and also a copy of it.[74] This is very likely the same as a picture now in Paris,[75] which is entirely in Jordaens's style of the 1620s [91]. Representations of the evangelists or their symbols occur from the fourth century onwards in the form of ivories, mosaics or wall-paintings, and later they were used to illuminate manuscripts. The theme was modified and developed in Italian painting and afterwards in the Netherlands, where it spread under Italian influence from the beginning of the sixteenth century. Rubens and his predecessors showed the evangelists together, writing or reading and accompanied by their emblems. Jordaens omitted these, but gave his four evangelists the unity of feeling that was mostly lacking in the work of earlier artists. He depicts them as sunk in thought or meditation: three are sun-tanned and wrinkled by age and outdoor work, while St John resembles the many fresh-faced youths already seen in various paintings. The four men are gazing at a large open book, one of four that appear in the picture. One of the men, with the noble features of Grapheus, divides his attention between what he is reading and what he is to write in his own gospel.[76] The old man beside him, with a musing expression, already figured as an apostle in *St Peter finding the tribute money* [82] and is based on the study of an *Old man with raised finger* [83].

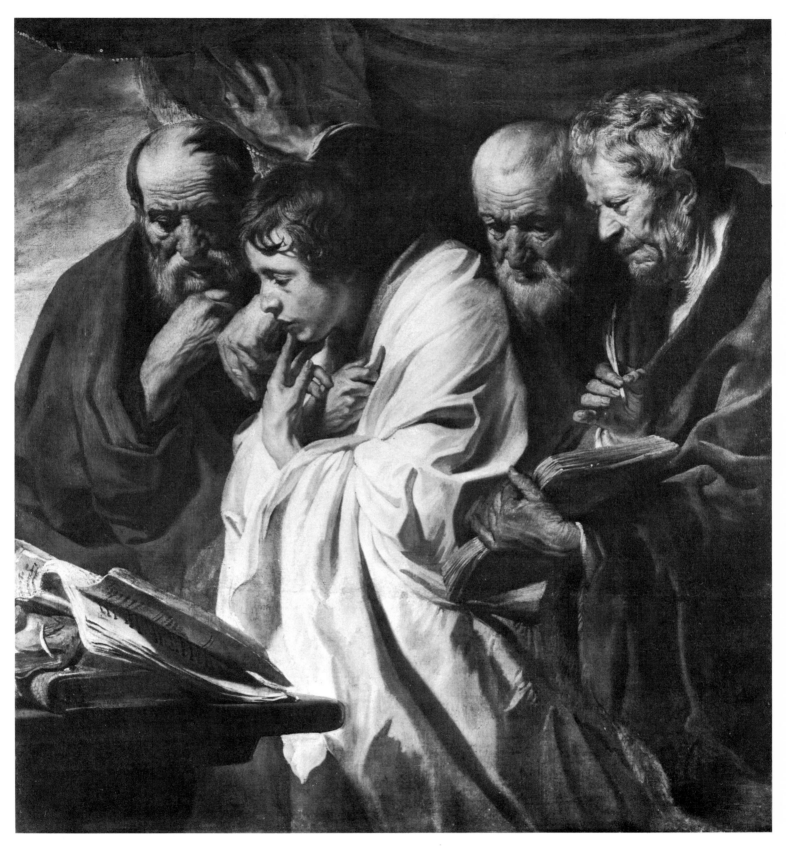

91 *The four evangelists*
1625–1630
canvas, 133 × 118cm
Paris, Musée du Louvre

92 *Study of a woman,*
looking upwards
circa 1628
paper on canvas, 39 × 36.5cm
Stuttgart, Staatsgalerie

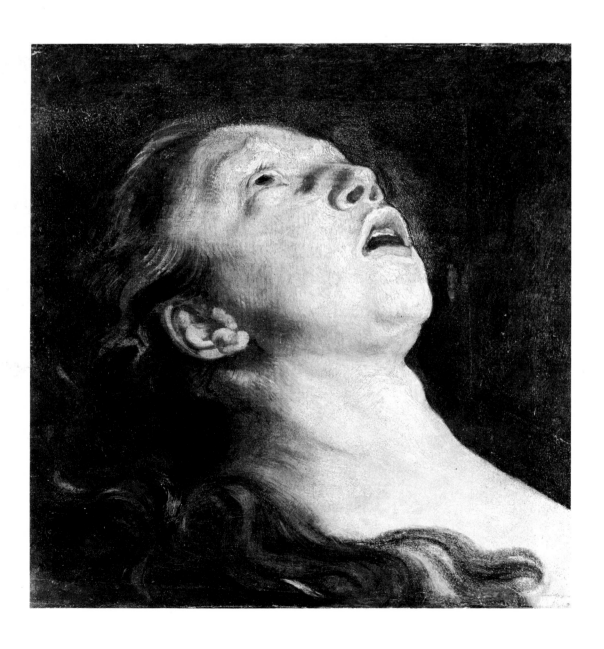

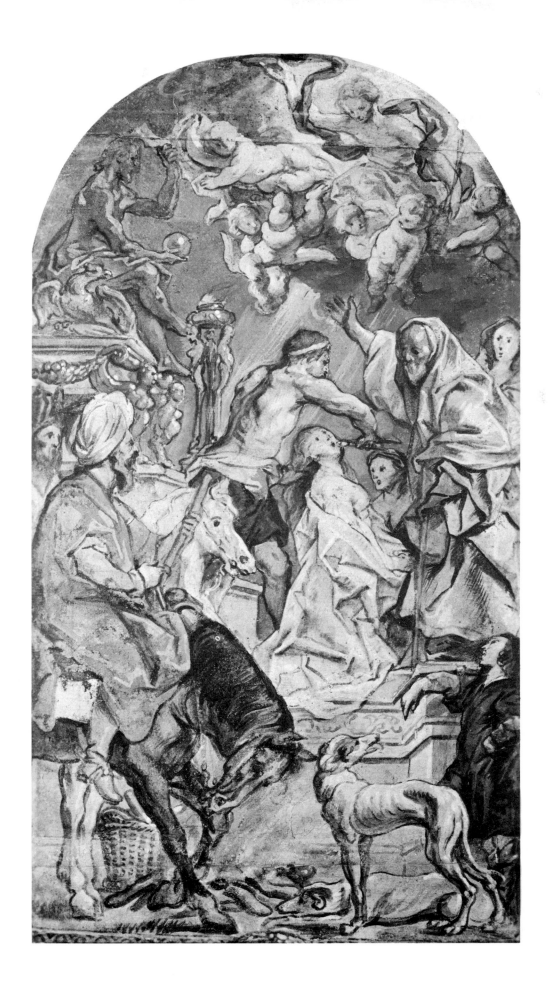

93 *The martyrdom of*
St Apollonia
circa 1628
drawing, 510 × 275mm
Antwerp, Stedelijk
Prentenkabinet

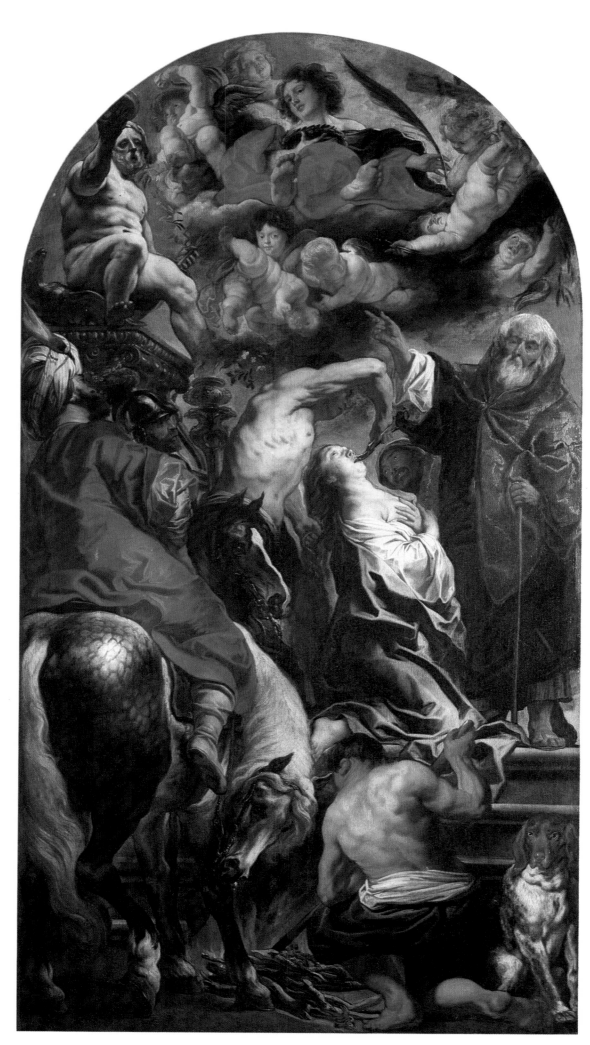

94 *The martyrdom of
St Apollonia*
1628
canvas, 409 × 213cm
Antwerp, Augustinian church

V

Fruitful years
circa 1628–41

Two large altarpieces – *The martyrdom of St Apollonia*, 1628, and *St Martin healing a possessed man*, 1630 – mark a certain alteration in Jordaens's style, and usher in a period which differs in several respects from the previous years. *The martyrdom of St Apollonia* [94][1] was painted for the Augustinians, who had established themselves at Antwerp in 1608 with the help of the archducal couple Albert and Isabella. Paintings were required for three altars in their church, built in 1615–18. Rubens painted a *Madonna adored by saints* for the high altar, Van Dyck a *St Augustine in ecstasy* for the side altar on the left, while Jordaens's canvas was intended for the right-hand altar dedicated to Apollonia and other saints. Van Dyck and Jordaens no doubt owed the commission to Rubens, who was on good terms with the Augustinians. The three pictures, which are all still *in situ*, were completed in 1628. The church was dedicated to all the saints and especially to Our Lady of Loreto, as indicated by an inscription over the main door. The Augustinians of Antwerp had a special devotion to the virgin martyr St Apollonia, who was invoked against toothache and whose relics were venerated in the church. Not only did they commission a picture of her martyrdom from Jordaens, but they also took care that she figured in Rubens's altarpiece. As far as is known, *The martyrdom of St Apollonia* is Jordaens's first great altarpiece of markedly vertical format. The subject, a typical Counter-Reformation scene, was unfamiliar to him, and it is not surprising that he sought inspiration from Rubens, who had already painted several dramatic works of this kind after the Venetian model, such as *The martyrdom of St Catherine* at Lille [95].[2] Jordaens found in these all the necessary elements of his own composition: the saint and her tormentors, the priest pointing to the idol and urging her to renounce her faith, and a heavenly group proclaiming the triumph of martyrdom. The way in which he combined these, however, betrayed his limitations. His heavy figures, piled one above the other, do not give a proper idea of their arrangement in space. The picture lacks Rubens's sense of organic composition and Van Dyck's graceful linear rhythm, so that in spite of its brilliant and varied colouring it can scarcely be compared with the other two altarpieces. For the martyred saint Jordaens made use of his *Study of a woman, looking upwards* at Stuttgart [92].[3]

An engraving of the picture was made by Marinus (*d* 1639).[4] To simplify the engraver's task and improve the result Jordaens painted a *modelletto* in oil on paper, now in the Petit Palais in Paris:[5] the composition was adapted to the dimensions of the engraving, and the distribution of light and shade modified

with a view to a more harmonious balance. Another such *modelletto* by Jordaens is *Christ before Caiaphas* at Sibiu, Romania,[6] also for an engraving by Marinus.[7] Rubens used the same technique where important engravings were concerned.

Two years later, in 1630, Jordaens painted another large vertical work, *St Martin healing a possessed man*, for the high altar of St Martin's church at Tournai. Removed by the French in 1794, it was restored by Napoleon in 1811 and placed in the Brussels museum [97].[8] Here again Jordaens was inspired by Rubens, especially *St Ignatius healing a possessed man* (1619–20), then in the Jesuit church at Antwerp.[9] As in the Rubens picture, the saint dominates the central event from a raised position. Jordaens executed no fewer than three elaborate *modelli* for this work [96],[10] but in spite of his pains it cannot be regarded as fully successful: the miraculous cure is not closely enough related, formally or psychologically, to the static figures of the saint and spectators. It is clear that large set pieces of this sort, depicting miracles or martyrdom, were not in Jordaens's line. He lacked the power to organise their plastic and chromatic elements into a compelling dramatic effect.

Numerous features which already pointed to a change of style in his latest works of the period 1619–27 are so developed in these two altarpieces that there is a definite appearance of a new type of vision. Large expanses of colour are now avoided, and in place of self-contained forms with smooth contours much use is made of angular, broken lines. No other artist in Antwerp at the time made systematic use of such broken lines, and it is hard to suppose that so striking a change took place without outside influence. A certain affinity with Baroccio in this respect suggests that Jordaens was acquainted with some of that master's work, either directly or through engravings which were widely circulated in the Netherlands. It is also noteworthy that from this time on, Jordaens paints muscles with undue prominence and disregard for anatomy. The excessive use of red, the application of more fluid paint and a certain looseness of touch gradually deprive his nudes of their former golden quality.

Four large religious compositions are closely related in style to *St Martin healing a possessed man*. First among these is *The four Latin Fathers of the church* at Stonyhurst College, Blackburn, Lancaster [98].[11] It can be reasonably assumed that this picture, which is unmistakably by Jordaens's own hand, is identical with 'A large framed canvas showing the four doctors of Holy Church, by Rubens and Jordaens', listed in the inventory of the estate of the Antwerp art dealer Herman de Neyt, who died in 1642.[12] To judge from the quality of the composition it was probably painted after a sketch by Rubens, perhaps in oils, though no such model has come to light. The composition was evidently a success, as other versions of it are known, which may have been painted in Jordaens's studio.[13] The second great religious painting, an altarpiece of *The triumph of the Eucharist*, is now at Dublin [99];[14] its original purpose is unknown. A female figure, seated on a lion and with a monstrance in her hand, symbolises the church; the Child Jesus, as Imperator Mundi, sits on a globe at her feet. To her left are Sts Peter and Paul and the Latin Fathers Augustine and Jerome; to the right, the two other Latin Fathers Gregory and Ambrose, two female saints and St Sebastian. The Holy Spirit, surrounded by cherubs, hovers above the woman's head. In general the composition resembles Rubens's *Madonna adored by saints* in the Augustinian church at Antwerp. Another religious work by Jordaens, *The sacrifice of Isaac* at Milan [100],[15] also owes much to Rubens: it is based on his work of the same title of about 1611–12, now at Kansas City.[16]

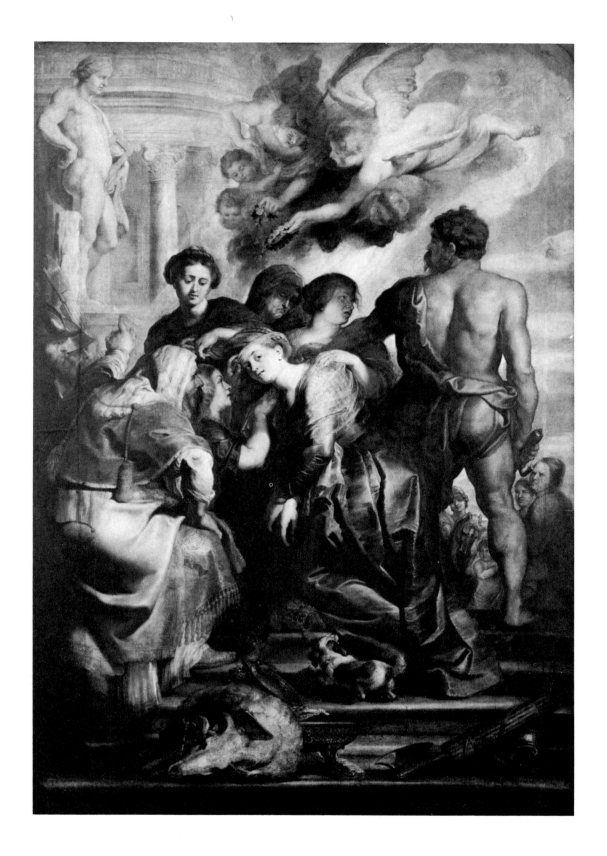

95 RUBENS
The martyrdom of St Catherine
circa 1618
canvas, 364 × 243cm
Lille, Musée des Beaux-Arts

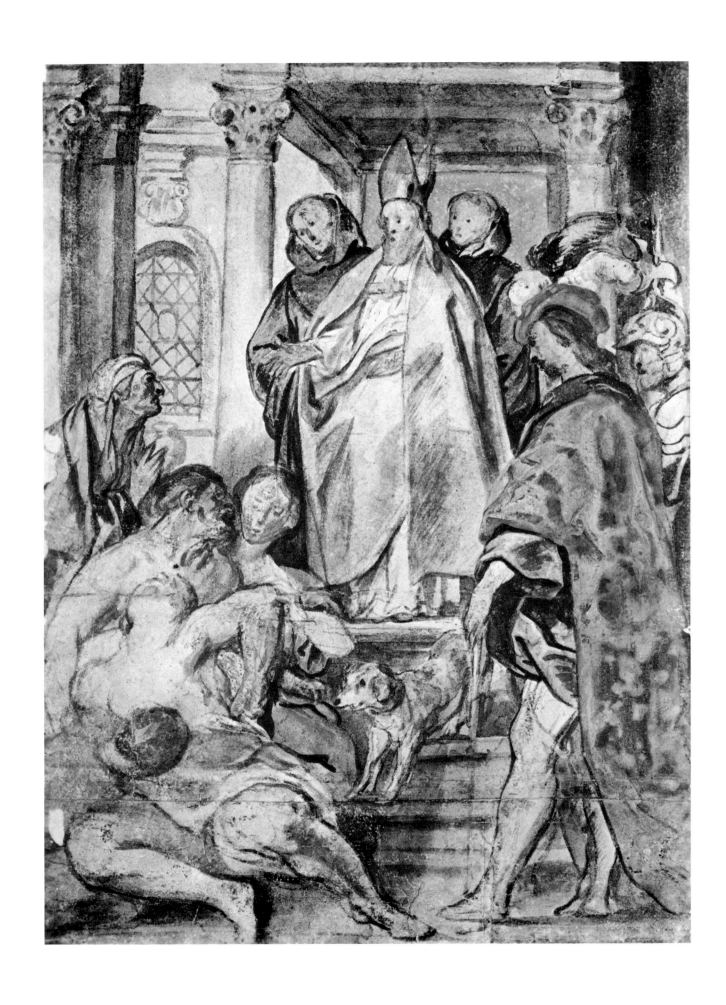

96 *St Martin healing a possessed man*
circa 1630
drawing, 450 × 315mm (a strip of 78mm has been added below)
Antwerp, Stedelijk Prentenkabinet

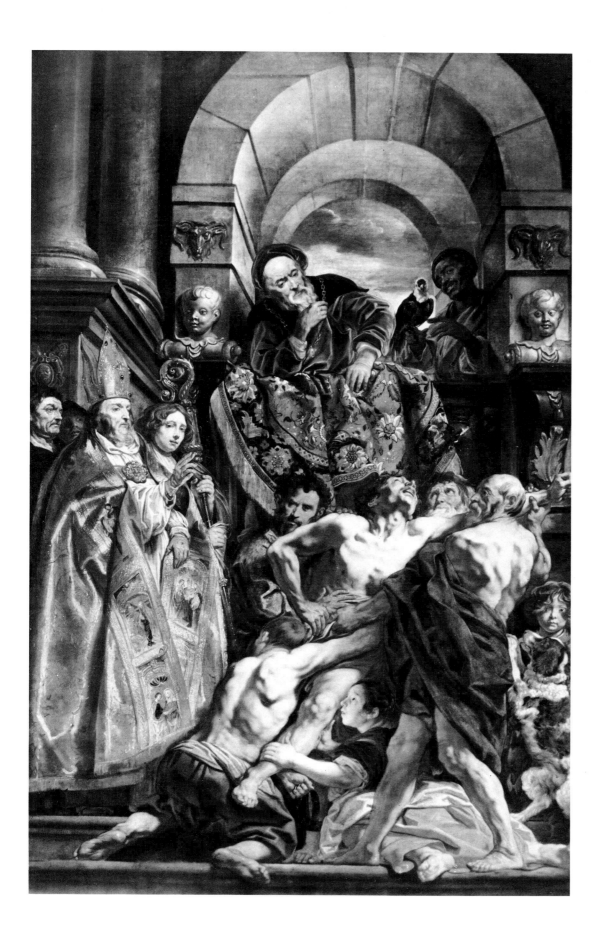

97 *St Martin healing a possessed man*
1630
canvas, 432 × 263cm
Brussels, Musées royaux des Beaux-Arts

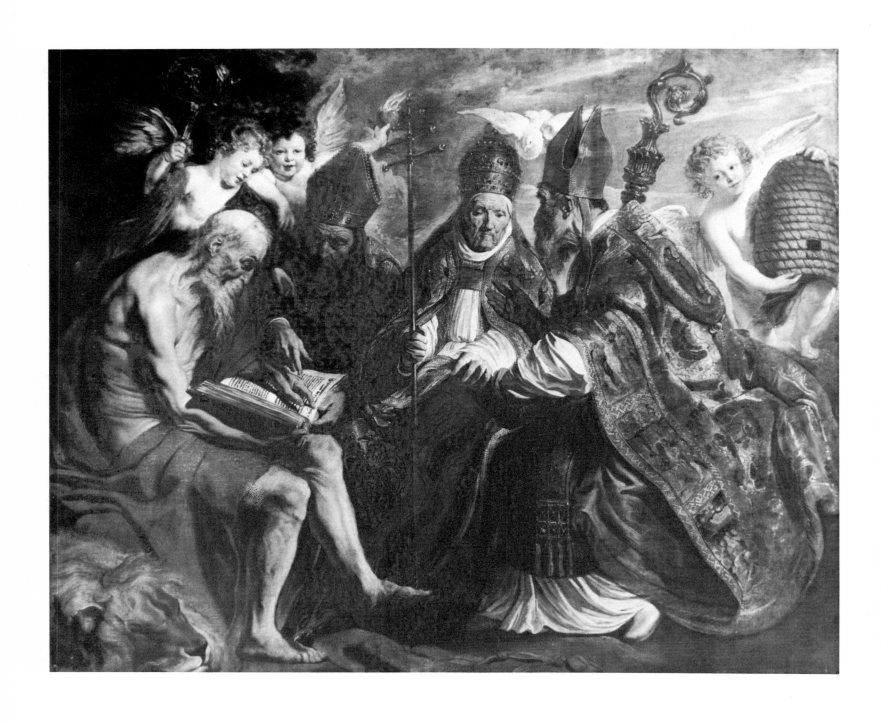

98 *The four Latin Fathers of the church*
circa 1630
canvas, 209 × 252cm
Blackburn, Stonyhurst College

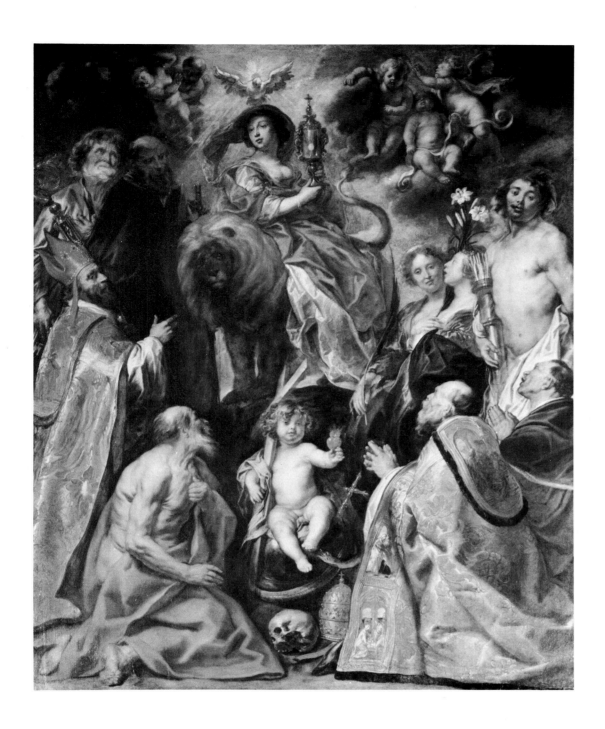

99 *The triumph of the Eucharist*
circa 1630
canvas, 280 × 231cm
Dublin, National Gallery of Ireland

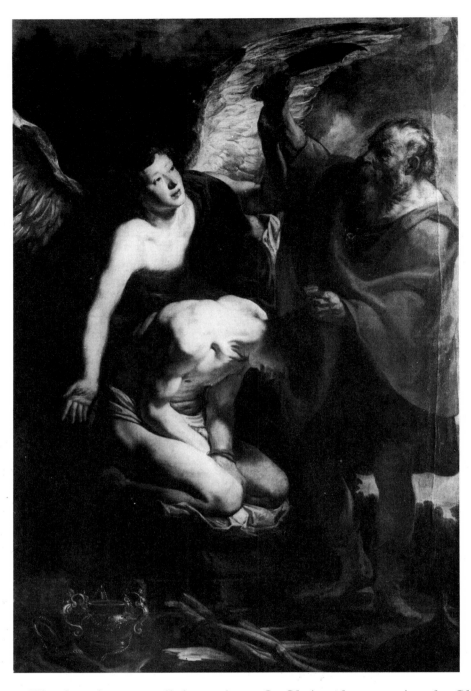

100 *The sacrifice of Isaac*
circa 1630
canvas, 242 × 155cm
Milan, Brera

The fourth great religious piece, *St Christopher carrying the Christ Child* at Belfast [101],[17] is again indebted to Rubens, this time to the outer panels of *The descent from the cross* in Antwerp cathedral, which depict the same scene. The enormous size of this canvas (312 × 161cm), with only a single main figure and two secondary figures, is connected with the special devotion to this saint as protector against the most feared disaster of all, namely sudden death. To guard against the danger of dying unconfessed, the faithful made a point of looking at St Christopher's image and praying to him as early as possible every morning. So that they should not have to waste time seeking him out in a dark chapel, it was customary to place enormous paintings or sculptures of the saint in churches, on the fronts of houses and even on city walls. Evidently the painting at Belfast was one of these.[18] This typically medieval devotion to St Christ-

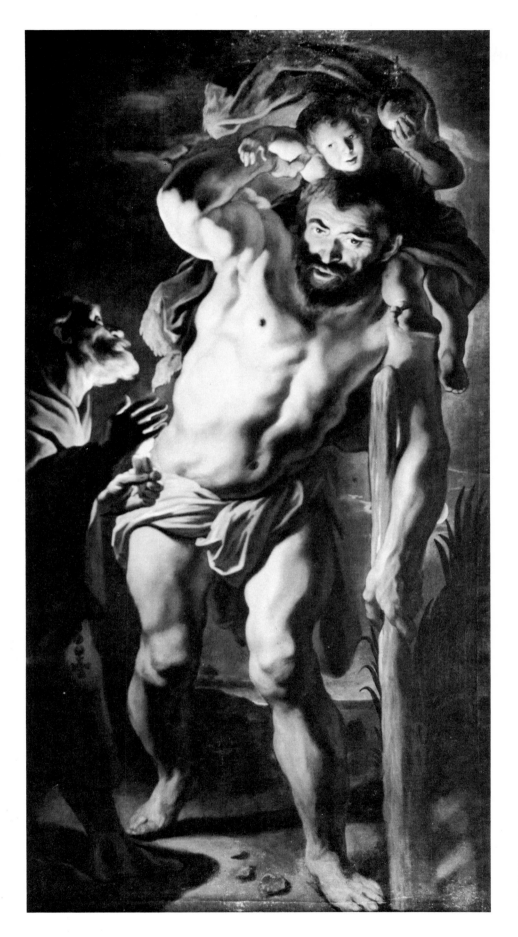

101 *St Christopher carrying the Christ Child*
circa 1630
canvas, 312 × 161cm
Belfast, Ulster Museum Art Gallery

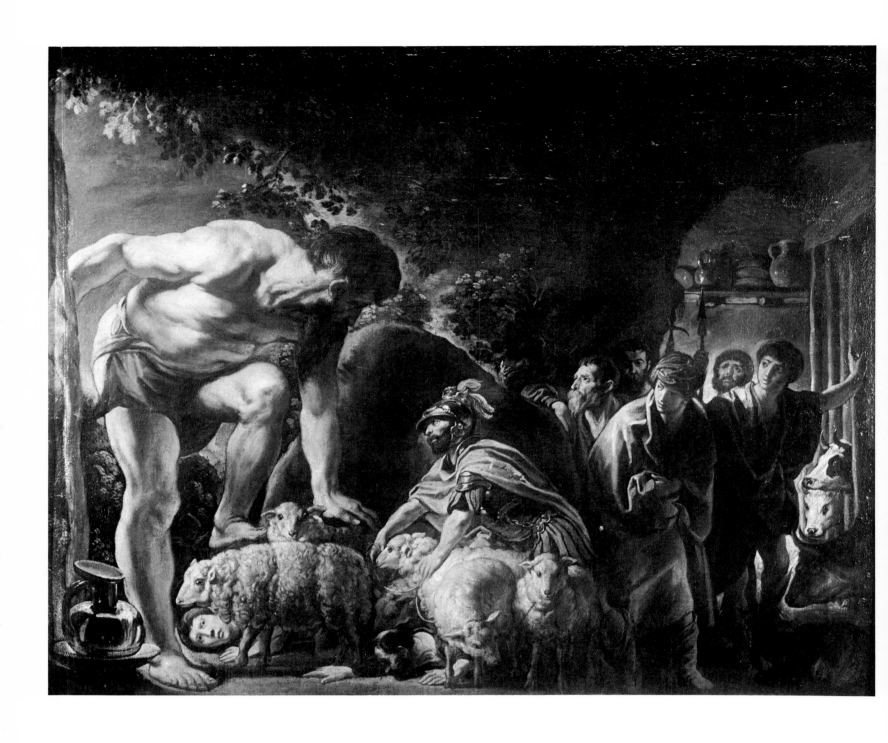

102 *Odysseus and Polyphemus*
circa 1630–35
canvas on panel, 76 × 96cm
Moscow, Pushkin Museum

opher began to wane from the fifteenth century onwards: it was attacked by Erasmus, and both the Reformers and the Counter-Reformers sought to expel St Christopher from the church. The fact that Rubens and Jordaens nevertheless painted such large pictures of him for display in churches testifies to the strength of the traditional belief. According to *The Golden Legend*, the saint bore the Christ Child across a river by night, and both artists represent the scene in half-light with many chiaroscuro effects.

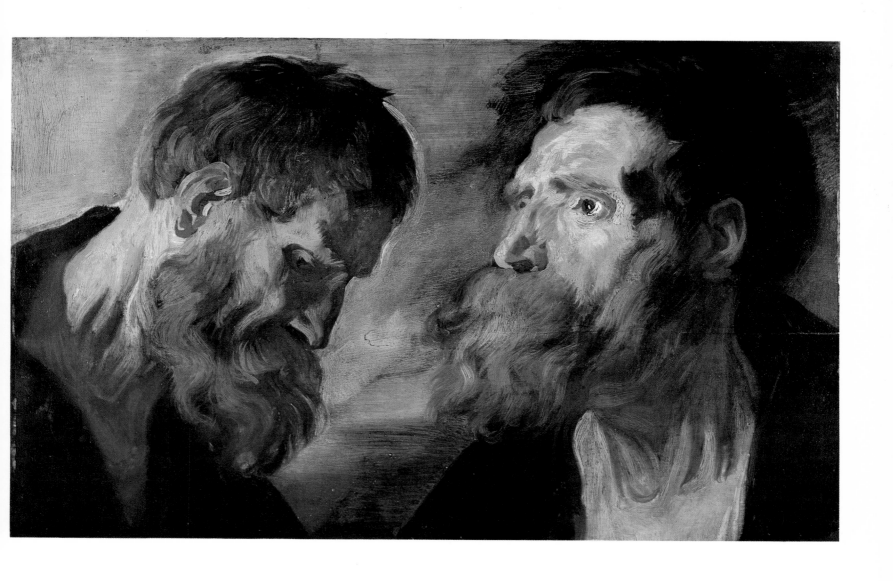

103 *Two studies of a man's head*
circa 1630–35
panel, 41 × 64.5cm
Karlsruhe, Staatliche Kunsthalle

Of somewhat later date, but still from the 1630s, is *Susanna and the elders* in Brussels [131],[19] a fine piece of work notable for the splendour of its colouring. Jordaens was evidently not greatly moved by the drama of the biblical story (Daniel 13:10–24): the luscious beauty does not seem much perturbed by her danger, and the faces of the elders suggest impotent admiration rather than unbridled lust. Jordaens was more interested in the luxurious setting wherein the rich Jehoiakim's wife makes ready for her bath: the marble fountain with its plump Cupid, the ewer of chased gold and above all the peacock, with its flowing tail like a cascade of sparkling jewels. Although the painting has an original and spontaneous air, it is not a product of Jordaens's own imagination: once again he relied on Rubens, in this case the latter's work of the same title at Stockholm (1614).[20]

In 1763 Mensaert noted in the church of St Martin's abbey at Tournai 'Un autre tableau qui représente Marte et Marie Madelaine, fait l'ornement d'un Autel; il est du même auteur [Jordaens]'.[21] This picture of *Christ in the house of Martha and Mary*, which at one time hung close to Jordaens's monumental *St Martin healing a possessed man* (1630), is now in the museum at Tournai.[22] It conveys little of the true meaning of the biblical story (Luke 10:38–42) in which Christ, without blaming Martha's diligence, declares that Mary has chosen the better part. Instead of affirming the supremacy of spiritual over material things, Jordaens confines himself to depicting a visit to a well-to-do seventeenth-century bourgeois interior. The scene also makes a radical breach with the tradition established by Pieter Aertsen and Joachim Beuckelaer in the sixteenth century, which treated the episode as the pretext for an elaborate kitchen still life. Although the picture has some fine elements, such as the figure of Christ and the head of the old disciple (after an oil sketch in the P. & N. de Boer Foundation at Amsterdam),[23] it is not entirely satisfactory.[24] The stiffness of some forms and the generally rather hard colour-scheme suggest the possibility of some studio assistance.

Many examples of *The flight into Egypt* with the Holy Family, an angel and three putti, show that this composition must have been very popular with Jordaens's patrons in the 1640s. A good version of 1641, the property of Baron R. de Borrekens, is in the chapel of the château at Vorselaar.[25] Certainly not of less quality, and perhaps the earliest of the known examples, is that at Moscow.[26] This completes the list of religious works of the period 1628–41.

Of special importance in Jordaens's work are his designs and cartoons for tapestries. These are so numerous that he may be regarded as one of the chief artists of his time in this sphere also, as will be shown fully in Chapter IX. At this point attention will merely be drawn to some paintings which, as can be seen from their subject-matter and style, were associated with tapestries in one way or another. In the first place these include pictures connected with Jordaens's earliest tapestry series, *The story of Odysseus* and *The history of Alexander the Great*, both of *circa* 1630–35, and *Scenes from country life, circa* 1635. Several are related to *The story of Odysseus* [104, 107, 110], though it is not always clear when they were painted or for what purpose: *Mercury visiting Calypso*, a sketch-like painting in the collection of Fru G. Reimann at Stensbygard, Denmark;[27] *Odysseus and Nausicaa*, a cartoon sold by Drouot in Paris in 1912[28] (a modified version of this was in the possession of P. van der Ouderaa at Antwerp in 1905);[29] *Odysseus and Polyphemus* in Moscow [102][30] – for a bearded companion of Odysseus, seen in profile, Jordaens used one of his *Two studies of a man's head* at Karlsruhe [103][31] and a more sketch-like variant is in the University of Kansas

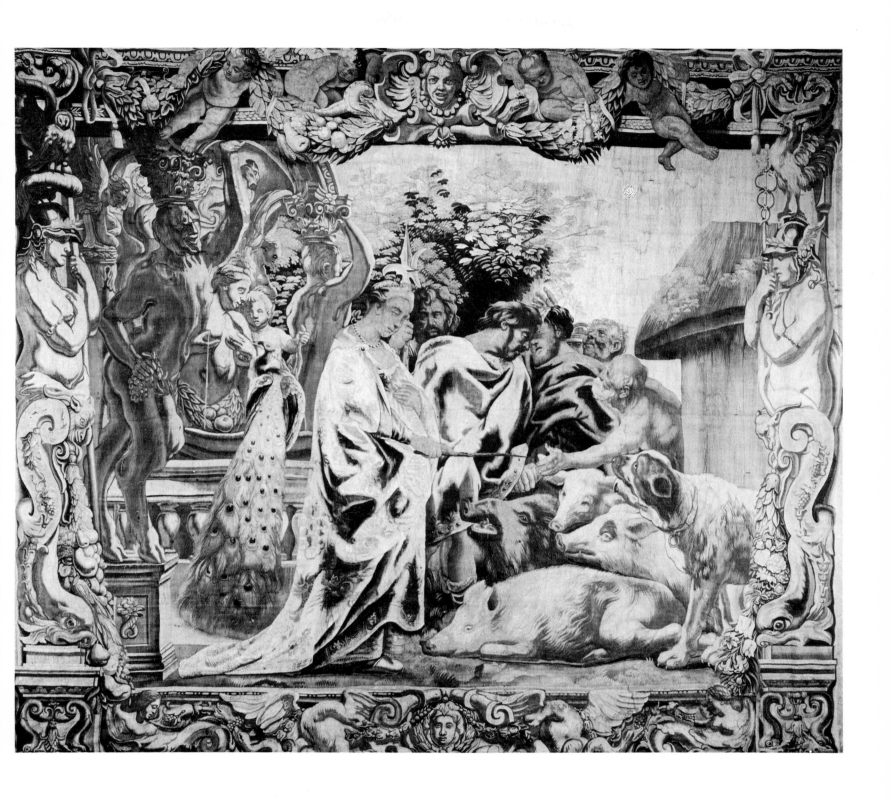

104 *Circe transforming Odysseus's men into swine* (*The story of Odysseus*)
designed *circa* 1630–35
tapestry, woven by E.R.C. and another unidentified weaver at Brussels
Mexico, private collection

Museum of Art[32] (Rubens, as appears from the inventory of his estate,[33] possessed a painting of this subject by Jordaens); *Odysseus threatening Circe*, formerly in the collection of the late Mrs Ruth K. Palitz in New York [105][34] (for the figure of Circe Jordaens used his *Study of a woman, looking upwards* at Stuttgart [92], already made use of for *The martyrdom of St Apollonia* [94]); *Odysseus taking leave of Circe and descending into Hades* at Ponce, Puerto Rico;[35] *Odysseus taking leave of Alcinous* at Leger and Sons' Gallery, London, in 1932;[36] and *Telemachus leading Theoclymenus before Penelope*, Granet museum, Aix-en-Provence[37] (a second version formerly belonged to Mr J. Wouters, Brussels).[38]

The story of Odysseus was not only intended as the illustration of an old myth

105 *Odysseus threatening Circe*
circa 1630–35
canvas, 81 × 119.5cm
Whereabouts unknown
(formerly in the collection of
Mrs Ruth K. Palitz, New York)

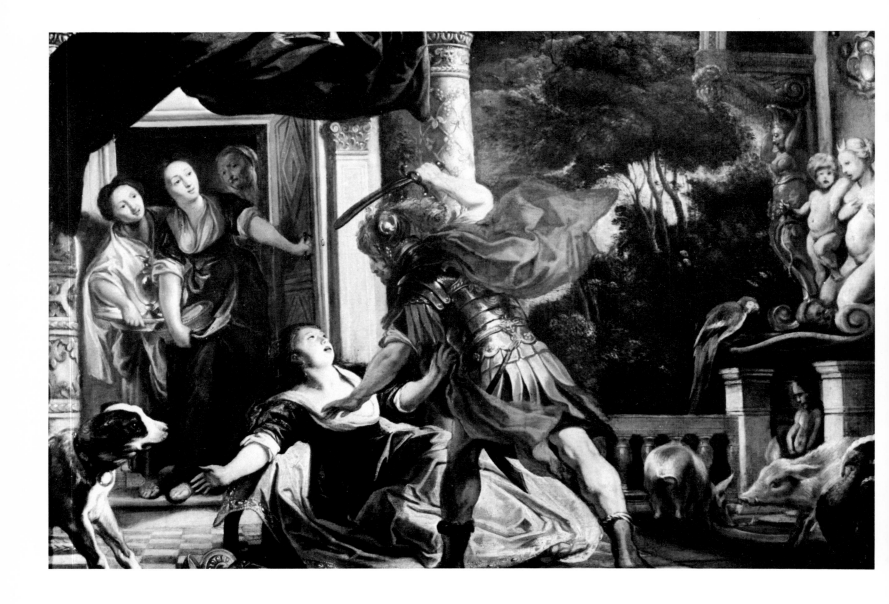

144

but as an incitement to noble feelings, based on the well-known *exemplum* of a brave, virtuous man overcoming the forces of evil. In the same way *The history of Alexander the Great* used historical facts to paint a picture of an ideal figure whose outstanding qualities were to be emulated. The large number of surviving versions of this series by Jordaens shows how popular it must have been. Curiously enough, little is known of its origin. A sketch-like work in the Palais des Archevêques at Narbonne[39] corresponds almost exactly with the tapestry *Alexander and Hephaestion consoling the family of Darius*, and the warrior in an oil sketch at Antwerp, *Two studies of women's heads and the torso of a warrior* [112],[40] appears in *Alexander wounded at the battle of Issus* [114].

106 *Two pigs*
circa 1630–35
drawing, 208 × 390mm
Amsterdam, Stedelijk Museum

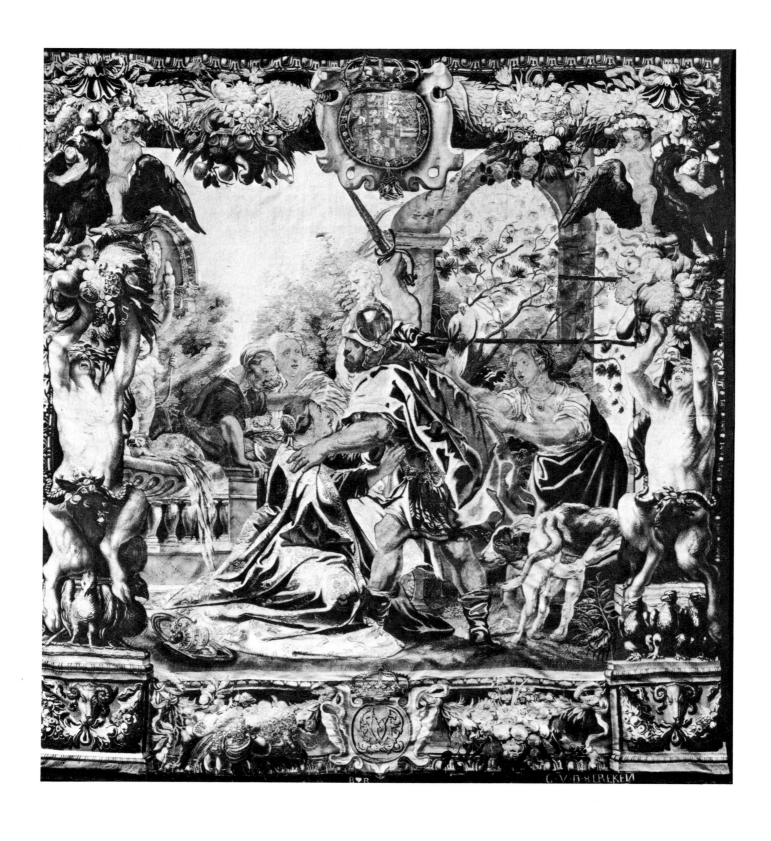

107 *Odysseus threatening Circe (The story of Odysseus)*
designed *circa* 1630–35
tapestry, 490 × 460cm, woven by G. van der Strecken, Brussels
Rome, Palazzo del Quirinale

146

108 *Two studies for posts forming part of decorative borders*
circa 1630–35
drawing, 400 × 145mm
Whereabouts unknown; sold in Paris, Drouot, 26 June 1950
(lot 79)

109 *Study of a post forming part of a decorative border*
circa 1630–35
drawing, 280 × 80mm
Switzerland, private collection

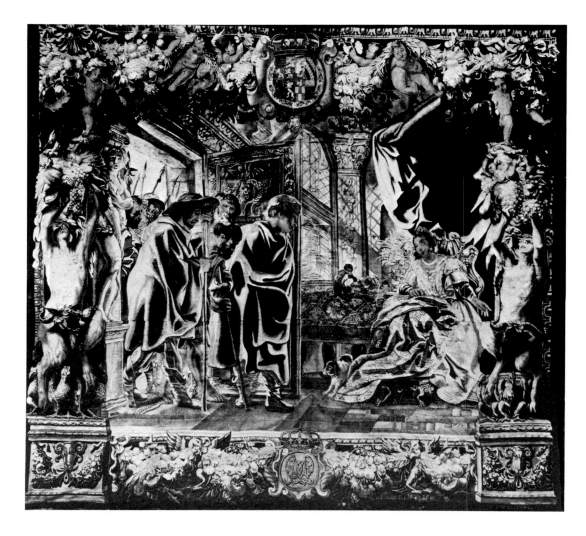

110 *Telemachus leading
Theoclymenus before Penelope*
(*The story of Odysseus*)
designed *circa* 1630–35
tapestry, 520 × 510cm, woven by
J. van Leefdael, Brussels
Rome, Palazzo del Quirinale

111 *Telemachus leading
Theoclymenus before Penelope*
circa 1630–35
drawing, 283 × 507mm
Stockholm, Nationalmuseum

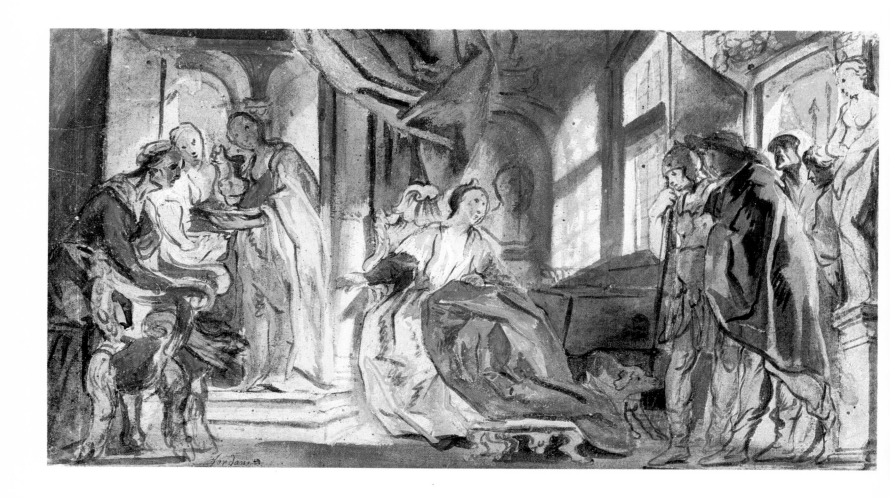

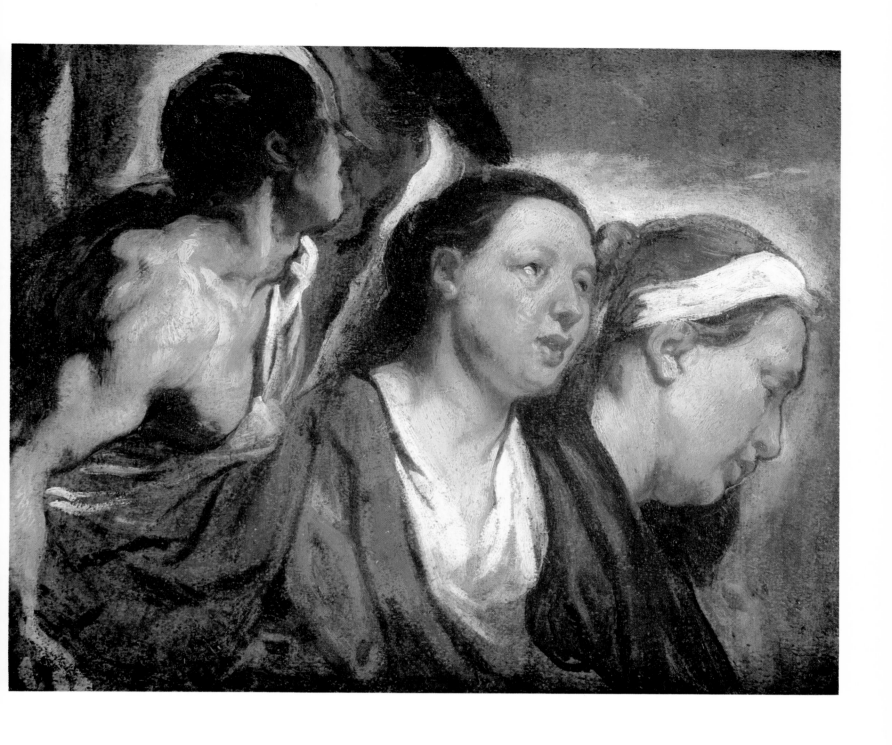

112 *Two studies of women's heads and the torso of a warrior*
circa 1630–35
paper mounted on panel, 41 × 51cm
Antwerp, Koninklijk Museum voor Schone Kunsten

113 *Soldiers attacking from a
ship*
circa 1630-35
drawing, 280 × 277mm
Paris, École Nationale
Supérieure des Beaux-Arts

114 *Alexander wounded at the
battle of Issus* (*The history of
Alexander the Great*)
designed *circa* 1630-35
tapestry, 770 × 420cm, woven by
Jacob Geubels, Brussels
Milan, Palazzo Marino

115 *Allucius and his bride before
Scipio*
circa 1630–35
drawing, 220 × 242mm
Rotterdam, Museum Boymans–
van Beuningen

116 *The presentation in the
temple*
circa 1630–35
drawing, 224 × 159mm
New York, Metropolitan
Museum of Art

151

117 *Study for a Mercury*
circa 1630-35
drawing, 185 × 128mm
Antwerp, Stedelijk
Prentenkabinet

Pictures connected with *Scenes from country life* are also rare. In a canvas at Glasgow[41] Jordaens repeated the composition of the tapestry *Maid-servant with a basket of fruit in front of an open door*, but he confined himself to reproducing the central part and thus showed the figures in half-length only [126]. Importance attaches to the painting *Piqueur seated amid a pack of hounds* at Lille [118],[42] signed *J. JoR fec* and dated *1635*, which corresponds broadly to the tapestry with the same title [124]. Compared with Jordaens's earlier work it shows a complete change in composition, especially the relation of the figures to the landscape: instead of the former predominating, the latter is now the real subject. The piqueur and hounds grouped to one side of the picture are only a means of attracting the eye to the landscape. Another change is the introduction of a strong perspective: it is hard to imagine a greater difference from Jordaens's earlier manner, in which the view was completely blocked by the foreground figures.

Jordaens's interest in myths and fables, which had led him at an early stage to paint figures of sculptural beauty, grew even stronger in the 1630s. To *The story of Odysseus*, which furnished the most signal example, other mythological

118 *Piqueur seated amid a pack of hounds*
signed and dated *J. JoR fec 1635*
canvas, 78 × 120cm
Lille, Musée des Beaux-Arts

scenes could be added. However, he clearly cared little for the supernatural aspect of the legends created under the bright sky of Hellas. True to his own temperament, he transformed ideal fantasy into everyday reality and placed the adventures of southern gods and goddesses in surroundings familiar to himself. The style of these works is naturally close to that of the religious scenes, as noted in the discussion of *The martyrdom of St Apollonia* [94] and *St Martin healing a possessed man* [97]. There is also a gradually increasing complication of forms, a growing animation of gestures and drapery, an increasingly subtle light composed of harmonies of golden-brown and grey, and finally the enveloping shadows which tend to produce a monochrome effect.

One of his favourite subjects was *The infant Jupiter fed by the goat Amalthea*, the earliest version of which, dating from about 1630–35, is in Paris [119].[43] The chief element in the composition is the cheerful, buxom figure of the nymph Adrastea, whose naked form shines out in contrast to the darker hues of Jupiter and a satyr. Jordaens's skill as an animal painter is seen in the smooth, sweeping strokes with which the goat is depicted, its hindquarters bathed in light and its shaggy head in half-shadow. With the same deftness he paints the gnarled tree in the foreground and the rich meadows stretching far away, under a light blue sky

119 *The infant Jupiter fed by the goat Amalthea*
circa 1630–35
canvas, 150 × 203cm (probably cut at top and sides)
Paris, Musée du Louvre

and clouds illuminated by the warm sun. It would be unusual if he had not added some moral or interpretive comment to the scene, and on the engraving by Schelte à Bolswert which varies only slightly from the painting there is a Latin text[44] of the following tenor: 'Is it to be wondered at that Jupiter yields to the power of love and strays into forbidden beds? Here he is being reared on goat's milk among satyrs: he has imbibed the goat's [lascivious] nature and is led by it'. Another engraving by Schelte à Bolswert, this time after Jordaens's *Pan playing the flute*, which is now at Amsterdam [120][45] and was painted at about the same time as *Jupiter and Amalthea*, bears an inscription of a purely bucolic nature.[46]

Among the many versions of *The infant Jupiter fed by the goat Amalthea* painted by Jordaens himself or with studio help is a particularly fine one at Kassel dating from about 1630–35 [121].[47] Although the central element is still the sumptuous form of Adrastea milking the goat, the spectator's attention is chiefly drawn to a humorous and anecdotic feature: the goat has overturned the milk-pail, and the infant Jupiter starts to bellow in fear that he will have to go thirsty. This is another instance of Jordaens's fondness for giving an everyday colouring to scenes depicting the gods.

120 *Pan playing the flute*
circa 1630–35
canvas, 135 × 176cm
Amsterdam, Rijksmuseum

121 *The infant Jupiter fed by the goat Amalthea*
circa 1630–35
canvas, 219 × 247cm
Kassel, Staatliche
Gemäldegalerie

122 *Piqueur seated amid a pack of hounds*
circa 1635
drawing, 355 × 502mm
London, Victoria and Albert
Museum

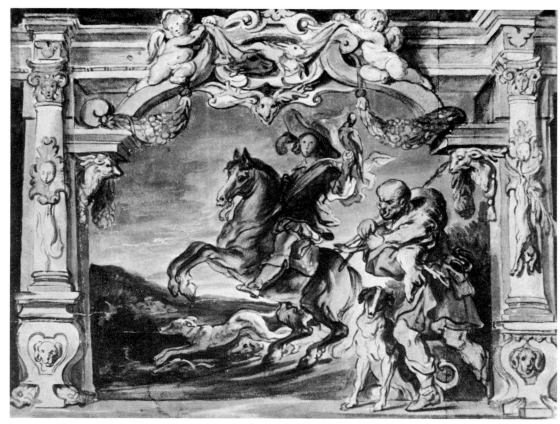

123 *Rider returning from the
hunt*
circa 1635
drawing, 352 × 454mm
London, British Museum

124 *Piqueur seated amid a pack
of hounds (Scenes from country
life)*
designed *circa* 1635
tapestry, 379 × 530cm
Vienna, Kunsthistorisches
Museum

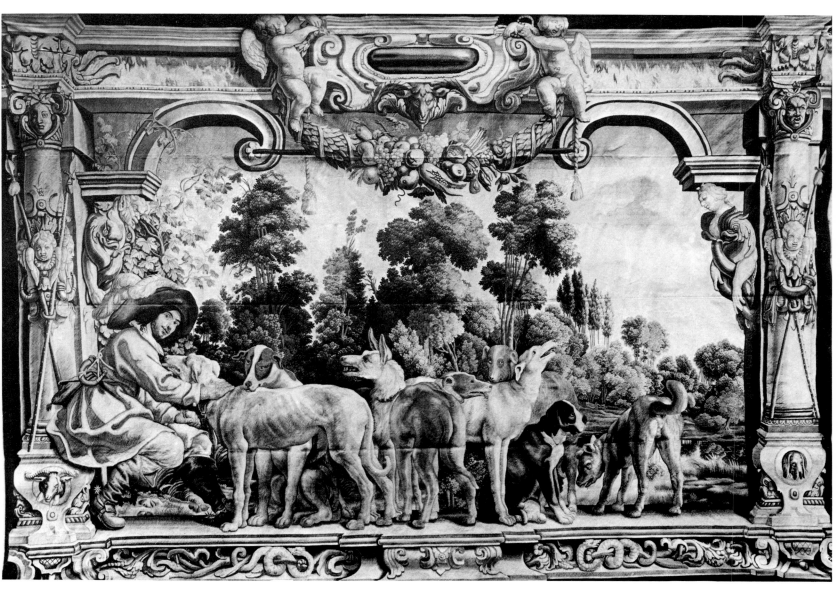

125 *View of a kitchen and a
table laden with food*
circa 1635
drawing, 215 × 288mm
Paris, École Nationale
Supérieure des Beaux-Arts

126 *Maid-servant with a basket
of fruit in front of an open door*
circa 1635
canvas, 116 × 156cm
Glasgow, Art Gallery

127 *Lady and gentleman in an arbour* (*Scenes from country life*)
designed *circa* 1635
tapestry, 381 ×263cm, woven at Brussels
Vienna, Kunsthistorisches Museum

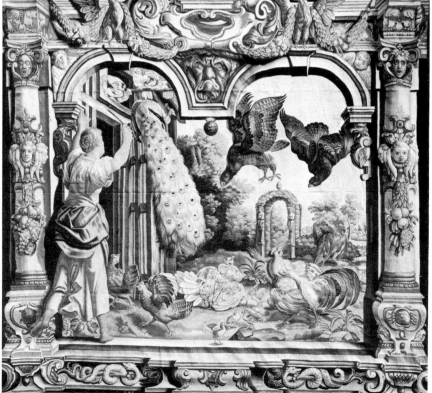

128 *Barnyard with swooping hawks* (*Scenes from country life*)
designed *circa* 1635
tapestry, 379 ×385cm, woven at Brussels
Vienna, Kunsthistorisches Museum

159

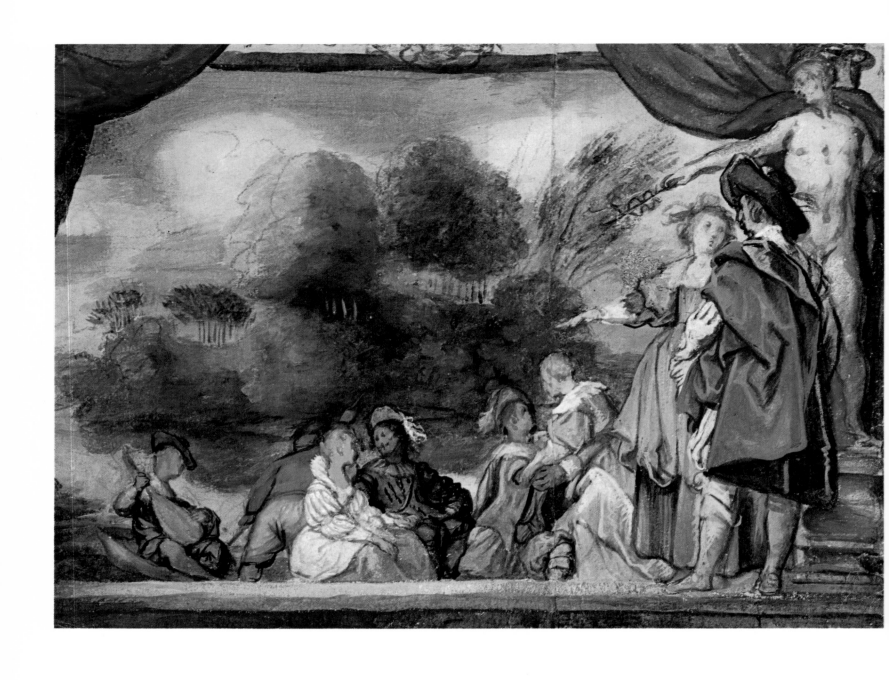

129 *The embarkment*
circa 1635
drawing, 280 × 381mm
London, British Museum

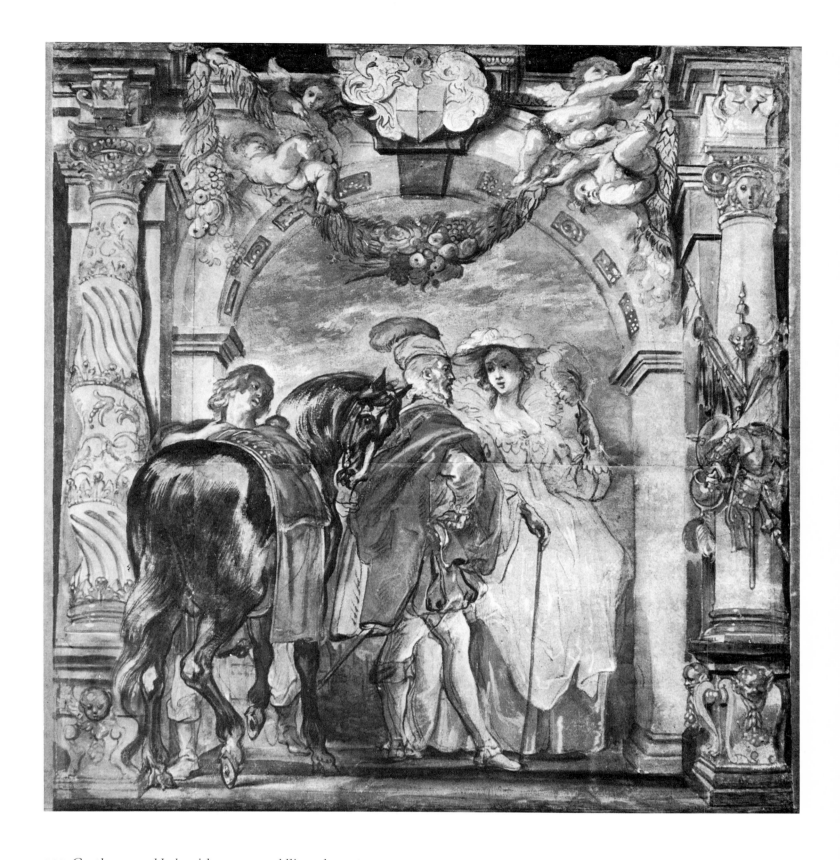

130 *Gentleman and lady with a groom saddling a horse*
circa 1635
drawing, 832 × 781mm
Northamptonshire, Castle Ashby, collection of the Marquess of
Northampton

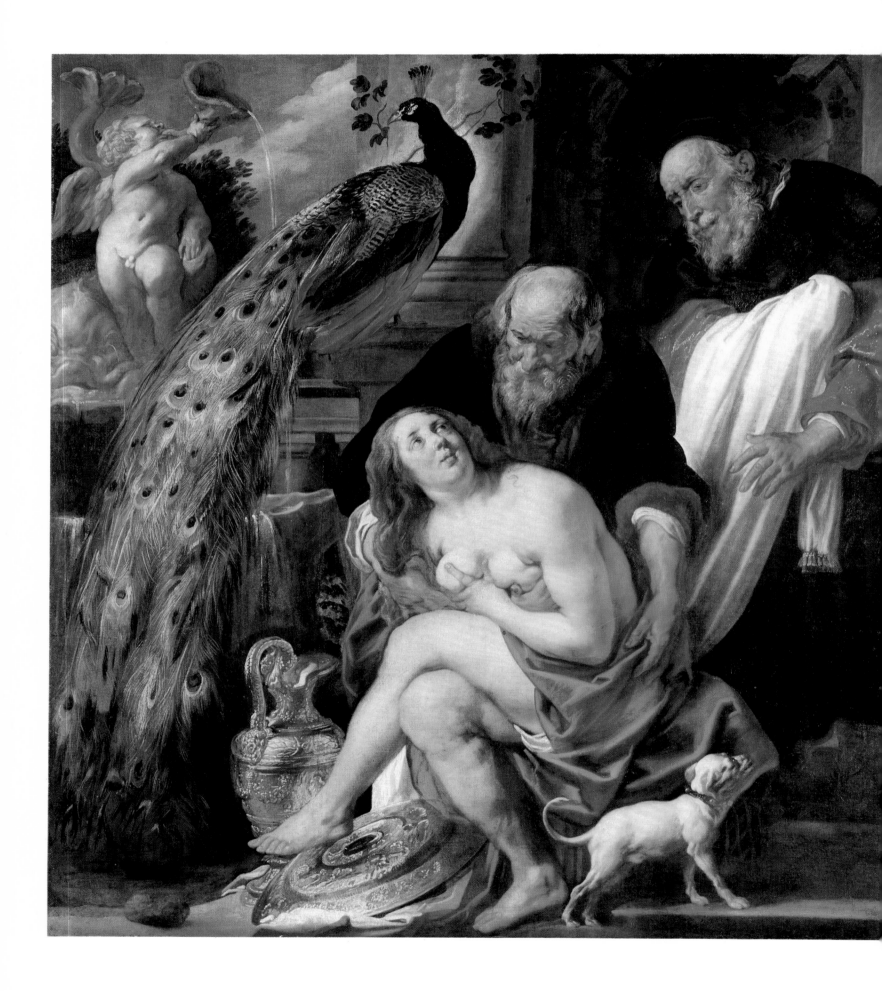

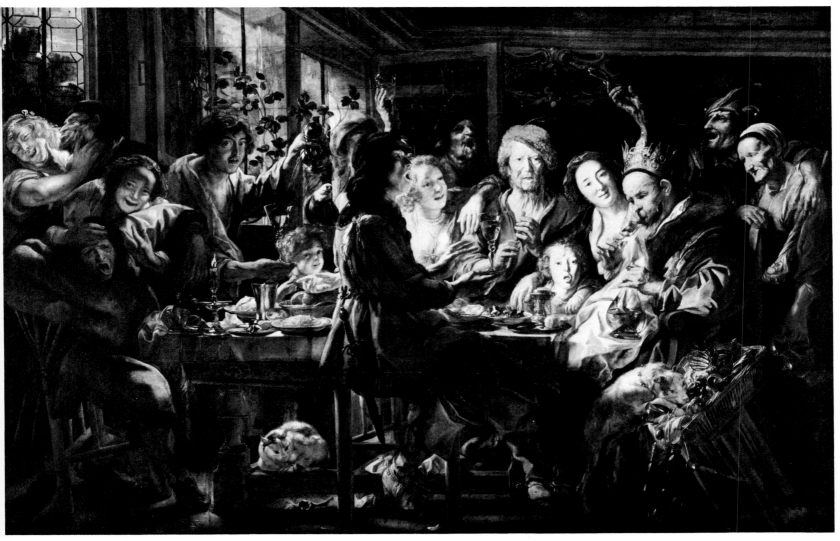

132 *The king drinks*
1630s; strip on left, 1650s
canvas, 243 × 373cm
Kassel, Staatliche Gemäldegalerie

131 *Susanna and the elders*
1630s
canvas, 189 × 177cm
Brussels, Musées royaux des Beaux-Arts

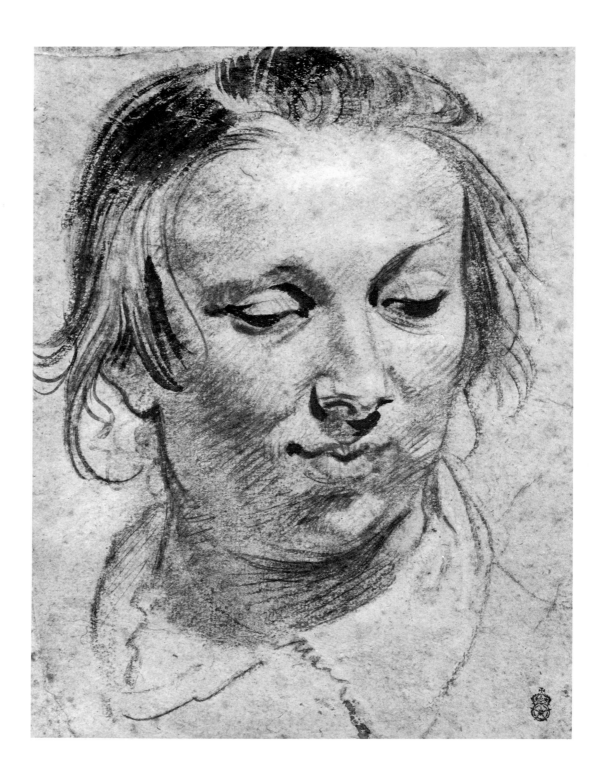

133 *Head of a woman*
circa 1635
drawing, 237 × 187mm
Whereabouts unknown (formerly in the César de Hauke
Collection, Paris)

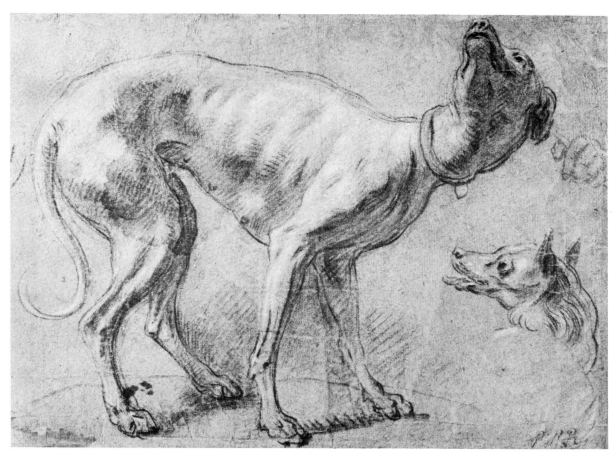

134 *Study of a dog*
circa 1635
drawing, 287 × 373mm
Antwerp, Stedelijk
Prentenkabinet

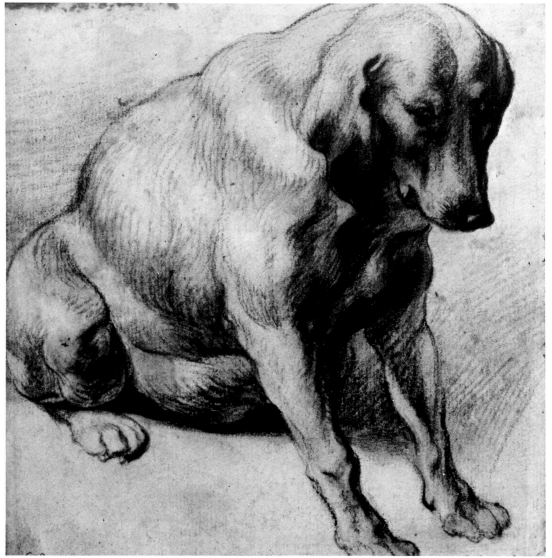

135 *Sitting bitch*
circa 1637
drawing, 155 × 143mm
Amsterdam, Rijksmuseum

136 *Bagpiper*
circa 1638
drawing, 216 × 152mm
Rotterdam, Museum Boymans–van Beuningen

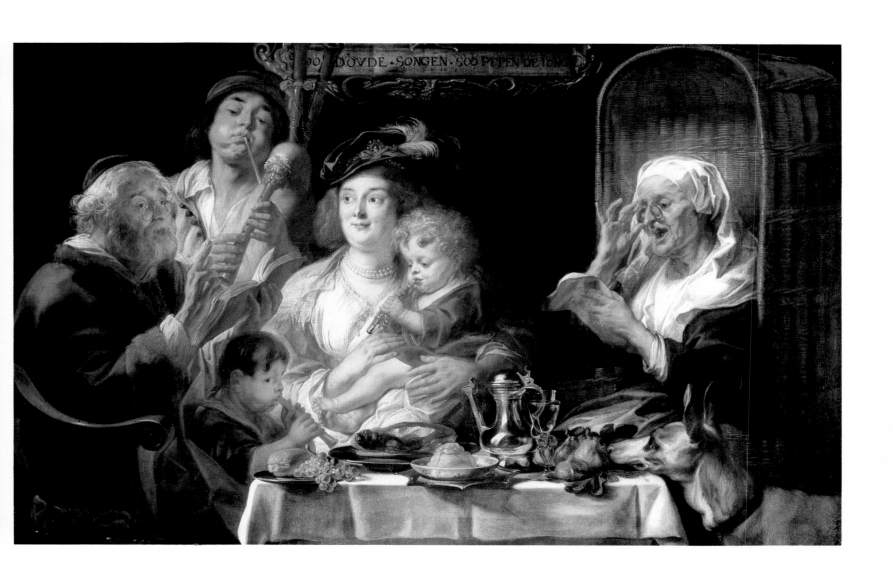

137 *As the old sang, so the young pipe*
signed and dated *J. Jor. fecit 1638*
canvas, 120 × 192cm
Antwerp, Koninklijk Museum voor Schone Kunsten

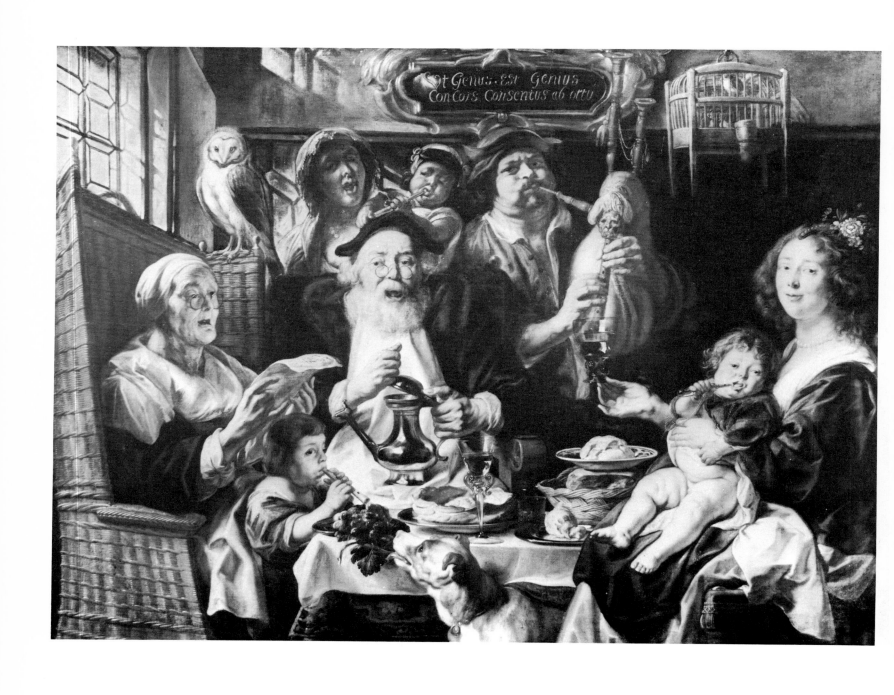

138 *As the old sang, so the young pipe*
circa 1638–40
canvas, 154 × 208cm
Valenciennes, Musée des Beaux-Arts (on loan from the Musée
du Louvre, Paris)

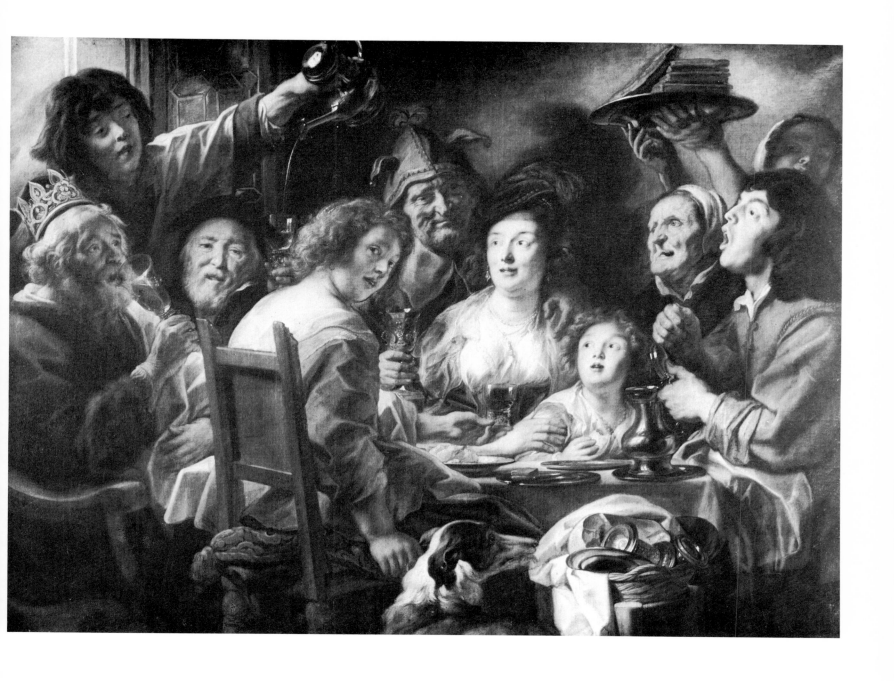

139 *The king drinks*
circa 1638–40
canvas, 152 × 204cm
Paris, Musée du Louvre

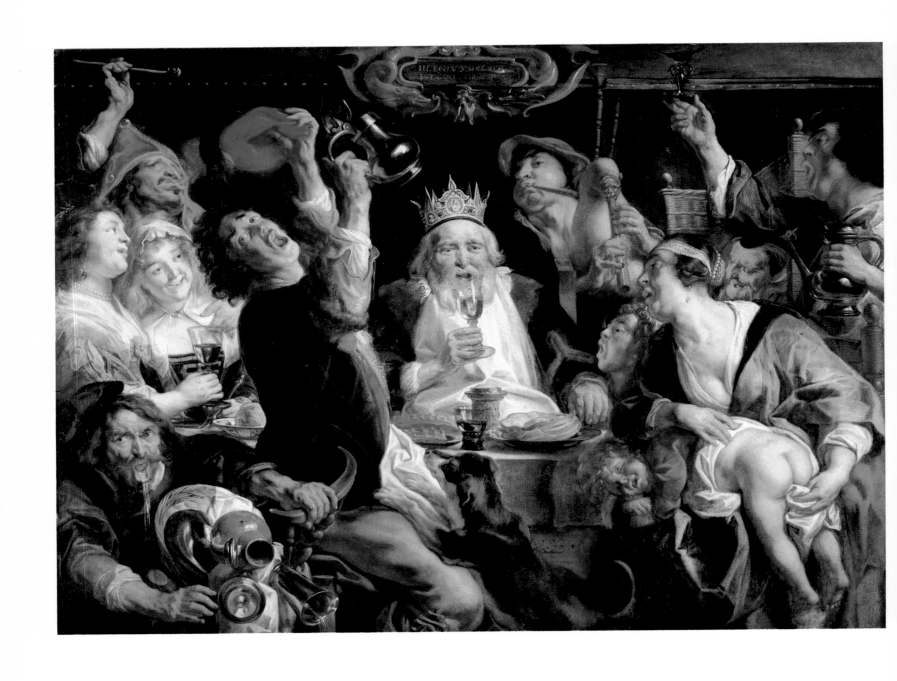

140 *The king drinks*
circa 1640
canvas, 156 × 210cm
Brussels, Musées royaux des Beaux-Arts

141 *Old man with a glass in his hand*
circa 1640
drawing, 187 × 137mm
Cambridge, Fitzwilliam Museum

142 *Head of an old man*
circa 1640
drawing, 341 × 261mm
Vienna, Albertina

143 *The daughters of Cecrops finding the child Erichthonius*
circa 1640
canvas, 150 × 208cm
Vienna, Kunsthistorisches Museum

144 *Diana and Callisto*
circa 1640
canvas, 80 × 118cm
Whereabouts unknown (formerly in the collection of
Mrs Ruth K. Palitz, New York)

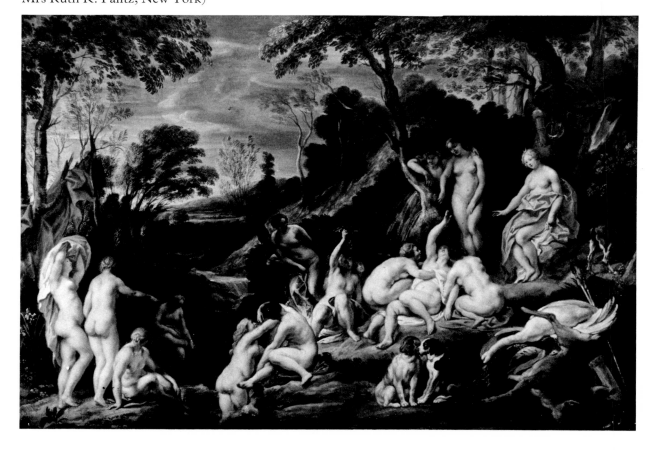

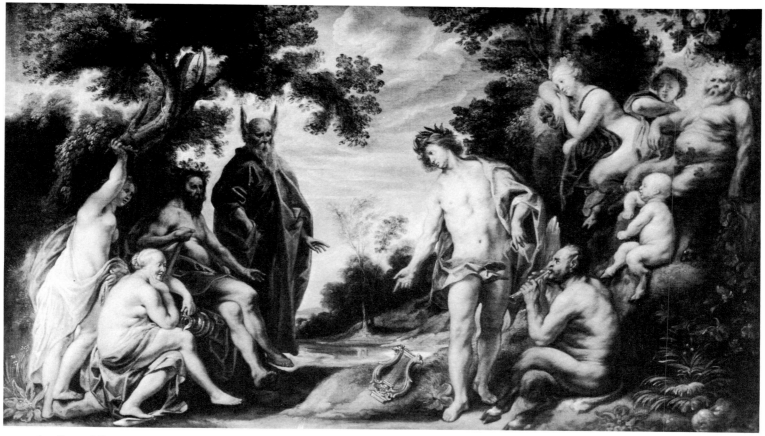

145 *Apollo and Pan*
circa 1640 (with studio help)
canvas, 73.5 × 123cm
Germany, private collection

146 *Diana and Actaeon*
circa 1640
panel, 53.5 × 75.5cm
Dresden, Gemäldegalerie

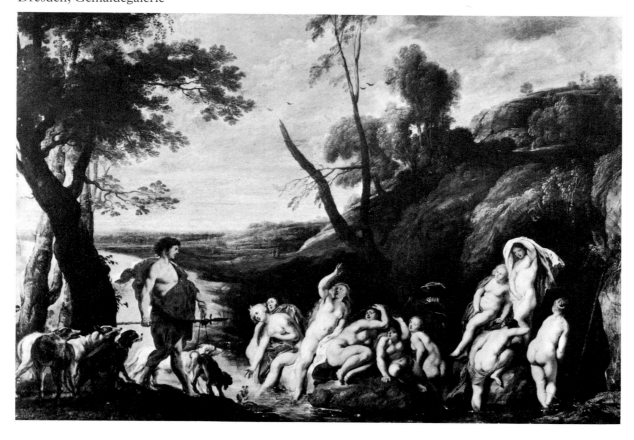

173

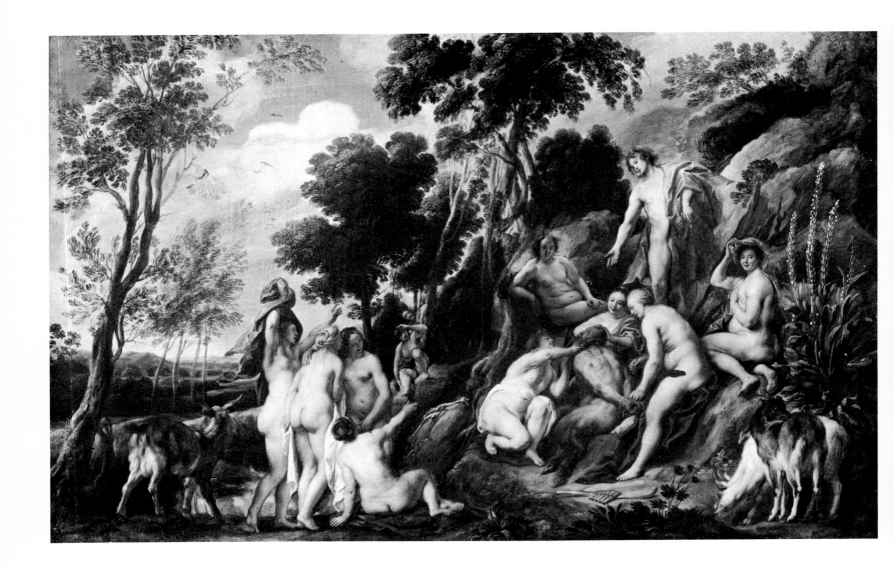

147 *Marsyas ill-treated by the muses*
circa 1640
canvas, 77 × 120cm
The Hague, Mauritshuis
(on loan from Rijksmuseum,
Amsterdam)

148 *Nude old man seated,
leaning on his forearm*
circa 1640
drawing, 340 × 210mm
Belgium, private collection

Shortly after Jordaens collaborated with Rubens to decorate the city of Antwerp for the 'Joyous Entry' of the Cardinal Infante Ferdinand in 1635, he and some other painters assisted Rubens to carry out a huge commission from Philip IV of Spain: the decoration of the king's new hunting lodge, the Torre de la Parada near Madrid. This called for a large number of animal and hunting scenes and over sixty mythological compositions, all of large size. Rubens himself designed the latter in the form of oil sketches: some of these he repeated in large format, but as time was short he mostly left this task to others. The paintings were commissioned in 1636, and by 11 March 1638 they were all on the way to Spain. Of five large canvases painted in this way by Jordaens,[48] *Vertumnus and Pomona* is at Lisbon[49] and the other four in Madrid: *The marriage-feast of Peleus and Thetis*,[50] *Apollo and Pan*,[51] *The overthrow of the giants*[52] and *Cadmus sowing the dragon's teeth*.[53] In general he followed Rubens's sketches closely, especially as regards the figures, but the works show features of his own style as well. In place of the summary indication of the background in the sketches for *Vertumnus and Pomona* and *Cadmus*, Jordaens depicted a spacious and elaborate landscape with leafy trees and undergrowth, typical of some of his own works of the 1630s.

Jacob Jordaens

In 1639 Jordaens painted a similar open landscape as the setting for the idyllic *Satyr with a nymph and two children*, formerly in the possession of Sr Iriarte at Madrid (present whereabouts unknown).[54] To about this period belong *The daughters of Cecrops finding the child Erichthonius* in Vienna [143][55] and four other mythological paintings with numerous figures: these, in the tradition of Flemish cabinet-pieces, again illustrate scenes from Ovid's *Metamorphoses*. In two of them Diana is the central figure. *Diana and Callisto*, formerly in the collection of the late Mrs Ruth K. Palitz in New York [144],[56] shows the goddess among her nymphs as the shameful secret of Callisto's pregnancy (by Zeus) is revealed (*Met.* II, 441–65); while in *Diana and Actaeon* at Dresden [146][57] she is about to sprinkle Actaeon with water before changing him into a stag as a punishment for seeing her naked (*Met.* III, 131–252). The other two pieces represent the challenging of Apollo, the god of music, by Pan and Marsyas respectively. In *Apollo and Pan* [145], in a private collection in Germany,[58] the two contestants appear before the arbiter Tmolus (*Met.* XI, 146–93), while *Marsyas ill-treated by the muses* in the Mauritshuis at The Hague [147][59] shows an episode between the defeat of Marsyas and his flaying alive by Apollo (*Met.* VI, 382–97).

Quite different from these cabinet-pieces is the conception of the large painting of *Prometheus bound* at Cologne [149].[60] This shows the titan fettered to a rock while an eagle tears at his liver as a punishment for stealing fire from heaven; Mercury, the executor of Jupiter's revenge, looks on with malicious glee. A clay figure lying on the ground recalls the fact that Prometheus created mankind, instilling life into the figure with a spark of divine fire: for this reason he was known as the first sculptor and, by extension, the first artist.[61] A heap of bones beside the figure is an allusion to Prometheus's wiliness. The story is that he once prepared an offering in two parts, one consisting of meat and the other of bones wrapped up in meat, and invited Jupiter to choose between them. Jupiter, perceiving the trick, chose the bones but punished Prometheus by refusing to grant him any of the divine fire, whereupon Prometheus stole it. Jordaens's picture is influenced by Rubens's version of the same subject at Philadelphia. Striving after monumentality, like Rubens, he confined the number of living figures to two and made the scene more vivid by placing it close to the spectator.

Among the mythological subjects painted by Jordaens in this period is *The story of Psyche*, a series commissioned by Charles I of England (*see* Chapter II). Jordaens spent much time on these canvases, intended for the ceiling and walls of Queen Henrietta's cabinet at Greenwich Palace. In 1640–41 he painted eight pieces which were sent straight to London. The series of twenty-two was never completed, however, and various difficulties even led to a lawsuit. When the work was interrupted Jordaens was busy with a further seven paintings. None of those belonging to the series can at present be identified with certainty. At about the same time he made cartoons for *The marriage-feast of Peleus and Thetis* and *Thetis leading the young Achilles to the oracle*, two tapestries which were probably added as *passtukken* to supplement *The story of Achilles*, a series after designs by Rubens. At Oberlin, Ohio, there is a *modello* for *Thetis leading the young Achilles to the oracle*, but in its present state it includes, besides the original composition, portions added to it subsequently by Jordaens or his studio. The cartoons are now untraceable (*see* Chapter IX).

Also in the 1630s, Jordaens painted the first versions of two subjects which he never tired of repeating thereafter: *The king drinks* and *As the old sang, so the young pipe*. Like *Satyr and peasant*, another favourite theme, these allowed

149 *Prometheus bound*
circa 1640
canvas, 243 × 178cm
Cologne, Wallraf-Richartz Museum

150 *Satyr carrying a horn of plenty, and a female satyr carrying a*
dolphin
circa 1640
drawing, 192 × 125mm
Moscow, Pushkin Museum

ample scope for his exuberant joy in life and for the display of his bourgeois sagacity. The works must also have been extremely popular with his clients, to judge from the number of surviving examples. Among the earliest of them, *As the old sang, so the young pipe* at Antwerp is dated by the artist *1638* [137].[62] This affords a firm basis for the chronology of the other examples of the same subject and for the different versions of *The king drinks*. As regards composition the two works are very close together, so that from time to time their subjects have been confused.

Jordaens altered the Flemish proverb 'as the old bird sang, so the young one twitters' – *ie* children imitate their parents – by substituting for *piepen* ('twitter') the word *pepen* or *pijpen* ('pipe' or 'play the flute'). The meaning of course remained the same, but instead of birds he was able to depict human beings in a domestic scene and to show both old and young making music after their own fashion. In the earliest version, at Antwerp, there is a prosperous bourgeois family assembled round a well-laden table: they are dignified and in good spirits, and it is easy to identify the grandfather as Adam van Noort. A work of this kind was well suited to adorn a bourgeois living-room, depicting as it did the easy comfortable life that endured from one generation to another. All the same, the transience of human affairs was not forgotten: later versions contain *memento mori* elements as a reminder of the hereafter. In 1644, when Jordaens undertook to supply cartoons for a series of eight tapestries illustrating *Proverbs*, he chose his subjects from the *Spiegel van den Ouden ende Nieuwen Tijdt* (1632), a collection of 'emblems' by the Dutch poet Jacob Cats, a bourgeois humanist of Calvinist persuasion who converted the formal precepts of religion into moral maxims: one of his subjects, again, was 'As the old sang, so the young pipe'.

This scene was reproduced in many variants and copies by the studio, with or without help from Jordaens himself. It would take far too long to enumerate them, and they vary so much in quality that it would scarcely throw light on Jordaens's artistic personality. It is better to confine attention here to works entirely by his own hand. Next to the version at Antwerp should be considered that in the Louvre [138],[63] perhaps a pendant to *The king drinks* in the same museum [139]: both were painted *circa* 1638–40. In the next few years Jordaens painted the versions at Schloss Charlottenburg in Berlin[64] and in the National Gallery of Canada at Ottawa [152].[65] In both these can be seen a niche with an arrangement of objects symbolising mortality: a skull, a guttering candle, books and documents yellowed with time, and blossoms destined soon to fade. As if all this were not clear enough, Jordaens added to the still-life in the Charlottenburg version a piece of paper reading *Cogita Mori*. It was not unusual for him to label his works in this way, for fear the spectator should not get the point. For similar reasons, in *The king drinks* at Vienna [158] (*see* p 181) the most important figures are identified by scrolls pinned to their costumes. In the Paris and Ottawa versions of *As the old sang, so the young pipe*, the grandmother holds in her hand a paper with the words of her song: it is the *Nieu Liedeken van Calloo* beginning with the words *Die Geusen* and celebrating the Cardinal Infante's victory over Prince Frederick Henry of Orange at Calloo near Antwerp in 1638.[66]

The feast of the Epiphany or Three Kings (Matthew 2:1–12), celebrated in Flanders as elsewhere on 6 January, was traditionally the occasion of a sumptuous dinner at which relatives and friends gathered together to eat, drink, sing and enjoy themselves. The feast began with the proclamation of a 'king', chosen by lot. Sometimes this was done with spills of paper, but often by hiding a bean in a large cake: the person who found the bean in his portion became 'king' and

presided over the festivities. According to the size of the company he appointed a larger or smaller number of assistants: the 'queen' – the only female role – the counsellor, the cup-bearer, the carver, the musician, the singer, the jester, the physician and so on. Jordaens, who depicted them all playing their parts, did not leave the choice of the main characters entirely to chance: the king in his pictures is always the oldest man, and the queen the best-looking woman.

This subject gave him yet a further opportunity to depict the Flemish bourgeoisie at table. It was the class to which he himself belonged: he had sat many a time with his fellows on such occasions; he knew what good trenchermen they were, how they enjoyed themselves, how heartily they laughed and sang, and how boisterous and even rowdy the feast could become when they had had too much to drink. In the Southern Netherlands in the seventeenth century elaborate banquets were the order of the day, and no opportunity of carousing was lost. When a new city council was appointed, when an important visitor came to town, when new deans or members were admitted to guilds, chambers of rhetoric or other societies – all these were excuses for a convivial meal. In convents and monasteries the practice was the same. Even on sad occasions, such as the funeral of a friend or relative, it was the custom to drown one's grief in drink and fortify oneself with good cheer. All this luxurious eating and drinking, traces of which still survive in Flemish customs, was looked at askance by the authorities, but their efforts to curb it evidently had little success.[67]

Jordaens painted the Epiphany feast innumerable times and in many different ways, but he always illustrated the moment at which the king raises his glass and the whole company shouts joyfully: 'The king drinks!' The earliest known version is at Kassel[68] and dates from the 1630s [132] – at all events the original part, for in about 1650–60 a wide strip was added to it on the left.[69] Again several types used by Jordaens a decade earlier recur, such as the old man seen full-face and holding a glass, in whom are recognised the features of Grapheus. The intimate character of the feast is best seen in a painting of about 1638–40 in the Louvre [139],[70] where almost all the figures probably represent Jordaens's immediate family or relations. The well-known head of Adam van Noort actually occurs twice in this picture, and probably Jordaens also used as models his wife and their three children Elizabeth, Jacob and Anna Catharina. As already suggested, this work may be a pendant to *As the old sang, so the young pipe*, also in the Louvre: in any case the two paintings are the same in size, format and style. Closely related to this work, but noisier and more crowded, is *The king drinks* in Brussels (*circa* 1640),[71] where the merry-making threatens to turn into a brawl [140]. Some members of the company have already lost control and are behaving in an unseemly fashion, like the 'physician' (!) who looks pitifully at the viewer as he discharges the contents of his over-full stomach. The rest of the company gesticulate merrily around the king – Adam van Noort again – who sits with dignity in the place of honour; he holds a goblet in his stiff, wrinkled hand and savours the sparkling wine with the air of a connoisseur. The life of the scene is admirably depicted in every stroke of Jordaens's brush. The expressions are accurately observed and rendered with ease and eloquence, while the accessories are painted with unsurpassable skill. The harmony of forms, the balance between light and shadow and the interrelation of colours combine to produce a masterpiece in which everything is essential and to which nothing could be added. Out of an unedifying scene in which the weaker and meaner aspects of human nature are displayed, Jordaens has made something noble and majestic, raising it to a level of pure beauty. Of no less quality, and certainly one of the best

treatments of this subject, is *The king drinks* at Leningrad.[72] Although painted shortly after the Brussels version and in the same soft, mellow tones, the Leningrad painting makes a quieter impression, chiefly because the gestures of those around the table are less violent.

The most elaborate version, originally in the possession of Archduke Leopold William and transferred to Vienna with his collection in 1656, is now in the museum there [158].[73] No fewer than seventeen guests of all ages can be seen, and the dignitaries are identified by scrolls affixed to their costumes. A stout, lethargic-looking king has just raised the glass to his lips and set off the general outcry. It would be wrong to suppose that Jordaens, for all his love of life, approved of the excesses involved in parties like these: his bourgeois sense of moderation was too strong, and it is not surprising to find the motto in a cartouche above the scene: *Nil similius insano quam ebrius* (nothing is more like a madman than a drunkard). With this version of *The king drinks*, dating from *circa* 1640–45, a new period of Jordaens's style is introduced: he departs increasingly from the technique of depicting half-length figures in the foreground, and aims at a more normal relationship between space and action. His characters are more often depicted full-length: they move more easily and seem to breathe more freely. At the same time, light plays a greater part: it radiates everywhere, lightening shadows and spreading a warm glow over people and animals. *The king drinks* in Munich[74] illustrates the compelling force of this new conception of space: although it bears the date *1646*, Jordaens actually painted it in the 1630s, but afterwards extended it on all four sides so as to give more prominence to the room in which the feast is held. The same increased emphasis on space can be seen by comparing *The king drinks* formerly in the Meeus Collection in Brussels[75] with an enlarged and developed version belonging to the Brussels museum.[76]

Old catalogues mention numerous works by Jordaens depicting convivial scenes and especially musical parties.[77] Apart from *As the old sang, so the young pipe* and *The king drinks*, many of those that have survived are of family concerts[78] or serenades in which the musical theme is of more importance than the domestic or social atmosphere. A *Man playing the bagpipes* (*circa* 1640–45) in a private collection at Genk (Belgium) [153][79] shows the artist himself, with bulging cheeks, playing the instrument with a concentrated air.

The description of Jordaens's activity would be incomplete without a mention of his collaboration with artists outside his studio. The first example to be noticed is a work of 1637 at Brussels: a large still-life by Adriaen van Utrecht to which Jordaens added three human figures and a dog, while retouching various other parts.[80] *The gifts of the sea* at Salzburg [167],[81] the still-life part of which is ascribed to Jacob van Es or Adriaen van Utrecht, contains no fewer than eleven robust figures by Jordaens. Among them are Neptune and Amphitrite pointing proudly to the fish suspended on their tridents, and Cupid angling for another fish to which Mercury points with the caduceus; these figures are surrounded by naiads and tritons. The lively gestures and somewhat artificial attitudes of all these nudes, as well as the bright colours and transparent shadows, are typical of Jordaens's style in the 1640s. As in the Brussels painting, he may also have retouched the still-life in this one. A third important example of collaboration is the *Vanitas*, also at Brussels,[82] in which the rich still-life is the work of Pieter Boel. Jordaens contributed a winged figure of Time with his scythe, a pair of putti, a skull and a parrot – all in a somewhat languid style with thin paint, in the manner of his latest period.

182

VI

Vigorous activity, with increasing cooperation by the studio

circa 1642–51

After Rubens's death in 1640 Jordaens became the first painter in the land: Van Dyck, who lived in England from 1632, died in 1641. From this time on, Jordaens received important commissions of the kind formerly offered to Rubens. However, while Rubens throughout his life avowedly preferred large decorative undertakings, these were not really to Jordaens's taste. His compositional powers and plastic imagination were insufficient, and he lacked the vision with which his great predecessor imparted an airy sublimity to animated Baroque structures in which foreshortening and the proportioning of space played an important part. Accordingly, since patrons expected this kind of work from him, he found himself more than ever obliged to seek inspiration from Rubens's compositional schemes. In this way he managed to meet requirements, but the long-term effect was detrimental to his style and the quality of his work.

In this period, pupils and studio assistants became of increasing importance. It appears from surviving records of disputes that Jordaens relied on them a great deal and often confined himself to putting the finishing touches on their work.[1] His studio, which resembled that of Rubens and was run on the same principles, must have presented the appearance of a small factory. However, he was much less critically minded and allowed himself to be carried away by the success of certain subjects, which Rubens would never have done. The studio turned out a flood of replicas, variants and copies to meet the lively demand for scenes like *Satyr and peasant, The king drinks* or *As the old sang, so the young pipe*. It has been illustrated how undiscriminating Jordaens could be on occasion and how ready he was, for instance, to enlarge existing works to the size demanded by the customer, so that a single picture may reflect his style at more than one period. Such practices make it hard for the critic to separate the wheat from the chaff, and, although a good many signed and dated works of the 1640s and 1650s are known, it requires discernment to tell a studio product of this period from a genuine Jordaens.

Several altarpieces were commissioned at this time by church authorities in towns and in the countryside. On 30 May 1641 the mayor of Rupelmonde, on behalf of the local churchwardens, invited Jordaens to paint a *Visitation* for Our Lady's altar [159]. The receipt for his fee is preserved in the church archives and is dated 14 October 1642, showing that the picture was completed by then. Removed by French Republican commissioners in 1794, it was presented in 1805 to the museum at Lyons, where it still is.[2] It is a bright picture of many

151 *Female nude, seen from the back*
shortly after 1641
drawing, 260 × 210mm
Edinburgh, National Gallery of Scotland

183

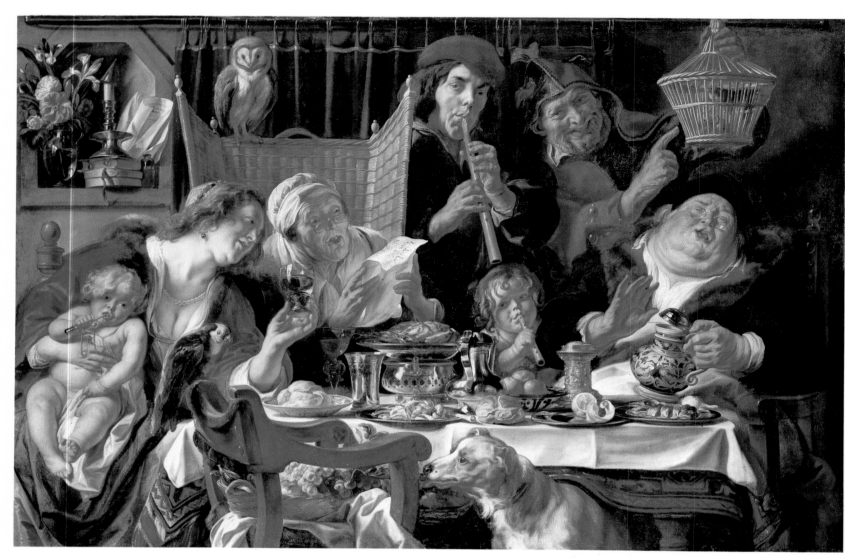

152 *As the old sang, so the young pipe*
early 1640s
canvas, 145 × 218cm
Ottawa, National Gallery of Canada

153 *Man playing the bagpipes*
circa 1640–45
canvas, 80 × 61cm
Genk, Belgium, private collection

154 *Cancer* (*The signs of the
zodiac*)
shortly after 1641
canvas, height *circa* 150cm
Paris, Palais du Luxembourg
(Senate Library)

155 *Gemini* (*The signs of the
zodiac*)
shortly after 1641
canvas, height *circa* 150cm
Paris, Palais du Luxembourg
(Senate Library)

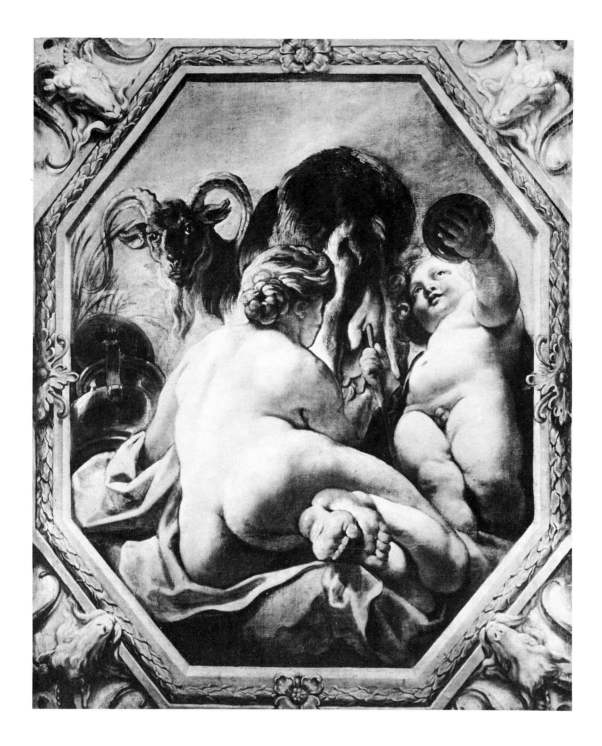

156 *Capricorn* (*The signs of the zodiac*)
shortly after 1641
canvas, height *circa* 200cm
Paris, Palais du Luxembourg (Senate Library)

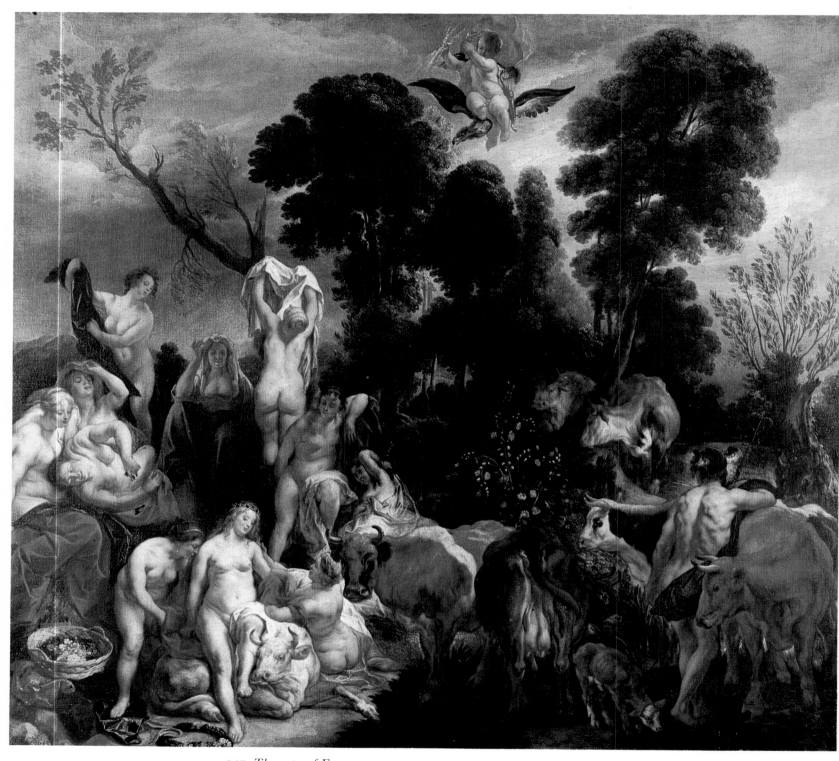

157 *The rape of Europa*
dated *1643*
canvas, 173 × 190cm
Lille, Musée des Beaux-Arts

158 *The king drinks*
circa 1640–45
canvas, 242 × 300cm
Vienna, Kunsthistorisches Museum
(detail page 191)

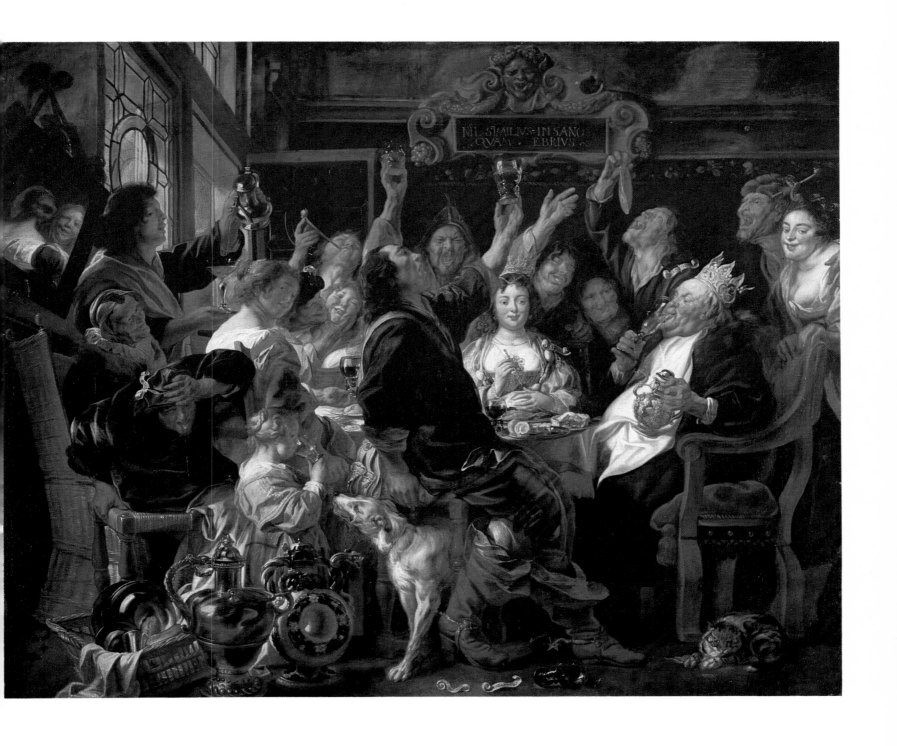

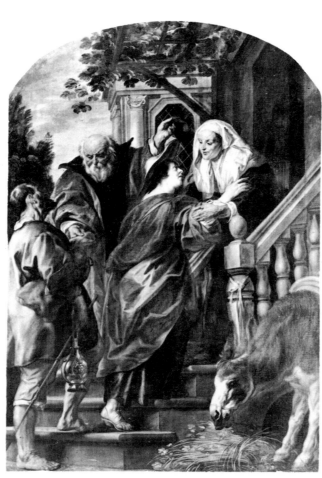

158 *The king drinks*
(detail)

159 *The visitation*
1641–42
canvas, 263 × 185cm
Lyons, Musée des Beaux-Arts

160 *Three studies of heads*
circa 1640–45
drawing, 230 × 310mm
Paris, Musée du Louvre

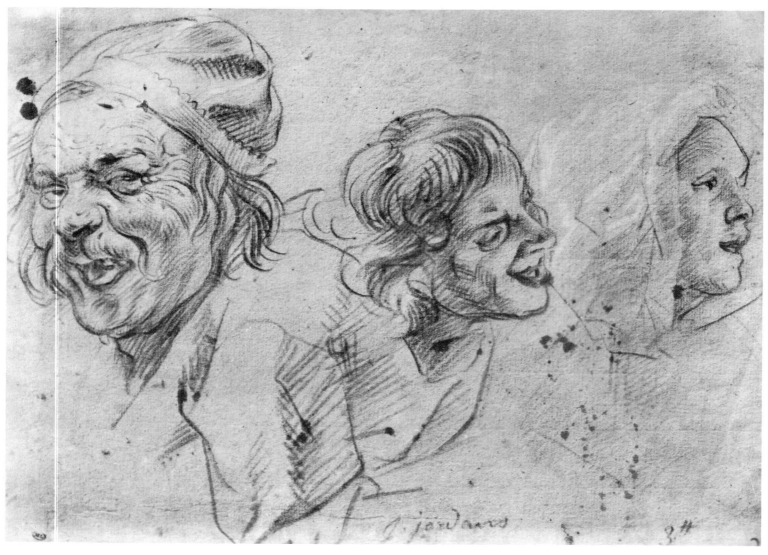

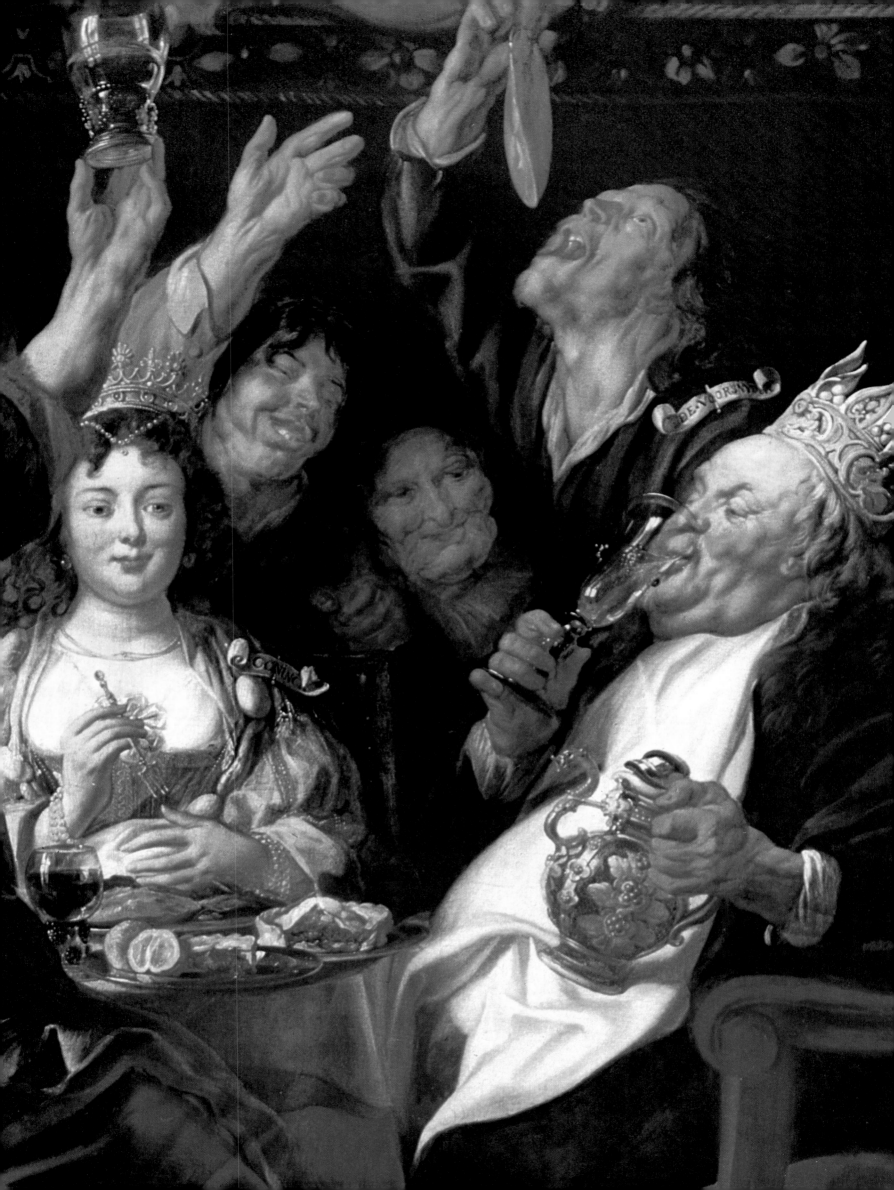

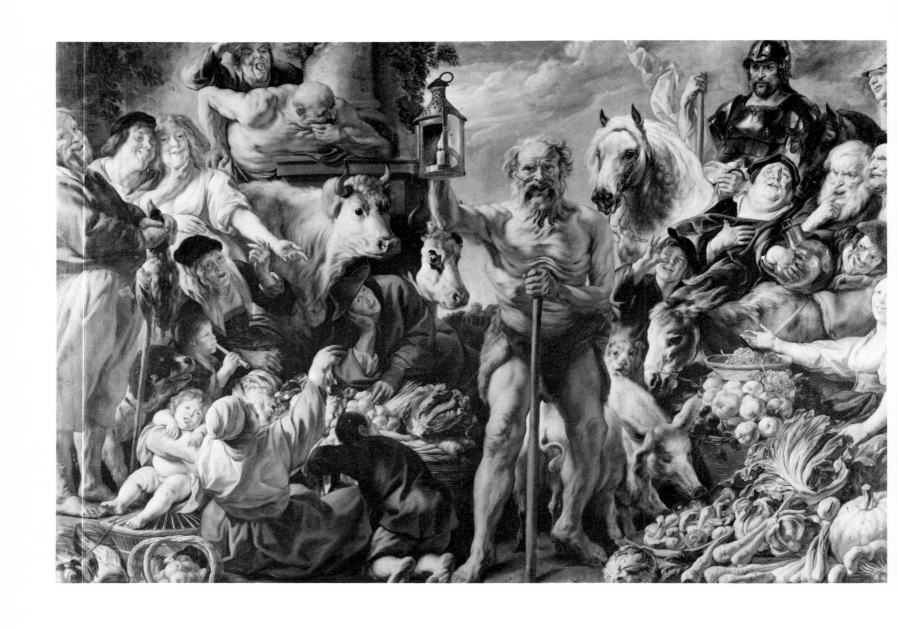

161 *Diogenes in search of a man*
circa 1642
canvas, 233 × 349cm
Dresden, Gemäldegalerie

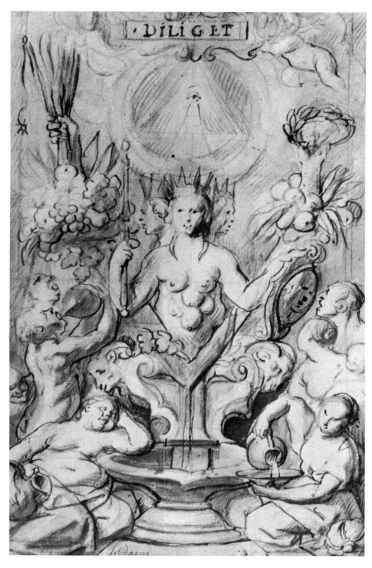

162 *'Diliget'*
circa 1640–45
drawing, 280 × 180mm
Leningrad, Hermitage

163 *Dog asleep*
circa 1640–50
drawing, 200 × 255mm
Besançon, Musée des
Beaux-Arts (on loan from the
Musée du Louvre, Paris)

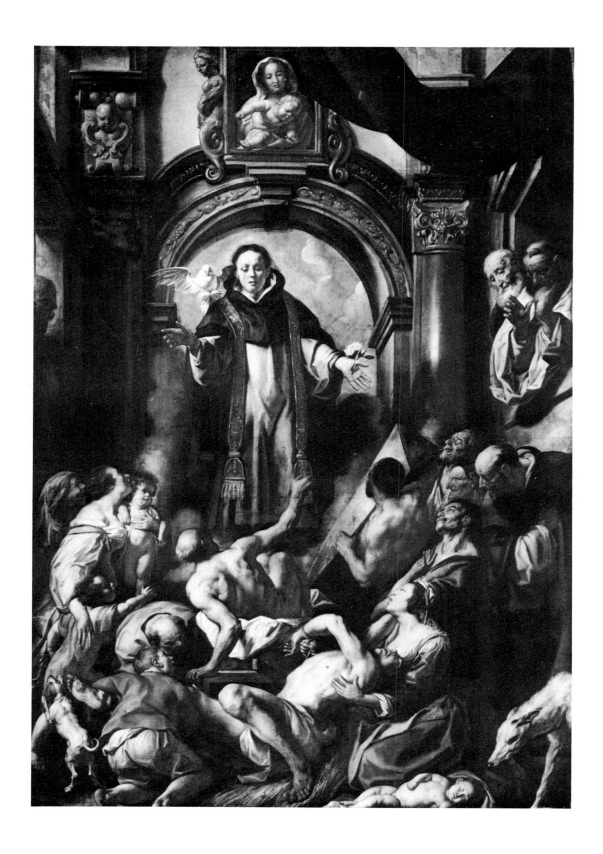

164 *The miracle of St Dominic*
circa 1640–45
canvas, 315 × 218.5cm
Oldenburg, Landesmuseum für Kunst und Kulturgeschichte

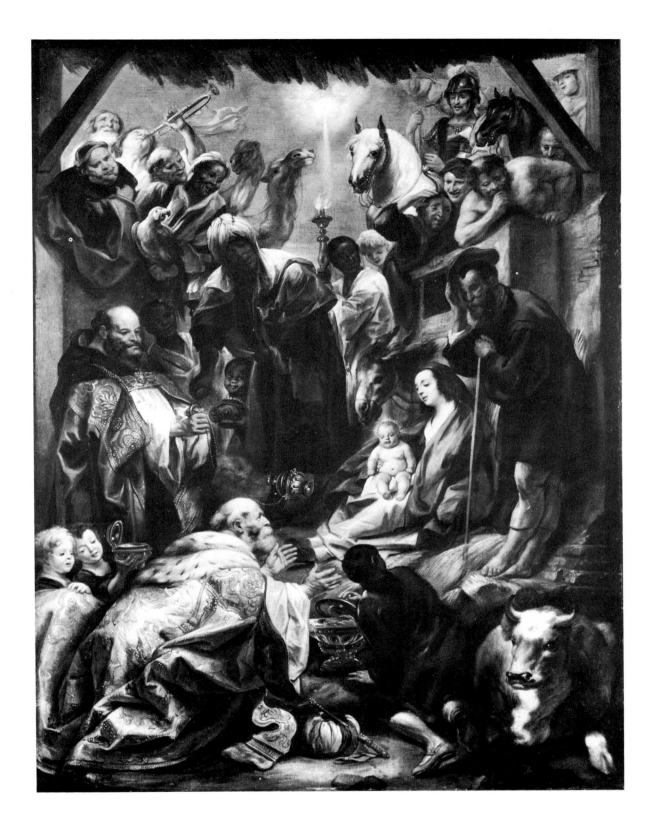

165 *The adoration of the Magi*
modello for the painting formerly at Dixmude, *circa* 1644
canvas, 156.5 × 115cm
Kassel, Staatliche Gemäldegalerie

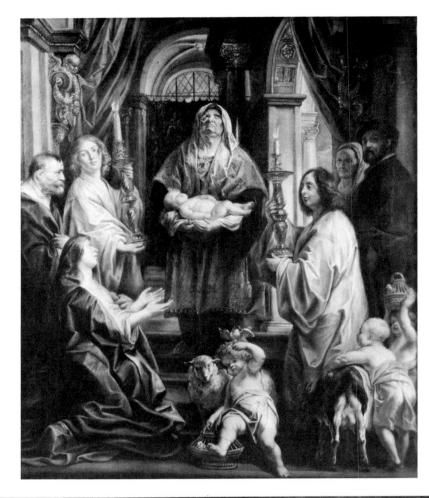

166 *The presentation in the temple*
circa 1645
canvas, 126 × 105cm
Antwerp, Rubenshuis

167 JORDAENS and an unidentified still-life painter
The gifts of the sea
circa 1640–50
canvas, 269 × 377cm
Salzburg, Residenzgalerie

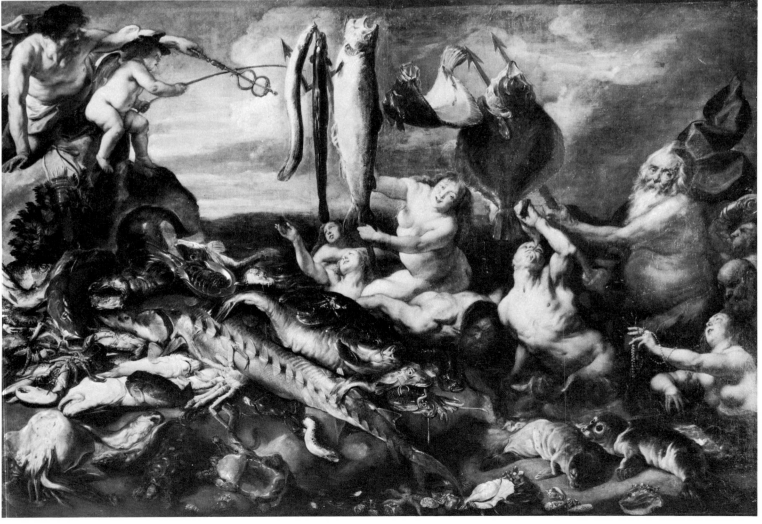

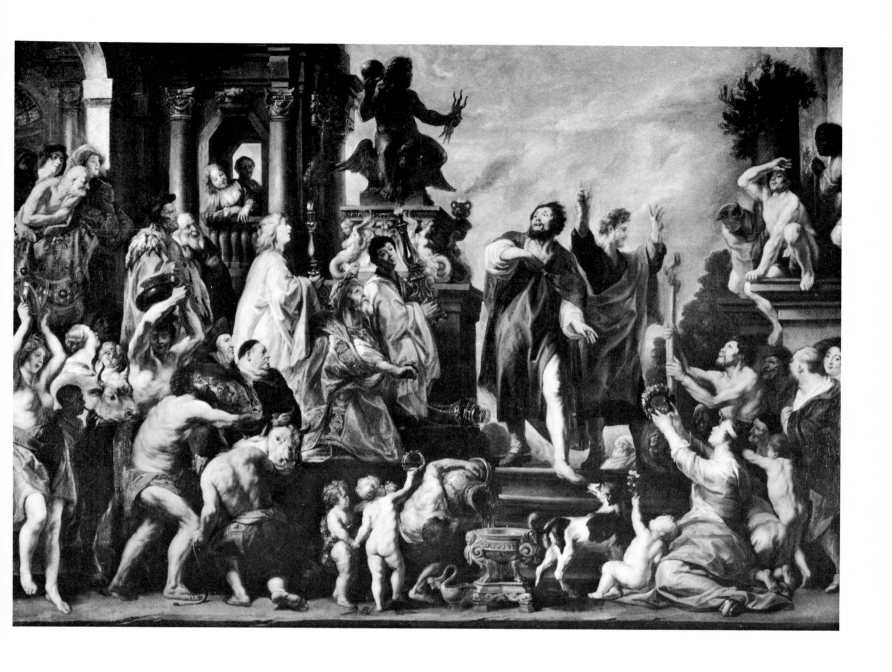

168 *Paul and Barnabas at Lystra*
signed and dated *J.Jor. fecit 1645*
canvas, 170 × 239cm
Vienna, Akademie der bildenden
Künste

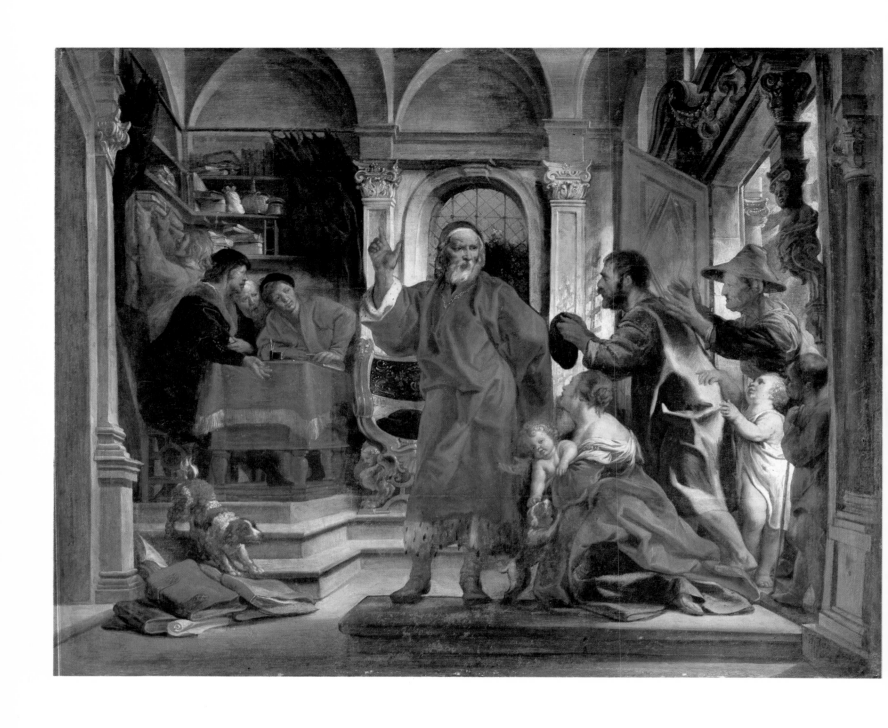

169 *St Ives, patron of lawyers*
signed and dated *J. Jor. fecit 1645*
canvas, 103 × 129.5cm
Brussels, Musées royaux des Beaux-Arts

colours, based on a Rubens composition[3] but lacking the distinction required to raise this simple family visit to the level of a biblical episode. A similar commission was received for an *Adoration of the Magi* for the high altar of St Nicholas's church at Dixmude [165].[4] The painting, signed and dated *1644*, was destroyed by fire in the First World War; Max Rooses, who had seen it, describes it as 'a festival of colour . . . radiant with bright, silvery sunshine', a harmony of dark bottle-green, scarlet, white, blue and half-tones.[5] The composition, again borrowed from Rubens, is, as it were, a variant of his *Adoration of the Magi* painted in 1624 for St Michael's abbey at Antwerp.[6] A comparison of the two affords an excellent illustration of how Jordaens interpreted and transposed the work of Rubens. As regards the composition, as in *The martyrdom of St Apollonia* [94] he arranged the figures in a single vertical plane, so that they lack the freedom of their counterparts in Rubens's more spacious works. The touching solemnity of the religious scene as Rubens so often depicted it has here degenerated into something more like a free-for-all: whereas Jordaens at one time managed to turn everyday folk into gods and goddesses, in this painting his kings wear the aspect of noisy, disrespectful plebeians.

The adoration of the shepherds at Lyons,[7] not dated but in the style of this period, was formerly in the Hospital for Incurables at Liège. Like the Rupelmonde *Visitation*, it was removed by the French in 1794 and later presented by Napoleon to the Lyons museum. A work in similar style, but smaller, is Jordaens's *Presentation in the temple* in the Rubenshuis at Antwerp [166].[8]

The subject of *St Ives, patron of lawyers*,[9] dated *1645* and now in the Brussels museum [169], is a hagiographical pendant to 'the judgement of Solomon': as illustrations of justice the two themes are often treated together, as for example on the panels of the *St Anne* triptych painted by Hendrik de Clerck in 1590 for Notre-Dame de la Chapelle in Brussels, and probably commissioned by lawyers or court officials. In 1630 the Antwerp jurists and advocates set up a Confraternity of St Ives, and on 3 July 1636 the lawyer Laurentius Briel founded a chapel in the saint's honour in St James's church in that city. From its format the present picture does not look like an altarpiece for the chapel, but it may have decorated the Confraternity's premises. This would have been appropriate as Jordaens has depicted the saint and his clients in an office with clerks busily at work; Ives himself looks less like a saint than a respectable business man. The picture is related to the *Proverbs*, a series of tapestries designed by Jordaens, *circa* 1645 [170] (*see* p 300).

Jordaens's signature does not necessarily guarantee the authenticity of his work. This may be shown by *Paul and Barnabas at Lystra* in the Academy of Fine Arts, Vienna [168],[10] which is not fully convincing despite the clear signature *J. Jor. fecit 1645*. In 1905 P. Buschmann Jr pointed out the lack of unity in the composition and the resulting absence of clarity. Some parts are well executed, but others must be regarded as the work of assistants. The numerous figures and the elaborate architectural décor show the influence of Veronese and Raphael, especially the latter's *Acts of the apostles*. Many later works by Jordaens exhibit such influence, such as that of Veronese in *Susanna and the elders* (*circa* 1640–45), executed with studio help and now in the Museo di Castelvecchio at Verona.[11] The figures in this painting are based on a lost work by Rubens,[12] but the architecture with its segment-shaped balustrade is borrowed from Veronese's work of the same title in the Doria Collection at Genoa.[13]

During the 1640s the architectural elements in Jordaens's work become increasingly elaborate and play a more prominent part. A striking example is

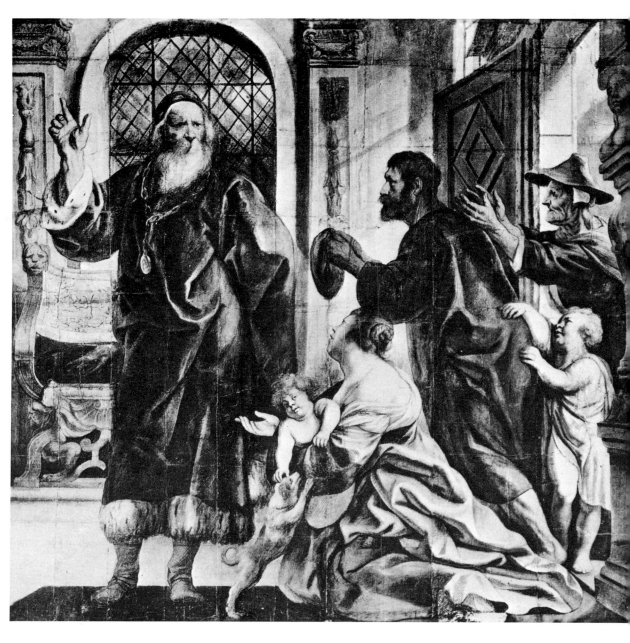

170 *Usury is a great evil, a
plague in the town*
circa 1645
cartoon, 300 × 312cm
Paris, Musée des Arts
Décoratifs (on loan from the
Musée du Louvre, Paris)

Christ driving the money-changers from the temple (*circa* 1645–50) in the Louvre
[197],[14] a lively scene set in an imposing marble edifice with pillars, arcades,
niches and gold ornamentation. Christ is seen wielding a scourge against
the merchants and hucksters who have turned the sanctuary into a den of
thieves. The centre of the composition is an inextricable medley of shrieking
people and startled animals. Some onlookers, including priests, wear expres-
sions of fear and amazement. In this scene, which can easily be interpreted as an
attack on certain abuses in the Catholic church, Jesus is the only noble-looking
figure, his countenance suggesting kindness and pity rather than indignation.
Jordaens, however, was mainly interested not in idealised characters but in the
rowdy assemblage of popular types in the sacred building. The static, decor-
ative architecture by which the turbulent scene is enframed shows that Von
Sandrart was right in observing[15] that Jordaens was acquainted with Veronese's
work. He must have known it indirectly for the most part, and more especially
through Rubens, who had studied the Venetian's monumental style and judi-

ciously made use of it in his own compositions. Rubens, like Veronese, had enough creative imagination to harmonise the architectural elements with the action of the characters, but this was beyond Jordaens's power: instead of integrating the borrowed motifs with his own work he merely accumulated them, as imitators usually do. Again and again he depicted balustrades with spectators leaning over them, or bases of pillars on which inquisitive people

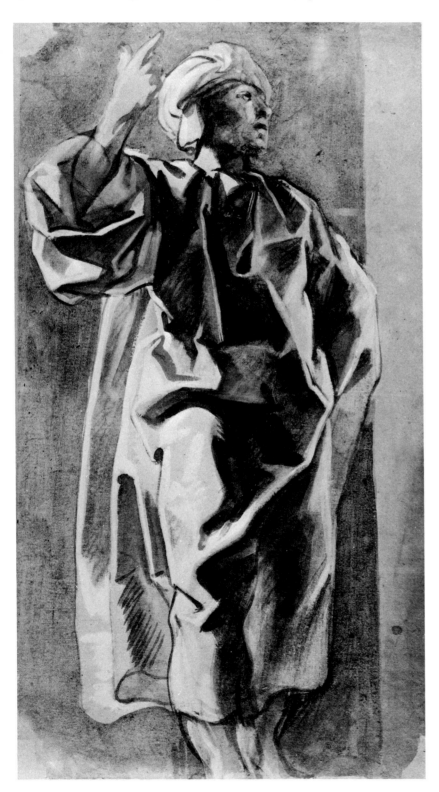

171 *Man standing, with raised hand*
circa 1645
drawing, 544 × 296mm
Paris, Institut Néerlandais,
Custodia Foundation (F. Lugt
Collection)

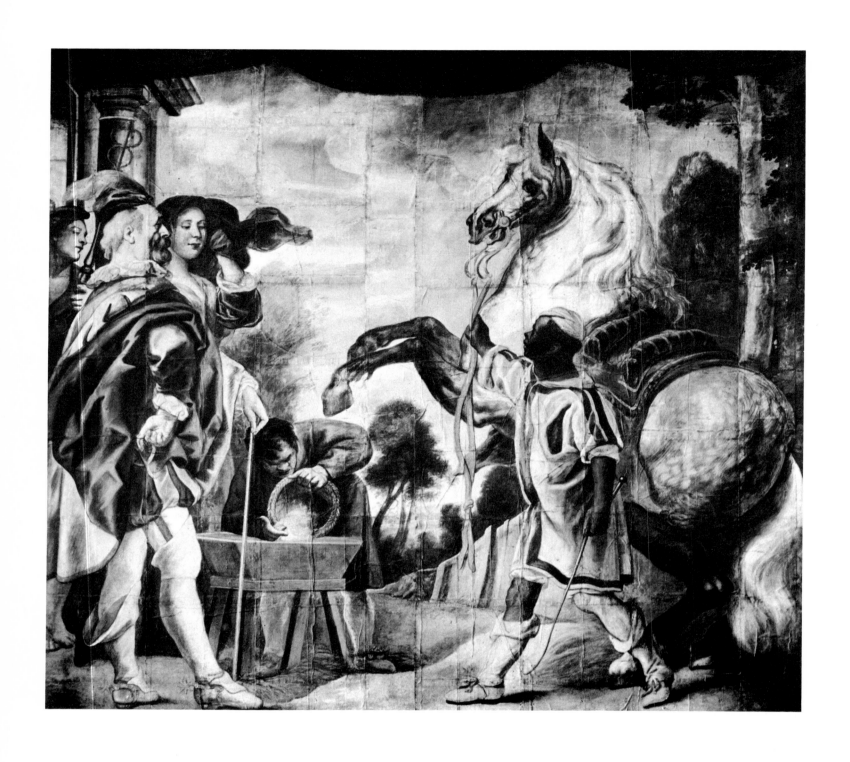

172 *The master's eye makes the horse grow fat*
circa 1645
cartoon, 345 × 366cm
Paris, Musée des Arts Décoratifs (on loan from the Musée du
Louvre, Paris)

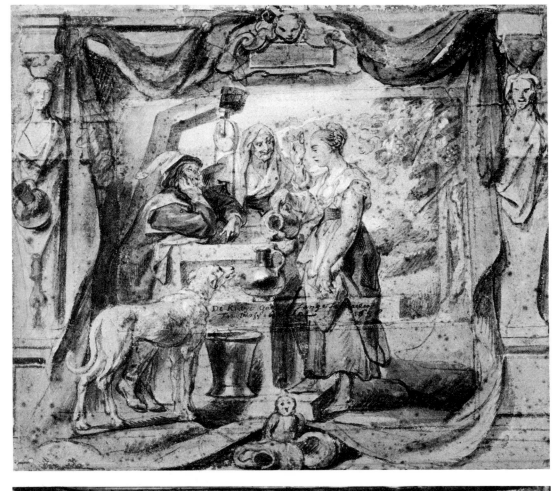

173 *He who loves danger shall perish by it (The pitcher goes once too often to the well)*
central fragment, dated *1638*
drawing, 270 × 315mm
Antwerp, Stedelijk Prentenkabinet

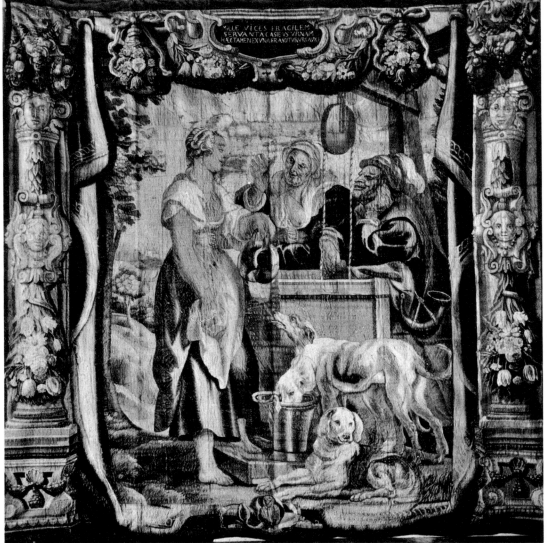

174 *He who loves danger shall perish by it (The pitcher goes once too often to the well) (Proverbs)*
designed *circa* 1645
tapestry, 365 × 357cm, woven at Brussels
Tarragona, Spain, Museo Diocesano

203

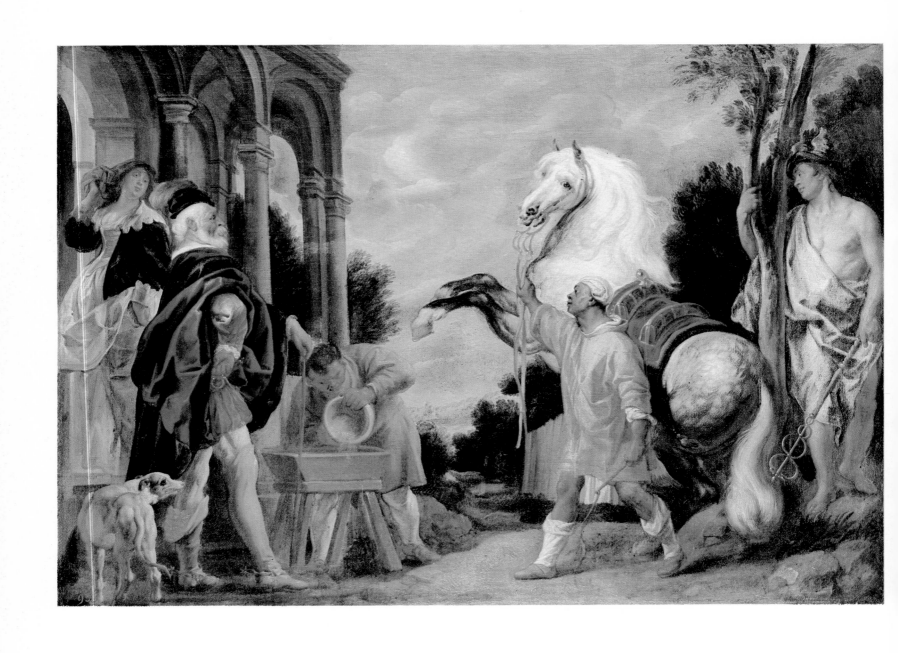

175 *The master's eye makes the horse grow fat*
signed *J.JOR fec, circa* 1645
canvas, 81 × 112cm
Kassel, Staatliche Gemäldegalerie
(detail opposite)

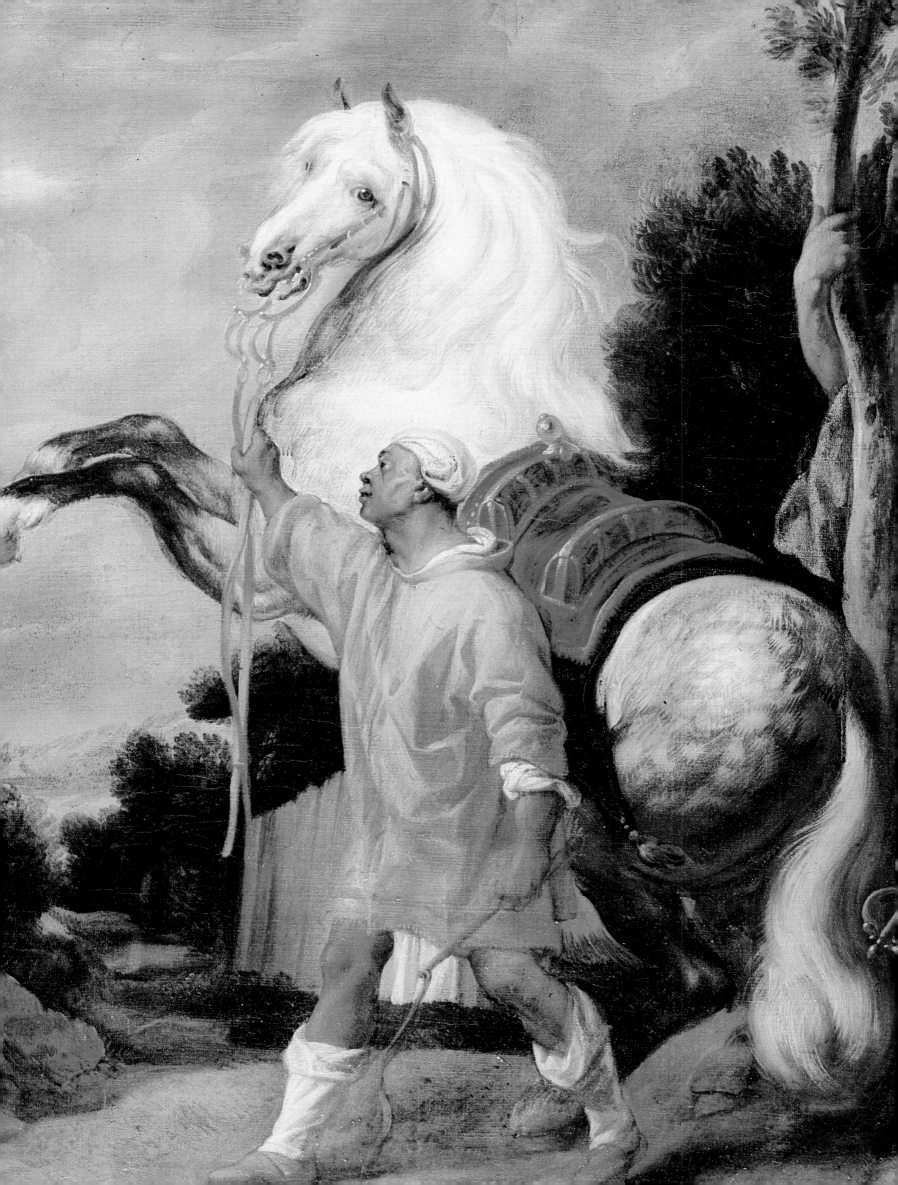

176 *They are good candles which
light the way* (*Proverbs*)
designed *circa* 1645
tapestry, 366 × 358cm, woven at
Brussels
Tarragona, Spain, Museo
Diocesano

177 *Two herms*
circa 1645
drawing, 230 × 172mm
Uppsala, University Museum

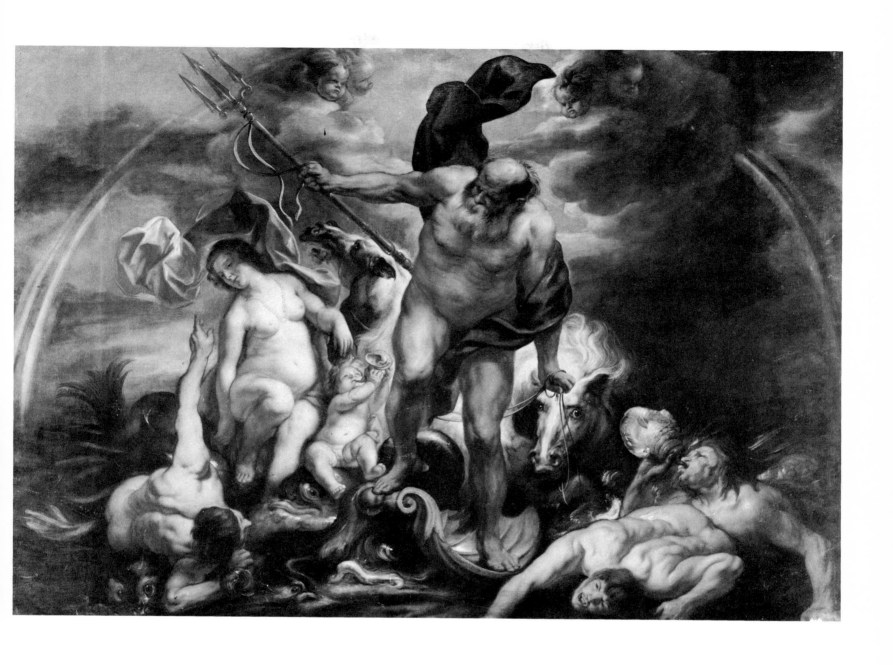

178 *Neptune and Amphitrite*
signed and dated *I. Iordaens 164..*
canvas, 200 × 306cm (enlarged on both sides)
Antwerp, Rubenshuis

have clambered up for a better view. Inevitably this unimaginative technique declined into a barren formula.

The 1640s brought another evolution in Jordaens's style. Chaotic groups of figures, which were formerly the exception, become more and more frequent, and characters on whom the action depends often lose their individuality. This change did not harmonise well with Jordaens's innate talent for depicting static, monumental forms, as seen in the bulk of his previous work. He did not have much sense of rhythm, and, as he failed to integrate his figures in a general movement, his powerful compositions often lack the animation one would expect. The clash between Jordaens's gift for static forms and his endeavour to produce a dynamic effect is also manifest in the relationship between his architecture and figures. The essential purpose of the architecture is to provide a framework and to impose a rhythm on the figures' movements, but in Jordaens's case it exceeds its proper role, becoming an autonomous décor which overshadows the figures and impairs their monumental character.

Christ driving the money-changers from the temple reflects the influence not only of Veronese but of another sixteenth-century Venetian, Jacopo Bassano: this can be seen from a glance at the latter's treatment of the same subject in London,[16] where many of the motifs are similar. Comparison of the two works also shows how Jordaens transformed the typical Mannerist composition along a receding diagonal into a schema in which all the figures appear in a single plane in the foreground. *Adam and Eve* (*circa* 1645–50) at Budapest[17] does not differ in composition from Jordaens's open-air scenes of mythology and allegory; the subject provided him once more with a welcome opportunity to paint nudes and animals. A *Conversion of St Paul*, for which Jordaens received 400 Rhenish guilders in October 1647, can no longer be traced. It was painted for the altar of St Paul in the abbey church at Tongerlo.[18]

The lamentation at Hamburg [199],[19] painted about 1650, is noteworthy for its pathos, unusual in Jordaens, and the physical majesty of Christ's body. The pose with outstretched arms and legs bent sideways is fundamentally the same as in Michelangelo's *Pietà* at St Peter's, Rome. It is an open question as to how Jordaens became acquainted with this model, or a later version of it by a follower of Michelangelo: perhaps through Rubens, several of whose works – such as *The Holy Trinity* at Antwerp[20] – show the same influence. Besides the Hamburg picture, Jordaens painted other versions of *The lamentation* about this time. Two of these, respectively in the *Béguine* church at Antwerp[21] and in Leningrad,[22] differ only slightly from each other; a third is in the Rubenshuis at Antwerp.[23] It is not easy to say how far Jordaens's assistants contributed to any of these works, but the last-mentioned was clearly painted with studio help.

Casting an eye back on Jordaens's work up to this point, it can be seen how varied his subjects were: religion, mythology, allegory and genre. The last three were indeed not divorced from religion in his mind, but were all seen in terms of his Christian outlook. During the 1640s and much of the next decade he continued to treat the same variety of subjects; subsequently religious themes, especially Protestant ones, came to predominate, and the others virtually disappeared from his repertoire.

The rape of Europa (1643) at Lille [157][24] added another to the long list of scenes depicting the adventures of antique deities. The religious and moralistic interpretation of this tale from Ovid (*Met.* II, 833–75), which Jordaens took as a subject in his early period, has already been noted above. The *Bathing goddesses* at Madrid[25] is an exception to his custom of placing such scenes in an idyllic

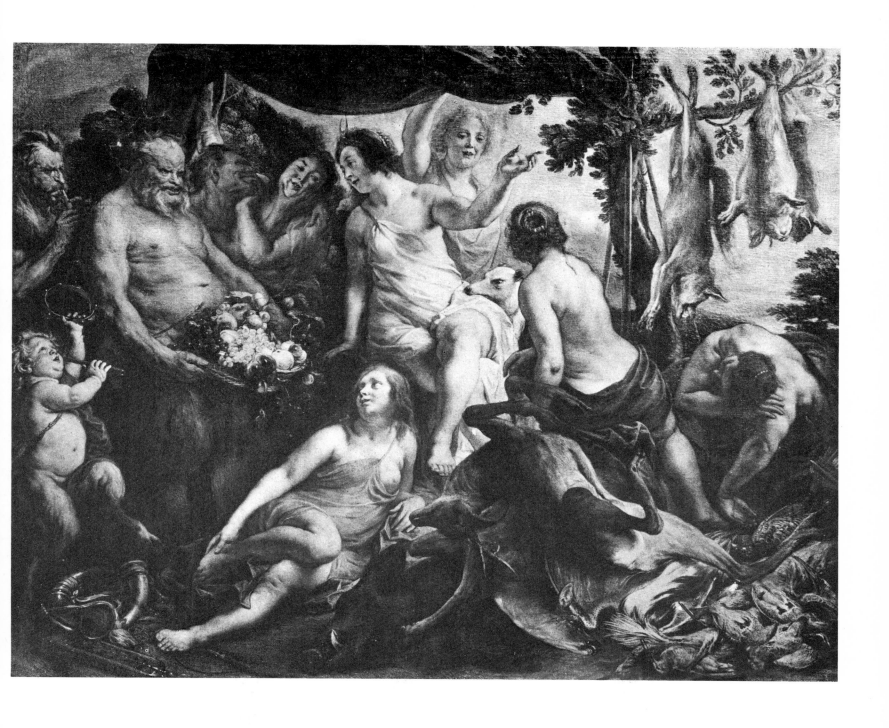

179 *Diana resting with nymphs, satyrs and booty*
circa 1645
canvas, 205 × 255cm
Whereabouts unknown (formerly in the Tony Dreyfus
Collection, Paris)

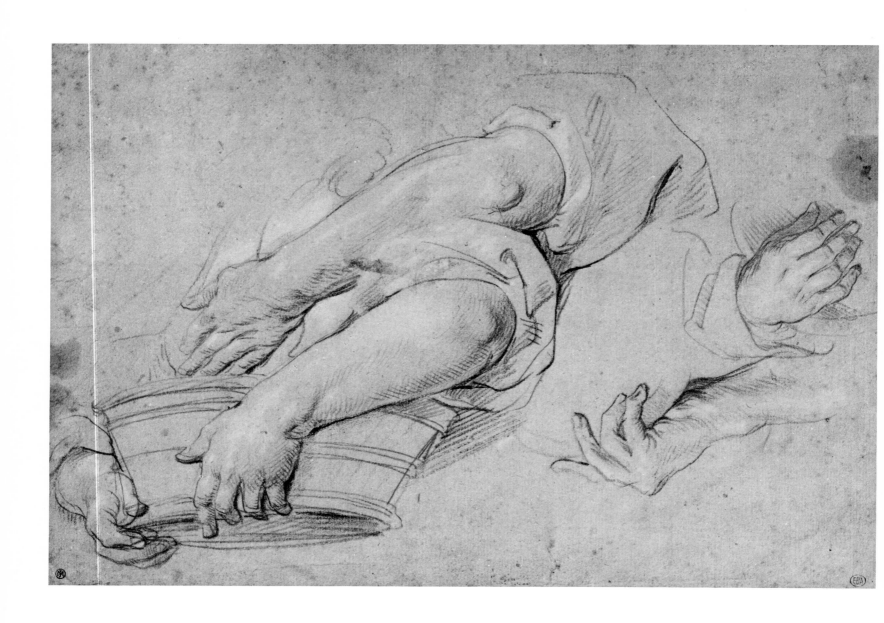

180 *Studies of arms and hands*
circa 1645
drawing, 229 × 337mm
Paris, École Nationale Supérieure des Beaux-Arts

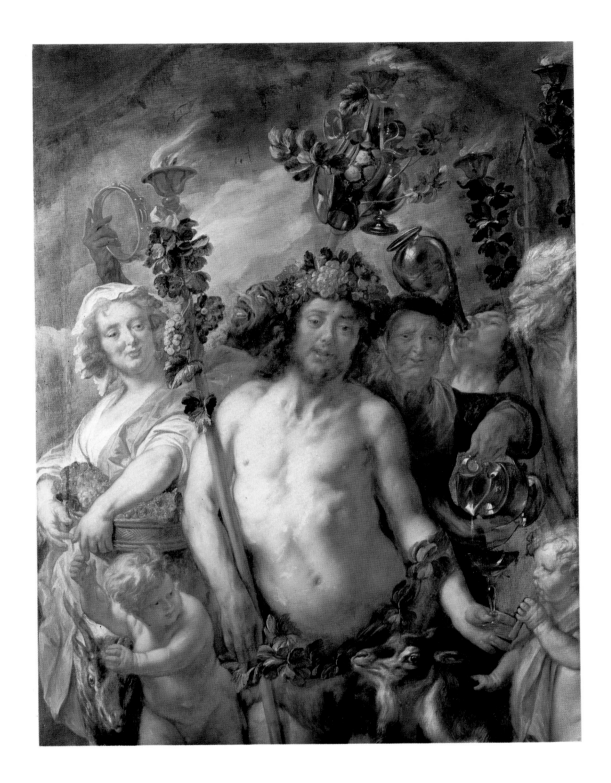

181 *The triumph of Bacchus*
circa 1645
canvas, 204 × 163cm (corners cut off at top; rectangular form
later restored)
Kassel, Staatliche Gemäldegalerie

182 *Two studies of a crouching
female nude*
circa 1640–45
drawing, 280 × 420mm
Washington, DC, National
Gallery of Art (Rosenwald
Collection)

natural setting. The goddesses and their female companions disport themselves in a basin beneath a fountain surrounded by monumental architecture, partly inspired by the portico and garden-house of Rubens's mansion at Antwerp. A further instance of Jordaens's dependence on Rubens and his world is *Homage to Venus* at Dresden,[26] which immediately calls to mind Rubens's masterpiece of the same title at Vienna.[27] In both paintings Venus, in the form of a marble statue, presides over a delirious world of bacchantes, satyrs and human beings. In Jordaens's version, as in his *Rape of Europa* and *Bathing goddesses*, the characters express their feelings by somewhat artificial and uncoordinated gestures, producing a theatrical effect; this, however, is redeemed by their beauty and grace of form. Jordaens's deities are no longer sturdy peasants: his Olympus is populated by naked, coquettish girls, somewhat affected in demeanour, and occasional effeminate members of the male sex. He is concerned now to charm rather than convince, to appeal to the feelings rather than the senses. His technique is well adapted to the new purpose: an harmonious palette of subdued tones without sharp contrasts, and sensitively modelled figures.

Some explanation of Jordaens's evolution towards a more delicate style may

212

be found in a letter of 24 March 1640 from Sir Balthazar Gerbier to Inigo Jones concerning the paintings for Greenwich Palace (*see* p 176). Gerbier confirmed that he would ask the Abbé Scaglia to ensure that, in a work intended for Queen Henrietta, Jordaens made 'the faces of the women as beautifull as may be, the figures gracious and suelta [slender]'. The importance that the English court attached to elegance is confirmed by another letter of Gerbier's, addressed on 4 February 1640 to Edward Norgate, a clerk of the privy seal, asking whether the king would not prefer to entrust the work to Rubens if the latter would do it for the same price. 'Both men', Gerbier wrote, 'are Dutchmen and not to seeke [*ie* well able] to represent robustrous boistrous druncken-headed imaginary Gods, and of the two most certaine Sir Peter Rubens is the gentilest in his representations: his Landskipps more rare, and all other circumstances more proper.'[28] The reason why Charles I approached Jordaens and not Rubens or Van Dyck, who was then in London, was simply one of economics. On the eve of the civil war, Parliament was keeping the king short of money in all respects including patronage of the arts, so that he was forced to find a painter who would not charge too much.

183 *Neptune creating the horse*
signed *J.JOR.*, *circa* 1645
canvas, 67 × 130cm
Florence, Pitti Palace

184 *Levade performed under the auspices of Mars and in the
presence of Mercury*
circa 1645
canvas, 96 × 153cm
Ottawa, National Gallery of Canada

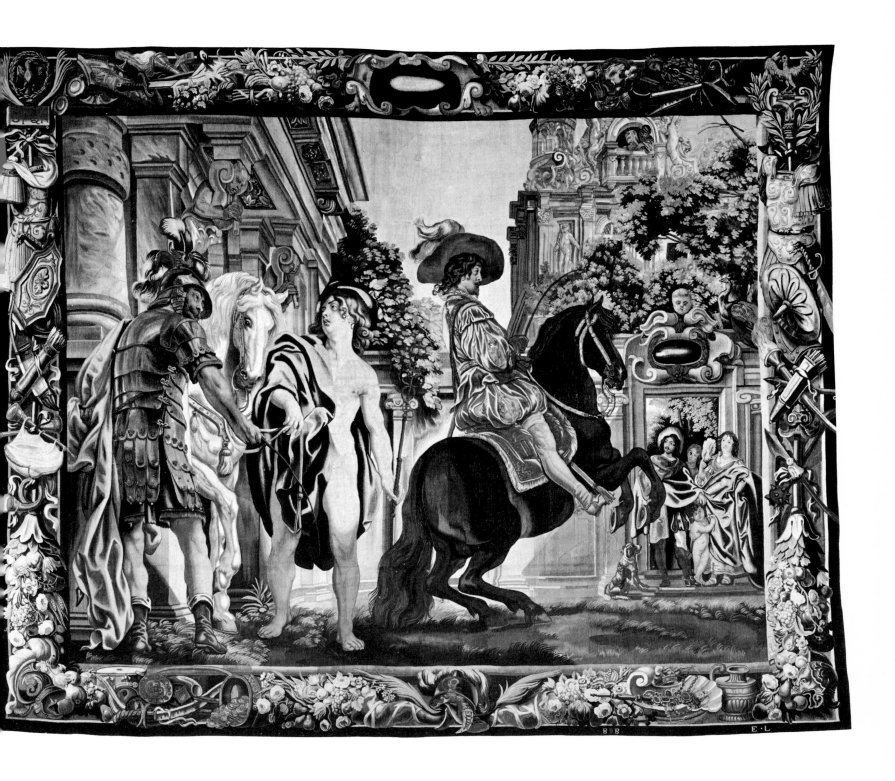

185 *Levade performed under the auspices of Mars and in the presence of Mercury (The riding-school)*
designed *circa* 1645
tapestry, 410 × 508cm, woven by Everaert Leyniers at Brussels
Vienna, Kunsthistorisches Museum
(*detail page 222*)

The quest for elegance and distinction was nothing new in the artistic world, and was reflected in the important commissions that emanated from various courts. Rubens had shown his awareness of the new trend in his Médicis cycle of 1622–25, in which the historical personages are full of aristocratic refinement. Although the new style was less suited to Jordaens's temperament he adapted himself to it at an early stage, hoping in this way to secure more commissions from the upper ranks of society.

To the mythological scenes already mentioned can be added the charming and tasteful *Triumph of Bacchus* at Kassel [181].[29] Bacchus, the god of wine, debauchery and carefree living, is generally depicted as a coarse, wanton reveller, but is shown here as a slim, attractive youth. In a similar style is *Diana resting with nymphs, satyrs and booty*, of which two versions are known, both in Paris: one formerly in the Tony Dreyfus Collection [179][30] and the other in the Petit Palais.[31] In each of these the youthful Diana is enthroned on raised ground among her companions. The trophies of the hunt are spread at her feet or hang from the branches of the trees, while an old satyr, accompanied by others making music, offers the goddess a basket of magnificent fruit.

Female nudes, which play such an important part in mythological scenes, are generally shown by Jordaens as sitting, crouching or recumbent. In the 1640s it is noticeable that these attitudes take on a certain languor. This effect is enhanced by the opulent forms of nymphs and goddesses, in which muscle increasingly gives way to fat. The figures lack resilience, and the most contorted attitudes, sometimes violently foreshortened, do not prevail against the overmastering effect of gravity. Sleep, which often fixes the female forms in artificial poses, symbolises the victory of what is dull and corporeal over will, energy and motion. This new vision is well illustrated by *Venus asleep* at Antwerp,[32] which depicts the goddess and two of her attendants resting beside a wood [192]. This work shows the inspiration of Rubens's *Cimon and Iphigenia* at Vienna [191],[33] where the three sensuous and skilfully painted nudes must have particularly impressed Jordaens: they recur in his work, for instance in another *Venus asleep* at Kiev,[34] in *Bacchus and Ariadne* at Boston [193],[35] and in *Antiope asleep* at Grenoble, dated *1650* [194].[36] In some of these paintings a velum or baldachin is hung between the trees by way of sheltering the goddesses and symbolising their dignity. Similar soft, plump female nudes, not asleep this time, can be seen in *Allegory of fruitfulness (Hercules subduing Achelous)*, dated *1649*, at Copenhagen,[37] where they form a kind of wreath round the Horn of Plenty. To one side are Hercules with his club and Achelous in the form of a bull, recalling the origin of the Horn: it was broken off by Hercules when he wrestled with Achelous, the river-god, for the hand of Deianira (Ovid, *Met.* IX, 1–100). Carel van Mander drew the moral from this scene that wealth and power go together: 'The cornucopia or horn of plenty means nothing other than the power of wealth: for everything is subjected to money, and the horn always represents power or strength'.[38] An *Allegory of fruitfulness* at Dresden [196][39] is similar in style to the Copenhagen picture. Although its composition resembles that of the *Homage to Pomona (Allegory of fruitfulness)*, circa 1623–25 at Brussels [79], a comparison of the two works shows how far Jordaens's art had evolved in a couple of decades.

His new idea of physical beauty was not confined to women: his men also become fatter and less muscular. The young ones, with fleshy, heavy limbs, represent material life and luxury, while the flabby old men show the physical degeneration due to riotous living. This is evident in works of about 1650 like

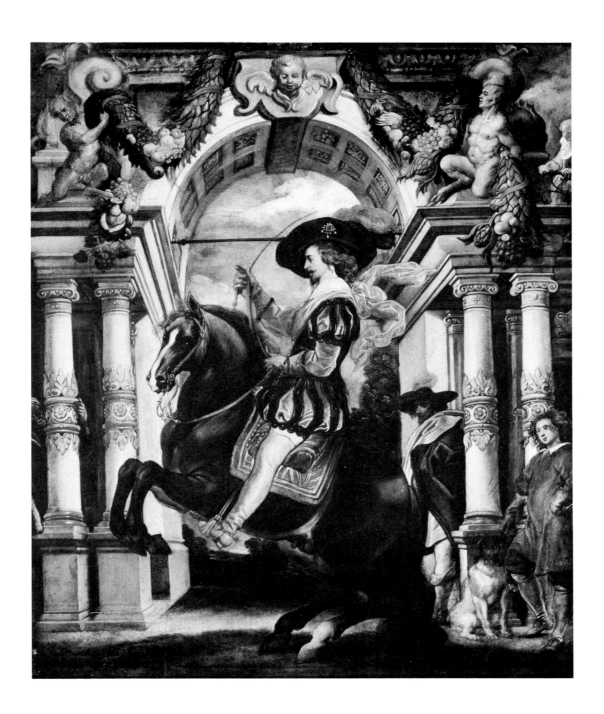

186 *Gentleman on horseback in front of a portico*
circa 1645
panel, 71 × 56cm (cut down on both sides)
Springfield, Massachusetts, Museum of Fine Arts (Gilbert H.
Montague Collection)

187 SCHELTE À BOLSWERT, after
JORDAENS
Mercury and Argus
engraving, 416 × 522mm

188 *Mercury and Argus*
circa 1646
canvas, 142 × 170cm
Belgium, private collection

The triumph of Bacchus at Brussels[40] or *Mercury and Argus* in the G. Dulière Collection, also at Brussels [195].[41] The youth in *The young Bacchus in a landscape* at Warsaw[42] shows at an early age the harmful effects of too much food and drink.

An *Atalanta and Hippomenes*, dated *1646* and sold in London in 1981, throws light on the chronology of the mythological scenes.[43] It represents the point in the foot-race at which Hippomenes, about to be overtaken by Atalanta, distracts her by throwing down one of the golden apples of the Hesperides. The poet Cats, in his *Sinne- en minnebeelden*,[44] remarks that this represents the way in which the devil uses wealth and honours to distract those attempting to pursue a virtuous life.

In the same year, 1646, Jordaens delivered five pictures to a certain Martinus van Langenhoven. This led to a lawsuit, as Van Langenhoven claimed that they were not the painter's own work. From a notarial deed executed by Jordaens in 1648 it appears that only two were entirely by his own hand, a *Vulcan* and a *Mercury and Argus*:[45] the former of these is no longer traceable, while the latter is in a Belgian private collection.[46] Jordaens's statement makes it clear *inter alia* that he did not hesitate to have the studio copy earlier works of his which he would then retouch and present as original. As to *Mercury and Argus* [188], although he did paint this himself, the group of human and animal figures is repeated literally from his painting of the same subject at Lyons [74], and the landscape setting is enlarged in accordance with Jordaens's new conception of space.

The gods had adventures on sea as well as on land, and in his youth Jordaens had depicted them, surrounded by tritons, naiads, horses and dolphins, in works like *The rape of Europa* [16, 20] and *The apotheosis of Aeneas* [43]. He now reverted to subjects of this kind and painted some scenes featuring Neptune and Amphitrite. These, of course, show the same stylistic qualities as his other mythological works of the 1640s: Amphitrite is a plump, fleshy nude with wide hips, Neptune an asthmatic old man, while the tritons are ill-favoured louts. Probably the earliest of these scenes is *Neptune creating the horse* (*circa* 1645) in the Pitti Palace at Florence [183];[47] it later formed the basis of the cartoon for a tapestry in the series called *The riding-school* (*see* Chapter IX). Close to it in style are *Neptune and Amphitrite* in the Rubenshuis at Antwerp [178][48] and *The abduction of Amphitrite*, formerly in the possession of the duke of Arenberg.[49]

Fields and meadows, shady woods and the wide waters of the sea were the natural habitat of the Olympic deities. They seldom visited the abodes of mankind, and thus few of Jordaens's mythological scenes depict interiors, except for friendly visits by minor deities as in the many versions of *Satyr and peasant*. However, Ovid relates (*Met.* VIII, 611–714) how Jupiter and Mercury, disguised as beggars, were received hospitably by the aged Phrygian couple Philemon and Baucis, having been denied a welcome everywhere else. Jordaens painted several versions, with or without studio help, of *Jupiter and Mercury in the house of Philemon and Baucis*: the best are those at Helsinki[50] and Raleigh, North Carolina.[51] All the versions show Jupiter and Mercury seated at table in a modest interior, while the impoverished couple offer them the best food they can: as a reward, they later escaped the vengeance which the gods meted out to the rest of the Phrygian people. Carel van Mander points out the moral: 'Here we see punished the greedy nature of mankind, and here is the reward of merciful kindness. For we often see in the world that poor people are full of love and charity, while the rich are mean-minded'.[52]

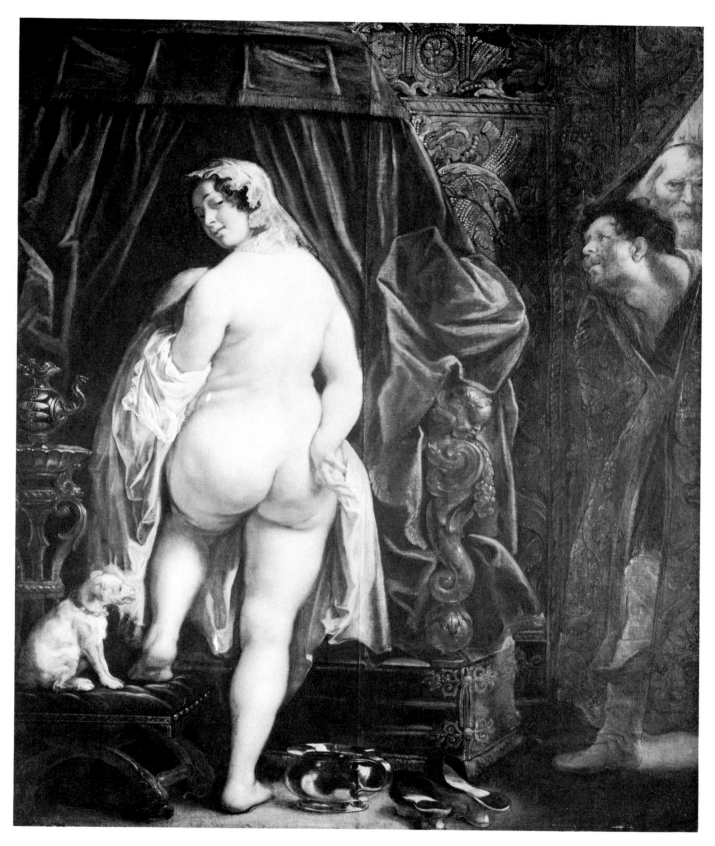

189 *King Candaules*
1646
canvas, 193 × 157cm
Stockholm, Nationalmuseum

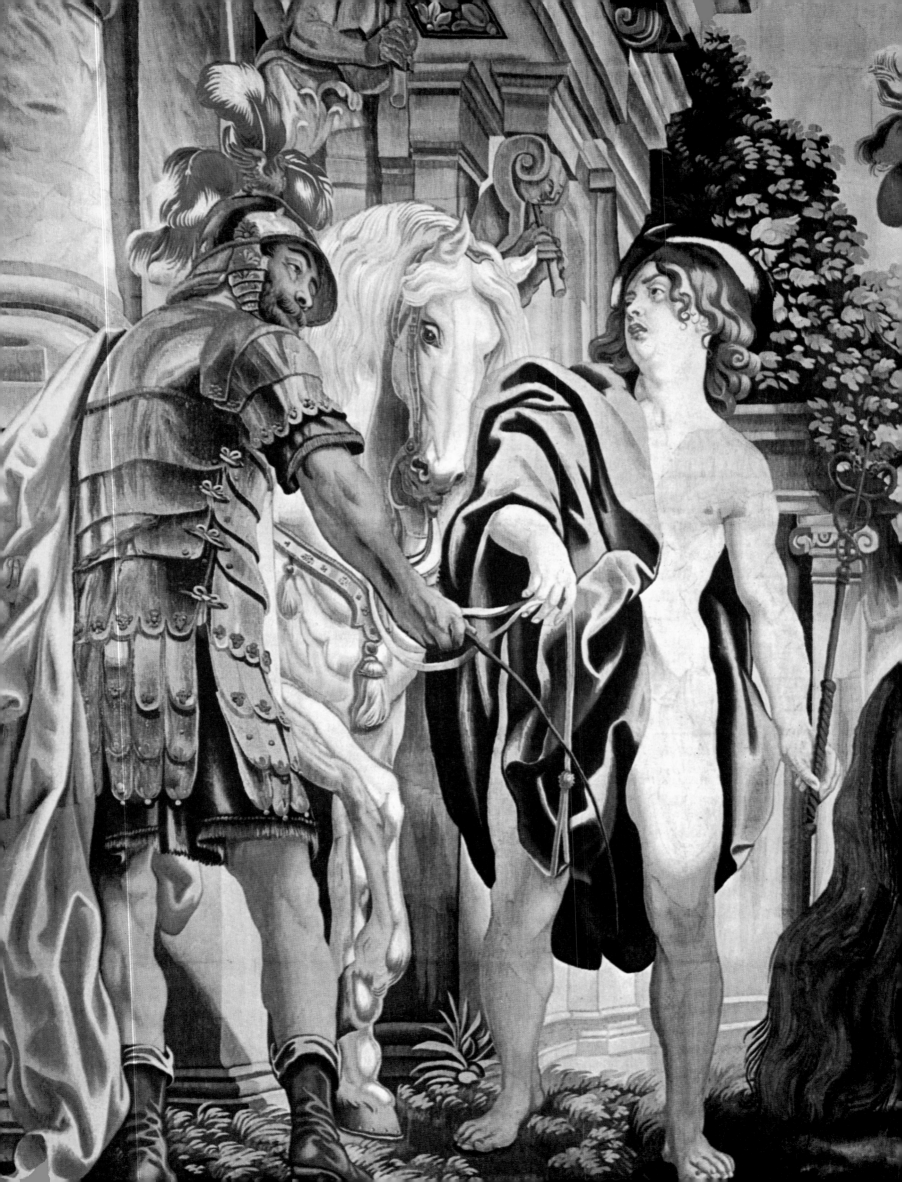

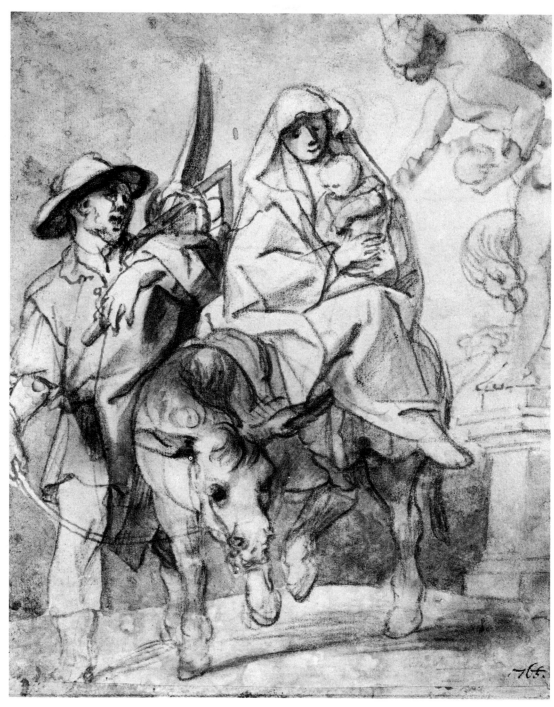

190 *The flight into Egypt*
circa 1645–50
drawing, 222 × 172mm
Rotterdam, Museum Boymans–van Beuningen

185 *Levade performed under the auspices of Mars and in the*
presence of Mercury (*The riding school*)
(*detail*)

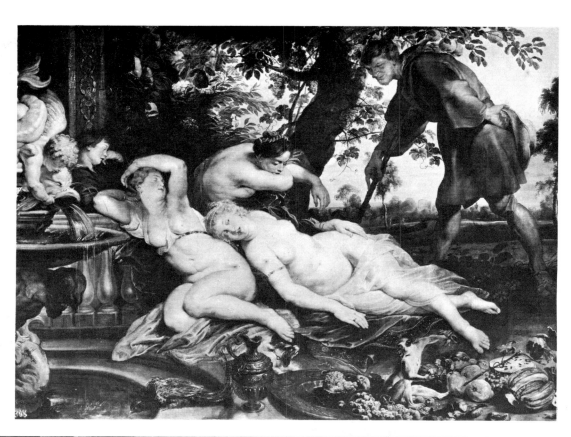

191 RUBENS
Cimon and Iphigenia
circa 1617
canvas, 208 × 282cm
Vienna, Kunsthistorisches
Museum

192 *Venus asleep*
circa 1645–50
canvas, 169 × 261cm
Antwerp, Koninklijk Museum
voor Schone Kunsten

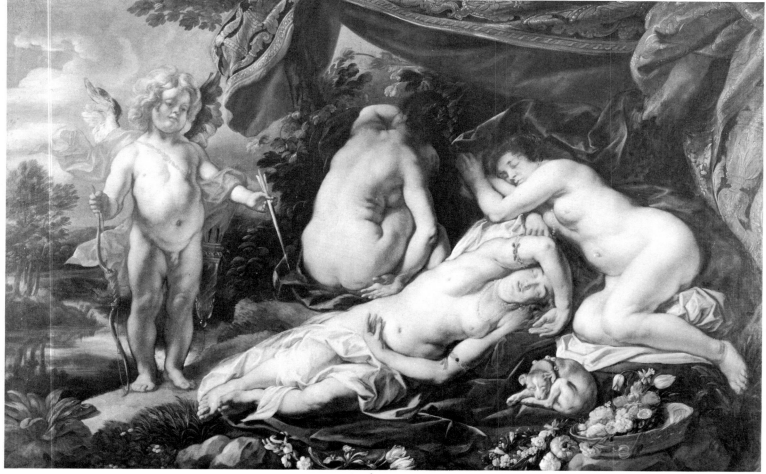

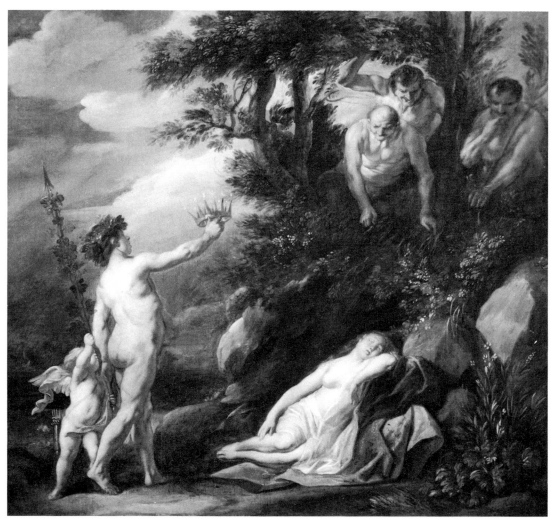

193 *Bacchus and Ariadne*
circa 1645–50
canvas, 122 × 127cm
Boston, Museum of Fine Arts

194 *Antiope asleep*
signed and dated *J.Jord. fecit 1650*
canvas, 130 × 93cm
Grenoble, Musée des Beaux-Arts

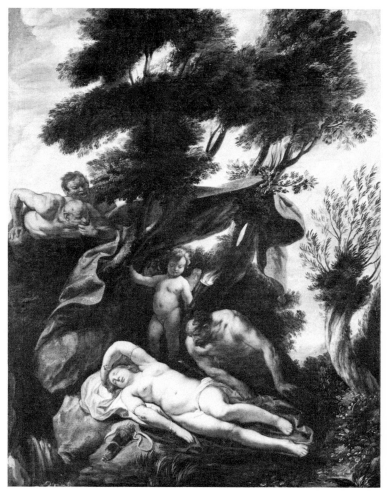

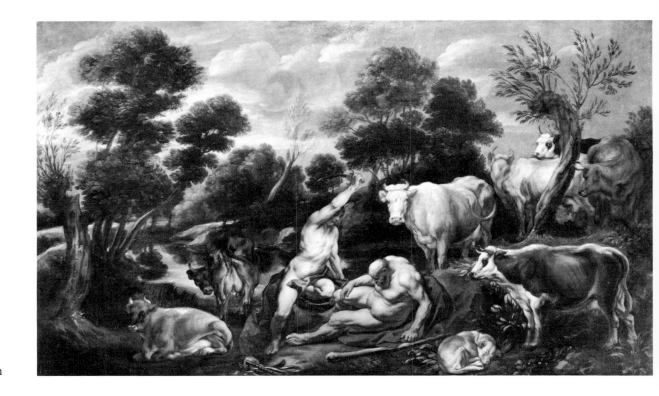

195 *Mercury and Argus*
circa 1650
canvas, 114 × 195cm
Brussels, G. Dulière Collection

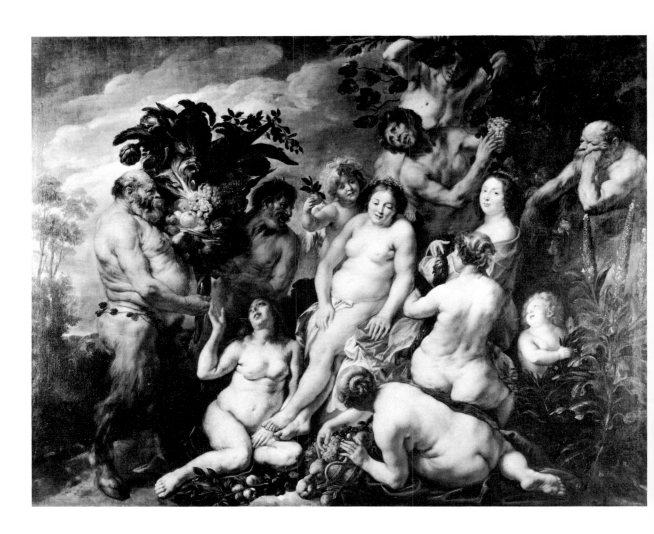

196 *Allegory of fruitfulness*
circa 1650
canvas, 240 × 315.5cm
Dresden, Gemäldegalerie

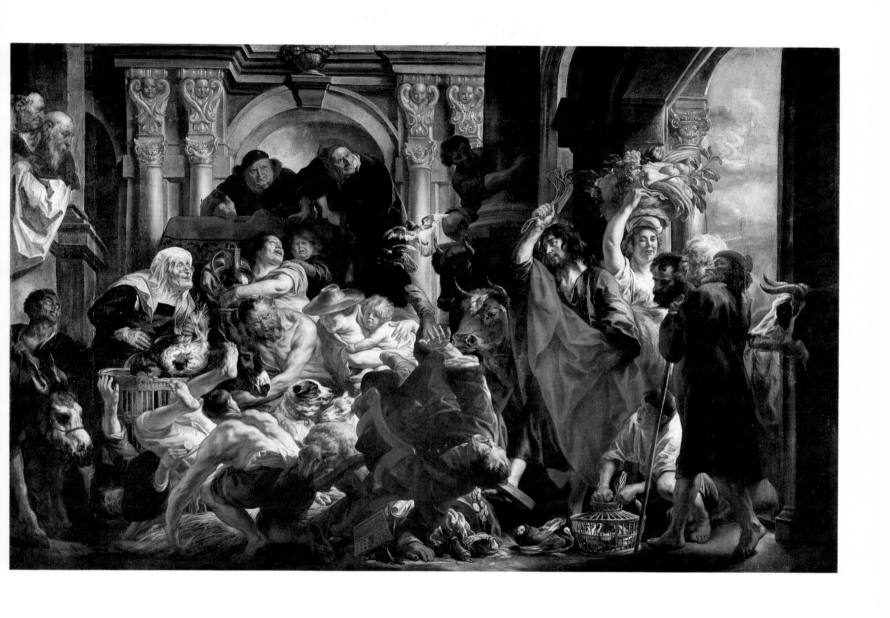

197 *Christ driving the money-changers from the temple*
circa 1645–50
canvas, 288 × 436cm
Paris, Musée du Louvre

198 *Head of a woman*
circa 1650
drawing, 125 × 129mm
(all four corners cut off)
Whereabouts unknown
(formerly in the A. G. B. Russell
Collection, London)

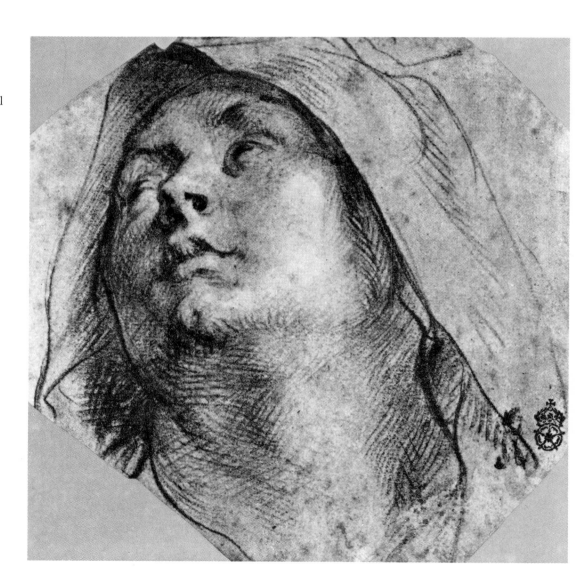

199 *The lamentation*
circa 1650
canvas, 207.5 × 191cm
Hamburg, Kunsthalle

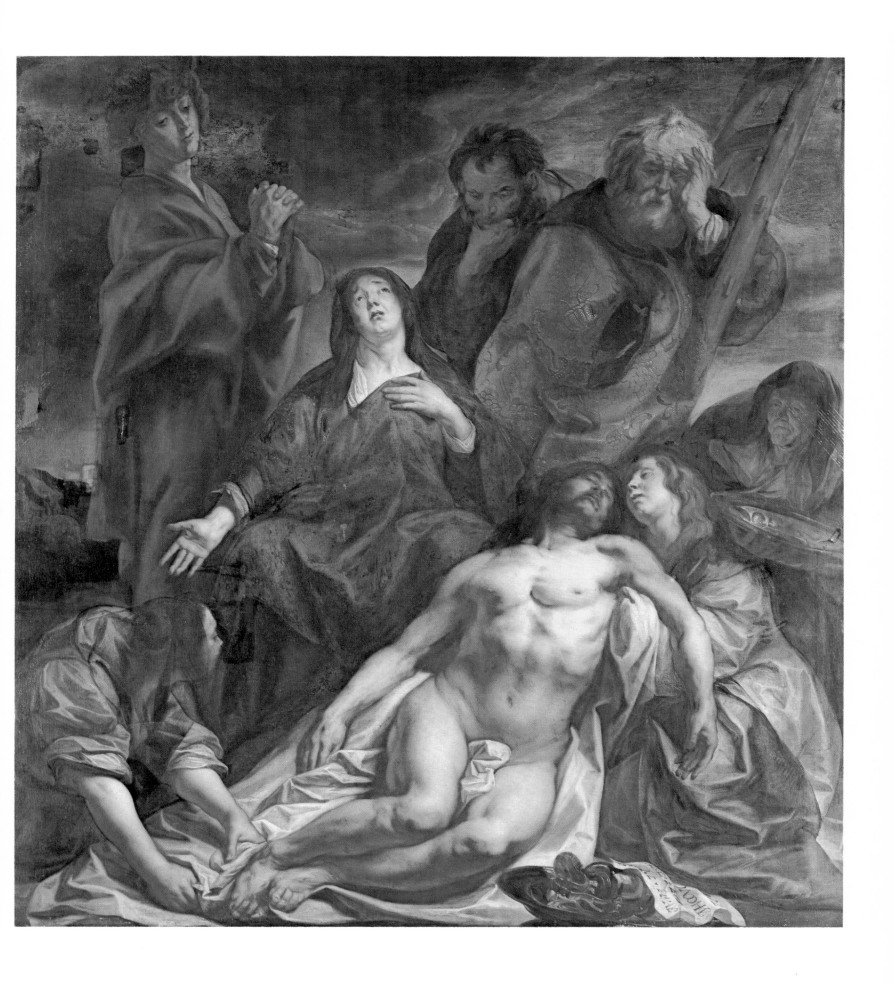

In 1648 the Swedish agent Johan-Philips Silvercroon ordered from Jordaens a series of thirty-five ceiling-pieces for Queen Christina's castle at Uppsala. This was a formidable task, as all the pictures had to be delivered by the following year. Documents show that the commission was at least partly executed, but the subjects are unknown (*see* Chapter II).

Despite all the time Jordaens devoted to religious and mythological paintings in the 1640s, he also produced other works, a good example of which is *Diogenes in search of a man* at Dresden [161].[53] This unusual painting, of large size and with a rich profusion of figures, gives the impression that Jordaens wanted to present something of his own forthright character in the burly figure of the cynic philosopher, striding briskly through the crowd and holding up a lantern in his search for a real man. His firm demeanour and mocking smile express confidence in his own convictions, despite the derision of the uncomprehending bystanders. An elaborate drawing for this composition,[54] in watercolour and bodycolour, bears the date *1642*, which is certainly compatible with its style.

The building of Jordaens's house in the Hoogstraat was probably finished in 1641, though some years elapsed before it was ready to live in. The interior decoration, which must have taken some time to complete, included two sets of ceiling pictures by Jordaens himself, *The signs of the zodiac* [154–156] and *The story of Psyche*. The former originally adorned the ceiling of a large room overlooking the street and shaped like a Greek cross. In the eighteenth century they were removed and sold by the then owner of the house, and since 1803 they have been framed in the ceiling of the Senate Library in the Palais du Luxembourg, Paris. They consist of octagonal or oval scenes set in a painted frame of square or rectangular shape; each scene comprises one, two, three or four figures.[55] Although strong in colouring, they are not wholly satisfactory: the perspective is faulty, and the figures are in contorted shapes which defy the laws of anatomy. They appear close to the spectator and there is scarcely any vista of blue sky beyond, as one usually expects in a *soffitto*.

Jordaens's ceiling-pieces do not bear comparison with those of Rubens, who was the first to introduce this form of decoration in Flanders under the influence of the Venetians, especially Veronese. Throughout Northern Europe, Rubens was generally regarded as the only artist capable of executing such works satisfactorily in accordance with the rules of perspective. Jordaens knew too little of the Italian models to achieve this, but followed Rubens's example as best he could. He must also have known, albeit indirectly, Giulio Romano's *Sala di Psiche* in the Palazzo del Te at Mantua,[56] of which there are reminiscences in his *Gemini* and *Capricorn*.

Among the pictures which gave rise to the dispute with Martinus van Langenhoven in 1646 was one representing the story of *King Candaules*. Although by Jordaens's own admission this work in its final form was not begun by himself, he claimed to have overpainted and reworked it in such a way that it was 'as good as his other ordinary works'.[57] The only known picture of this subject by Jordaens is at Stockholm;[58] it bears the date *1646*, and it may therefore be reasonably assumed that it is the one delivered to Van Langenhoven [189]. The story of Candaules was not a very common theme but was occasionally treated in both Dutch and Flemish painting of the seventeenth century. Candaules, king of Lydia in the seventh century BC, was murdered and succeeded by one Gyges. The Greek legend gives two versions of the story. According to one of them, Candaules used to boast of his wife's extraordinary beauty; Gyges, one of the king's favourites, expressed scepticism, whereupon Candaules allowed him

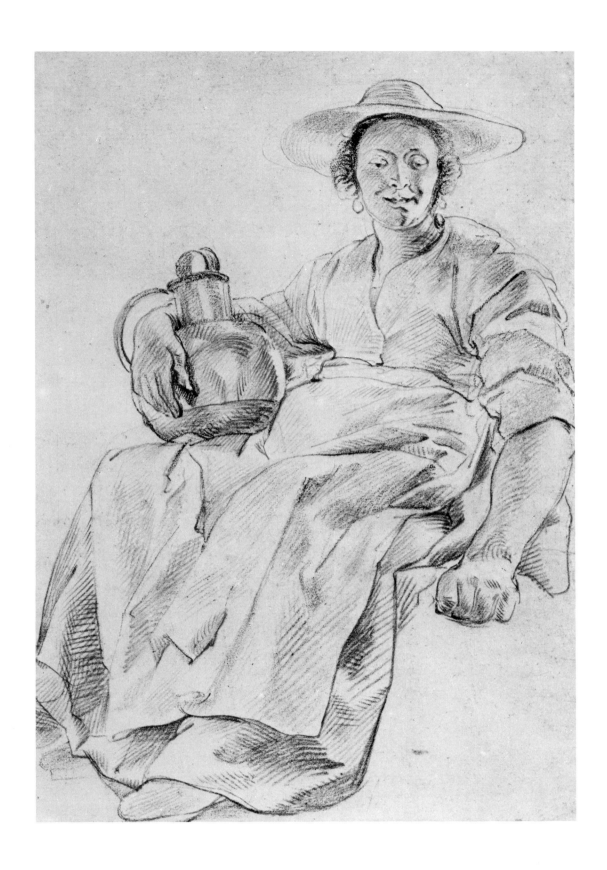

200 *Woman seated, with a jug*
circa 1650
drawing, 320 × 216mm
Brussels, Bibliothèque royale

to see Queen Tydo naked without her knowledge. When the queen learnt what had happened, she was so incensed that she made Gyges choose between being killed himself or murdering Candaules and ruling Lydia as her husband. From this story, which no doubt also was given a moral meaning in the seventeenth century, Jordaens chose the moment at which Gyges, hidden in the queen's bedroom, watches her cast off her last garments. Thus he was able to paint another of his many ideal female nudes: of winning appearance, soft and luxurious in form, her skin gleaming in the bright light.

In the context of religious paintings *St Ives, patron of lawyers* at Brussels, dated *1645* [169] has already been mentioned. The same scene recurs in a tapestry of the *Proverbs* series commissioned in 1644 [170], this time with the inscription *Ingens est usura malum, mala pestis in urbe* (usury is a great evil, a plague in the city). In the same way a genre painting of *circa* 1645 at Kassel [175][59] was used for the *Proverbs* series with the title *Oculus domini pascit equum* (the master's eye makes the horse grow fat) [172]. Jordaens did not hesitate to delete figures or replace them by others so as to modify the sense of a picture. Thus the tapestry *Natura paucis contenta* (nature is content with little) is based on the painting *Satyr and peasant* of *circa* 1640–45 at Brussels.[60] For this work, which also belongs to the *Proverbs* series, he replaced the satyr by two children, thus depriving the peasants' simple repast of the dignity conferred on it by the fable. Some years later he used the same *Satyr and peasant* as a basis for *The porridge-eater* at Kassel,[61] where the satyr's place is taken by an old peasant drinking.

Some paintings are also connected with *The riding-school*, a tapestry series of about the same date as *Proverbs*. The most important of these are four carefully executed *modelli*. *Neptune creating the horse* in the Pitti Palace at Florence has already been mentioned under mythological subjects [183]. Two others – *Mars and Mercury leading horses to Venus*[62] and *Levade performed under the auspices of Mars and in the presence of Mercury, Venus and a riding-master*[63] – are in the Marquess of Bath's collection at Longleat, Wiltshire, while *Levade performed under the auspices of Mars and in the presence of Mercury* is at Ottawa [184].[64] Each of these corresponds broadly with one of the tapestries [185]. The art of equitation is also illustrated by a *Gentleman on horseback in front of a portico* at Springfield, Massachusetts,[65] which shows a rider in sumptuous attire executing a levade [186].

VII

Later life

circa 1652–78

Jordaens was now nearly sixty. His health was good, and he continued to paint vigorously with the aid of the studio. His work was admired on all sides, and commissions poured in from ruling circles and church authorities, as well as the bourgeoisie. One of the most important was the decoration of the Orange Hall in the Huis ten Bosch (House in the Wood), the summer residence near The Hague of Amalia van Solms, widow of Prince Frederick Henry of Orange (*see* Chapter II). Amalia had deeply loved and admired her husband, and on his death in 1647 resolved to turn the great hall of the palace into a memorial to his exploits as statesman and commander. Dutch and Flemish artists were accordingly commissioned to decorate the walls and dome with allegorical pictures, which are still to be seen there. Jordaens's *Triumph of Frederick Henry* of 1652[1] occupies the largest wall surface and is the dominant feature of the decoration, which also includes his painting *The triumph of Time*. Entering the Orange Hall, the visitor is confronted by a bewildering accumulation of pompous scenes amid which it is hard for the eye to find a resting-place; *The triumph of Frederick Henry* is the best of these works as well as the largest. Some elements in it are less happy than others, but it should not be forgotten that Jordaens was restricted in his choice and treatment of subjects by directives from the architect Jacob van Campen and from Amalia's counsellor Constantijn Huygens (*see* p 32). The enormous canvas (850 × 820cm) is populated by no fewer than seventy figures, with Frederick Henry seated on a chariot in the centre. The symbolism is not always easy to grasp, and it is not surprising that Jordaens supplied an elaborate written description for Amalia's benefit. The composition falls into two parts, a terrestrial scene below and a celestial one above. The former is peaceful and lucidly arranged, the latter turbulent and confused, while the architectural décor *à la* Veronese does not harmonise as well as it might with the assemblage of human and animal figures. In short, Jordaens lacked the ingenuity and lightness of touch to impose perfect order on the profusion of pictorial elements. Nevertheless the huge canvas with all its animated figures, prancing horses and rich garlands of fruit makes a pleasing and festive impression, owing largely to its wealth of colour. Although Jordaens's works at this time were increasingly dominated by brown and grey tones, in *The triumph of Frederick Henry* his palette reverted to its former brilliance.

In a long letter addressed to Huygens from Antwerp in 1651, Jordaens stated that he intended to submit four or five sketches for the princess and her advisers to choose from. The three surviving *modelli* show what pains Jordaens took in planning the work and are respectively at Antwerp,[2] Brussels [203][3] and Warsaw.[4]

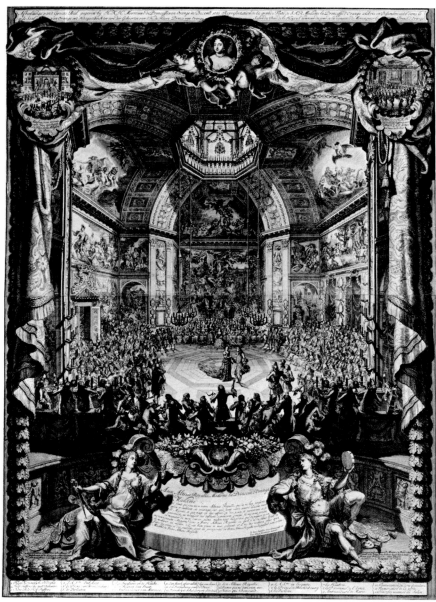

201 DANIËL MAROT
(*circa* 1663–1752)
*Court ball in the Orange Hall of
Huis ten Bosch near The Hague*
engraving, *circa* 1686

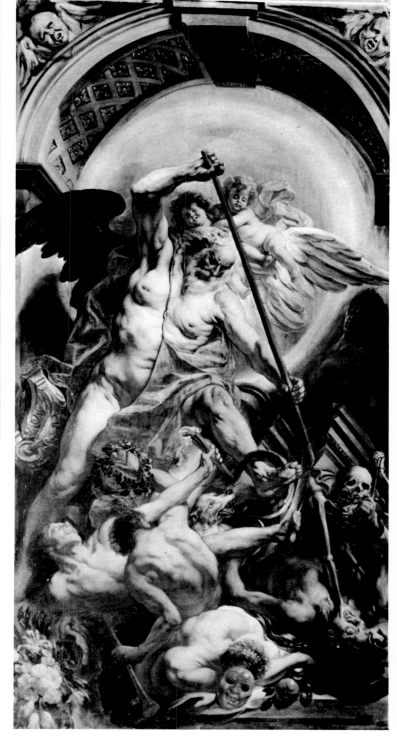

202 *The triumph of Time*
1652
canvas, 383 × 205cm
The Hague, Huis ten Bosch

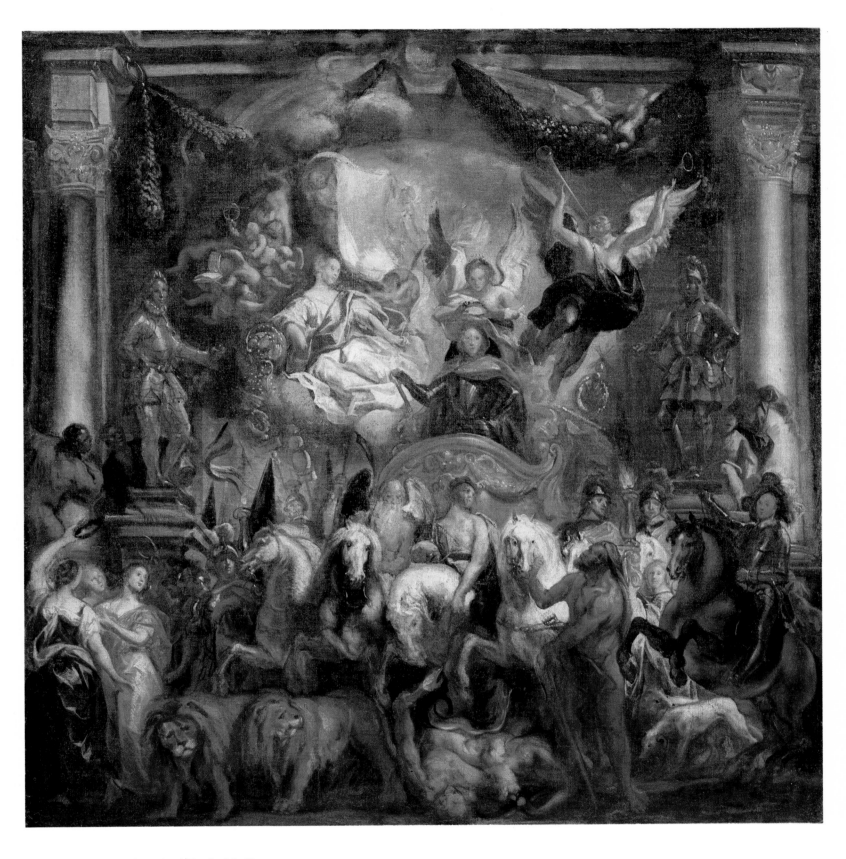

203 *The triumph of Frederick Henry*
circa 1651
canvas, 120 × 117cm
Brussels, Musées royaux des Beaux-Arts

The main lines of *The triumph of Time* [202],[5] as of *The triumph of Frederick Henry*, were laid down by Jacob van Campen, who indicated that Time should be depicted both as a destroyer and as a renewer. Accordingly Chronos is shown, with the help of Death, as curing the evils brought about in history by anger, passion, deceit and envy, while the new age is announced by two children on Chronos's shoulders.[6] The huge figure of the aged man personifying Time is one of the most powerful in all Jordaens's work.

Although constantly busy with a flood of orders, Jordaens found time to continue with the decoration of his own home. *The signs of the zodiac*, painted to adorn the ceiling of the large room facing the street has already been mentioned (*see* p 230). He now painted a second series of eight ceiling pictures for a drawing-room to the right of the inner court, representing *The story of Psyche* [204–206, 213].[7] One of these bears the date *1652*, by which time the whole series was probably completed. The pictures remained *in situ* until 1877, when the owner of the house, Charles van der Linden, moved them to his mansion on the Mechelse Steenweg in Antwerp. Six of them are still on the ceilings there and two hang as wall pictures (one being only a fragment). The series illustrates the myth of the princess Psyche, who is abandoned by her divine bridegroom Amor (Cupid) in punishment for her curiosity, but after many trials is eventually reunited with him on Olympus (Apuleius, *Met.* (*The Golden Ass*), IV–VI). Psyche is taken as an allegory of the human soul, constantly pursued by love and eventually finding it through suffering: the theme was a popular one with artists ever since Raphael depicted it in a series of frescoes for Agostino Chigi at the Villa Farnesina in Rome. Numerous engravings were made after Raphael's work, and others by the 'Master of the die' from designs by Michiel Coxcie (Hollstein, V, p 62).[8] Rubens, like many young artists of his time, visited the Farnesina when he was in Italy and admired and studied Raphael's frescoes. He painted scenes from *The story of Psyche* after his return to Antwerp, and Jordaens may have drawn inspiration from these.

The series in Jordaens's house originally comprised: *The love of Cupid and Psyche*; *Psyche's curiosity*; *Cupid's flight*; *Psyche carried up to Olympus by Mercury*; *Psyche received by the gods*; *The offering to Apollo*; *Six putti with festoons*; *Four putti with festoons*.[9] From the picture *Cupid's flight* only a fragment remains, showing Cupid escaping with his bow in his right hand. As a whole, *The story of Psyche* is not one of Jordaens's best works. It is in a brownish-red tone, varied by patches of rather feeble colour, and once more shows Jordaens's imperfect command of perspective. The foreshortening is grossly exaggerated and the figures are sometimes seen at such a sharp angle that they telescope and lose their shape while displaying the least interesting parts of their anatomy. Jordaens evidently had in mind some of Rubens's ceiling-pieces: *The offering to Apollo*, for instance, could hardly have been painted but for *Abraham and Melchizedek* in the Jesuit church at Antwerp. But Jordaens did not realise, as Rubens did, the need for 'give and take' in work of this kind: he had not the skill to avoid unnecessary difficulties and display his figures in airy poses that pleased the eye even if they were not always anatomically correct.

The scene of Jupiter's eagle helping Psyche to fetch water from the Styx, guarded by dragons (Apuleius, *Met.* VI) was depicted by Jordaens in a work now in the Pau museum.[10]

A group of seven etchings inscribed *Iac. Iordaens inventor 1652* is generally attributed to Jordaens.[11] These are inadequate attempts by someone who was clearly not a master of the graphic art, and, although in each case the com-

position can be ascribed to Jordaens without difficulty, it is questionable whether they are entirely his own work. Since no other models are known, the point cannot be determined. Some authors, however, maintain that in 1652, when Jordaens was so famous and still at the height of his powers, no one would have dared to use his name without his consent, while, if he had commissioned anyone to make the etchings, he would have chosen a better craftsman.[12] Three of the etchings are of religious subjects: *Christ driving the money-changers from the temple* is a simplified version of the painting of the same title in the Louvre [197], while *The flight into Egypt* derives from a drawing at Edinburgh[13] and *The lamentation* from one in the Institut Néerlandais in Paris.[14] Three others are mythological: *The infant Jupiter fed by the goat Amalthea* and *Mercury and Argus*, both subjects often treated by Jordaens in a different form, and *Jupiter and Io*, the title of a painting at Besançon.[15] *The master pulls the cow out of the ditch by its tail* is a subject from the *Proverbs* series.

To conclude the year 1652 mention must be made of *The Holy Family with various persons and animals in a boat* at Skokloster, Sweden,[16] a signed and dated picture that has suffered much damage and is reworked in several places [207]. Although certainly not a masterpiece it may be regarded as typical of Jordaens's work at this period, as well as pointing to future trends in his style. There are also many old acquaintances among the figures. In Jordaens's earlier years it was quite common for him to re-use drawings and sketches of his own, but in the 1650s this practice almost got out of hand: the picture at Skokloster is crammed with figures of men, women, children and animals that are familiar from such works as *Peter finding the tribute-money in the fish's mouth*, *The king drinks*, *As the old sang, so the young pipe*, *Christ driving the money-changers from the temple*, *Diogenes in search of a man* and others. Jordaens's further output thus becomes less and less interesting, as he confined himself for the most part to applying old formulae, modifying prototypes or combining existing fragments. Apart from occasional fine bits of painting, his later work is mostly of poor quality. The colouring is reduced to a monotonous grey with some displeasingly hard accents or to a practically uniform brown, and the paint is so thinly applied that the canvas is visible almost everywhere. As to the figures, they often produce a disturbing effect by their angular attitudes and over-rhetorical gestures.

Many of these criticisms apply to *Susanna and the elders* (1653) at Copenhagen [208],[17] the composition of which is based on Rubens,[18] while the seated figure of Susanna is borrowed from Tintoretto.[19] The almost caricatured faces of the greybeards, as well as their garments and Susanna's white linen towel, are rendered in hard, abruptly broken lines, while the modelling of the female nude is weak and lacking in tension. As to the composition, Jordaens again places the figures in close-up as he did at the beginning of his career. This tendency continued to develop and was accompanied by a special interest in striking profiles and frontal views, so that the principal figures showed up clearly against a confused background of foreshortened, intertwined figures. In the Copenhagen picture, Susanna's body in profile contrasts powerfully with the vaguer outlines and wooden appearance of the two elders. A replica of this work, dated *1657*, belongs to the Verwaltung der Staatlichen Schlösser und Gärten in Berlin:[20] although changed from a horizontal to a vertical format, it agrees with the original in its main elements and in all essential details. Despite the signature, Jordaens painted only the main parts, leaving the rest to the studio. This is typical of his later years, when he seldom completed a picture by his own hand. A *Susanna and the elders*, executed about 1660, at Lille,[21] shows the rapidity with

206 *Psyche carried up to Olympus by Mercury* (*The story of Psyche*)
circa 1652
canvas, *circa* 210 × 130cm
Antwerp, Van der Linden Collection

204 *The love of Cupid and Psyche* (*The story of Psyche*)
circa 1652
canvas, *circa* 250 × 310cm
Antwerp, Van der Linden Collection

205 *Psyche's curiosity* (*The story of Psyche*)
circa 1652
canvas, *circa* 130 × 230cm
Antwerp, Van der Linden Collection

239

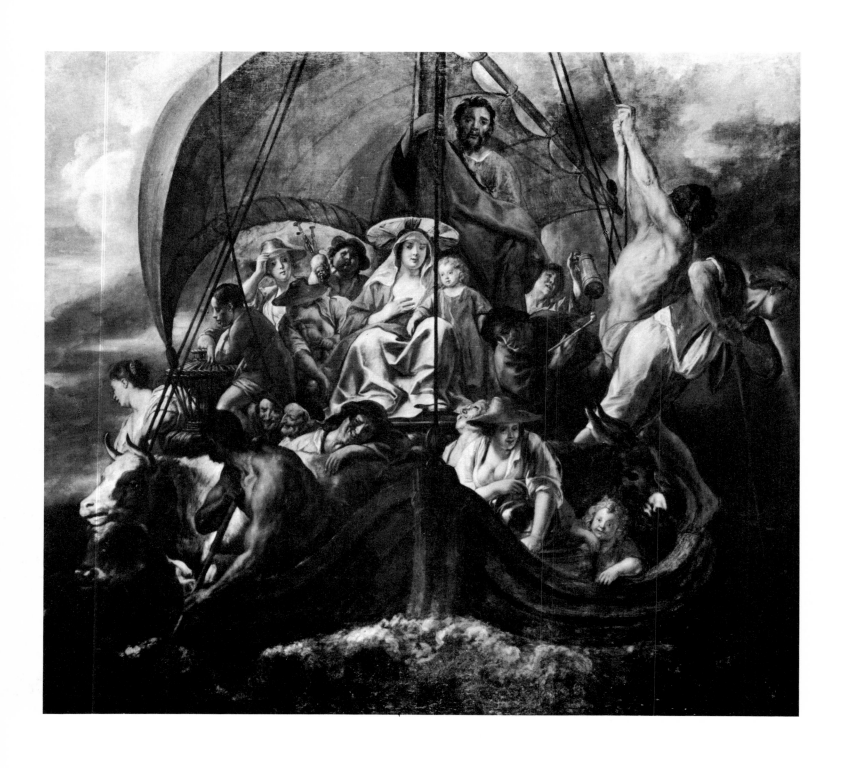

207 *The Holy Family with various persons and animals in a boat*
signed and dated *IOR Fe A° 1652*
canvas, 222 × 254cm
Skokloster, Sweden, State Museum

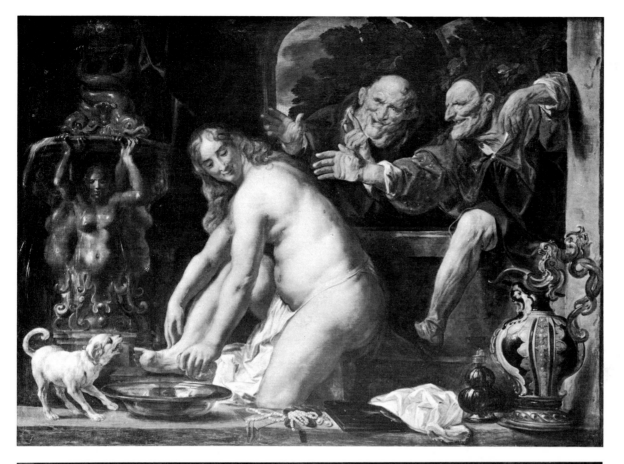

208 *Susanna and the elders*
signed and dated *Jac. Jordaens
fecit 1653*
canvas, 153.5 × 203cm
Copenhagen, Statens Museum
for Kunst

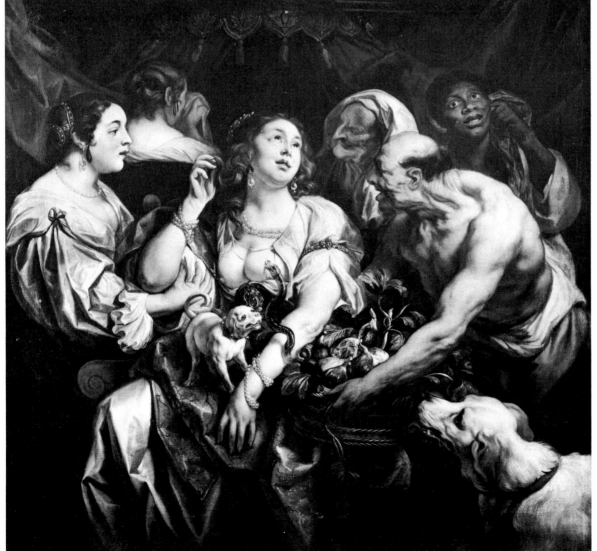

209 *The death of Cleopatra*
signed and dated *J.JOR. fe. 1653*
canvas, 171 × 172cm (including
strips added by an unknown
hand)
Kassel, Staatliche
Gemäldegalerie

241

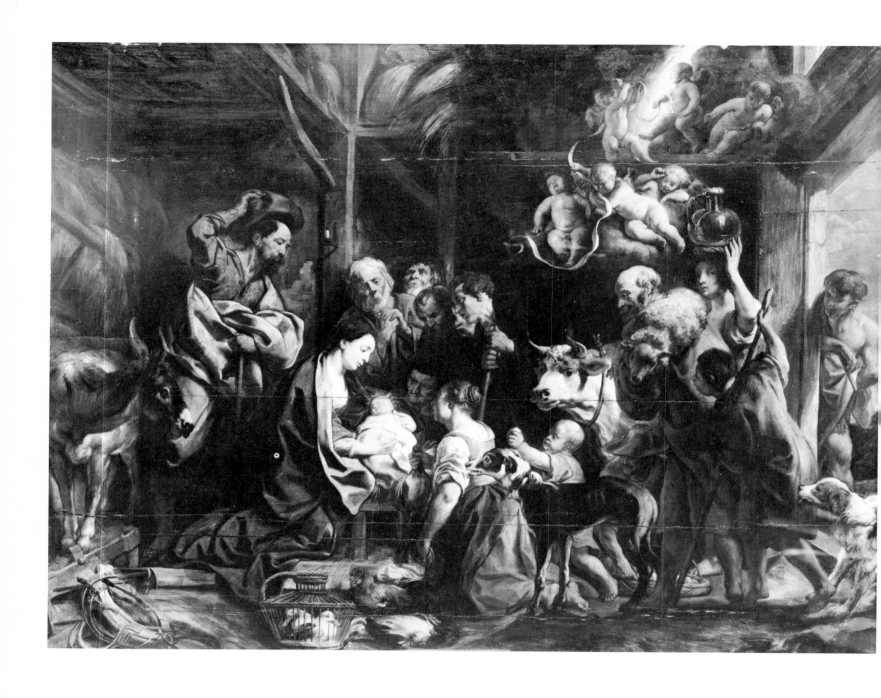

210 *The adoration of the shepherds*
circa 1653
panel, 114 × 165cm
Bristol, City Art Gallery

which Jordaens's art declined: it is faulty in composition, the forms are vague and the colours are uninteresting and lacking in brilliance.

Large paintings, mostly of religious subjects, succeeded one another without interruption in the 1650s. As many are dated, their chronology presents few problems. *The Last Judgement*, painted in 1653 for the town hall at Veurne (Furnes) and now in Paris,[22] shows strongly the influence of Rubens's 'Large' and 'Small' *Last Judgement* and his *Fall of the rebel angels*.[23] Three *Adorations of the shepherds*, at Antwerp,[24] Bristol [210][25] and Munich [211][26] respectively, are close in style to the oil sketch of the same subject at Frankfurt am Main, dated *1653*.[27]

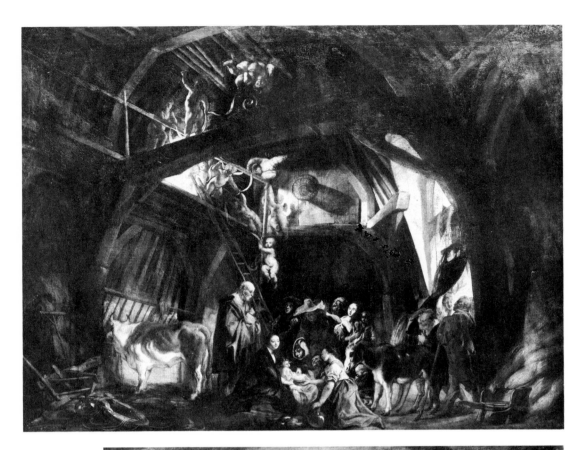

211 *The adoration of the shepherds*
circa 1653
Munich, private collection
(1938)

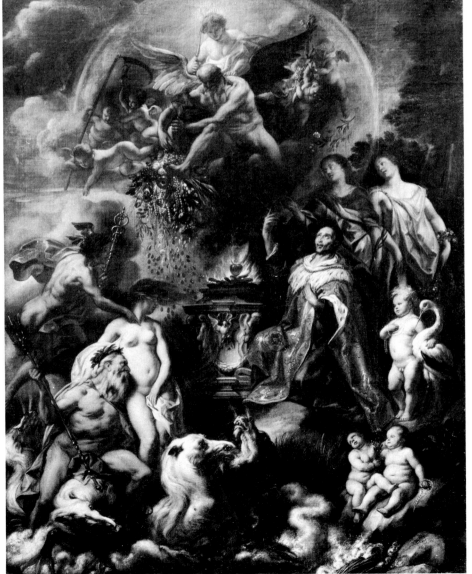

212 *Allegory of the peace of Münster*
signed and dated *J.Jor fec. 1654*
canvas, 184 × 139.5cm
Oslo, Nasjonalgalleriet

243

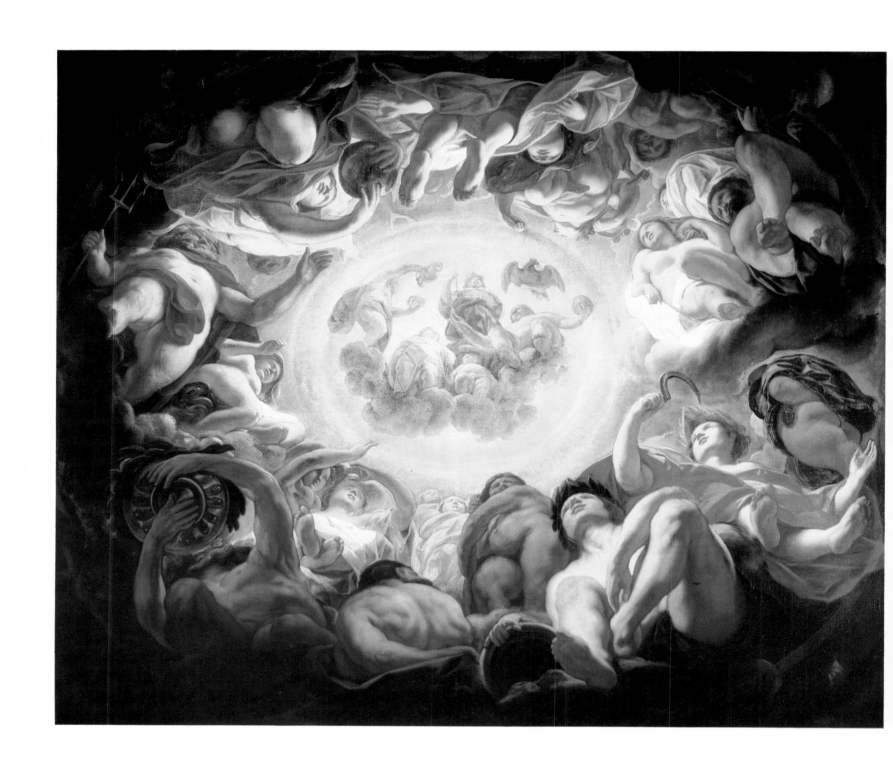

213 *Psyche received by the gods* (*The story of Psyche*)
circa 1652
canvas, *circa* 250 × 300cm
Antwerp, Van der Linden Collection

244

The testament of the chevalier Jacomo-Antonio Carenna, dated 9 March 1669, mentions 'due pitture similmente fatte a misura', each hanging over a door in the 'saletta maggiore' of his house on the Meir at Antwerp: these were by Jordaens and represented scenes from *The history of Cleopatra*.[28] Very probably *The death of Cleopatra* (1653) at Kassel [209][29] is one of these works, and the other may be *Cleopatra about to dissolve the precious pearl* at Leningrad.[30]

A painting of 1654 at Oslo has traditionally been regarded as an *Allegory of the peace of Münster* [212].[31] Although Jordaens did paint political allegories, such as *The triumph of Frederick Henry*, there is some doubt whether this title is correct. To the same year belongs a *Christ in the garden of olives* painted for the Antwerp Augustinians and now in St Catherine's church at Honfleur.[32] Also in 1654 or soon after, Jordaens painted a *Last Supper* for the Augustinians, which is now in the Antwerp Museum of Fine Arts.[33] Both these works were rounded at the top; the latter, inspired by Rubens,[34] was afterwards enlarged to a rectangular shape. Descamps, who saw both pictures *in situ*, described them in his travel notes of 1769[35] together with *The martyrdom of St Apollonia*. An oil sketch of *Christ in the garden of olives* was in the Dutch art trade in 1960.[36]

214 *Christ blessing children circa* 1655
canvas, 253 × 277cm
Copenhagen, Statens Museum for Kunst

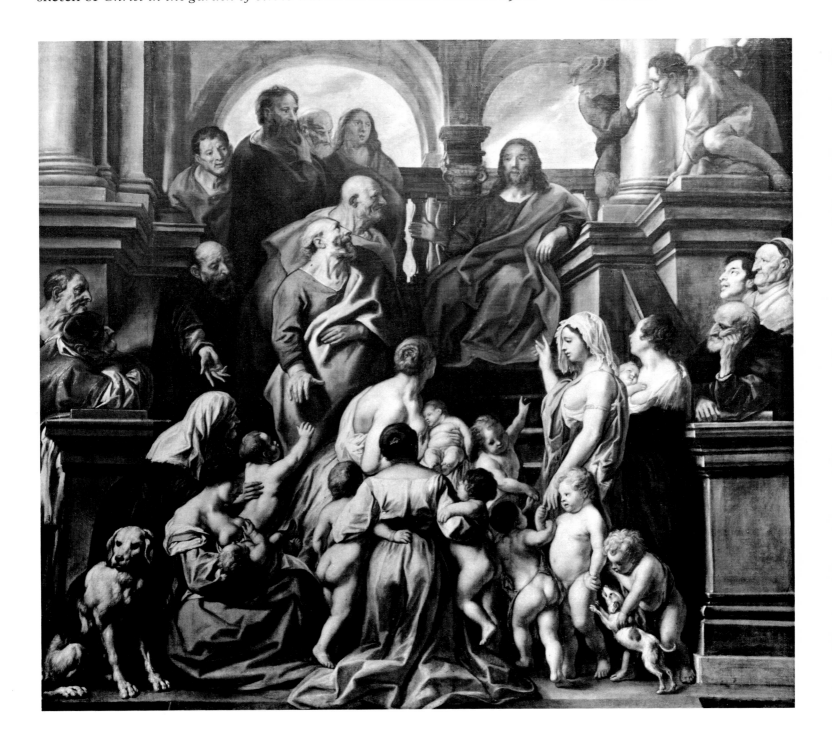

246

216 *The adoration of the shepherds*
signed and dated *I.I.Fecit 1657*
canvas, 284.5 × 203.5cm
Raleigh, North Carolina, North Carolina Museum of Art
(presented by John Motley Morehead, New York)

215 *Goat*
circa 1655
drawing, 252 × 200mm
New Haven, Connecticut, Yale University Art Gallery (Everett
V. Meeks Fund)

247

217 *Christ carrying the cross*
circa 1655–60
canvas, 240 × 175cm
Whereabouts unknown (formerly in St Francis Xavier's church,
De Krijtberg, Amsterdam)

218 RUBENS
Christ carrying the cross
1636–37
canvas, 560 × 350cm
Brussels, Musées royaux des Beaux-Arts

To the year 1655 belongs *The healing of a paralytic*, signed *I.Iord. 1655* and sold on 9 June 1939 at the Hôtel Drouot in Paris;[37] its present whereabouts are unknown. Of about the same date is *St Charles Borromeo imploring the Virgin's intercession for the plague-stricken*, an altarpiece for a chapel in St James's church at Antwerp, where it still is.[38] This chapel, completed in 1656, was founded by Jacomo-Antonio Carenna, for whom Jordaens painted the two scenes from the life of Cleopatra (*see* above). Carenna, a former city almoner and a Milanese by birth, chose as patron of the chapel St Charles Borromeo, archbishop of Milan, who had been canonised in 1610. St Charles was regarded in Counter-Reformation times as the perfect type of bishop: renowned for his corporal works of mercy, he was extolled as a living refutation of the Protestant doctrine that works did not avail to salvation. During the plague in Milan in 1576 he showed his charity by, among other things, caring for orphaned children, and in the foreground of the altarpiece there is a child being taken from its mother who has just died. At about the same time, Jordaens painted a second version of this work, now at Schloss Schwedt an der Oder.[39]

Some other altarpieces can be dated to the period 1640–45 on purely stylistic grounds. One of these is *The miracle of St Dominic* at Oldenburg [164],[40] in which can be seen various elements from *The Virgin adored by saints*, painted by Rubens for his mother's tomb in the church of St Michael's abbey at Antwerp.[41] The two works have in common the dominating figure of the titular saint and the triumphal arch crowned with the picture of a miraculous Madonna. *The assumption of the Virgin* at Ghent[42] is, if possible, even more indebted to Rubens, as it reproduces almost literally the composition of his painting of the same subject in Antwerp cathedral.[43] Jordaens followed the same schema in a second treatment of the subject, now in the Teirninck Institute in Antwerp.[44] *The martyrdom of Sts Felicitas and Perpetua*, now lost but formerly in the sanctuary of the Augustinian church in Antwerp,[45] shows essentially the same composition as *The martyrdom of St Apollonia* [94], painted by Jordaens in 1628 after models by Rubens. The same is true of two oil sketches for an altarpiece of *The martyrdom of St Lawrence*, one in the University Museum at Uppsala[46] and the other at Brussels;[47] it is not known whether any finished work was based on these.

The form of all these works is more and more schematised: the attitudes and gestures are stereotyped, and all individuality finally disappears. Nothing is left of the varied beauty and rich expressiveness of Jordaens's best years. The colour-scheme is dominated by the bluish-grey and ochreous yellow of the figures and the drab grey of the architecture: while not inharmonious, this, in the end, becomes monotonous and boring. Finer effects of light are replaced by the sterile illumination of more or less neutral expanses of colour. The architecture has degenerated to the level of a stage set, as can be seen, for instance, in *Christ blessing children* in Copenhagen [214],[48] where the figures occupy the steps of a complex structure inspired by Genoese palaces. This late style undoubtedly includes classical elements: the uniting function of architecture in the composition, the symmetry and the idealised characters; there is little foreshortening or use of overlapping and diagonals.

It may be wondered how this alteration in Jordaens's style came about. Classical tendencies manifested themselves around the middle of the seventeenth century in other art centres, particularly in France, but it is more than likely that Jordaens's personal circumstances played a part. It was in the 1650s that he openly declared his adherence to Calvinism, which he had probably embraced

some time previously, and his Protestant convictions were reflected in his choice of subject-matter. The Catholic authorities, who must have known of his conversion, nevertheless still offered him commissions, and he continued to paint for them altarpieces of the old type; but at the same time he painted several works on subjects of his own choice, generally related to the Old or the New Testament. Among these there is scarcely any joyful messages but rather prophecies, parables, preaching and moralising scenes, and sometimes moral maxims. The change in subject-matter led to a modification of style: it cannot be accidental that the young Jordaens expressed himself in cheerful pictorial language, while in his later Calvinist period his works are full of restraint and sobriety.

219 *The triumph of Minerva circa* 1655–60
drawing, 380 × 600mm
Belgium, private collection

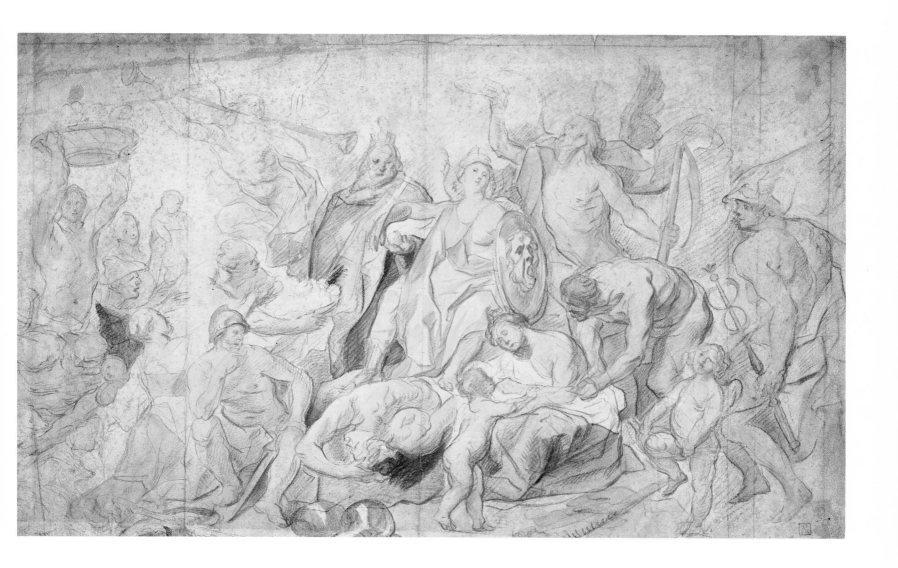

The *Adoration of the shepherds* dated *1657*, now at Raleigh, North Carolina [216],[49] was an addition to his long series of paintings of this subject. Like Jacopo Bassano, who was again the object of his admiration, he introduced many rustic types into the scene. Some parts of the picture are executed with great skill, while others are merely sketched in brown with little concern for modelling. A *Family concert* of 1658, formerly in Berlin,[50] was destroyed in 1945. Apart from these two, no dated works from the second half of the 1650s are known, but a good many more must have left the studio. Probably one of them was *Christ carrying the cross*, formerly in St Francis Xavier's (De Krijtberg) at Amsterdam [217],[51] which is based on Rubens's late treatments of the subject [218].

Numerous paintings for which Jordaens's assistants were wholly or partly responsible show that their part in the studio's output remained considerable. As Jordaens's creative powers and the quality of his work had greatly declined, it is not always easy to distinguish his painting from theirs, especially as he was liberal with his signature. Thus a picture like *Isaac blessing Jacob* at Lille,[52]

220 *Allegory of the teaching of St Augustine*
circa 1655–60
canvas, 112 × 166.5cm
Aschaffenburg, Gemäldegalerie

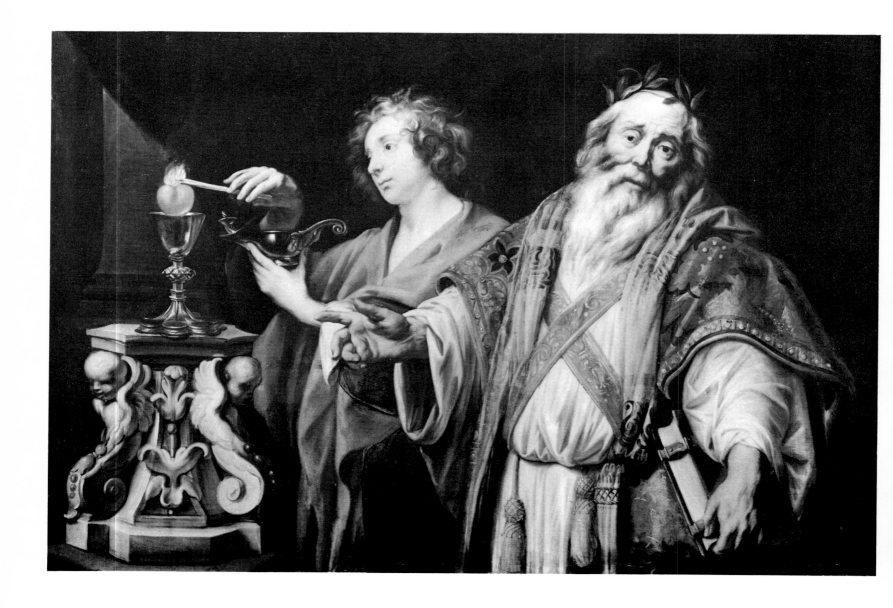

though signed and dated *1660*, is not more convincing than some others which can be regarded as typical studio products. This can be seen by comparing it with some works that were really painted by Jordaens about that time, such as *Allegory of the teaching of St Augustine* at Aschaffenburg [220][53] or the typically Protestant *Christ among the Pharisees* at Raleigh, North Carolina;[54] or again *I come to bring righteousness* (Matthew 5:20) at Lille,[55] *Be reconciled to thy brother* (Matthew 5:23–24) at Ghent,[56] and *Christ and the woman taken in adultery* (John 8:3–11), also at Ghent.[57] All these genuine works are in horizontal format.

221 *Five women in the street* inscribed *1 October 1659* drawing, 205 × 120mm Geneva, collection of Mr and Mrs H. F.

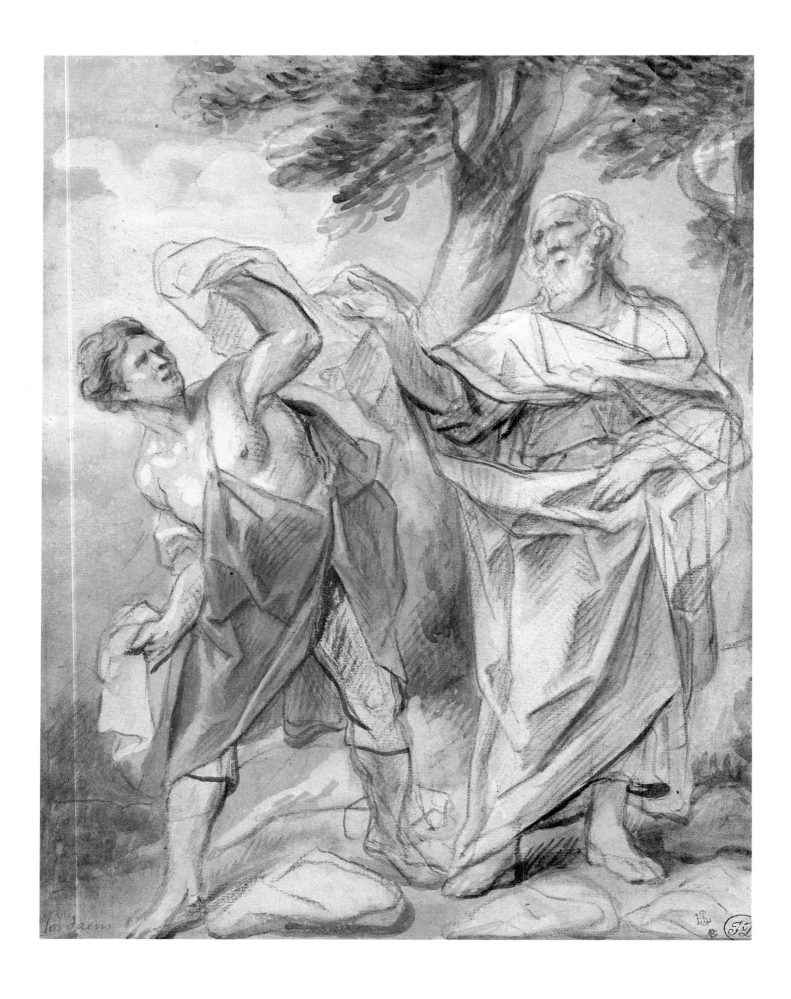

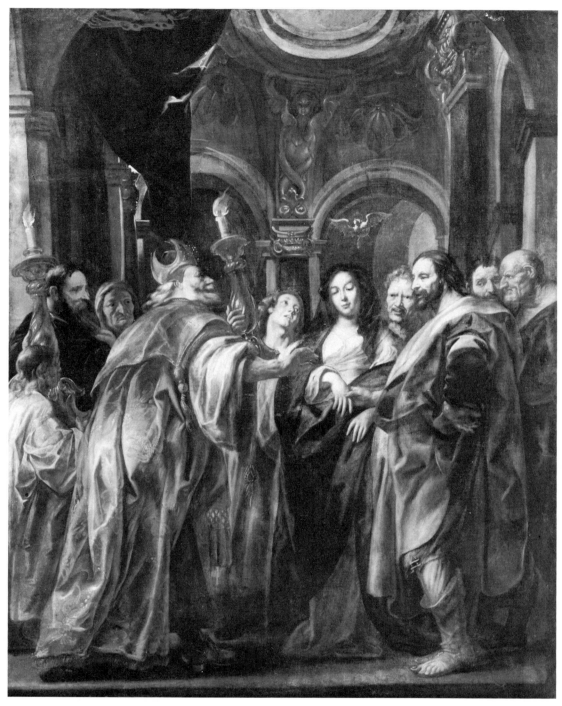

223 *The marriage of the Virgin*
circa 1660
canvas, 274 × 213cm
Brussels, Musées royaux des Beaux-Arts

222 *Jeroboam I receiving part of the garment of the prophet Ahijah*
circa 1660
drawing, 313 × 247mm
Belgium, private collection

255

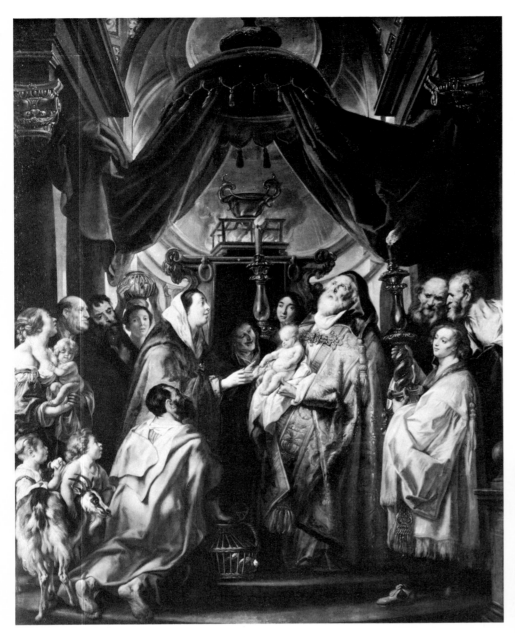

224 *The presentation in the temple*
circa 1660
canvas, 395 × 305cm
Dresden, Gemäldegalerie

225 *The vision of St Bruno*
circa 1660
canvas, 75 × 53.5cm
Destroyed 1945 (formerly in
the Kaiser Friedrich Museum,
Berlin)

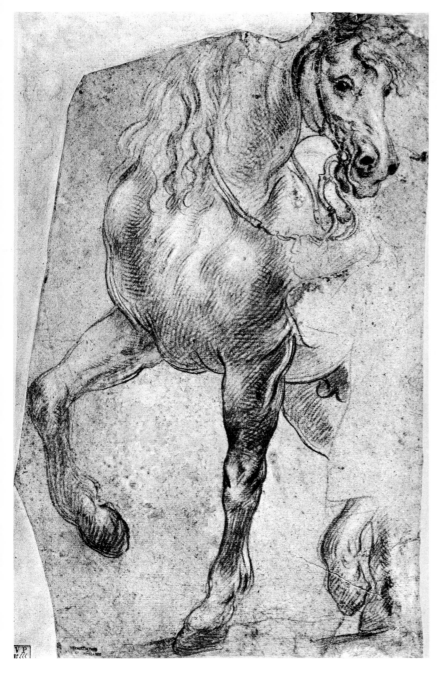

226 *Horse*
circa 1661
drawing, 340 × 258mm
Bremen, Kunsthalle

227 *Christ on the cross*
circa 1660
canvas, 479 × 280cm
Bordeaux, St Andrew's cathedral

228 *Homage to the poet*
circa 1660
drawing, 205 × 215mm
London, Duits Collection

229 *Christ among the doctors*
signed and dated *J.Jor. fec. 1663*
canvas, 429 × 330cm
Mainz, Mittelrheinisches Landesmuseum

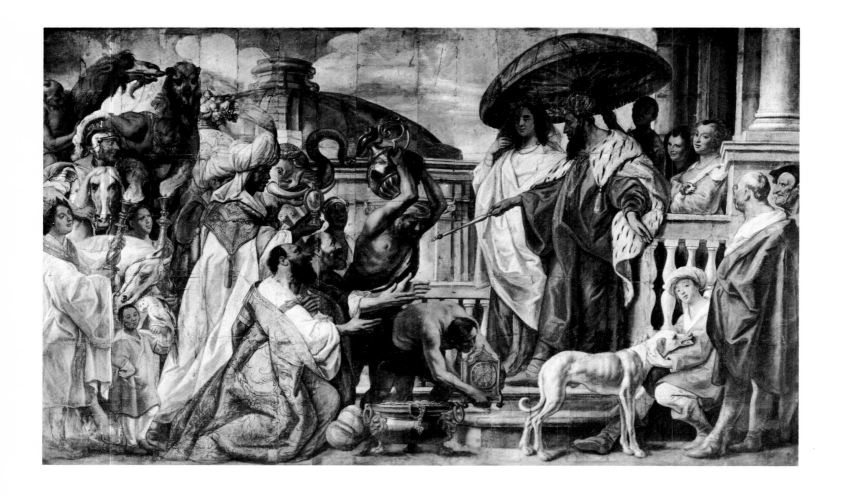

230 *The homage of Caliph Harun al-Rashid to Charlemagne*
early 1660s
cartoon, 300 × 522cm
Arras, Musée des Beaux-Arts (on loan from the Musée du
Louvre, Paris)

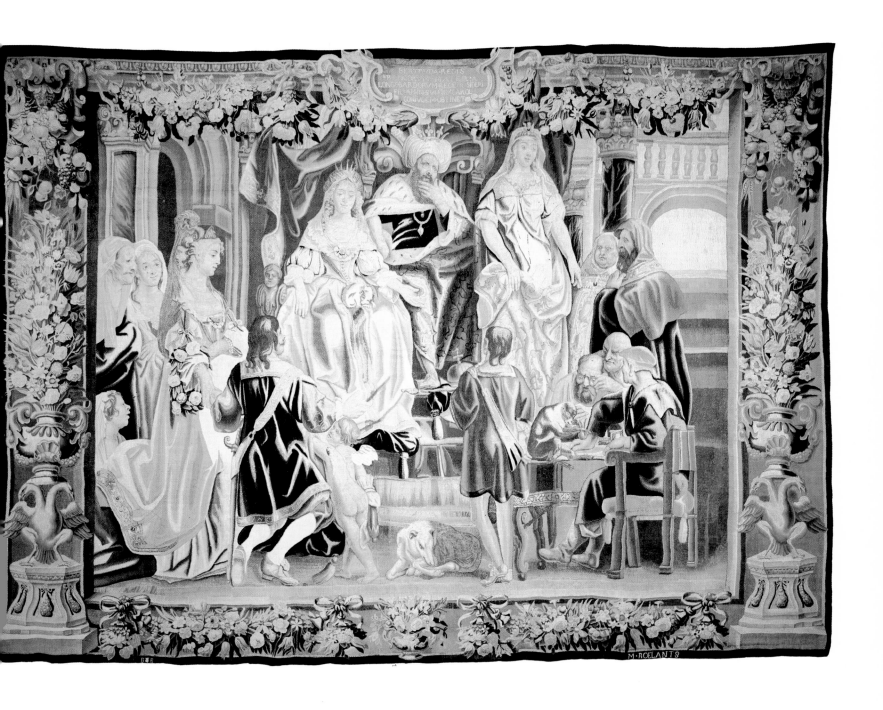

231 *Charlemagne's mother Bertrada obtains for him the hand of the daughter of the Lombard king Desiderius* (*The history of Charlemagne*)
designed early 1660s
tapestry, 371 × 482cm, woven by Matthijs Roelants, Brussels
Antwerp, Rockoxhuis

Although Jordaens's powers were visibly declining and many inferior paintings were leaving his studio, he still received important commissions. One of these was a huge *Christ on the cross* for the high altar of St Gommarus's church at Lier, where Descamps saw it in 1769. Removed by the French in 1794, it was placed in the Bordeaux museum and afterwards in the cathedral of that city [227].[58] Once again the composition is based on Rubens, who had painted many versions of *Christ on the cross* for Antwerp altars. Another *Christ on the cross* inspired by Rubens adorned the high altar of the Oratorian church at Mons in the eighteenth century and is now in Tournai cathedral;[59] an oil sketch for it is in a private collection in New York.[60] Other sketches, like *The resurrection* at Ghent[61] and *The vision of St Bruno*, formerly in Berlin [225],[62] were probably also connected with altarpieces, which are not known. The sketch at Ghent is, so to speak, a paraphrase of Rubens's *Resurrection* in Antwerp cathedral.[63]

Some of these altarpieces, painted about 1660, show that the master was still capable of expressive work: for instance *The presentation in the temple* at Dresden [224],[64] based on Pontius's engraving[65] after the right-hand panel of Rubens's *Descent from the cross* in Antwerp cathedral. The general composition and the group formed by the principal figures follow the model almost literally, but Rubens's heroic style is transformed into something relaxed and familiar. A smaller and perhaps somewhat earlier *Presentation* is at Greenville, North Carolina.[66] More solemn in character is *The marriage of the Virgin* at Brussels [223],[67] owing chiefly to the monumental figures in the foreground with their contemplative air. As far as size is concerned, the most impressive of these works is *Christ among the doctors*, 1663, painted for the high altar of St Walburga's at Veurne and removed by the French in 1791; Napoleon presented it to the museum at Mainz, where it still is [229].[68] Veurne (Furnes) is in Western Flanders not far from Dixmude: in 1644 Jordaens had painted an *Adoration of the Magi* for the latter place, and the new commission may have been due to admiration for the earlier work. However, about twenty years had passed and the later picture cannot bear comparison with its predecessor. Instead of bright tones and sunny illumination there is a sombre colour-scheme lacking in freshness; moreover the Baroque composition is replaced by a symmetrical arrangement inspired by Maarten de Vos. The work certainly has decorative qualities, but the execution is somewhat careless. Moreover, while some of the heads show masterly powers of characterisation, others are disturbingly crude and savour of caricature. The same composition in horizontal form is found in a second version of *Christ among the doctors* at Munich,[69] executed with help from the studio.

Apart from the large altarpieces painted for Catholic churches in Jordaens's later years, he received commissions from official bodies in Protestant Holland, including decorations for the town hall of Amsterdam and the Landhuis at Hulst. Of the four works ordered by the burgomasters of Amsterdam, three are still *in situ*: *Samson routing the Philistines* (Judges 15:15)[70] and two scenes of the Batavian rebellion against Rome, *Gaius Julius Civilis attacking the Roman camp by night*[71] and *The peace between Gaius Julius Civilis and the Roman leader Cerialis*.[72] Not much good can be said of these works, painted in 1661: they are sombre, overloaded and confused, and are probably mostly the work of the studio. A *David and Goliath*,[73] commissioned at the end of 1664, is lost.

The three paintings which still decorate the mantelpiece of the great hall, formerly the court of justice, in the Landhuis at Hulst form a simple ensemble. The large picture in the centre shows Justice as a young woman pointing to the table of the law, on which can be read *Deut. 1.v.16* followed by the text 'Hear the

causes between your brethren, and judge righteously between every man and his brother, and the stranger that is with him'. Next to Justice are Moses and Aaron, and a naked woman with a mirror, representing Veritas. Behind this group is an angel with a pair of scales and a sword, the attributes of Justice, and Fortitudo (Courage), a woman in armour embracing a column. A tame-looking lion, symbolising power, slumbers at Justice's feet. The decoration to the left of the mantelpiece consists of five putti: one of these, behind a shield with a Medusa head and lit by a torch, is using a rod to drive away two others, holding a mask and a sceptre. Below is an inscription reading 'The Lord abhors all who are blood-thirsty and deceivers, he punishes all the unrighteous', followed by the reference *Sap. 5.v.7*. The canvas on the right shows only two putti, one holding scales and a measuring-rod, the other with a sword, crown and sceptre. Here the inscription reads 'Two measurements and two [swords] are an abomination to the Lord, yea both of them'.[74] This heavily allegorical ensemble dates from 1663; with its loose modelling and monotonous colouring, it is of no great aesthetic value.

The subject of Justice was so successful, however, that Jordaens repeated it several times, as for example in a painting of 1663 which was in the court of justice at The Hague when it was destroyed in 1945.[75] A third picture of *Justice*, sometimes called *Human law founded on divine law*,[76] belonged to a group of three paintings which Jordaens presented to the chamber of the guild of St Luke in 1665 to celebrate the foundation of the Antwerp Academy. It is now in the Antwerp museum along with the other two works, which together form an *Homage to the poet*:[77] this shows the poet receiving from a Muse a draught of hippocrene, the sacred fount which gushed from Mount Helicon when the winged horse Pegasus stamped the ground with his hoof. A personification of Painting witnesses the scene together with Apollo, Mercury and some other Muses. The *Homage to the poet* decorated the ceiling of the chamber together with *Antwerp, nurse of painters* by Boeyermans.[78] Jordaens's colleagues showed their appreciation with a costly present and some verses which were recited in his honour, but their admiration was probably aroused by his past achievements rather than the works with which he had endowed the chamber. Indeed, anyone recalling the luxuriant and monumental work of the first half of his career can only be amazed at the falling-off of his creative powers.

Jordaens went on painting until an advanced age, no doubt with ever-increasing help from the studio. He also remained active in the field of tapestry: in the early 1660s he designed the cartoons for a *History of Charlemagne* [230, 231]. The last pictures of which the chronology is certain are dated *1669* and are in St Joseph's chapel of Seville cathedral: a *Circumcision*[79] and an *Adoration of the Magi*,[80] of equal size. These dull and sombre works, composed of motifs already repeated *ad nauseam*, form a melancholy conclusion to the career of an artist whose talent was once so rich but whose personality appears in the end to have regressed instead of developing.

VIII

Jordaens the portrait-painter

Although art critics from the fifteenth to the seventeenth century agreed in maintaining that religious, historical and mythological subjects were more important than portraits, there probably was and still is no other form of art that so directly and perfectly expresses the moods and aspects of human nature. Besides portraying the outward appearance of his subject, the artist is able to express the most profound impulses of the human soul and the mysterious background of our common humanity. Thus a portrait, by definition, is the result of two aims that are in a sense diametrically opposed to each other, namely individuality and universality. It sets out, in the first place, to show in what way the model differs from other human beings, and even from himself at a different time or in different circumstances: this is what distinguishes a portrait from an 'ideal figure' or a 'type'. On the other hand, it also aims to show what the model has in common with his fellow-men and what elements are part of his character irrespective of time and place: in this way a portrait differs from a figure in a genre or narrative painting. Thus, for instance, the greybeard in Jordaens's *As the old sang, so the young pipe* at Antwerp [137] is immediately recognisable as Adam van Noort, but it is a genre painting rather than a true portrait, because the old man is completely absorbed by a specific activity: the picture presents him as an individual, but it does not present a human being in his totality.

If carried to extremes, the two criteria would cancel each other out: a unique personality would be reduced to an infinite number of individual peculiarities and would thus cease to be a completely human being, while if the artist showed nothing but universal human traits the portrait would cease to be that of an individual. Thus every portrait-painter is obliged to strike a balance between the two requirements, and the way in which he does so will depend on his period and circumstances and, of course, his personal taste. Very broadly it may be said that in the fifteenth century the individual aspect was stressed, with the result that portraits tended to be descriptive and static: the sitter became a self-contained entity, showing little of his inner life and, as it were, having no history. The High Renaissance and Baroque periods, on the other hand, emphasised totality and consequently an interpretive, dynamic approach: the subject was portrayed as a representative of mankind in general, full of vital energy and functionally determined by his relation to others and by his own past.[1] Jordaens's portraits belong to this category: he seeks to render not only the external and personal appearance of his sitters, but above all their quality as human beings. As if they felt the need to make themselves known, they face the spectator directly and sometimes even with a challenging air.

In any period, the style of portrait-painting is influenced by national culture and by the evolution of ideas concerning significance, form and beauty. Each generation has its own image of humanity; each social class has its own physical type, its own style of dressing, its own gestures and bodily movements.

Jordaens's portraits depict members of his family or his immediate circle, the Antwerp bourgeoisie. Rubens and Van Dyck painted members of this class, but their subjects also included reigning princes and the high aristocracy, who were outside Jordaens's range. His temperament led him to confine himself to his own milieu: he lacked Rubens's power to elevate his models to a higher level than that of the everyday and to give them the dignity necessary for a good ceremonial portrait, nor did he have Van Dyck's gift for discovering and emphasising all the charm and beauty that a particular model might possess.

A portrait-painter is also affected by the personal wishes of his subject, which are mostly not of an artistic kind but may influence the content and form of the work. The sitter who has commissioned the portrait is usually critical of the result, and this type of art is consequently more liable than others to be the occasion of a dispute. The subject wants to make as good an impression as possible, and expects the portrait to show him at his best. This sometimes leads the painter to gloss over less favourable aspects, as Jordaens did from time to time. The artistic theories of the seventeenth century were also designed to give some satisfaction to the sitter's natural *amour propre*.

Carel van Mander (1548–1606), who had spent some years in Italy, returned home with different artistic ideas including the dogma first formulated by Vasari (1511–74) that portrait-painting was an inferior form of art. In the *Schilder-Boeck* (1604) he repeatedly expressed pity for artists who had to make a living in this way. He agreed that it was important to study nature, but, along with other critics of the Renaissance and Mannerist period, he contended that the artist's duty was not to conform slavishly to reality but to improve it according to the idea of perfection formed in his own imagination. As portraits were more closely bound to nature than other works, Van Mander took a disparaging view of them. Nevertheless, shortly after his death the art of portrait-painting achieved great heights in both the Southern and the Northern Netherlands. Van Mander's own best pupil, Frans Hals, specialised in this field and became one of the greatest portraitists of all time. The art developed differently, however, in the two countries. Whereas Northern artists kept as close as possible to reality in their portraits as in genre, landscapes and still lives, the South to a large extent remained faithful to the Renaissance ideal of beauty and elegance. In portraiture this led to a softening of realism and often to a breadth of treatment which favoured the sitter's desire to be seen in a flattering light.

By comparison with Jordaens's output in other categories, relatively few portraits of his have survived. Some of these are portraits of himself, either alone or with relatives; he also painted kinsfolk by themselves, some of them more than once. Other portraits are of bourgeois worthies who wished to be immortalised with their wives or fiancées, or by themselves. He did not paint crowned heads or the nobility, nor members of the clergy, eminent artists or men of letters, such as used to commission imposing portraits of themselves from other Flemish artists. Furthermore, none of his known portraits are of religious donors.

Whether for reasons of vanity or of family affection, the bourgeoisie commissioned portraits to adorn their own dwellings. These did not provide the best conditions for preserving the paintings, many of which have been lost in the

course of time. They lacked the protection enjoyed by royal or ecclesiastical collections: some were preserved by family pride, but many were banished from living-room to attic when later generations began to forget who the subjects were. Variation in taste was probably a still more important factor in deciding whether or not they survived; in the eighteenth century they proved quite unsuitable for the new type of domestic interior, and thus many disappeared.

Jordaens's style as a portraitist evolved in the same way as in his other compositions. The similarity, however, was not entirely a matter of course. During the last quarter of the sixteenth and at the beginning of the seventeenth century, the Flemish masters, especially those of Antwerp, took a different view. From the time of Frans Floris (d 1570) their art in general had been more and more influenced by the Italians, but in portraiture they held to the national tradition and concentrated on the loving reproduction of reality. Rubens's return from Italy in 1608 brought a radical change: in every genre his unique personality effected a synthesis between the North European and the Italian style, and from then onwards Flemish artists expressed themselves in portraiture in the same manner as in their other works.

Two group portraits of about 1615–16, at Leningrad and Kassel respectively, are generally regarded as Jordaens's earliest works of this kind and they are noteworthy for both their quality and their iconography. The first[2] shows Jordaens with his parents, sisters and brothers, all gathered round a table [232]. Jordaens père sits facing out with a glass in his hand, while on the nearer side are his wife with a child on her lap and the painter, with a lute on his knee, looking towards the spectator. The mother is surrounded by children of various ages, and a maid comes forward with a dish of fruit. Altogether there are eight children including Jacob himself. Documents show that the couple had in fact had eleven before this date, but three had died. As J. S. Held pointed out,[3] they are represented in the painting by cherubs hovering in the air, one of whom points up to heaven while another extends a hand over the living members of the family to bless and protect them. Two girls on the far side of the table gaze up at the cherubs with an attentive and loving expression.

This fashion of depicting lost children may seem strange to present-day attitudes but was quite usual in the seventeenth century, the cherubs representing the souls of the departed. People who took the after-life for granted and firmly believed that their children were in heaven found it a natural expression of piety and parental love. The baptismal registers show that a daughter Anna was born to the Jordaens family in 1595; in 1597 another infant was baptised with the same name, showing that the first had died. In the same way, and in accordance with normal practice at the time, their daughter Elizabeth, born in 1613, was named after her sister who had died in 1605. The third cherub probably represents another daughter named Susanna, born in 1610, of whom nothing more is heard.

The group portrait at Kassel[4] shows Jordaens, again with his lute on his knee, in the company of his wife Catharina van Noort, her parents, her younger sisters Anna and Elizabeth and her brothers Jan, Adam and Martinus [233]. To judge by its style and the apparent ages of the children, this work can also be dated about 1615–16. As Catharina's family are presenting her with flowers, the occasion is evidently the young couple's betrothal or their marriage on 15 May 1616.

232 *Portrait of the Jordaens family*
circa 1615–16
canvas, 178 × 138cm
Leningrad, Hermitage

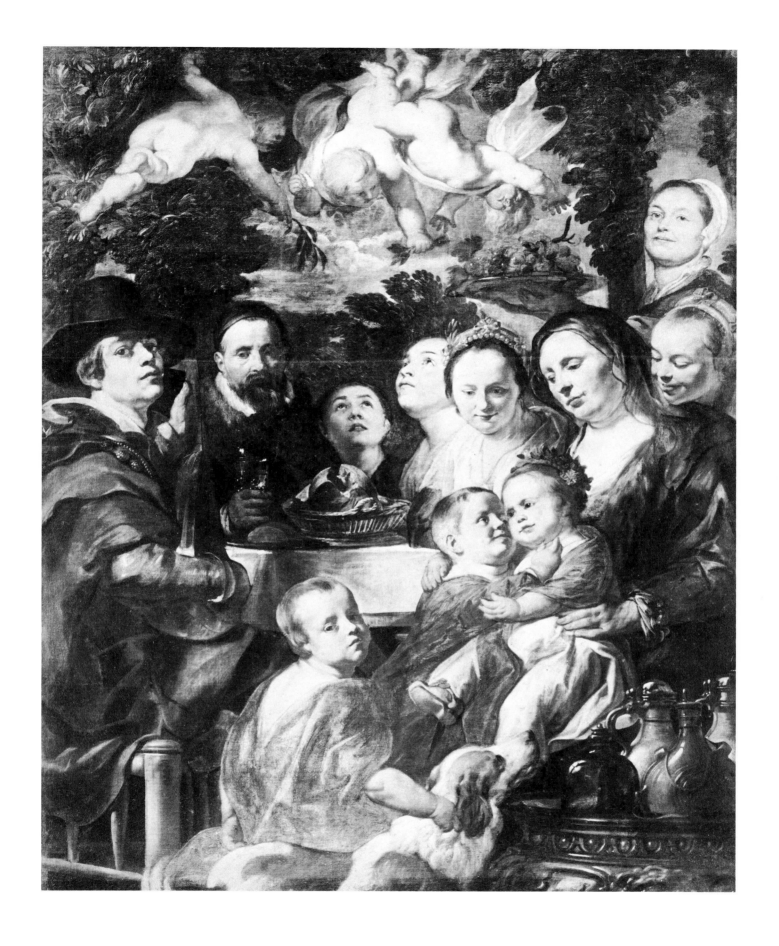

233 *Jordaens with the*
Van Noort family
circa 1615–16
canvas, 114 × 146.5cm
Kassel, Staatliche
Gemäldegalerie

A portrait of 1621–22 at Madrid[5] shows the Jordaenses with their first child
[234]. Catharina, seated on a chair, is easily recognised by her slit-eyes, pro-
minent nose and broad lower lip. At her side is the mischievous-looking Eliz-
abeth, aged three or four, whom her father was so often to use as a model.
Somewhat behind them, as behoved a servant, stands a maid holding a basket of
fruit. All four of them are looking at the spectator as if to draw him into their
company. The painting is full of charm and spirit, thanks to the dignity of the
figures and its pictorial qualities: the composition is well balanced, the colours
lively, the brushwork rhythmic and assured.

This picture is not simply a group portrait and a representation of daily life,
but had a symbolic meaning in terms of contemporary ideas. To the modern eye,
the subject of a work of art is of minor importance: in the spirit of 'art for art's
sake', attention is concentrated on the execution. In Jordaens's day, however,

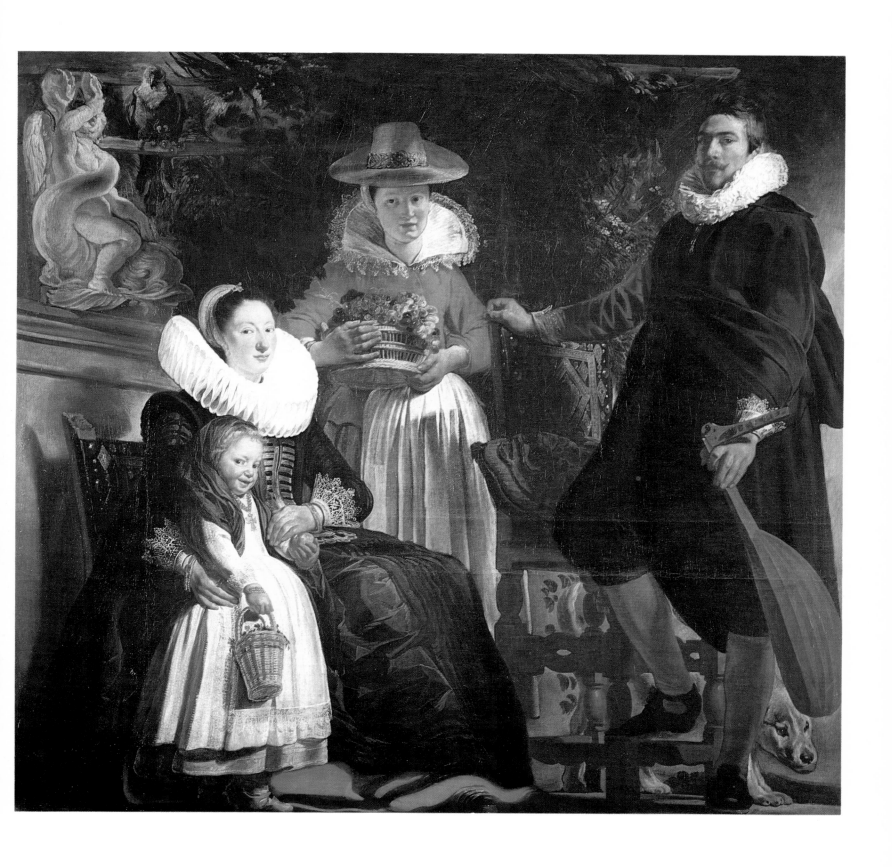

234 *Portrait of the Jordaens family*
circa 1621–22
canvas, 181 × 187cm
Madrid, Prado

the essential feature was the scene depicted, including allegorical elements which might be either on the surface or understood. A painting like this portrait shows a complete interaction between reality and allegory, or in Panofsky's terms 'disguised symbolism'. It is natural for the present-day spectator to fail to recognise this duality, or to discern at first glance that the picture is also intended to symbolise wedded bliss and to extol the virtues of love and fidelity in marriage.

By depicting himself and his family in a garden, Jordaens upholds the long tradition of the medieval *jardin d'amour*, the sojourn of Venus, which continued into the eighteenth century with Watteau's *conversations galantes*. The theme is a frequent one in the Netherlands and especially in the South, where Rubens was to bring it to a dazzling apotheosis. Jordaens and his wife stand beside a fountain, against a background of intertwined greenery symbolising the inseparability of man and wife: this is found again in Rubens's *Self-portrait with Isabella Brant* at Munich (1609–10) and Frans Hals's *Portrait of Isaac Massa and his wife Beatrix van der Laen* at Amsterdam (1622). The fountain was a common feature in the *jardin d'amour*, symbolising the fount of love. Here it is in the form of Cupid and a dolphin: Cupid was the son of Venus, who was born of the sea-foam. On a perch beside the fountain is a parrot. This bird was sometimes taken to represent sensuality, but was especially associated with eloquence. Various seventeenth-century authors, including Jacob Cats, used it to proclaim their moral maxims; in this picture it probably serves to extol the happiness of true love.

Here, as in the Leningrad and Kassel portraits, Jordaens is holding a lute. Quite possibly he was musical and was fond of playing this instrument,[6] but the lute is a frequent symbol in paintings of amorous themes: 'Amor docet musicam'. In poetry the lover himself might be identified with it, as the instrument whose strings were played on by a woman's love. Thus it may well be symbolic here, and the same applies to the apple held by little Elizabeth: by reason of its beauty and taste, this fruit is an ancient symbol of love. Finally, married love is based on trust; this virtue is traditionally represented by a dog, the faithful and vigilant animal *par excellence*, and there is one in this picture, though he is partially concealed behind his master.

All symbolism crystallises around the great antitheses of human life – birth and death, light and darkness, good and evil – and thus in the last analysis points to another world beyond the present one. The lower calls to mind the higher, each fragment suggests the whole, and the transitory is no more than a figure of the eternal. The foliage and the fountain, Cupid and the parrot, the lute and the dog – all these, with their symbolic meaning, prompted the seventeenth-century spectator to look beyond everyday reality to a world of deeper and more important values.

The *Portrait of a young couple* at Boston, Massachusetts [235][7] resembles the portrait of Jordaens and his family at Madrid as far as costumes and style are concerned, and was painted about the same time. The richly dressed pair look out at the viewer; a vine clings tenaciously to the architecture behind them. As in contemporary literature, the vine symbolises the steadfast love and loyalty required for a successful marriage. Also of about the same date is the *Portrait of a young gentleman* in the Uffizi at Florence.[8] The model, as yet unidentified, holds a book, presumably indicating that he is a scholar. This forceful, engaging figure, whose pose is somewhat reminiscent of portraits by Frans Hals, was afterwards reworked and overpainted by Jordaens himself. He left the head and

235 *Portrait of a young couple*
circa 1621–22
panel, 122 × 92.6cm
Boston, Museum of Fine Arts
(Robert Dawson Evans
Collection)

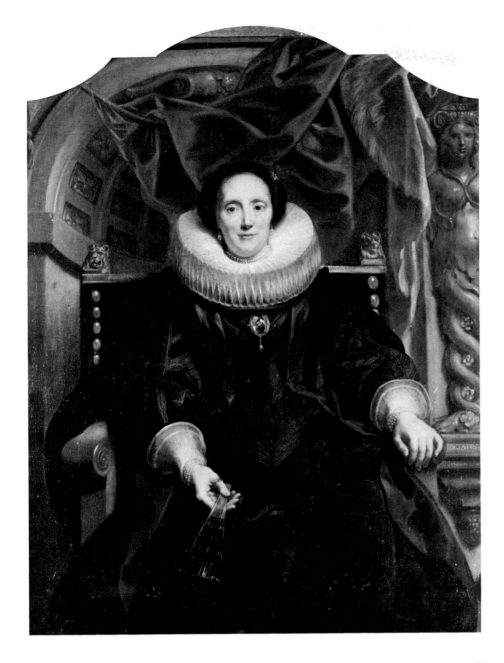

moustache and an imperial; he wears a black costume with a flat white collar and white cuffs, and a cloak thrown over it; in his left hand he holds a broad-brimmed felt hat. He is depicted against a Baroque background consisting of an open arch with blue sky beyond, a red curtain and a herm against a pilaster. Beneath this herm, the verticality of which emphasises Le Witer's stature, is the inscription *AETATIS. 44, 1635,* indicating the date of the portrait and the sitter's age. However, there is another date on the painting: the collection-bowl lying on a table is inscribed *A° 1623,* in which year Le Witer became the city almoner of Antwerp.[10] He was also a churchwarden of the cathedral, and is named as such on three bells belonging to the carillon, one cast in 1654 and the other two in 1655.[11] He died on 4 October 1678 and was buried in the church beside his wife.[12]

The younger of the two women is Le Witer's wife, Catharina Behagel [237]. Seated in a heavy oak armchair, she gazes benignly at the spectator. Her whole

237 *Portrait of Catharina Behagel, wife of Rogier Le Witer*
1635
canvas, 152 × 118cm
Vorselaar, Baron R. de Borrekens Collection

238 *Portrait of Madeleine de Cuyper*
probably 1635
canvas, 152 × 118cm
Vorselaar, Baron R. de Borrekens Collection

aspect is that of a dignified *bourgeoise*; her social status is attested by the black silk dress with its white pleated collar and cuffs and the many jewels, including pearls round her neck and arms, earrings and a locket on her breast. The décor is similar to that of her husband's portrait, including a niche with a coffered ceiling, partly hidden by a red curtain, and a female herm. Her age is shown by the inscription *AETATIS. 38* at the foot of the herm, and the painting is signed *J. Jordaens fecit 1635*. Catharina died at Antwerp on 18 July 1666 and was buried in the cathedral.[13]

The third portrait is of Rogier's mother, Madeleine de Cuyper, who is also seated in an armchair and is dressed somewhat severely in black [238]. Her white goffered collar and cuffs are of modest dimensions, and she wears no jewels. A small black widow's cap covers the back of her head and projects over her forehead in a U-shape; the fact that she is a widow is emphasised by the herm in

239 *Portrait of Catharina Behagel, wife of Rogier Le Witer*
1635, or shortly before
drawing, 292 × 197mm
Paris, Institut Neérlandais, Custodia Foundation (F. Lugt
Collection)

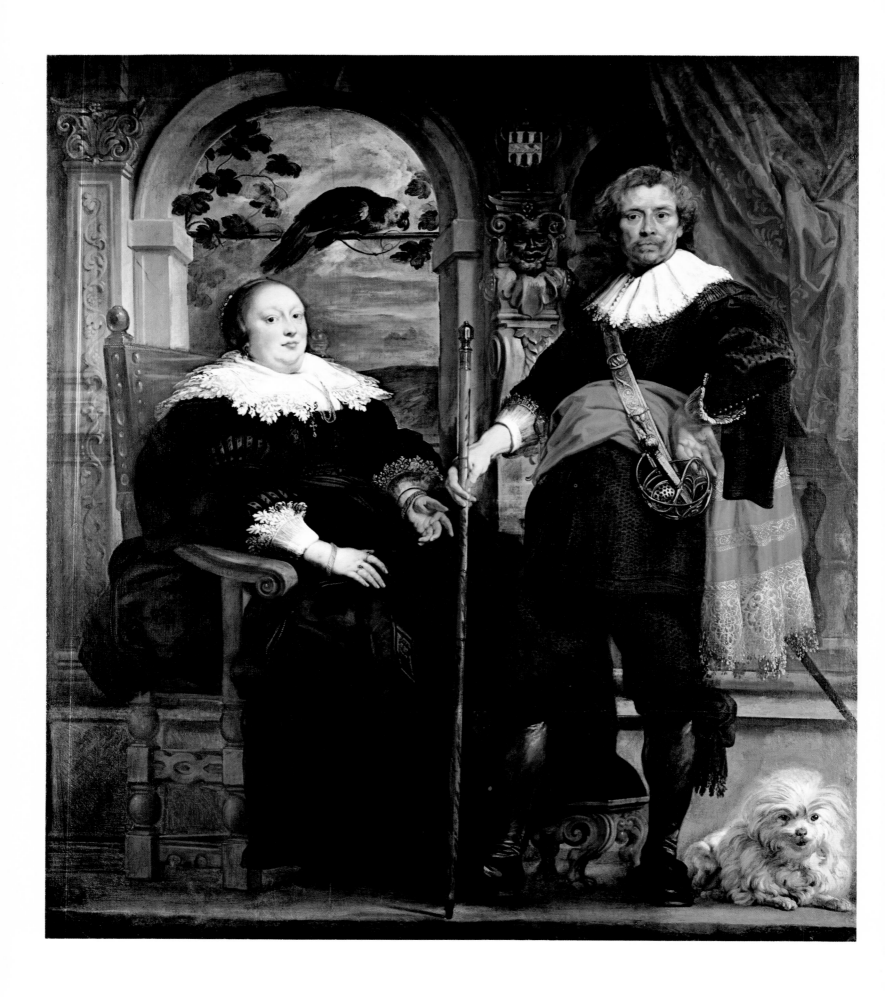

profile in the background, in the form of an old woman whose garment is thrown over her head as a sign of mourning. The symbolism is accentuated still further by a vase in a niche in which a tulip is growing. The tulip especially, and flowers in general, were a symbol of mortality, recalling Job's words (14:1–2): 'Man that is born of a woman is of few days . . . He cometh forth like a flower, and is cut down'. The old lady is approaching the end of her days, living on memories and placing her hope in the hereafter. Her piety is evinced by the prayer-book she holds, and she had given proof of it in about 1617 when she presented one of Jordaens's earliest works, a *Christ on the cross* [45] to St Paul's church at Antwerp. Although the portrait of Madeleine de Cuyper is not dated, it may be presumed to have been commissioned and painted at the same time as those of her son and daughter-in-law. It is not impossible that the three portraits were meant to form an ensemble, but this would be unusual, and it is perhaps safer to regard those of Le Witer and his wife as forming a pair, and that of his mother as an independent work.

Companion portraits of spouses were common in the seventeenth century, in both Southern and Northern Netherlands: Rubens and Van Dyck painted them, as did Rembrandt and Hals. Although the status of women improved considerably during the century, men continued to take precedence and, in accordance with the laws of heraldry, wives were placed on the left of their husbands: this was not an absolute rule, but was not often broken.

Pairs of portraits like the Le Witers's, showing the husband standing and the wife sitting, were frequent at Antwerp in the early seventeenth century. As in many other fields, Rubens led the way: a good example is furnished by his portraits of the archduke Albert and the infanta Isabella, painted in 1609 and now at Vienna.[14] The genre is most usual, however, with Van Dyck, who specialised in portraits more than Rubens, and who painted Antwerp bourgeois couples in this fashion, life-size, before he left for Italy in 1621. Among such works is his fine double portrait of the painter Frans Snijders and his wife Margareta de Vos.[15] Jordaens's pendent portraits are very similar in composition to Van Dyck's; it appears that they date only from the 1630s, so that it is easy to see which artist learnt from the other.

The style of Van Dyck's portraits certainly had a great attraction for Jordaens and spurred him to emulation. However, a comparison shows that he endowed his models with quite different qualities. Whereas Van Dyck's subjects are natural, relaxed and full of refined grace, Jordaens's express mental and physical power, human warmth and innate dignity. Le Witer is presented as a man of absolute integrity, conscious of his rank and responsibilities; his wife, full of self-assurance, meets the viewer's gaze frankly and proudly, while his aged mother has evidently withdrawn into herself, purified by experience and resigned to destiny.

Two drawings, one of Le Witer in the Uffizi at Florence[16] and the other of Catharina Behagel in the Institut Néerlandais in Paris [239],[17] give an idea of the way in which Jordaens prepared his portraits. Both already contain all the essential elements of the paintings, but this does not mean that no changes were introduced. For instance, the background in the portrait of Le Witer was made more spacious and monumental, while the sitter's head was accentuated by being placed more against the background of the sky. The heads of both spouses were made less round and heavy-looking, while Le Witer's hair was made longer and more elegantly arranged, an instance of Jordaens's anxiety to meet his clients' wishes.

240 *Double portrait*
1636–39
canvas, 213 × 188cm
London, National Gallery

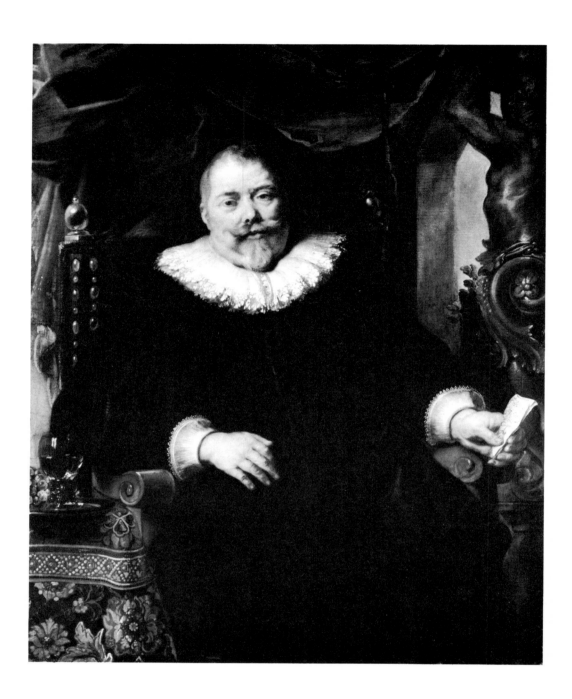

241 *Portrait of Johan Wierts*
circa 1635
canvas, 134.5 × 108.5cm
Cologne, Wallraf-Richartz
Museum

Two portraits, now in the Wallraf-Richartz Museum at Cologne,[18] depict Johan Wierts and his wife, a couple who belonged to Jordaens's immediate circle [241, 242]. The paintings were acquired together by the museum in 1877 and had probably never been separated. The merchant Wierts and his wife were another distinguished bourgeois couple, blessed with fortune and good health; they are both seen wearing black, with white collar and cuffs. He is identified by a document in his hand which reads: 'Eersamen / dischreten / S Joha[n] / weerts / Coopman / Tott / Ant[werpen]'. His wife's maiden name is not known. Wierts was on good terms with Jordaens and testified in his favour when he brought a lawsuit in 1641 against the executors of the Abbé Scaglia, who refused to pay for *The story of Psyche* which Scaglia had ordered and which was incomplete at the time of his death (*see* p 26). In a formal statement of 27 February 1642 Wierts declared that he was 'an importer of Rhenish wines, domiciled in the Stoofstraat

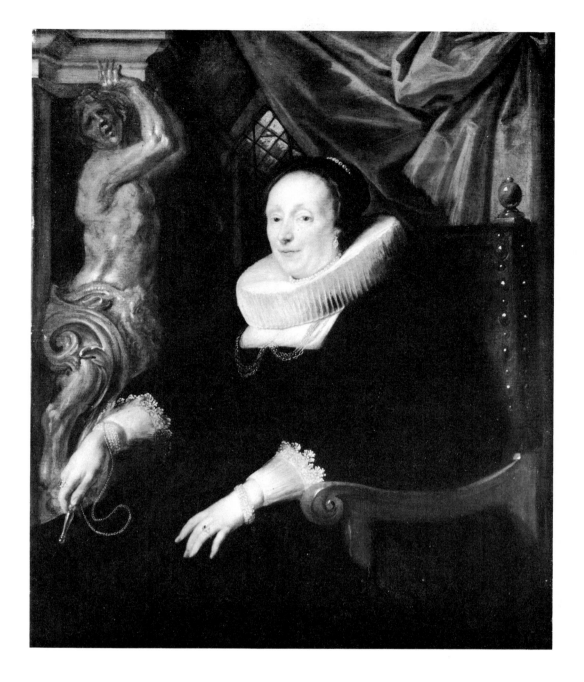

at Antwerp, aged about 55 and on familiar terms with Jordaens, whom he often visited to admire his paintings'.[19] These details throw additional light on the pair of portraits: for instance, it is now clear why Wierts has beside him a large wine glass and a bunch of grapes. From his statement it can be construed that his date of birth would have been about 1587, and further information as to the chronology is afforded by inscriptions on the pedestal of the herm placed at his side: these, although damaged by the folding of the canvas over the stretcher, can be read as *AETATIS 4.* and, underneath, *163*. If Wierts was born about 1587 and in his forties, he must have sat for his portrait between about 1627 and 1636. Combining this deduction with the date *163.*, the portrait could have been executed between 1630 and 1636; the same would apply to that of his wife, which is stylistically similar. In 1890, when the inscription was perhaps less damaged, Rooses read it as *AETATIS 48*;[20] if this can be trusted the more

242 *Portrait of Johan Wierts's wife*
circa 1635
canvas, 134.5 × 108.5cm
Cologne, Wallraf-Richartz Museum

precise date of *circa* 1635, which is quite compatible with the style and costume, seems preferable.

Wierts's statement that he was on 'familiar' terms with Jordaens goes to confirm Rooses's supposition[21] that he was the father of Jordaens's son-in-law; the latter, Johan II Wierts, who married Anna Catharina Jordaens, was a Jansenist and member of the Council of Brabant at The Hague.

Wierts and his wife are depicted in the same kind of luxurious surroundings as the Le Witers, if not more so. They are both in armchairs, facing each other, and thus appear less separate than the Le Witers, where the husband is standing and the wife sitting. The Wiertses are seen as a true couple who have experienced the vicissitudes of life together for many years. To emphasise their married bliss still further Jordaens has included an ivy plant, signifying constant love and conjugal fidelity.

A *Portrait of a man in an armchair* sold in London in 1970[22] is similar in style and costume to that of Wierts and can be assigned to the same period. The subject is unknown, but the ink-stand and collection of papers suggest that it is a scholar or perhaps a high official, in view of the stately effect of the ample cloak thrown over his shoulder and the gloves held in his hand. Possibly there was once a female counterpart to this portrait.

In 1958 the National Gallery in London, which had been rather poor in works by Jordaens, acquired a remarkable *Double portrait* [240][23] ceded to the nation by the eleventh duke of Devonshire in lieu of death duties. This shows a richly dressed couple in front of a décor consisting of two arches, one giving a view of the open air. The wife, a corpulent figure with a round head and short neck, sits in a wide armchair with a red velvet back. Her richly embroidered black silk dress has a broad flat collar and bell-shaped cuffs; she wears many jewels, including a small cross. Looking out of the painting, she seems with her left hand to point towards her husband, who stands squarely with legs apart on the right-hand side of the picture, also gazing at the spectator. He is clearly a person of importance, as is shown not least by his clothing: a black doublet with a soft white pleated collar and a broad red sash. He holds a staff of office in his right hand, and by his side is a two-handed sword slung from an ornate baldric. As usual, symbolism plays an important part. The lively white lapdog at his master's feet represents marital fidelity and constancy, as do the parrot and the vine-tendrils seen against the outdoor light.

The identity of this imposing pair is not certain, but it is usually supposed that they are Govaert van Surpele (1593–1674) and his wife. This identification rests almost entirely on a coat of arms on the centre pier, recognised by Hymans as that of the Van Surpele family from the Brabant town of Diest. Although this is probably not by Jordaens it dates from the seventeenth century, and it may be presumed that it was not added without authority. Taking account of the period to which the painting belongs, the most likely member of the family seems to be Govaert, who was an important figure in the government of his native town: he was *échevin* (alderman) from 1629 to 1632, burgomaster in 1634–35, 1649–50 and 1651–52, and *président de la loi* in 1636–37. The staff identifies him as a man in authority, and the baldric and sword suggest a military office. In many ways his accoutrements recall those in Hals's militia pieces, as for example Colonel Johan Claesz Loo in *Officers and sergeants of the St Hadrian civic guard company, circa* 1633.[24] In any case there were three civic militia companies at Diest: St George's guild (crossbowmen), St Barbara's (arquebusiers) and St Sebastian's (longbowmen); however, by the seventeenth century these had largely lost their

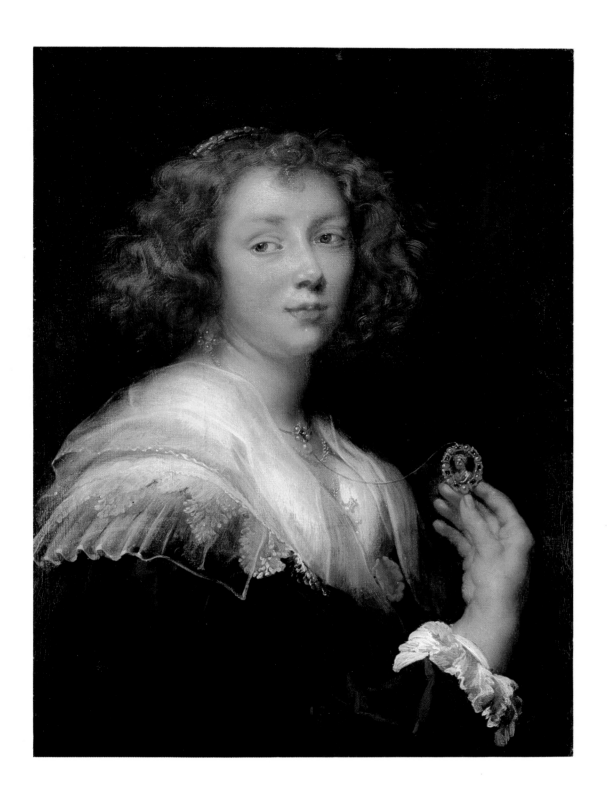

243 *Portrait of a lady*
circa 1637
canvas, 74 × 55cm
Vienna, Akademie der bildenden Künste

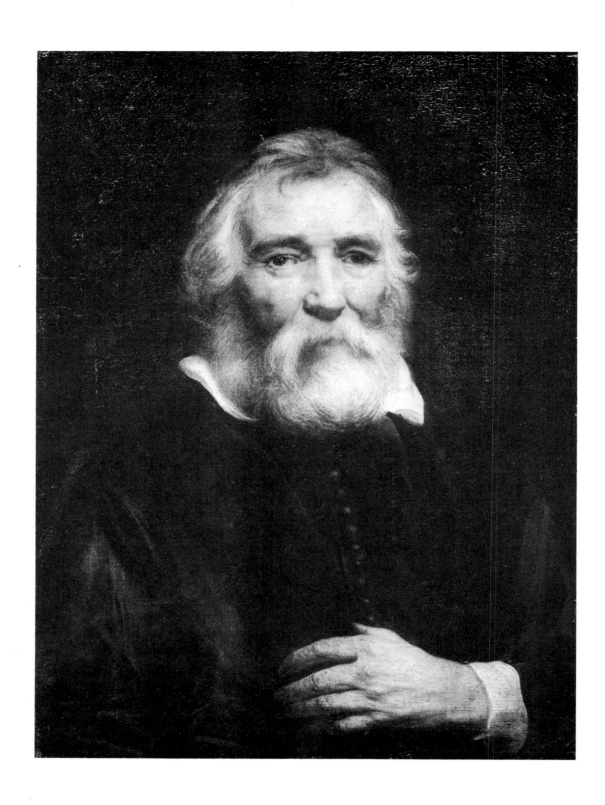

244 *Portrait of Adam van Noort*
circa 1640
canvas, 74.5 × 55.5cm
Destroyed 1945 (formerly in the Kaiser Friedrich Museum,
Berlin)

true military character. It is not known to which of them Van Surpele belonged, but he is more likely to have been a member of the first or second, for which the subscriptions were fairly high, than the more modest St Sebastian's guild.

Van Surpele was twice married: first, in 1614, to Catharina Cools, who died in 1629, and then, in 1636, to Catharina Coninckx, who died only three years later. All the stylistic evidence indicates that the portrait was painted in the later 1630s;[25] it is therefore fair to assume that the stout lady is Catharina Coninckx, and that the work dates from between 1636 and 1639.

In portraits like those of the Le Witer family, the Wiertses and Van Surpeles, Jordaens succeeded in combining all the formal elements of the composition into a harmonious whole. The sitters give an impression of complete physical well-being and mental equilibrium; they do not appear involved in any incident or action, yet convey a sense of irresistible vitality. Occasionally, as in the figure of Van Surpele, Jordaens tries to emulate the dash and elegance that had become fashionable at Antwerp since Van Dyck's return from Italy. The vivid colouring of his earliest portraits has become fuller and softer; instead of a bright morning light his figures now seem to be bathed in the rays of noon or evening, and the hard shadows have given place to a glimmering half-light. The technique and method are also different: the brushwork is more supple and fluent, the paint more thinly applied, more fluid and in places transparent. In short, Jordaens's youthful exuberance has become mellower and more sedate.[26]

The same qualities could be found in the *Portrait of Adam van Noort* painted about 1640 [244], formerly in Berlin but destroyed by fire in the Flakturm Friedrichshain, where it had been placed for safety along with other works of art.[27] The portrait shows Van Noort at an advanced age, and was probably painted shortly before he died in 1641. Daniel Papebrochius stated at the beginning of the eighteenth century that it was executed after Van Noort's death;[28] but the portrait gives such an impression of sympathy and direct contact with the model that it must in all probability have been painted from life. An engraving after the portrait, by Hendrick Sneyers of Antwerp, was published in 1662 in Cornelis de Bie's *Het Gulden Cabinet vande edele vry Schilder-Const*.

A half-length *Portrait of a lady* in the Vienna Academy museum [243][29] should also be mentioned. A young woman with broadly flowing locks holds up towards the spectator a rich jewel consisting of a bust *à l'antique* set in a frame of pearls and diamonds. The purpose of her gesture is not clear, unless it is simply to express her pride in such a handsome possession. The same soft-faced young woman, painted in light, transparent colours, occurs from time to time in works by Jordaens, as for example *The king drinks*, *circa* 1638–40, in Paris [139]. In this as in other genre paintings he used models from his own family circle, such as Adam van Noort for the king, and probably his own wife and youngest daughter for the mother and child behind the table. With them is a woman of about twenty whose features resemble those of the lady in the Vienna portrait. This may well be Jordaens's eldest daughter Elizabeth, who was born in 1617 and thus came of age about the time when both pictures were painted.

Not many preparatory portrait drawings have survived from this period. In the case of subjects that recurred frequently the painter might expect to re-use his compositions with or without modification and would probably keep them on hand, whereas drawings for portraits were used on the one occasion only. Two of those that exist have been mentioned in connection with the portraits of Rogier and Catharina Le Witer: these are sketch-like studies in black chalk.

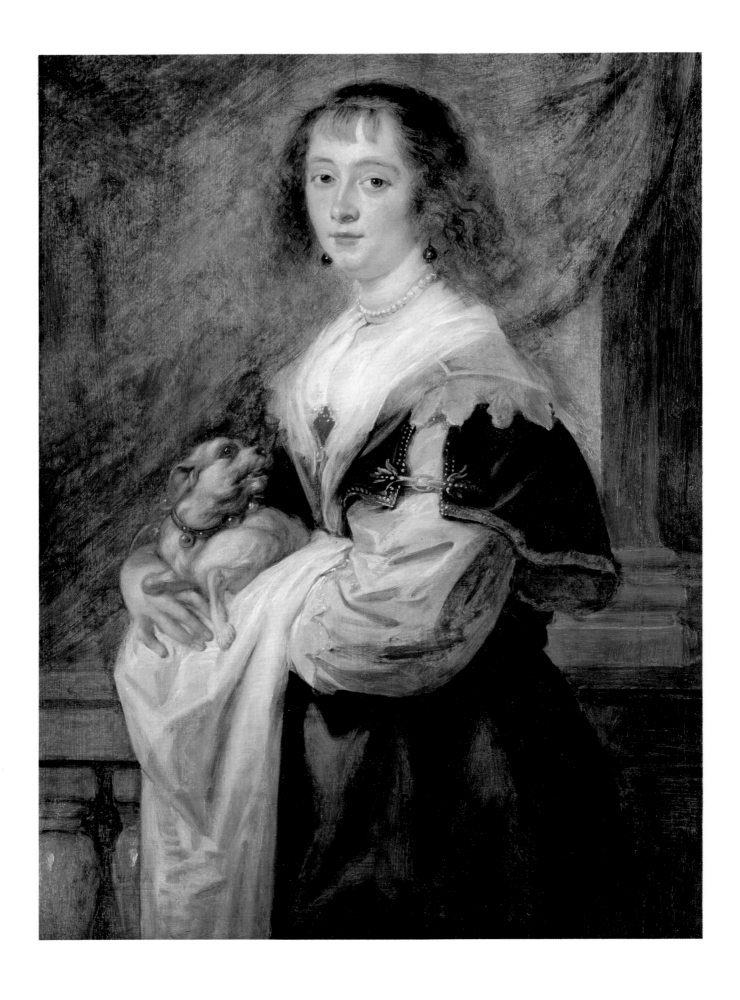

Two in the Louvre, depicting a husband and wife,[30] are in a more elaborate technique using red and black chalk and wash, heightened with white body-colour, and are finished to the extent that they resemble actual portraits. Two painted versions of the couple are based on them; in the course of time the counterparts were separated, and the paintings are now in four different collections. Those of the husband are at Leningrad[31] and in the Thyssen-Bornemisza Collection at Castagnola,[32] while those of the wife are at Buscot Park, Oxfordshire [249][33] and the Brussels museum.[34] Opinions differ as to which belongs with which, and in what order the works were painted. Those at Leningrad and Buscot Park, which are somewhat better than the other two, bear an indication of the sitter's age: for the man *AETATIS 73*, for the woman [AE]*T. 66*. The other two paintings give the same information, and in addition are dated *1641*. The versions differ only in details, and the studio may have had some hand in them.

This prosperous-looking couple has not yet been identified. In the drawings in the Louvre they have a stiff, impassive appearance, but in the finished versions this is changed. Jordaens has placed them to one side of the composition, allowed more space above their heads and provided a richer décor, and they look out of the painting with a frank expression. They are also slimmer and look more distinguished, no doubt because Jordaens was given to flattering his models.

Another problem of identification concerns the *Portrait of a lady in an armchair*, painted about 1640–45, at Antwerp.[35] The sitter, engrossed in a book, bears a clear resemblance to Jordaens's mother, Barbara van Wolschaten, as she appears in the family group at Leningrad painted some decades earlier [232]. But, as she died in 1633, Jordaens cannot have painted her from life in the 1640s. If it is really she, the portrait must have been based on a study for the Leningrad painting, or that painting itself.

The *Portrait of a lady* formerly owned by Lord Chesham and now in the Oskar Reinhart Collection at Winterthur [245],[36] shows a woman in front of a balustrade and a column to which some blue drapery is attached. She wears a bronze-green dress with white sleeves, and a muslin kerchief over her shoulders and breast. Her pose and expression are of great elegance, and the lapdog adds a further graceful note.

As the ancient maxim 'Know thyself' testifies, men in all ages have been fascinated by their own nature. Artists, in particular, have felt the need to portray themselves and thus achieve immortality together with their works. For centuries, like Narcissus, they have contemplated their own image, painting and sculpting themselves as they would like to be or dissecting their personalities with ruthless sincerity. In the Middle Ages sculptors often adorned pulpits and choir-stalls with carvings of their own heads, while painters introduced themselves into altarpieces as pious, unobtrusive 'extras'. By the end of the fifteenth century these incidental figures evolved into independent self-portraits, and the glorification of mankind in the Renaissance allowed the artist's personality to express itself to the full. The aged Leonardo, who wrote 'The mirror is our teacher', sat before a looking-glass to draw his own fine head, resembling that of a prophet. Dürer deified himself in the semblance of Christ, while Michelangelo ventured on the first self-caricature: his faun-like countenance and broken nose disturb the harmony of *The Last Judgement* in the Sistine chapel. Finally there is the unique case of Rembrandt, who from his early youth to the end of his life analysed himself in over a hundred self-portraits.

This type of portrait, in which the artist is his own model, creates special

245 *Portrait of a lady*
circa 1640–50
panel, 98.5 × 73cm
Winterthur,
Oskar Reinhart Collection

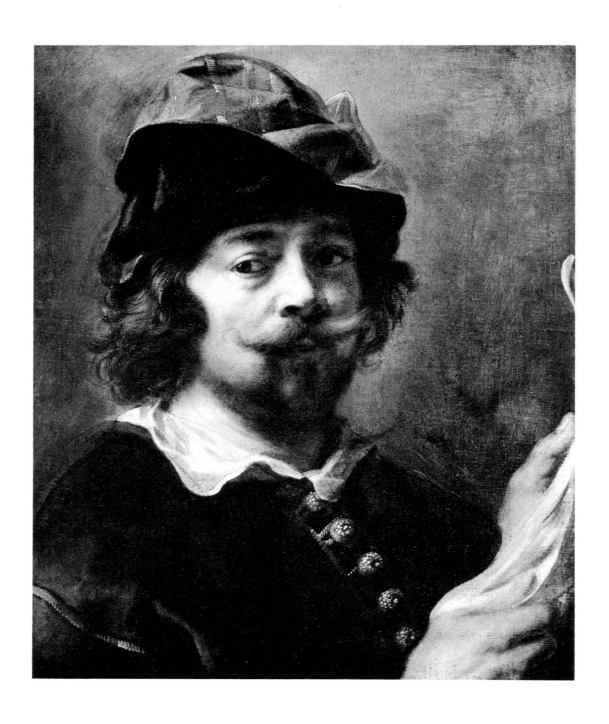

246 *Self-portrait*
circa 1640
canvas, 56 × 46cm
Kiel, Professor Dr Hans Pau Collection

247 *Self-portrait*
circa 1640
drawing, 103 × 88mm (with
added border 151 × 128mm)
Berlin-Dahlem, Staatliche
Museen

problems. In the first place, he cannot see himself as a spectator does, but only in mirror-image; on the other hand, he knows more about the intimate feelings of his 'model' than if he were painting another person. The dichotomy between seeing and being seen is in fact the essence of a self-portrait.[37]

Apart from the family groups at Leningrad, Kassel and Madrid, Jordaens painted some portraits of himself alone. They are not very numerous, and it may be assumed that, like Rubens and Van Dyck, he was not overmuch interested in his own personality. None of the Flemish masters produced a pictorial autobiography after the fashion of Rembrandt. The first of Jordaens's individual self-portraits, now in the collection of Professor Hans Pau at Kiel [246],[38] must have been painted about 1640; it shows him half-length, holding an engraving and turning his head towards the viewer. The penetration of his glance reflects the intensity with which he must have scrutinised his appearance and expression in the looking-glass. An engraving by Jacob von Sandrart, reproducing this portrait in an oval shape and without showing the hands, was published by the German painter and art historian Joachim von Sandrart as an illustration in his *Teutsche Academie der edlen Bau-, Bild-und Malereikünste* (1675).[39] Also in about 1640, Jordaens painted himself again in the same jerkin, buttoned to the top, with a narrow white collar, and wearing the same striped headgear, in a drawing now in the Print Room at Berlin-Dahlem [247]:[40] in this less solemn version he looks at the viewer with a mocking, mischievous expression.

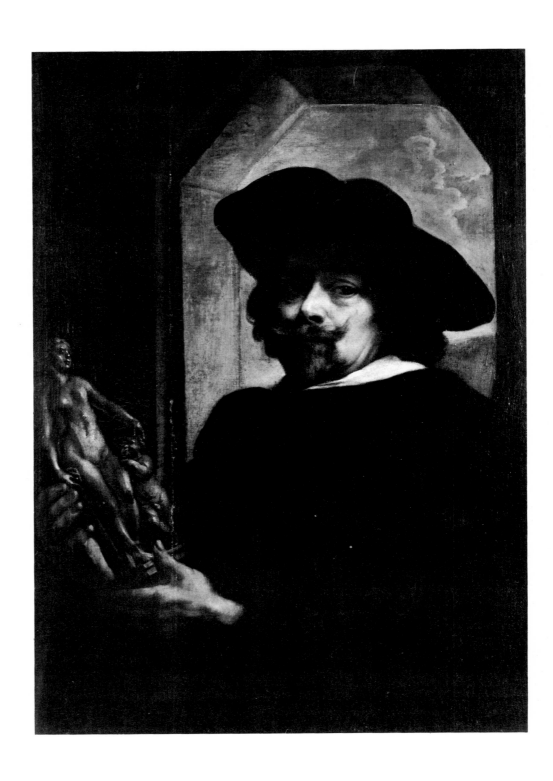

248 *Self-portrait*
circa 1640–45
canvas, 100 × 68cm
Angers, Musée des Beaux-Arts

Somewhat later is the *Self-portrait* at Angers [248],[41] in which he is seen holding a piece of sculpture which fairly closely resembles Georg Petel's ivory *Venus and Cupid* in the Ashmolean Museum, Oxford. Wearing an ample cloak and a wide-brimmed hat, he stands in front of an open window the upper corners of which are cut off diagonally: this type of setting is also found in the 1641 *Portrait of a lady in an armchair* at Buscot Park, Oxfordshire [249]. Until identified as a self-portrait by J. S. Held in 1940, the picture at Angers was generally thought to represent the Flemish sculptor François Duquesnoy.

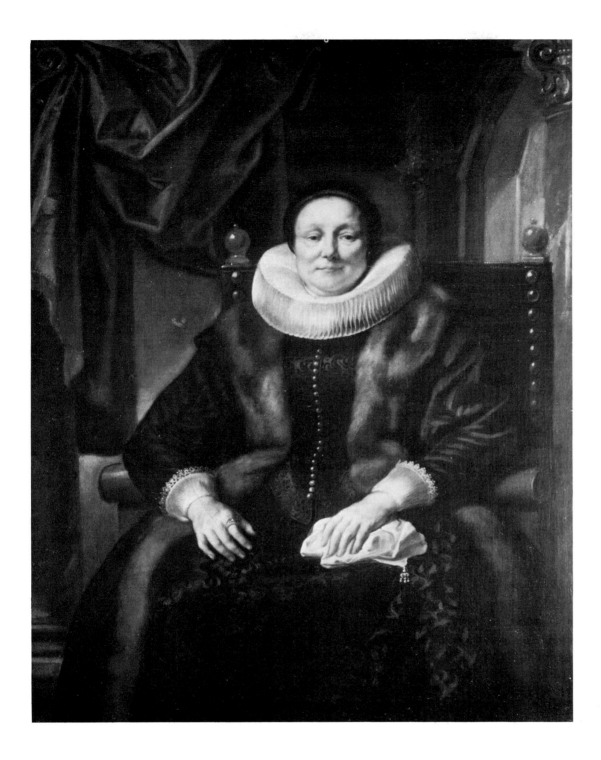

However, Duquesnoy, who was born at Brussels in 1597, went to Italy at the age of twenty-one and died there in 1643; he never returned to his native land,[42] and Jordaens therefore could not have painted him from life. The piece of sculpture was not, as previously believed, an indication of the sitter's profession, but expressed Jordaens's own pride in possessing such a costly object. The composition may well have been inspired by Van Dyck's *Portrait of Duquesnoy* at Brussels, where the model is also in full face and holds a piece of sculpture, and perhaps this is why Jordaens's *Self-portrait* was wrongly identified for so long.

249 *Portrait of a lady in an armchair*
circa 1641
canvas, 149.5 × 114cm
Oxfordshire, Buscot Park,
National Trust

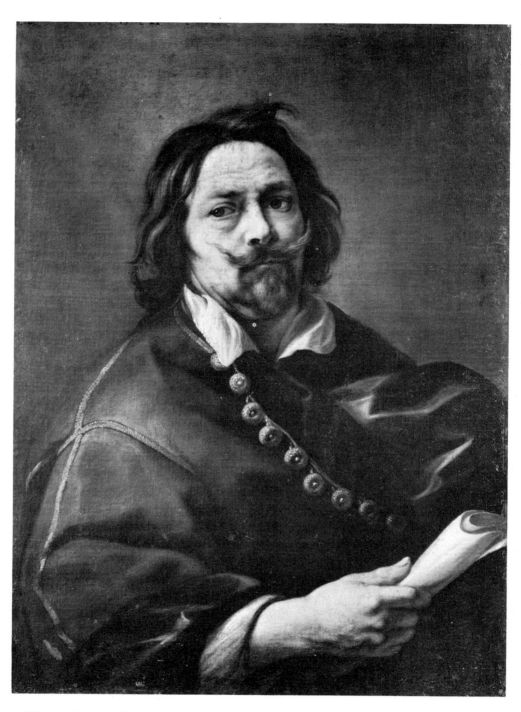

250 *Self-portrait*
late 1640s
canvas, 81.5 × 59cm
Munich, Alte Pinakothek

Two other self-portraits, showing Jordaens at about the age of fifty-five, must date from the late 1640s. One is at Munich [250]: an engraving after it by Pieter II de Jode (1601–74) appeared in the collective work *Images d'hommes d'esprit sublime*, published by Johannes Meyssens at Antwerp in 1649. As in the self-portrait at Kiel, Jordaens is seen half-length in front of a neutral background. By this time he was older and stouter, and his wrinkled countenance shows the effects of time. He faces the spectator with a somewhat weary but proud and resolute expression; in his hand is a rolled-up paper, probably an engraving. The second, somewhat weaker self-portrait, in the collection of Thomas Harris in London in 1953,[43] shows him in a similar pose. This time the background consists of pillars and a curtain, while the paper is definitely an engraving.

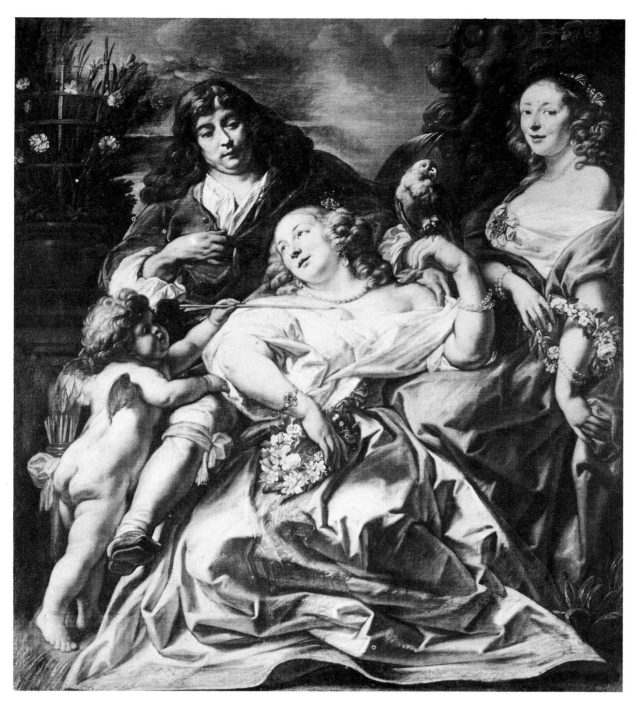

Besides the family group of Jordaens with his parents, brothers and sisters
[232], the Hermitage at Leningrad also possesses a painting of two ladies and a
gentleman together with the young Cupid [251].[44] One of the ladies sits facing
out and turns her head towards her companion, who is seated on the arm of the
chair, his hand on her shoulder. Cupid aims an arrow at her heart, and their love
is further indicated by a fountain with dolphins in the background. None of the
figures has been identified, but the picture almost certainly celebrates an en-
gagement. As in the Kassel portrait [233], showing Jordaens with Catharina van
Noort and her family, there are flowers on the young woman's lap, this time in
the form of a wreath. In the background is a pot of carnations, an ancient symbol
of betrothal.[45]

251 *Group portrait*
circa 1650
canvas, 176 × 151.5cm
Leningrad, Hermitage

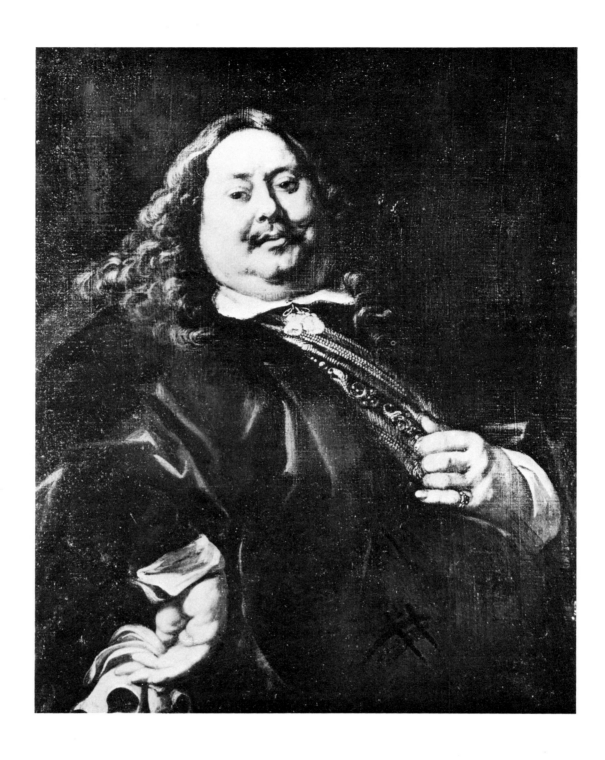

252 *Portrait of a stout gentleman*
circa 1650
canvas, 94 × 73cm
Paris, Musée du Louvre

This fine collective portrait, Jordaens's last great work of its kind, is outstanding for the rich warmth of its colour-scheme. Its balanced composition, robust forms and flowing lines accurately express the sensuous atmosphere in which the bourgeois trio take their pleasure. The same rare perfection of colour, form and expression distinguishes some other works by Jordaens at this time, including the *Portrait of a stout gentleman* in the Louvre [252].[46] This is evidently a figure after the painter's own heart, and he is depicted with interest and undisguised pleasure. Despite his corpulence he wears a jaunty air; the expression in his pear-shaped countenance is proud and disdainful, as if to check any disrespectful amusement on the spectator's part.

A work like this shows how far Jordaens had gradually evolved from the quiet, balanced style of his portraits in the 1630s. Form and colour are now subordinated to rhetorical exuberance. As in Rubens's late portraits, the compositional field is fully occupied by stately, massive figures. Jordaens did not, however, possess Rubens's ability to exalt the model to a higher, more poetic level; however arrayed, the subject preserved his familiar, everyday appearance.

The last known portraits by Jordaens are certainly not his best. His eye was less keen, his hand wearied, and he had clearly lost his creative enthusiasm. His models are slackly and feebly drawn, with none of their earlier vitality. Dull colours and uninspired, unemphatic brushwork contribute to this commonplace effect. All these weaknesses can be found in a portrait of the 1650s, *Lady in an armchair, with a fly-swat*, Robert Finck Gallery, Brussels (1965),[47] in two other portraits of the same lady, also with a fly-swat, at Indianapolis[48] and Cologne[49] and in *Portrait of a gentleman in an armchair* at Budapest.[50] Each one is only a shadow of Jordaens's former achievement in portraiture.

IX

Jordaens the tapestry-designer

The greatness of Flemish painting is beyond dispute. For centuries artists were at work in the Low Countries and their achievements belong to the highest that Europe has to show. A world whose endeavours were fixed on luxury and brilliance gave them every opportunity to display their talent and fruitful industry; princes and ambitious courtiers, prelates and rich merchants vied in supplying them with commissions.

In the Southern Netherlands the lead was taken by the French princes, followed in turn by the Burgundians and Habsburgs. The same combination of prosperity with a need to 'adorn the forms of life with beauty', as Huizinga concisely puts it, led to the simultaneous development of applied art and especially the art of tapestry. From a European point of view tapestry is even more distinctive of the Southern Netherlands than the work of their great painters. Over the centuries there were other brilliant schools of painting besides the Flemish, but no other country can boast of a tapestry-making industry that maintained its high level without a break from the fourteenth to the eighteenth century.

The technique of tapestry-weaving goes back into antiquity. After the Chinese it was practised in the third century AD by the Copts in the Nile valley, as is shown by the discovery of many remains of tapestry in the excavations at Antinoe. When the Arabs conquered this area they also acquired the art of tapestry-weaving, adapting patterns to their own taste and to the prescriptions of their religion. They introduced it into the regions later conquered by them, particularly in Spain, and it is very probable that influences from there affected the technique and patterns of tapestry-work in the Christian West. The oldest known example of West European tapestry is that from the church of St Gereon at Cologne. It dates from the eleventh century, and the iconography shows strong Byzantine and Near Eastern influence. No surviving Flemish tapestry is older than the late fourteenth century, though it is possible that the art was practised on the banks of the Scheldt and its tributaries during the high Middle Ages.

In the fourteenth century Paris was a major production centre and the chief market for tapestries, but the Southern Netherlands were steadily gaining in importance. More and more tapestries were sold, warehouses were established and the industry developed on a scale sufficient to supply most of Europe. Arras, then part of Flanders, superseded Paris before the end of the century, and soon after 1400 the Southern Netherlands established the supremacy they were to enjoy for centuries.[1] The finest tapestries now known were manufactured at Arras, Tournai and Brussels, but there were many other important centres.

Rubens and, after him, Jordaens were outstanding designers and played significant roles in what has been called the great age of Flemish tapestry in the seventeenth century; but by then, the industry had already begun to decline. Changes in fashion and life-style led to the construction of homes with numerous smaller rooms and to the increasing use of other kinds of wall covering such as gilded leather. For this reason demand for tapestries fell off, while Flemish weavers had to meet competition increasingly from many foreign workshops, several of them established and operated by émigrés from the Netherlands. The decline at first only gradual, rapidly gained momentum and in 1794, the last important workshop in the Southern Netherlands, that of Jacob van der Borght at Brussels, closed down.

Tapestry designs played an even more important part in Jordaens's total output than in that of Rubens. He had in a sense been trained for this particular art: in 1615 he was enrolled in the Register of St Luke's guild at Antwerp as a *waterschilder* (painter in watercolour). Few authors apart from Rooses have paid much attention to the term. Rooses believed that artists of this category produced both cartoons for tapestries and wall decorations painted in watercolour on canvas; he saw no distinction between the two forms, and referred to both alike as *patronen* (cartoons). In fact, however, although some 'water-painters' may have sporadically designed cartoons for tapestries, they generally did not do so. Paintings in watercolour on canvas, and occasionally on paper, were used as a cheaper form of wall-covering instead of tapestries and cordovan or gilded leather, and were usually produced by second-class artists who specialised in this type of work.

Although other artists besides Jordaens were registered as 'water-painters' they were relatively few in number, which suggests that this craft was not very much developed at Antwerp. From 1544 to 1631–32 they are referred to as canvas-painters, watercolour-painters, water-painters, water-painters on canvas or water-canvas painters, the various terms all indicating clearly that they painted in watercolours on canvas. The most important centre for this type of painting was nearby Mechlin, seat of the Netherlands government until 1546. There were many watercolour-painters there in the sixteenth and the beginning of the seventeenth century, though by then they had begun to decrease. Van Mander states in his life of Hans Bol, a Mechlin painter, that in the mid-sixteenth century there were in that city over 150 studios of watercolour-painters, and that they continued to flourish in the seventeenth. Perhaps this figure should not be taken too literally, but it is certain that important Antwerp dealers used to procure paintings of this type from Mechlin for export purposes. The principal firm of dealers, the Forchondts, sent them to Spain, Portugal and especially Vienna, where they maintained branches.

Many painters from Mechlin settled in Antwerp owing to its proximity and overseas links and the demand for their products there. Thus there are in the Antwerp Register such entries as Anthonis Bessemer, 'canvas painter from Mechlin' (1544) and, in 1577 and 1591, two more natives of Mechlin: Hans Boons, 'painter in water-colour', and Françoys de Leeuw, 'canvas painter'. After Mechlin was overrun and plundered by the Spanish in 1572, the Antwerp guild offered temporary asylum and financial privileges to painters from that city. No fewer than forty took advantage of the offer: unfortunately their names are not known, but presumably some were painters in watercolour.

It is not surprising, therefore, that Jordaens was trained as a watercolour-painter, and he may well have painted in watercolour on canvas during at least

the first years of his career: there was a demand for such work, and moreover the elder Jordaens, as a linen-merchant, provided painters on canvas with their raw material and knew the market for their products. The fact that no such work by Jordaens has been discovered does not argue against this: of the enormous number of such canvases painted at Mechlin and Antwerp in the sixteenth and seventeenth centuries very few have survived, owing to their vulnerability to water and damp.

Jordaens soon became known as a major artist, and in view of his success it was natural for him to give up painting in watercolour and turn to the more lucrative medium of oils: the more so since, at the beginning of his career, the art of watercolour painting on canvas underwent an economic crisis which foreshadowed its early decline. From this time on, besides pictures in oils Jordaens began to execute cartoons for tapestries; it is, however, hard to fix the exact time when he began to do so.[2]

In the seventeenth century two techniques were used for tapestry cartoons: bodycolour on paper and oils on canvas. It is supposed that the great majority were in the former technique, although scarcely any have survived and the records only occasionally speak of designs 'on paper' or 'in rolls'. Jordaens seems invariably to have used paper for his cartoons: some have been preserved in whole or in part, while others are referred to in documents.[3] Rubens used both techniques: paper for *The history of Constantine* and *The life of Achilles*, canvas for *The history of Decius Mus* and the *Eucharist* series.[4]

Those who believe that Jordaens executed cartoons for tapestries in his early years[5] quote a statement by the eighteenth-century critic François Mols that certain cartoons sold at Antwerp in about *1774* bore the date *1620*. The question, however, is whether these were really cartoons or independent canvases in watercolour. From the fifteenth century onwards there are examples of dated tapestries but none of dated cartoons, by Jordaens or anyone else.

The earliest cartoons by Jordaens about which there is information from written sources were executed between 1644 and 1647. The dating of any that may be prior to this must rely on stylistic analysis. In so far as can be discovered, all the tapestries executed to his designs formed part of sets or ensembles: it is indeed a special feature of tapestry to unfold a story in consecutive scenes. However, in the Baroque period the basic principle of a continuous story, which is the unifying feature of a consistent series, was not always respected. In some cases a general theme was illustrated by depicting one of its aspects after another, while in other cases a succession of scenes was designed to give comprehensive depiction of a particular activity. In Jordaens there are both types: *Proverbs* and *Scenes from country life* belong to the first category, and *The riding-school* to the second.

Among the earliest sets of tapestries for which he designed cartoons is *The story of Odysseus*.[6] Taken as symbolising the victory of a wise and virtuous man over the forces of evil, these Homeric scenes had frequently been represented in the sixteenth century in various techniques. No doubt the most famous example is the *Galerie d'Ulysse* in the château at Fontainebleau, a series of now lost murals executed for Francis I by Primaticcio in 1541–70: the heroic themes were no doubt also intended to commemorate the exploits of the French king. Not only Italian and French but many Dutch artists worked to adorn the palace at Fontainebleau, so that the fame of the *Galerie d'Ulysse* soon reached the Low Countries: before the end of the century, cartoons of the same subject were designed and tapestries executed in the main Flemish workshops. In the seven-

teenth century interest in Primaticcio's series continued unabated. Rubens copied it freely in some drawings of about 1630,[7] Theodoor van Thulden reproduced it accurately in a collection of fifty-eight engravings published in Paris in 1633,[8] and in the course of the century Odysseus's adventures were depicted in tapestry form by several Brussels workshops. One of these was the firm of Jacob Geubels the Younger, from whom the future King Wladyslaw IV of Poland (1632–48) ordered a ten-piece *Story of Odysseus* in 1624.[9]

Jordaens's cartoons for *The story of Odysseus*, painted in about 1630–35, were also made into tapestries in Brussels. At least two versions were manufactured, but the number of pieces each comprised is unknown, as they have only survived in part. Two tapestries from a first series were with French & Co. of New York in 1956 and are now in a private collection in Mexico: *Circe transforming Odysseus's men into swine* [104] (*see* p 144) and *Odysseus taking leave of Alcinous*. Both bear the Brussels mark and on each there is a different unidentified weaver's mark. Several pieces belonging to a much later version were at one time in the Italian royal collection and are now in the Quirinal, Rome, and at Turin. These are: *Mercury visiting Calypso* (Rome); *Odysseus building a ship before taking leave of Calypso* (Turin); *Odysseus threatening Circe* (Rome) [107] (*see* p 144); *Odysseus taking leave of Alcinous* (Rome, Turin); and *Telemachus leading Theoclymenus before Penelope* (Rome [110] (*see* p 144), Turin). This second version, woven by G. van der Strecken and J. van Leefdael, was purchased by Charles Emmanuel II, duke of Savoy (1638–75); it was probably delivered to him in 1666, and paid for in the following year.[10] The duke's arms appear in the border of each piece, and also the monogram of his second wife, whom he married on 10 May 1665.[11] It may thus be inferred that the series was woven, from existing cartoons, no earlier than 1665–66.

There is a total of six scenes in the above two series, but almost certainly Jordaens designed others which have been lost. Their subjects may be guessed from *Calypso provisioning Odysseus's ship*, a drawing in the Antwerp Print Room,[12] the paintings *Odysseus and Polyphemus* in Moscow and *Odysseus taking leave of Circe and descending into Hades* at Ponce, Puerto Rico, and finally *Odysseus and Nausicaa*, a cartoon sold in Paris in 1912 and now lost.[13] This makes a total of ten subjects, but the original series may have comprised even more – other paintings connected with *The story of Odysseus* have already been referred to. As to drawings, there are three others besides the one just mentioned: two versions of *Odysseus building a ship before taking leave of Calypso*, one in Paris at the Ecole Nationale Supérieure des Beaux-Arts[14] and the other at Besançon,[15] and *Telemachus leading Theoclymenus before Penelope* in Stockholm [111].[16]

Few subjects have been so popular with Western artists as the story of Alexander the Great. At the end of the Middle Ages he was universally renowned for courage and chivalry. With an insatiable appetite for fabulous stories and with evident delight in Alexander's fantastic adventures, artists depicted him leading expeditions to the ends of the earth, conquering imaginary monsters and exploring the highest heaven and the depths of the sea. What now appears a world of pure legend was regarded by the civilised West as historical reality. Innumerable manuscripts in various languages of the East and West had preserved the memory of the great king as a conqueror of peoples, lands, animals, air, sea and women, in so far as he was not himself subdued by the latter.

The intense literary activity that surrounded the life of Alexander, and that was reflected in book illumination, tapestry and no doubt wall paintings, origi-

nated in the medieval veneration for the heroes known as the Nine Worthies. These were three representatives each of Old Testament and classical times and the age of chivalry: Joshua, David and Judas Maccabeus; Hector of Troy, Alexander the Great and Julius Caesar; and Arthur, Charlemagne and Godfrey of Bouillon. The dukes of Burgundy were foremost in their admiration of these heroes; they identified with them, sought to emulate their exploits, and decorated their residences with illustrations of them.[17]

In course of time, the attitude towards Alexander shifted somewhat. Medieval man, with his taste for miracles, had fastened on the hero's legendary, fabulous character and his wonderful deeds. By degrees, however, legend gave place to history. The antique theme was still admired, but emphasis was laid on Alexander's campaigns and military triumphs as they were related by Curtius Rufus, Plutarch and Diodorus. Besides his gifts as a general he was extolled for his humane behaviour, as an ideal man uniting all the noblest qualities. This is the spirit in which the seventeenth-century cartoons are to be interpreted.

Until Charles Lebrun executed his *History of Alexander the Great* for Louis XIV, Jordaens's cartoons[18] were the most famous of the Baroque period. His original *Alexander* series dates from about 1630–35 and comprises eight pieces:[19] *Alexander saved from drowning in the Cydnus*; *Alexander wounded at the battle of Issus*; *Alexander and Hephaestion consoling the family of Darius*; *Alexander receiving the surrender of a city*; *Alexander and the wife of Spitamenes*; *Alexander presented with arms and adored as a god by his people*; *Alexander killing the lion*; and *Detachment of troops in a landscape*. Many versions of it are known. The *editio princeps,* woven at Brussels, belonged to Cosimo III de' Medici around 1697. In about 1920 four pieces from this series were acquired by the dealer G. Zerega at Genoa. One of these, *Alexander wounded at the battle of Issus* [114] (*see* p 145), was purchased by the city of Milan for the Palazzo Marino; another, *Alexander killing the lion*, is in the collection of Princess Borghese Caraman-Chimay, Rome, while a third, bearing the full signature of Jacob I Geubels, formerly belonged to W. Guggenheim. A second series of eight pieces, woven by Jan Leyniers at Brussels, was sold in Rome in 1668 by the Fleming Pietro Bacchille and acquired by Cardinal Flavio Chigi; it is now in the Palazzo Chigi in Rome. Of a third series, also woven by Jan Leyniers but with a different border, four pieces are known: *Alexander wounded at the battle of Issus* and *Alexander killing the lion*, both in the possession of Queen Elizabeth II at Holyrood House, Edinburgh; *Alexander saved from drowning in the Cydnus* in the Bucharest museum; and *Alexander and Parmenion*, sold by Graupe, Berlin, in 1935. A fourth and incomplete series in the Museo de Santa Cruz at Toledo was woven by A. van den Dries and comprises six pieces: *Alexander saved from drowning in the Cydnus*; *Alexander wounded at the battle of Issus*; *Alexander receiving the surrender of a city*; *Alexander and the wife of Spitamenes*; *Alexander presented with arms and adored as a god by his people*; and *Alexander killing the lion*.

Of a fifth series only one piece is known: *Alexander and Hephaestion consoling the family of Darius* in the Philadelphia Museum of Art; this series was also woven by Jan Leyniers, and its border differs from the others. A sixth series, complete but of later date and less good quality, is in the Galleria Alberoni, Piacenza. Some individual pieces are also known. In 1968 Mayorkas Bros, New York, had two Brussels tapestries with the same border as the *editio princeps*, but woven from portions of cartoons: *Alexander wounded at the battle of Issus* and *The restitution of Bucephalus to Alexander(?)*. Another piece, *Alexander receiving*

the surrender of a city, which bears the Brussels mark and that of A. van den Dries, was formerly in Lord Swansea's collection and, in 1920, in the Welbeck Galleries, Cardiff. Finally, in 1928 an *Alexander and Hephaestion consoling the family of Darius* was in the possession of Mrs Fanny Unander-Scharin, Stockholm.

Nothing has remained of the cartoons, except possibly a *Bust of a helmeted warrior in armour* at Besançon,[20] a fragment of a cartoon which was used for *The history of Charlemagne* and perhaps previously for *The history of Alexander the Great*. There are, however, two composition sketches on paper, both for *Alexander wounded at the battle of Issus*: one, at Berlin,[21] is in pen and brown ink and corresponds to the left side of the tapestry; the other, at the Ecole Nationale Supérieure des Beaux-Arts in Paris [113] (*see* p 145),[22] is in a richer technique with watercolour and bodycolour and was used for the right-hand side. A painting at Narbonne[23] agrees, apart from slight variations, with the tapestry *Alexander and Hephaestion consoling the family of Darius*. Mention should also be made of an oil sketch at Antwerp, *Two studies of women's heads and the torso of a warrior* [112],[24] the latter figure in which was used for *Alexander wounded at the battle of Issus*.

Among the most successful of Jordaens's tapestry designs were *Scenes from country life*,[25] a set of eight pieces executed in about 1635 (*see* p 153): *Piqueur seated amid a pack of hounds* [124]; *Rider returning from the hunt*; *View of a kitchen and a table laden with food* [125]; *Gentleman playing the lute, and lady with a fan, in a portico*; *Lady and gentleman in an arbour* [127]; *Maid-servant feeding hens*; *Barnyard with swooping hawks* [128]; and *Maid-servant with a basket of fruit in front of an open door*. On the face of it these are everyday scenes, some connected with hunting or with farm life, others showing young couples in an arbour or in the open, while others depict fruit, vegetables and products of the barnyard and of the chase. But the series is more than a realistic representation of country pursuits: there are also moral implications, though these are less obvious. For instance, the barnyard scene shows poultry, doves and a peacock being threatened by two birds of prey. A maid tries to drive off the hawks with a stick but seems to have come too late, and the animals themselves do not appear to have realised their danger in time. All of them were too slow, physically and mentally, and their dilatoriness is emphasised by a tortoise and a crab on the pedestals of the half-columns that flank the picture. There is clearly an allusion here to the Flemish proverb which says that if you behave like a chicken or a dove, you will be devoured by the hawk sooner or later.[26] In the same way, *Maid-servant with a basket of fruit in front of an open door* is not merely a genre scene but an illustration of the adage *Sine Cerere et Baccho friget Venus*. The maid is offering food and drink to a loving couple, and the picture contains many allusions to love: the dove, sacred to Venus, on the base of the left-hand column, the sensual parrot on its perch, and the satyr riding a goat, who typifies virility. Although these secondary meanings are not equally prominent throughout the series, there is hardly a scene in which they are not suggested, often by decorative elements in the composition itself or in the architectural framework.

The *Scenes from country life* were woven in several versions of which two complete ones are preserved, at Hardwick Hall, Derbyshire, and in Vienna. Both were woven in Brussels: the first by Jacob Geubels, Catherine van den Eynde and Conrad van der Bruggen, the second by Conrad van der Bruggen and Hendrik Rydams. Five pieces from a third series, woven in Brussels by Conrad van der Bruggen and I.T.B., are at the castle of Náchod in Bohemia and

comprise: *Piqueur seated amid a pack of hounds*; *View of a kitchen and a table laden with food*; *Gentleman playing the lute and lady with a fan*; *Maid-servant feeding hens*; and *Maid-servant with a basket of fruit in front of an open door*. Six were formerly in the Braquenié Collection, later sold in the United States, and seven in the Desfossés Collection, sold in Paris in 1929. Other single tapestries are preserved in different places. Thus there are specimens of *Gentleman playing the lute and lady with a fan* in the Musées royaux d'Art et d'Histoire in Brussels, the Belgian Embassy in Paris and the Palace Hotel in Madrid. Another was shown at Antwerp in 1930, when it belonged to Baron Cassel; while yet another was sold by Giroux at Brussels on 2–3 April 1954 (cat. no 767, fig XXIV; signed *IAQ GEUBELS*) and in the Bestégui sale at Venice in 1964. A specimen of *Rider returning from the hunt* is at Bucharest. The marks on some pieces all denote Brussels workshops.

Some composition sketches for this series have survived. They are executed in bright watercolours and bodycolour on paper, and are among the finest existing sheets by Jordaens. Among these drawings, probably also used as *modelli*, are: *Piqueur seated amid a pack of hounds*, Victoria and Albert Museum, London [122];[27] *Rider returning from the hunt*, British Museum, London [123];[28] *View of a kitchen and a table laden with food*, one specimen in the Louvre[29] and another in the Ecole Nationale Supérieure des Beaux-Arts, Paris;[30] and *Maid-servant with a basket of fruit in front of an open door* in the Staatliche Museen at Berlin-Dahlem.[31]

A painting at Lille, signed and dated *1635* [118], shows broadly the same composition as *Piqueur seated amid a pack of hounds*, and is literally reproduced in reverse image in a tapestry belonging to a series of seven *Hunting scenes* in the Kunsthistorisches Museum, Vienna. These scenes, all signed *D. Eggermans F.*, were delivered to the Austrian court by Bartholomeus Triangl in 1666, on the occasion of the marriage of Emperor Leopold I to Margarita Teresa of Spain. The other six pieces are all based on compositions by Rubens.[32] Another painting by Jordaens, at Glasgow [126], agrees in reverse image with the central part of *Maid-servant with a basket of fruit in front of an open door*.

The series of *Proverbs*[33] is a typical example of the way in which Jordaens combined animation with quiet everyday life, humour with seriousness and an abstract idea with a naturalistic form (*see* p 232). It is the first of his sets of tapestries of which there is certain knowledge from written sources. On 22 September 1644 he contracted with the Brussels weavers Frans van Cotthem, Jan Cordys and Boudewijn van Beveren to supply cartoons for 'a set of tapestries, figured work, representing such proverbs as he may find appropriate'.[34] The eight tapestries woven from these cartoons have the following titles: *As the old sang, so the young pipe*; *The master's eye makes the horse grow fat*; *He who loves danger shall perish by it*; *They are good candles which light the way*; *Usury is a great evil, a plague in the town*; *The master pulls the cow out of the ditch by its tail*; *Nature is content with little*; and *Ill-gained, ill-spent*. All these proverbs or sayings can be found in Jacob Cats's *Spiegel van den Ouden ende Nieuwen Tijdt*, a collection of 'emblems' published at The Hague in 1632, and express the wisdom of the society to which Jordaens and Cats belonged. Both men were Calvinists, and Calvinism was, from the first, the religion of the bourgeois middle class. Jordaens is in fact the chief representative in seventeenth-century Flemish art of the tradition which converted the formal teachings of religion into a series of secular moral precepts. Of the maxims here illustrated, not all are as clear as could be wished. The saying about candles, however, is apparently an

admonition to practise virtue from our earliest years, while the master and the cow means that everyone should look after his own.[35]

With his usual economy, in some cases Jordaens used existing compositions of his own to illustrate the proverbs. For instance, *As the old sang, so the young pipe* reproduces the painting of the same title dated *1638*. *He who loves danger shall perish by it* is based on a composition drawing, enlarged on all four sides, inscribed *The pitcher goes once too often to the well*, and dated *1638* [173]; while for *Nature is content with little* Jordaens adapted one of his numerous versions of *Satyr and peasant*, omitting the satyr so as to leave only a peasant family enjoying a humble meal.

A set of these tapestries was purchased in 1647 by Archduke Leopold William, governor of the Spanish Netherlands, who had probably commissioned them; he later bequeathed them to his chamberlain Jan-Adolf von Schwarzenburg. It appears from an inventory drawn up in 1663, two years after his death, that Leopold William possessed two sets of *Proverbs*, one woven by Boudewijn van Beveren and Jan Cordýs in Brussels and now at Hluboká, Bohemia, in one of the former Schwarzenburg palaces, and the other, interwoven with gold thread, which is lost. Another series of *Proverbs*, this time supplemented by ten other tapestries after cartoons by Jordaens, belongs to the Museo Diocesano at Tarragona, Spain [174, 176].

Two cartoons of *Proverbs* have survived: they belong to the Louvre in Paris and are on loan to the Musée des Arts Décoratifs. *The master's eye makes the horse grow fat* [172] is of course a warning to masters to see that their beasts are properly looked after, but also a more general hint to those in authority to make sure that their subordinates work hard. The other cartoon is in fact a large fragment, namely the right-hand half of *Usury is a great evil*, showing a company of poor people, the victims of usury, seeking the aid of St Ives, patron of lawyers [170]. The left-hand half of the cartoon is missing, but judging from the tapestry would have depicted clerks working at a table.

Four composition sketches are known: *As the old sang, so the young pipe* at Edinburgh; *They are good candles which light the way*, in the possession of A. Stein, Paris (1977); *Satyr and peasant* in the Pierpont Morgan Library, New York; and, as already mentioned, *He who loves danger shall perish by it* in the Municipal Print Room at Antwerp. All these are in watercolour and bodycolour on paper. Various other sketches may also be connected with the *Proverbs*: some were probably made for the tapestry series but rejected, while others were independent compositions.[36] A number of study drawings of figures and borders also belong here.[37] In addition, there are a few paintings which either played a direct part in the genesis of the tapestries, like *The master's eye makes the horse grow fat* (*circa* 1645) at Kassel and *St Ives* (1645) at Brussels, or were used for them in the same way as *As the old sang, so the young pipe* (1638) at Antwerp and *Satyr and peasant*, Brussels.

In 1658 Jacob van Meurs at Antwerp published a substantial volume, richly illustrated by Abraham van Diepenbeeck, entitled *La méthode nouvelle et invention extraordinaire de dresser les chevaux . . . par le . . . prince Guillaume et comte de Newcastle*. This was a translation of an English work by William Cavendish, earl and subsequently duke of Newcastle (1592–1676), who had been tutor to the future Charles II and, in the civil war, commanded the royalist army in the north of England. After the defeat at Marston Moor he withdrew to the Continent and, in 1647, settled at Antwerp, where he rented Rubens's house from the painter's widow Helene Fourment (who had remarried in 1645). He

remained in exile until 1660. Skilled in all forms of horsemanship, he founded a riding-school that soon became famous and was visited by many distinguished personages on their way through Antwerp.[38]

Cavendish's interest in riding was shared by his contemporaries, who regarded it as a pleasant and noble occupation, necessary for health of mind and body. The ancients took a similar view, and the oldest surviving treatise on equitation is Xenophon's *Peri Hippikes*, probably written by the great general and statesman in 362 BC. Owing to the unending wars and migrations in later centuries, the art of riding gradually declined. Interest revived during the Renaissance, and one of the best-known riding-masters of the time was the Neapolitan nobleman Federigo Grisone, who wrote a pioneering work in 1552. The art spread from Italy to northern Europe, where one of its principal champions was Antoine de Pluvinel (1555–1620), tutor to the Dauphin, afterwards Louis XIII. Pluvinel's posthumous work *Le manège royal*, with sixty engravings by Crispyn van de Passe the Younger, appeared in 1623 and had such success as to warrant Dutch and German translations. Cavendish was an admirer of Pluvinel, and the latter's example may well have encouraged him to publish his own manual on the training and riding of horses.

Horses have always been important in Western art, whether painting or sculpture in wood, stone or bronze. It is natural to find them in tapestries, which were primarily intended for the social class that admired the horse most fervently. Horse-riding was not within everybody's reach, and the rider's elevated position had its symbolic importance also. In the earliest fifteenth-century tapestries the horse confers dignity on saints, emperors, warriors and noble huntsmen, and this was still the case in the sixteenth century and later. Barend van Orley, for instance, gives it an important role in his cartoons, as in *The battle of Pavia* where knights in armour fight one another or attack the infantry with lances. *The hunts of Maximilian* depict riders on horseback galloping after their prey in the woods near Brussels, and *The members of the House of Nassau* figure in stately equestrian portraits commissioned by themselves. Rubens in the seventeenth century ascribed the same dignified role to the horse, for instance in *The history of Decius Mus*.

Tapestries were also designed in which the horse was the principal figure. For example, a prince's favourite animals might be depicted, as is probably the case with the *Royal horses* woven at Mortlake about 1635 after cartoons by Frans Cleyn.[39] The same admiration for the horse may be the origin of three large *modelli* on paper, now in the collection of the Marquess of Northampton at Castle Ashby, Northamptonshire,[40] which were executed by Jordaens for a tapestry series of which no specimen has yet come to light [130] (*see* p 232). In addition to such 'portraits of horses' there is a second class of tapestries devoted, like the illustrated works of Pluvinel and Cavendish, to the related skills of training and riding horses. These are generally referred to in archives as *Riding-school* or *Horses in action*.

Documents of the early 1650s mention Jordaens as a designer of cartoons for tapestries of this kind. On 5 July 1651 Frans de Smit or Smits, an Antwerp merchant, declared before a notary that he had supplied the merchant Pieter van Houte and his brother-in-law Pieter Tonnet with 'two paper cartoons of Horses in Action by Jordaens, the one of eight rolls and the other of nine rolls, at 600 guilders each'. The designs were to be sent to Hamburg as samples but returned to De Smit within six weeks, or compensation would be claimed.[41] On 21 November of the same year Carlos Vincque, a leading Antwerp merchant,

ordered seven tapestries from the Brussels weavers Everaert Leyniers and Hendrik Rydams, 'of large horses, accompanied by figures, painted by Jordaens', the cartoons for which had been shown to him.[42] The date on which these were delivered is recorded in a third document, drawn up at the request of another Antwerp merchant, Jan de Backer, who on 18 November 1654 ordered from the same firm 'a chamber of fine tapestries, . . . seven pieces . . . of Large Horses, after the cartoons painted by Jordaens', stipulating that they should be of the same quality as those delivered to Vincque on 30 July 1652.[43] The fact that Jordaens's cartoons are mentioned in these documents of 1651–54 does not mean, however, that they were executed in those years: their style points to a somewhat earlier date.[44]

Some tapestries of this kind, woven after designs by Jordaens, have survived. A complete series of eight, by Everaert Leyniers and Hendrik Rydams, are part of the rich tapestry collection of the Kunsthistorisches Museum in Vienna [185] (see p 33). They were bought from the Vienna dealer Bartholomeus Triangl by the emperor Leopold I, probably on the occasion of his marriage to Margarita Teresa of Spain;[45] this was in 1666, when the Spanish Riding-School, which is still famous at the present time, had long been established at the Hofburg in Vienna. The first tapestry of the series, which is somewhat more monumental and dynamic than the rest, shows Neptune creating the horse by striking with his trident at the bank covered with aquatic plants. Amphitrite is seen in her chariot, and the sea-god and his consort are attended by tritons, nereids and dolphins. The sequence of the other pieces is difficult to determine. In what is probably the second, Mars and Mercury are shown leading horses to Venus. The other six tapestries each show a horseman executing one of the traditional figures: levade, capriole, ballotade etc. In three of them he is accompanied by Mars, Mercury and a riding-master; in the other three by Mars only.

In these tapestries Mars, after the usual fashion of seventeenth-century art, is represented as a warrior in armour and wearing a helmet, while Mercury is a vigorous, half-naked youth with the caduceus. Their presence is accounted for by the astrological beliefs connected with their respective planets. In Renaissance and Baroque times no one doubted the influence of the heavenly bodies on the physical constitution, complexion and character of man and beast, and especially of horses. The importance of such ideas is well brought out in *La gloria del cavallo*, an encyclopedic work on horsemanship published at Venice in 1566 by the Neapolitan Pasquale Caracciolo. All horses, he declares, are under the protection of Mars, but are also influenced by other planets which, among other things, determine their colour. Mercury is associated with a grey, tan, honey-coloured or piebald coat and with a mettlesome nature, while horses in the sign of Mars have a chestnut or fiery-coloured coat and are bad-tempered, restive, impatient, violent and changeable. Mars and Mercury thus figure in *The riding-school* as loyal protectors of their respective animals.[46] It is, however, typical of the more rational and practical outlook of the seventeenth century and of Jordaens, the bourgeois philosopher *par excellence*, that the influence of the planets is of secondary importance. The main thing is the riding-lesson, the demonstration of the correct way to execute the various figures: a didactic intention, not surprising at a time when bourgeois society was feeling the need to teach and moralise.

The tapestries of this series are known by their size as the *Large horses*, to distinguish them from another set of *Small horses*. No other version of them is known, except perhaps a few single pieces,[47] and none of the cartoons have

survived. Four carefully executed *modelli* exist: *Neptune creating the horse*, in the Pitti Palace at Florence; *Mars and Mercury leading horses to Venus* and *Levade performed under the auspices of Mars and in the presence of Mercury, Venus and a riding-master*, both owned by the Marquess of Bath, Longleat, Wiltshire; and *Levade performed under the auspices of Mars and in the presence of Mercury* at Ottawa [184]. Each of these *modelli* corresponds to a tapestry in the series, but in the latter the compositional field is reduced, mainly by leaving out secondary elements. Jordaens usually made compositional or study drawings for the cartoons, but in this case none are known except a sheet in Washington with *Two studies of a crouching female nude* [182],[48] used for the figure of Amphitrite in the *modello* for *Neptune creating the horse*; in the tapestry, however, the goddess is in a different pose.

The contract of 21 November 1651 by which Leyniers and Rydams undertook to make a set of 'Large horses in action' for Carlos Vincque after cartoons by Jordaens stipulated that they must be of the same quality as 'two chambers of smaller tapestries of horses in action' that Vincque had previously bought from the same firm. A series of *Small horses*, apparently complete, was purchased in 1655 at the latest by the archduke Leopold William; after his death it came into the possession of his majordomo Jan-Adolf von Schwarzenburg, and it is still in the family home at Hluboká, Bohemia. It consists of eight pieces, all bearing the name of Leyniers or Rydams. Single tapestries that have come to light, belonging to other sets of *Small horses*, are mostly signed in the same way.[49]

There is no dispute as to Jordaens's authorship of the cartoons for the *Large horses*, but there is not the same unanimity concerning the *Small* ones. Compared to the *Large horses* in Vienna, the *Small horses* at Hluboká are inferior in many respects: the composition lacks harmony, the human and animal figures are often stiff and clumsy. Some pieces are almost literal repetitions of those in Vienna, while others reproduce them only partially, so that the content is impoverished. On the other hand, the borders of the *Small horses* contain elements strongly reminiscent of Jordaens, which is not the case with the borders of the Vienna tapestries. Clearly the two series did not originate independently. This is not surprising, since they were both for the most part woven by Leyniers and Rydams, who were close collaborators. In general tapestry-weavers paid attention to various non-artistic factors including the wishes of customers, and they did not hesitate, when it suited them, to transfer scenes, or portions of them, or even borders from one series to another.

The story of Odysseus, *The history of Alexander the Great*, *Scenes from country life*, *Proverbs* and the *Riding-school* are undoubtedly the most familiar examples of Jordaens's work in this field. He did, however, design cartoons for other tapestries, of which there is less complete information. Sets of tapestries were not indivisible units, and it was generally possible to order single pieces. A series might also be added to for practical reasons, as for example to cover a larger wall surface: this happened with *The story of Achilles* and *Hunting scenes*, woven to designs by Rubens and supplemented by what was probably Jordaens's work.

Rubens designed *The story of Achilles* in the early 1630s, perhaps to the order of the firm of Fourment and Van Hecke, in which his father-in-law Daniël Fourment had been a partner since 6 December 1630. The series originally consisted of eight pieces, but was enlarged to ten, as is stated in the firm's inventory drawn up on 23 July 1643, after Daniël Fourment's death. The two extra pieces were in all probability *The marriage-feast of Peleus and Thetis* and *Thetis leading the young Achilles to the oracle*, both from cartoons by Jordaens.[50] The only surviv-

ing exemplar of the former, in the Palazzo Carignano at Turin, bears the Brussels city mark and the weaver's name, Geraert van der Strecken, while a drawing for the tapestry is in the Orléans museum.[51] *Thetis leading the young Achilles to the oracle* is known in three versions, all of them woven in Brussels: one, at Boston, bears Geraert van der Strecken's monogram, another, in the Palazzo Reale at Turin, was woven by Frans van den Hecke, while a third, at San Francisco, is signed by Jan Raes. A *modello*, painted in oils and afterwards enlarged by Jordaens himself, is in the Allen Memorial Art Museum, Oberlin, Ohio.[52]

A unique tapestry in the cathedral at Santiago de Compostela, belonging to a series woven by Jan Raes in Brussels, is called by some authors *The young Achilles and Pan*, suggesting an eleventh episode of Achilles's life,[53] but it may in fact represent *The young Jupiter and Pan*. In any case it is based on a cartoon by Jordaens; the same scene, with slight variations, forms the subject of a painting of his, formerly in Gaston von Mallmann's collection at Blaschkow in Bohemia.[54]

The *Hunting scenes* comprise seven pieces in all, signed by the Brussels weaver Daniël Eggermans. Sold to the Austrian court in 1666 by the Vienna dealer Bartholomeus Triangl, they are now in the Kunsthistorisches Museum in Vienna. Six are more or less faithful versions of known paintings or sketches by Rubens, while the seventh is a reproduction in reverse image of Jordaens's painting at Lille, *Piqueur seated amid a pack of hounds* [118].[55]

A series wholly designed by Jordaens was that of *Famous women*. The existence of several tapestries from this series is known from their having been in the art trade or mentioned by historians, although their present whereabouts are unknown. Most of them bore the Brussels mark, so it is supposed that the whole series was woven there; some bore the names of the weavers J. Cordys or J. Foppens, others the initials I.D.P. or H.D.P. To judge from surviving reproductions, Jordaens's cartoons for these must have been executed in the second half of his career. Eight subjects have so far been identified, though there may have been more: *Mark Antony and Cleopatra*; *Solomon and the Queen of Sheba*; *David and Abigail*; *Artemisia and the ashes of Mausolus*; *Judith and Holofernes*; *Dido and Iarbas*; *Semiramis, Queen of Babylon*; and *Esther and Ahasuerus*.[56] The theme of 'famous women' was familiar in the seventeenth century and may have derived from that of the Nine Female Worthies who appear in fourteenth-century tapestries.[57] To the original nine were added various women of biblical, historical or legendary fame, as types of particular virtues or for other reasons. Jordaens's set of *Famous women* may perhaps be regarded as the counterpart to a series of *Famous men* that was highly popular in the seventeenth century.

Overburdened with commissions and deadlines, Jordaens did not hesitate to re-use and adapt old compositions and motifs. There are abundant examples of this in his work, and the *Famous women* were no exception. No fewer than six cartoons of this series, simplified iconographically and with amended inscriptions, were transformed into illustrations of proverbs and sayings: they are among the ten tapestries that were added to the *editio princeps* of the *Proverbs* to form a set of eighteen, now in the Museo Diocesano at Tarragona. In this way *Mark Antony and Cleopatra* turned into *Musica recreat cor hominis*; *Solomon and the Queen of Sheba* into *Post tenebras spero lucem*; *Artemisia and the ashes of Mausolus* into *Post funera superstes amor*; *Judith and Holofernes* into *Tandem bona causa triumphat*; *Dido and Iarbas* into *Verba ligant homines*; and *Esther and Ahasuerus* into *Non sine cautela*.[58] The cartoon of *Artemisia and the ashes of*

Mausolus was also used for a tapestry which may have represented Olympias (mother of Alexander) and a lady of her suite and which, according to an inscription, belonged to a series entitled *The history of Philip of Macedon and Alexander the Great*[59] – another instance of Jordaens's lack of artistic probity in such matters.

Among the original Nine Worthies, early medieval Christendom was represented by King Arthur, Charlemagne and Godfrey of Bouillon. Charlemagne was certainly not the least illustrious of these; his name was revered for centuries, and in Jordaens's time there were still crowned heads who wished to ornament their walls with tapestries showing his famous deeds. One such series, *The history of Charlemagne*, was woven from cartoons designed by Jordaens in the early 1660s. The total number of pieces it comprised is not known, but eight are preserved through two nearly complete sets and several isolated weavings. There may have been more tapestries in the series as ten pieces were once in the Royal Collection at Turin. Six of these are now in the Palazzo del Quirinale at Rome: *Charlemagne's mother Bertrada obtains for him the hand of the daughter of the Lombard king Desiderius* – a more complete version of this, woven in Brussels by M. Roelants, is in the Rockoxhuis at Antwerp [231];[60] another, also woven in Brussels but by Jan Frans van den Hecke, was sold at Parke-Bernet, New York, 8–10 March 1944; *Charlemagne, the conquerer of Italy, presented with a crown and keys*; *The coronation of Charlemagne*; *The homage of Caliph Harun al-Rashid to Charlemagne* – another version woven in Brussels by Jan Leyniers and Jan Frans van den Hecke, was sold at Parke-Bernet, 8–10 March 1944 (a composition drawing is in the P. & N. de Boer Foundation, Amsterdam, an oil sketch is in the collection of Mr and Mrs van den Broeck-Visser, Brussels, and the cartoon is in the Arras museum [230]);[61] *Charlemagne appoints his son Louis partner in the reign and his grandson Bernard king of Italy*; and *Charlemagne in prayer*. Their borders show the arms of Charles Emmanuel II, duke of Savoy, and the monogram of his second wife, Giovanna Battista of Savoy-Nemours, whom he married in 1665. It appears from a document in the Archivio di Stato at Turin that the tapestries were delivered in 1666 and paid for in 1667, so they were presumably executed in 1665–66. The signatures or monograms show that the work was carried out by the Brussels weavers J. Cordys, J. Leemans, G. Roelants, J. van Leefdael and H.D.P. Another set belongs to the Prince de Ligne, Château d'Antoing, Belgium, and comprises seven pieces: *Charlemagne's mother Bertrada obtains for him the hand of the daughter of the Lombard king Desiderius*; *Charlemagne, the conqueror of Italy, presented with a crown and keys*; *Irene, the empress of Greece, sends messengers to Charlemagne*; *The coronation of Charlemagne*; *Charlemagne appoints his son Louis partner in the reign and his grandson Bernard king of Italy*; *Charlemagne in prayer*; and *The trophies of Charlemagne*. They were all woven in Brussels, *circa* 1660–61, by M. Roelants, J. Cordys and H.D.P. Some cartoons for this series were used previously or subsequently for the exploits of other heroes. Thus an *entre-fenêtres* in the Quirinal which represents *Charlemagne in prayer* (before his decisive victory over the Lombards) reproduces a portion of a cartoon at Arras executed around 1640 for *Gideon and the three hundred warriors*; on the other hand, the cartoon of *The coronation of Charlemagne* was later used for a tapestry clearly inscribed as representing *The coronation of Alexander*, despite the anachronistic presence of pope and bishops.

The casual way in which cartoons were treated, in whole or in part, is perhaps best illustrated by *Alexander the Great and Diogenes*, a tapestry in the Palazzo Venezia in Rome, which contains motifs derived from several cartoons. Thus

the group consisting of a negro servant, a horse and a dog comes from *Gideon*, while a boy with a parrot on his wrist is borrowed directly from *The homage of Caliph Harun al-Rashid to Charlemagne*. It is difficult to suppose that this clumsy work was executed with Jordaens's approval: it must rather be considered an example of plagiarism.[62]

Many of Jordaens's tapestries were woven at Brussels. After a temporary decline the workshops of the Southern Netherlands were enjoying a revival which lasted till well on in the century, thanks in large measure to the quality of the designs supplied by such artists as Rubens and Jordaens. Much profit accrued from the export of tapestries to foreign countries. Figure tapestries were made in other centres as well, but they did not equal those of Brussels, and orders continued to flow in to the Brabant capital.

Few of Jordaens's cartoons have survived: at most five can be identified, besides some fragments. An idea of the rest can be formed from extant tapestries, but there are others which are known only from documents or which are presumed to have existed for various reasons. Thus a written source reveals that Jordaens designed cartoons for an Old Testament series, *The history of Jeroboam I*. Five of these are listed as belonging to the estate of the Antwerp tapestry dealer Michiel Wauters, who had bought them from Jordaens's house after his death: 'First, where the prophet is attacked by lions (III [I] Kings 13:23–5); item, another ditto; item, the anointment of Jeroboam; item, a battle in which Jeroboam appears; item, the wife of Jeroboam comes to the prophet'.[63] There exist some drawings for this series, dated about 1660: *The wife of Jeroboam I and the prophet Ahijah* (I Kings 14), in the Bernard Houthakker Gallery, Amsterdam (1968); *Jeroboam I receiving part of the garment of the prophet Ahijah* (I Kings 11:29 ff), in two versions, one in a private Belgian collection [222], the other formerly in the Hermitage, Leningrad; *Jeroboam I punished for setting up the golden calves, and his withered hand healed by the prophet* (I Kings 12:28–13:6), in the Royal Library, Brussels; and *Jeroboam I punished by the prophet* (I Kings 13:1–6), in the Grenoble museum.[64]

Jordaens may also have painted cartoons for a *Story of Herse* (one of the daughters of Cecrops). This was quite a familiar theme in the Southern Netherlands: for example, a series of six pieces was woven in several versions in about 1570 in Willem de Pannemaker's atelier at Brussels.[65] Among the designs bought by Wauters from Jordaens's estate was one of 'Zephalus', *ie* Cephalus, the son of Mercury and Herse, who committed suicide in despair at having accidentally killed his wife Procris while out hunting. Jordaens's interest in the story of Herse is also shown by two drawings: *Mercury and Herse* in the Museum of Art, Rhode Island School of Design, Providence, Rhode Island,[66] and *Mercury discovering Herse and her companions*, known only from a copy in the Municipal Print Room, Antwerp.[67]

The list of cartoons bought by Wauters from Jordaens's house comprises twenty-eight subjects, and apart from those already mentioned there may well be others related to sets of tapestries; but it is hard to tell, as the titles are too vague or abbreviated. Some may denote individual pieces, and account must also be taken of the possibility that the compiler of the list did not correctly recognise all the subjects.

Apart from the cartoons that had undoubtedly belonged to Jordaens, Wauters left numerous others including 'The works of the Apostles, in eight pieces'. In addition he possessed a series of 'Works of the Apostles, in six pieces', the authorship of which is not mentioned in the inventory.[68] In view of Wauters's

interest in Jordaens's cartoons, these too may well have been the latter's work,[69] more especially as he made drawings of several related scenes around 1655, which include: *Paul and Barnabas at Lystra*, formerly in the Max Rooses Collection, Antwerp; *Paul healing a cripple at Lystra*, in New York; *The scourging of Paul and Silas*, at Frankfurt am Main; *Paul before Ananias*, at Rotterdam; *Paul, Silas and Timothy before the city-gate of Philippi*, formerly in the Brod Gallery, London; *Paul, Silas and Timothy at Philippi*, in the Municipal Print Room, Antwerp; and *Possessed man attacking the sons of Sceva at Ephesus*, in Rotterdam.[70]

All this does not exhaust the account of Jordaens's achievement in tapestry: much preparatory work and many actual tapestries may have been lost. There are various drawings which may have been intended for this purpose. Among religious subjects, for instance, this can be said of *The making and worshipping of idols* (1658), in the Ecole Nationale Supérieure des Beaux-Arts, Paris, and the stylistically similar *Give, and it shall be given unto you*, in the Pierpont Morgan Library, New York;[71] or a group of drawings of about 1660 consisting of *The priests of Baal and the prophet Elijah* at Copenhagen, *The priests of Baal humiliated by Elijah*, in the Smith College Museum of Art at Northampton, Massachusetts, and *Elijah awakened by the angel*, formerly at Leningrad.[72] Four drawings of about 1645 entitled *Veritas Dei*[73] depict St Paul with various allegorical figures illustrating Galatians 6:8, and may have been sketches for a piece in the series of *Acts of the apostles*. Alternatively they may relate to a *Triumph of religion* (or *of the Eucharist*), although no such series has as yet been traced. There are also *The presentation in the temple* (*circa* 1630–35) at New York [116][74] and *The sacrifice of Isaac* (*circa* 1650) at Berlin-Dahlem,[75] drawings in which the border is already depicted and which were designed as *modelli*. Among non-religious drawings there is an *Allegory of the month of March* (*circa* 1655–60) at Leningrad,[76] probably a design for a series of *Months* and perhaps connected with a cartoon entitled *Astronomy*, which appeared at the Frans Pauwels sale (Brussels, 1803);[77] or again an *Allegory of Truth* (*circa* 1660) at Grenoble,[78] which was probably likewise a *modello* for a tapestry.

Jordaens's contribution to the art of tapestry was of great importance. True, in this field as in others he was overshadowed by Rubens, but the latter's interest in tapestry was limited, whereas Jordaens devoted a considerable part of his working life to it. His cartoons and the tapestries based on them show that he took an interest in subjects of every kind: religious, mythological, historical, allegorical and moralising genre scenes. All these works, in which his personality was reflected, form a corpus of no less value than his painting. Their number and quality entitle him to be called one of the chief, if not actually the foremost, designers of tapestry cartoons in the second and third quarters of the seventeenth century.

X

Jordaens the draughtsman

Jordaens was not only a great painter but an extremely prolific draughtsman: his known drawings number between 425 and 450.[1] His fellow-artists Rubens and Van Dyck also left a large number of drawings, as did other Flemish painters of this period. This may have been partly due to the nature of their finished works, comprising elaborate compositions with many figures and often of large size. The style of the time, moreover, called for much preparatory work. Flemish Baroque preferred organisation to isolation, it was dynamic rather than static, and it tended to replace simple themes by complicated ones. Another reason for the number of drawings lay in the working methods of the studio. Jordaens's atelier must have resembled Rubens's in many respects and presented a similar picture of feverish activity. Apart from Rubens, and without forgetting Frans Floris, there was probably no Flemish painter who at any time organised a productive studio comparable to that of Jordaens. The consequences of this as far as drawings are concerned are easy to imagine and are confirmed by historical research: the more assistants and pupils there were, the more drawings were produced. As the studio grew in size, the drawings became not only more numerous but more elaborate. Rapid compositional sketches gave place to finished *modelli* which could be submitted to customers for approval and reproduced in full size by assistants (*cnapen*). In addition many figure studies were drawn for the latter's benefit, such as were hardly ever produced by Jordaens when he was young and worked single-handed.

Jordaens was a typical 'draughtsman-painter', that is to say his drawings are pictorial rather than simply linear. He employed wash, watercolour and body-colour and most of his composition sketches use these painterly techniques, singly or more often combined. Unlike Rubens, whose sketches are in oil on panel, Jordaens generally used paper. He also painted some oil sketches, but most of these are on canvas and date from the second half of his career. His preference for sketching on paper with wash, watercolour and bodycolour was undoubtedly connected with his training as a 'water-painter'.

He was extremely thrifty with paper and many sheets consist of strips joined together, sometimes in curious shapes. He often enlarged a drawing, either at once or after a lapse of time, by transferring it to a larger sheet or adding pieces to it, and he used scissors and paste freely to cut off or cover unwanted portions. This applied both to his own drawings and to those of others, which he had no scruple about reworking.

The study of Jordaens's drawings is complicated by the existence of many sheets executed in his style by unknown hands, frequently those of apprentices

(*leercnapen*), who were constantly busy with chalk, pen and brush, copying the master's pictures but also his much more numerous drawings. They naturally adopted his style, sometimes so faithfully that it is very hard to tell originals from copies. Jordaens tended to surround himself with assistants who seem to have lacked personality and made no attempt to develop a style of their own — they were, in fact, craftsmen rather than artists. The whole atmosphere was that of a workshop in which aesthetic problems were apt to take second place to those of production and marketing, and this lack of artistic integrity is a further source of confusion in judging the studio's output. Jordaens's own drawings exhibit great variety, owing to the general development of his style and the different purposes for which they were required.

During his long career, Jordaens received the most varied commissions, and the related drawings differ greatly in style and technique. In his earliest period (to *circa* 1618), when he was chiefly concerned with composition sketches for religious and mythological scenes, he was very conservative in his methods. Whereas he later used black, red and white chalk, watercolour and bodycolour, in these early years he confined himself almost entirely to pen and brush in brown ink, a technique learnt from Rubens. After preliminary work in black chalk he would use a pen to outline the figures in broken strokes, and in some cases would retrace the outline more than once before finding a satisfactory solution. Modelling is suggested by hatchings with the pen and tip of the brush, while the shadows are indicated by a broad application of wash, account always being taken of the general balance of light and shade. In drawings of this kind, where the painterly predominates over the linear, and whose sketch-like freedom goes back ultimately to Italian models, Jordaens established the composition as he first conceived it and as it would appear, perhaps with slight variations, in the final painting.

In these drawings he never went into detail or elaborate retouching. With a rapid stroke, sometimes lacking in firmness, but with a gusto which sought to emulate that of Rubens, he endeavoured to suggest rather than analyse. His figures for the most part stand side by side in hieratic attitudes without any effect of movement, in poses that give a sense of inner tension. In his earliest work some forms can be seen in which the anatomy of the figures is obscured by the supple, delicate play of lines [31, 46]: these reveal the origins of his art and its affinity with the Mannerist painters of his native city. But this type of elegance soon gives way to the realistic and monumental depiction of figures, the models for which are clearly taken from everyday life. They are generally seen somewhat from below, and at an early stage he used light effects in the manner of Caravaggio, with sharp contrasts in the modelling of physical forms and the treatment of cast shadows [34, 52]. When the subjects are transferred to canvas there is generally a tendency to place the figures closer together, so that they fill the compositional field and are even cut off by the frame. In this way the background is screened from view, giving the early compositions their characteristic, highly decorative appearance.

It is clear that in this period Jordaens drew studies of detail or individual figures that were to form part of compositions. Although only two studies of heads from life exist [48] and one exceptional sheet with studies of a sculpted head [39], the recurrence of particular types of heads in his pictures shows that he must have drawn models from life and afterwards used them repeatedly in successive works. It may be that he also painted some studies of this kind in oils, as he was later to do in the case of Grapheus for example, but no instance of this

has come to light. On the other hand there are several full-length drawings from life of male nudes [29, 30] that recur in similar poses in some of his paintings, a practice borrowed from Rubens. From the beginning, Rubens's influence on Jordaens was not confined to techniques and the use of figure studies but extended to composition, as may be seen from drawings in which Jordaens copied pictures by his great predecessor.

The extant drawings of the period *circa* 1619–27, when Jordaens reached the height of his powers as a painter, consist, like those of the previous years, almost entirely of composition sketches for pictures, but in addition to religious and mythological themes, these now include allegory and genre [56, 65, 66, 77, 78]. Apart from these there are only a few studies of figures and heads, drawn from life [70, 72] and used for the detail of composition sketches. There are as yet no designs for tapestries or drawings executed for their own sake. The sober technique of Jordaens's early years is still the rule: a preliminary drawing in chalk, which might now be red as well as black, was worked over with pen and brush in brown ink. In a few more elaborate drawings the brown wash is supplemented with watercolour and bodycolour.

In the previous period Jordaens was fond of sharply illuminating his groups of figures, and, although he mostly relied on sunlight for this purpose, he sometimes also used an artificial source such as a candle or brazier. In the present period he made increasing use of the latter. The source of light is at times hidden by procedures typical of Caravaggio, for example by placing a figure in the foreground to conceal it from view and to act as a *repoussoir*. The effect is to intensify the illumination of some figures and objects, giving them a bright and visionary quality, while the areas that are not picked out in this way are plunged into impenetrable darkness.

Jordaens's style of composition has evolved also. The figures no longer crowd the area to bursting-point: they are still in the foreground, but there is more space between them and especially over their heads. In this way they are less emphasised and less overwhelming, and the scene as a whole is easier to grasp. There is still not much sense of background, but now the people and animals have room to move, and their mutual attitudes are more natural than before. In addition the figures tend to become slimmer, so that the general effect is less monumental and in a minor key; there is a more intimate atmosphere, an increased sensitivity foreshadowing the work of later years.

At this period Jordaens had some pupils in his studio: four were registered in the Lists between 1620 and 1624. It is unlikely that he had assistants (*cnapen*) as well, as the high quality of the paintings produced at this time, and especially their free, rhythmical brushwork, show them to be entirely his own work.

In the years *circa* 1628–41, Jordaens broadened the range of his activity and played an increasingly prominent part in the artistic life of Antwerp. He received important commissions, such as great altarpieces for clerical patrons, and created new prototypes of genre paintings with a moral import, such as *The king drinks* and *As the old sang, so the young pipe*. As he had previously done with *Satyr and peasant*, he reproduced these scenes in numerous permutations, and from now on in ever-increasing quantity. He also began to make designs and cartoons for elaborate sets of tapestries: *The story of Odysseus, The history of Alexander the Great* and *Scenes from country life*. All this required the help of many collaborators, and his studio gradually increased in size: in 1641 he had no fewer than six assistants, while three apprentices are mentioned in the Lists between 1633 and 1641. Jordaens became prosperous and, like Rubens, was able

to build himself a handsome dwelling with a capacious studio. His style and technique continued to be influenced by Rubens, and from this time onwards architectural settings in the manner of Veronese feature in his work; he also seems to have been impressed by Baroccio's compositions.

Besides numerous composition sketches in pen and brush and brown ink, sometimes worked up lightly in watercolour, he now began to prepare elaborate *modelli* for submission to patrons and subsequently for imitation in the studio [93, 96, 115, 116, 129, 130]. For these he used rich watercolour and bodycolour, at first over sketches in pen and brown ink but later, as a rule, over preliminary work in black chalk. As regards the handling of line, Jordaens at this time developed a preference for abrupt, angular forms, thus sacrificing in some degree the fresh, spontaneous character and truth to life of his early sketches. However, he was skilled at expressing the essential with a minimum of effort, and at this time he possessed the art, which he afterwards often failed to display, of stopping when there was no more to be said. Instead of robust, exuberant popular types with their rounded forms, he frequently drew elongated, mannered figures belonging to a world of aristocratic refinement. With their small heads and ascetic-looking bodies, they suggest extreme spirituality and are the antithesis of bourgeois materialism, let alone any form of rusticity.

Some of the designs for the tapestry series of *Odysseus* [111], *Alexander the Great* [113] and *Scenes from country life* [122, 123, 125] are among Jordaens's finest drawings. A few of the figures may be somewhat theatrical or unduly prettified, but what makes these works captivating is the charm and grace which pervades them. The plain-spoken, monumental realism of Jordaens's earlier style is no longer apparent. The approach is more engaging, imbued with moderation and appealing to the mind and heart rather than the senses: an effect enhanced by the technique of the drawings and the subtlety of their cool colour-scheme.

Studies of figures and heads from life, which were previously rather scarce, are now numerous [117, 133, 136, 141, 142, 148, 151] and various animals are also depicted [106, 134, 135]. These studies are usually in the *trois-crayons* technique of black and red chalk, somewhat heightened with white. Some especially plastic and luminous studies of drapery suggest awareness of similar drawings by Cigoli. Different designs for tapestry borders are known [108, 109, 150]. Jordaens continued to paint portraits assiduously, as he had done from his youth, and at this time he made some fine preparatory studies [239, 247].

After Rubens's death in 1640, Jordaens was the greatest painter in the land, and commissions became more plentiful than ever. Besides the upper clergy and the bourgeoisie, his services were now in demand from royal and aristocratic circles, including Charles I of England, Christina of Sweden and Amalia van Solms, widow of Prince Frederick Henry of Orange. He continued to design many tapestries: the series of *Proverbs* belongs to this period. The studio was operating at full blast, with the assistants working as a team and making every possible use of available materials – a system not always conducive to artistic merit. It led, however, to the execution of many drawings, a large number of which have survived. Jordaens made sketches of compositions and figure studies; his pupils learnt their craft by drawing copies of works in the studio, and soon adopted the master's style. It was all the easier for them to do so as by this time he had developed a routine based on the use of broken and angular lines. This became increasingly automatic and led to a petrifying of his style, the angularity often producing a restless, disturbing effect.

At this period composition sketches for paintings and tapestries were still executed in chalk, watercolour and bodycolour, though the use of bodycolour was diminishing [162]. Red chalk predominated in many drawings, giving them a character of their own [190]. Others, washed in much-diluted watercolour in half-tones – blue-grey, lilac and pink – are strikingly cool, light and translucent. For studies of figures [171, 180, 182, 200], heads [160, 198] and animals [163] Jordaens generally continued to use red and black chalk, somewhat heightened with white. There are some low-warp tapestries of this period for which cartoons and various designs for borders in watercolour and bodycolour have survived [177]; some of these in fact date from the 1630s. Together with the composition sketches, studies and cartoons, these illustrate the different stages of activity involved in the production of Jordaens's monumental tapestries.

From *circa* 1652 to 1678 Jordaens and his studio continued to work vigorously. Together with Flemish and Dutch colleagues (*see* pp 233, 236) he was entrusted with the task of decorating the Orange Hall of the Huis ten Bosch near The Hague. The lion's share of this work fell to Jordaens, and later he was commissioned to decorate part of the new Amsterdam town hall. As before, he painted numerous altarpieces for churches at Antwerp and elsewhere, as well as allegories and genre scenes for his bourgeois clientèle. He also continued to design tapestry cartoons. Many works produced at this period reflect the increasing strength of his Protestant convictions.

With a few exceptions, the work of Jordaens's last decades is not of very high quality. He introduced little innovation, relying for the most part on old formulae and variations on prototypes, or combining elements from earlier compositions. The angularity of the figures and their rhetorical gestures became more pronounced and were finally exaggerated into a lifeless schema. This applies to paintings and drawings alike; in the latter, the media used are niggardly and are confined to chalk and pen in brown ink, occasionally reworked with diluted watercolour [215, 219, 221, 222, 226, 228]. Elements from the large repertoire of forms accumulated over the years are repeated again and again, but are sadly lacking in expressiveness. These summary compositions, with their lack of depth and the elementary handling of form and line, were only too easy to imitate, and it is in this period that the most difficulty arises in distinguishing Jordaens's work from that of his copyists and followers.

XI

Jordaens the man and the artist

The names of Rubens, Van Dyck and Jordaens, the trio of painters who conferred lustre on seventeenth-century Antwerp, are closely linked with one another. All were extremely prolific, their works are in many ways comparable in subject-matter as well as in style, and all three had a predilection for large-scale works. However, while their artistic affinity is beyond question, their positions in contemporary society differed widely.

Rubens and Van Dyck were both court painters who served the aristocracy and were in time ennobled themselves; Jordaens, on the other hand, was on the side of the people and the bourgeoisie. Rubens grew up in a humanistic environment and Van Dyck came of a patrician family; both enjoyed an upper-class education which enabled them to move freely in the highest circles, including the courts of Europe. They were men of wide culture who had travelled and knew several languages. They regarded painting as a noble occupation, and were convinced of the superiority of the artist's calling to all forms of craftsmanship. Jordaens belonged to a class that expected much less from life. His father had made a good living as a respected linen-merchant, but the family's outlook and habits did not take much account of refined cultural values. Jacob himself, as A. Stubbe wrote, was 'a worthy bourgeois who devoted his whole life to ensuring his own standard of living. He regarded that standard, along with his artistic talent, as entitling him to be treated respectfully by people of every class, to have a say in the city's affairs, to follow his own bent in political and religious matters, and in short to go his own way in all circumstances, regardless of anyone's opinion'.[1] This defiantly bourgeois attitude, at a time when community life centred on the court and aristocracy, gave Jordaens a special position as a man and an artist, and accounts for the limited range of his social connections. He saw little or nothing of humanists, philosophers, lawyers, archaeologists or historians – in contrast to a learned man like Rubens, who was on friendly terms with many scholars at home and abroad – and he had even less to do with courtiers and the nobility, from whom Van Dyck was inseparable all his life.

But, while it is not hard to perceive the effect of Jordaens's family background and education on his mode of life, it is less easy to fathom the depths of his personality, what he was like as a man, and what characteristics made him a prolific, prosperous and universally respected artist. Apart from his work there is not much evidence to help solve this puzzle. His self-portraits give some idea of his temperament as well as his outward appearance. They are few in number, however: he clearly felt no compelling need to explore his own personality, and apart from three family groups there are no more than four paintings which

show Jordaens by himself. However, these various portraits do have the advantage of presenting him at different ages: at about twenty-three, first with his parents, brothers and sisters [232] and again with the Van Noort family [233], then five years later with his wife and their first child [234], and later still as a man of forty [246, 247] and again of fifty [250]. Most of these are head-and-shoulders or half-length portraits or show him sitting on a chair, giving little indication of his build and stature; however, he appears as a tall, stalwart young man in *Portrait of the Jordaens family, circa* 1621–22 [234]. He grew stouter with advancing years, and in the later portraits even corpulent. He wore a moustache and imperial according to the fashion of the time; his auburn hair was at first close-cropped, but in riper years he wore it shoulder-length. He painted himself without embellishment. With his strong cheekbones, thick lips and somewhat irregular features, he gives an impression of being proud and strong-willed yet not entirely sure of himself. From his penetrating gaze one might suppose him to be unalterably serious, if it were not for some portraits that show him with a mischievous and quizzical look, proving that he could also see the humorous side of life.

An etched portrait of Jordaens by Van Dyck presents a very different picture, but it cannot be a likeness: it depicts a refined, aristocratic individual such as Van Dyck himself was, and Jordaens in his more ambitious moments may have aspired to be. In any case one must be cautious in judging a man's character from his recorded appearance, especially when other contemporary evidence is lacking. In Jordaens's case there is very little, and all of it relates to his last years. Mathias Schuyts, a painter from Hamburg, visited him in 1669 and found him very friendly and polite.[2] Joachim von Sandrart, who also met him personally, only writes that in his seventy-eighth year he was living comfortably at Antwerp and was highly esteemed there.[3] Constantijn Huygens, who visited him with the Prince of Orange in June 1677, noted in his *Journal* that Jordaens talked incoherently and sometimes quite beside the mark.[4] All these references to Jordaens in his old age do not tell us much, and they are the only known written sources.

Jordaens was not a great letter-writer like Rubens, who left some 250 of them. Jordaens's surviving letters are few and are mostly business communications in a dry, unrevealing style. Only one strikes a personal note of indignation and gives a glimpse of his character. This was written on 23 April 1651 to Huygens, who acted as intermediary for *The triumph of Frederick Henry* commissioned by Amalia van Solms and for this purpose had sent Jordaens a sketch and description by the architect Jacob van Campen. After begging leave to express himself freely, Jordaens complained that Van Campen was seeking to tie him too closely and that he could not be thus kept in leading-strings; he must, he said, be granted 'the freedom that is especially requisite on such an occasion . . . for my own protection in the sight of posterity'.[5] Here is an indication of Jordaens's sense of independence and confidence in his own artistic merit, as well as his concern for the opinion of future generations.

Virtually nothing is known about the life Jordaens led, who his friends were or what kind of social relations he maintained. Considering the volume of his work, he must have been not only extremely energetic but also constantly busy. Year in, year out, he produced a vast number of pictures, sketches, studies and cartoons, the clockwork regularity of his output showing that he had imposed on himself the discipline of an orderly artistic life. He did not, like Rubens, exercise a second profession as a diplomat, nor was he a restless wanderer like Van Dyck.

There is no sign of any non-artistic activity on his part, nor does he seem to have had much intellectual curiosity. In short, to all appearances he led the simple, quiet family life of a bourgeois who was also an accomplished craftsman, which does not mean that it was free of everyday cares. There were, for example, disputes over his work which sometimes led to lawsuits. This might happen to anyone, but perhaps Jordaens's temperament was a contributory cause. When, in 1621, the city magistrates instructed him to assume the office of dean of the guild of St Luke, he demurred on financial grounds and had to be compelled to take the oath on pain of a fine.[6] In 1641 he sued the heirs of Cesare Alessandro Scaglia for arrears of payment in respect of the commission of Charles I of England, negotiated through Scaglia, for a set of pictures of *The story of Psyche*.[7] Between 1641 and 1649 there is a record of lawsuits with his neighbours Frans Rijssels and Melchior Oosterinncx concerning lights and party walls.[8] In 1645 he appealed against a lower-court verdict which had gone in favour of the treasury of the Orphanage (*Weesmeesterkamer*).[9] Other legal disputes with, for example, Hieronymus de Lange in 1645[10] and Martinus van Langenhoven in 1648,[11] concerned the price or quality of work delivered. The frequency of these cases suggests that Jordaens was not always an easy man to deal with and was certainly a staunch defender of his own interests. The fact that he openly proclaimed himself a Calvinist in a hostile Catholic milieu shows that he had plenty of resolve and the courage to assert his ideas against opposition from any quarter.

To accomplish his large output he needed not only energy but skill and rapidity of execution. Joachim von Sandrart's statement that he once painted a *Pan and Syrinx* with life-size figures in six days (*see* Chapter IV) is no doubt exaggerated, if only because contemporary technique made it necessary to allow the paint to dry several times; moreover it was fashionable to make such hyperbolical claims. All the same, Von Sandrart's evidence should not be dismissed entirely: all Jordaens's pictures show that the brushwork was executed with a firm hand and in a steady, unbroken rhythm.

It is a somewhat complicated matter to place Jordaens in the setting of seventeenth-century art. His work was constantly in a state of development throughout his long career, and shows great varieties of style. Tensions between his personal disposition, his upbringing and the society in which he lived contributed to making his work uneven and disparate in character. It is difficult to sum up all these influences, to appraise Jordaens's originality and assign to him a definitive place in the history of European art. P. Buschmann Jr attempted to do so in his monograph, which despite its modest size is of great value for its time, and Max Rooses also tackled the problem at length. On the whole, however, it is A. Stubbe who shows the fullest insight into the relations between Jordaens's art and the political, religious and cultural circumstances of his time. As the title of Stubbe's long essay – *Jacob Jordaens en de Barok* – indicates, he takes as his frame of reference the Baroque style which dominated the art and civilisation of seventeenth-century Europe.

The Baroque period was that of absolute monarchy and the divine right of kings, whose splendour was a reflection of the glory of God. Raised high above the rest of society, the prince appeared to his people amid a court whose brilliance enhanced the impression of his superhuman grandeur. Wherever this type of monarchy and its attendant aristocracy held sway – in London or Vienna, Paris or Madrid – the Baroque style was the prevailing art-form. The church tended more and more to follow suit: not only were the palaces of its

dignitaries, their cathedrals and private chapels adorned with Baroque splendour, but so were many churches in the city and countryside. Spiritual and temporal leaders competed in employing the most able architects, sculptors, painters and musicians. They made no distinction between local and foreign artists, Catholics and Protestants: art, like science and the rest of cultural life, was independent of confessional differences as of national boundaries, and anyone who had made his name could exercise his talents wherever he pleased. Artists vied for the favour of the higher clergy and the nobility, but more ardently still for that of the monarch, who was the embodiment of civilisation and whose patronage meant wealth and fame. To a degree never equalled before or since, the service of art in those days was identical with serving one's prince.

Baroque art was, first and foremost, royal and aristocratic in nature, inspired as it was by the power, radiance and splendour of authority. Only what was princely or exalted seemed a fit subject of interest in the monarchical countries of Europe, that is to say all but a few exceptions such as Holland. In our days of social equality it is hard to realise the depth of reverence and obsequiousness that artists showed towards their patrons.

The majesty that is such a striking feature of seventeenth-century art is distinguished by heroic proportions, animation on a grand scale, and classical restraint. The first of these qualities is perhaps best seen in architecture, which transcended the harmonious limitation of the Renaissance ideal: Baroque palaces, and the life that was lived in them, left no room for intimacy or human simplicity. In the same way, Baroque churches did not encourage medieval and mystical feelings of self-abasement. Places of worship which had once provided a quiet retreat for the individual believer were turned by the Counter-Reformation into religious palaces where all the resources of art served as vehicles of clamorous propaganda. In the second place, compared with the mainly static art of the High Renaissance, Baroque art and especially the High Baroque of the Southern Netherlands is characterised by heroic animation and *joie de vivre*, the voluptuous expression of inexhaustible youthful strength, as seen most clearly in the work of Rubens. Yet, in spite of all this exuberance, the heroic elements conform to classical laws of order which produce a harmonious balance and clarity of composition. Baroque was not a bourgeois or republican form of art, and in Holland it remained a rarity. In the Southern Netherlands, by contrast, thanks to the Counter-Reformation and to Rubens's genius, it flourished to a remarkable degree. It was, however, largely confined to painting: the influence of the church and Rubens combined was insufficient to affect architecture, sculpture, literature, music, scholarship and social life, so as to constitute an all-round Baroque culture on the European scale.

Flemish Baroque was a peripheral phenomenon: it arose in the border area where the monarchism of southern and central Europe came into collision with the combatant, self-confident Dutch republic. Having no native princes of their own, the Southern Netherlands lacked a royal court, the customary nucleus of a Baroque culture. The archduke Albert and his consort Isabella were conscious throughout of the modesty of their political and financial resources. They endeavoured to maintain a regime of sufficient brilliance to enhance their authority, but it was only a humble imitation of what other European rulers were able to achieve. Fortunately for artists there was also the church, the only social force that displayed truly creative activity and called forth the resources of the various classes of society, combining them into an impressive religious and artistic movement. Allied to Philip II and protected by him, the church had

gone through difficult times during the Netherlands' struggle for freedom, but it now enjoyed the benefits of the Spanish victory in the South. This brought about a massive return to Catholicism, so that in Antwerp and many other cities Calvinism, which had been professed by a large majority of the population before 1585, had practically disappeared by about 1600.

Well-to-do families provided funds with which to build, restore or decorate churches, monasteries and convents. These were not lavish by Baroque standards, but they sufficed to meet the demands of the principal patrons – canons, abbots and prelates who did not belong, as in other Catholic countries, to a proud and ambitious nobility but to the middle class. The modesty of resources and of commissions meant that religious architecture in the Southern Netherlands was of no great consequence at this time, while secular architecture was quite insignificant compared with that of foreign countries. In the same way, sculpture was unable to develop fully for lack of commissions on a grand scale. But, while architects and sculptors did not succeed in making seventeenth-century Flanders a centre of European importance, painters were more successful as a result of Rubens's providential influence. Although of bourgeois origin he succeeded in imparting an aristocratic nobility to temporal scenes, which he depicted with passionate vehemence but also with classical self-command. It was this aspect of his talent that caused him to be so much admired by foreign princes and church dignitaries and to receive so many important commissions from them.

The Flemish primitives, in line with Gothic tradition, were more attuned to matters of the spirit than to the stylistic canons of formal beauty. The sixteenth-century Romanists were the first to escape the preoccupation with spiritual problems and pay attention to criteria of pure form, but they did not succeed in creating a style that came anywhere near to rivalling the Italian Renaissance. All too often, they remained half-way between strict objectivity and formal artistic beauty. Rubens managed to do what the Romanists had failed in: free from all spiritual concern, he saw the beauty of transitory life and transfigured it into permanence by means of an exalted style. To do so he followed Italian models closely, but in a highly original way. He alone was able at all times to reconcile the many contrasts implicit in his work: between fidelity to nature and obedience to the rules of form, between multiplicity of content and clarity of composition, between the frequent sensuality of the subject-matter and the spiritualising dominance of an intellectual style. Where Rubens directly influenced his Flemish contemporaries they produced a monumental type of art which bore comparison with the best work of foreign painters and was admired at many European courts. Where his influence was slight or transient, as was increasingly the case after his death, Flemish Baroque painting diverged along the two main lines that Rubens had combined, the classic and aristocratic on one hand and the realistic on the other.

Artists of the first type, such as Van Dyck, used the aristocratic aspects of Rubens's art to create a formula which appealed to the increasingly refined taste of European court circles, and thus gravitated to foreign countries as their natural centre. Jordaens, the most important representative of the realistic tendency, underwent Rubens's direct influence as much as any other artist of his time. This did not merely enrich his art, however: Rubens's passionate heroics distracted Jordaens from his natural vocation, that of faithfully reproducing reality. From this point of view his work has a hybrid quality, such as could only have arisen in the Southern Netherlands at that time. Without realising how

contradictory the process was, he transposed the rhetorical eloquence of religious, mythological and historical Baroque into a popular language that sometimes verged on caricature. In so doing he did not hesitate to inflate vulgar details to giant proportions or deck out bourgeois incidents in the most florid style. His art was that of a bourgeois lacking an appropriate milieu, whereas he had only to cross the border into Holland to find an atmosphere that would have been ideally conducive to the unity of his style. His exuberant, free and easy, loud-laughing character was not that of a Dutchman, but in his developing civic consciousness he was closer to the Dutch than to his fellow-countrymen. It was this attitude which gradually estranged him from the Spanish regime and Catholic conformism of the Southern Netherlands, until in the end he proclaimed his inner convictions by openly adopting Calvinism.

Lack of refinement was what chiefly distinguished Jordaens's art from that of Rubens and Van Dyck, and made him an unsuitable choice for the task of creating Baroque interiors for secular and ecclesiastical rulers. His 'official' works were sometimes remarkably impersonal and, more often still, displayed a strange contrast between the exalted theme and the vulgarity of this or that figure. Although his prosperity placed him above ordinary craftsmen, he felt close to them by reason of his social origin and day-to-day contacts, and was better equipped to paint what he had seen and enjoyed with his own eyes than elegant and courtly figures, the profiles of which he sometimes borrowed from official artists. As a result he was ignored by the Spanish court and that of Brussels, received no important commissions from Italy, France or Germany, and was only once entrusted with work for Charles I of England, in not very flattering circumstances. Only after Rubens's death, when he had become the first and indeed the only great painter in the land, did he obtain one or two commissions from rulers in northern countries, where the standard of magnificence was less high and the perfection of Baroque art was not expected.

Jordaens's work, however, was most popular with the burghers of the Southern Netherlands, many of whom were still well-off in spite of the closing of the Scheldt, the growing weight of taxes and the ever-recurring wars. Their good fortune in such troubled times was an inducement to this class to display their prosperity openly, either by luxurious feasting and drinking or by over-decorating their houses. Jordaens also found many customers among the Catholic clergy, who were mostly of bourgeois origin and less exacting in matters of art than the higher clergy of other European countries. About a third of his work comes under the heading of Catholic iconography, and a good deal of his increasing wealth was due to such commissions. Here too, however, his natural bent and especially his lack of refinement denied him access to cathedrals and bishops' palaces or to Jesuit houses with their classical tradition. Whereas Rubens received many clerical commissions from abroad, interest in Jordaens's religious work was confined to the Southern Netherlands and, as a rule, to inconspicuous churches, sometimes in obscure localities. The Jesuits, who were the champions of the Counter-Reformation, bought innumerable pictures and statues for their newly built colleges and churches, but their spiritual requirements were ideally met by Rubens, who received many important commissions from them. Jordaens recognised and admired the qualities that made Rubens's work so attractive to the followers of St Ignatius and to many others: he strove to emulate them, and did not hesitate to seek inspiration from Rubens's effortless compositions with their exultant animation of form and colour. Indeed, he followed Rubens's output almost year by year, painting

works that closely resembled the master's in both iconography and form, and this dependence is often visible in secular as well as in religious works.

Like most European artists of the time, including Rubens and Van Dyck, Jordaens was a kind of pagan as far as the effect of religion on his art was concerned. His beliefs might be serious, but it was only occasionally that his work showed any sign of their penetrating to the depths of his being. He was never, like Rembrandt, an explorer of the soul, and seldom a truly religious artist: his work was concerned more with the glorification of temporal things. This attitude, together with practical calculation, may explain why he, a Calvinist, continued to paint pictures for the Catholic church and thereby supported the cult of saints, although Protestants were violently hostile to this practice. It is still distressing that an artist should, for the sake of material advantage, place his talent at the service of a cause to which his conscience is opposed.

Baroque art enlarged the boundaries of nature in all directions, and it is therefore not surprising that Jordaens was never a 'naturalist' in the historical sense of one who seeks to present reality undisguised. Even in homely or informal scenes like *Satyr and peasant* or *The king drinks*, he depicted a superhuman and preternatural world which was not a result of experience but the fruit of his imagination. In so doing he largely helped to create the legend of the invincible primal strength and exuberance of the Flemish people. He filled his compositions with life-size figures and an awe-inspiring décor, like the abundant sheaves in his *Allegories of fruitfulness* or the ostentatious architecture that appears in so many paintings. In depicting heroic scenes he relied to a great extent on size and quantity: his figures are not only large and imposing, they are often so numerous as to produce an effect of crowding. Rubens, who also used a profusion of figures, composed his scenes in a classic and organic fashion. Taking the general effect as his starting-point, he subordinated the formal and tonal aspects of individual features to the overall demands of clarity, and thus was able to combine smoothly the most heterogeneous elements. For Jordaens this objective presented a constant problem, and the individual parts of his compositions, distinctive as they are, sometimes give the impression of being accidentally juxtaposed, awkwardly numerous or uncomfortably crowded.

Jordaens had no great difficulty with foreground scenes in which a limited number of figures confronted the spectator in close-up and full attention could be devoted to reproducing material details. His troubles began with the depiction of numerous figures in depth. This is seen by comparing the bewildering accumulation of figures in his *Triumph of Frederick Henry* with Rubens's *Coronation of Marie de Médicis*, where the no less numerous figures are so skilfully deployed that each one occupies its proper place without detracting from the main theme. The disorder and superfluity often met with in Jordaens's work is not so much due to the number of figures and other elements as to the limitations of his compositional talent. He also lacked the virtuosity with which Rubens showed his figures moving effortlessly in space. His perspective was often faulty, especially when he had to depict ethereal beings hovering in mid air. This was already noticed in his lifetime, for in 1640 Sir Balthazar Gerbier wrote to the Abbé Scaglia, apropos of Jordaens's decorations for the ceiling of Greenwich Palace: 'Perhaps the Sieur Jordaens will be glad to get rid of the said soffitto, on account of the foreshortenings'.[12] Jordaens must have been fully conscious of his limitations, and perhaps this is why he so often based himself on Rubens's compositions, while after the latter's death his own shortcomings in this respect are more conspicuous than ever.

The numerous tapestries designed by Jordaens occupy a special position. Although some of the finished sets came into the possession of ruling houses, there is no known case in which this was due to a direct order. Art dealers commissioned cartoons from Jordaens, and naturally stipulated that they should conform to the canons of aristocratic taste, which explains the lofty style of most of these works. Thanks to his training as a 'water-painter' he was fully acquainted with the decorative requirements of tapestry work, but his cartoons would certainly have presented a different appearance had it not been for Rubens's designs, which to a great extent set the prevailing fashion. This applies both to the theatrical rhetoric of Jordaens's pieces and to the way in which the elaborate borders are related to the central field, so as to form a greater compositional and iconographical unity. But even in his most fashionable tapestry designs Jordaens's own approach is marked by some special feature or another.

Rubens's heroic figures seldom laugh, and scarcely ever cry out. The vehemence of his scenes is expressed in purely visual terms; the tense attitudes and gestures of the figures, the fluent, rhythmical groupings and the profusion of colour are worked with classic mastery into a concise, self-contained whole. This dynamic organisation of form and colour was far removed from the static, somewhat ponderous style that was native to Jordaens. He lacked a sense of rhythm, with the result that his figures do not form part of a general movement and his compositions are not inspired by a crescendo of action. He used other means to convey the animation of domestic scenes, whether families making music or Epiphany feasts, where the general *joie de vivre* is expressed by loud laughter and shouting. There was in fact an inner contradiction in Jordaens's temperament between his popular ancestry and the bourgeois outlook that went with his successful career and the circles in which he moved. He approaches popular themes in a bourgeois manner and bourgeois themes like a man of the people, and this further accentuates the hybrid nature of his art.

His work seems to lack any keen feeling of the sublimity of events or the psychological depths of character. Such sensitivity was alien to him, and he was not the man to read the secrets of souls in bodily features. His figures are not strongly individualised: he portrays what is general and typical, and the force of his characterisation is due to the impression created by a whole individual rather than to subtle analysis of facial expression.

To Baroque artists light was the source, and bright colours the expression, of an inexhaustible delight in nature, and the human form was the symbol of sensual beauty *par excellence*. Light, colour and Olympian nudity attained their supreme triumph in the Antwerp school of painting, and were the closest bond between Jordaens and contemporary European artists. In the course of his career he depicted light in many ways. To begin with he expressed it in hard, cool patches contrasting with heavy cast shadows. Later he diffused it more broadly, first in a triumphant glow and then in flowing gradations and gleams of illumination. In his last works light and shade are again contrasted, but here, unlike his early period, the light increasingly yields to a general sombreness. The development of his treatment of colour was similar. After a short stage during which he imitated the shimmering effects of his Antwerp predecessors he came to prefer strong, bright colours juxtaposed in broad patches. However, he soon gave up this system of local colour in favour of warmer tones interacting and merging into one another. Finally, the tonality of his last pictures is overwhelmingly a dull grey-blue or monochrome brown.

Light and colour play an important part in the painting of nudes, an art in

which Jordaens was an accomplished master. Anatomical proportions, the play of muscles, the contours and complexion of the flesh – all these had no secrets for him, and he rendered them with inspiration and virtuosity in a great variety of forms. As with so many Baroque artists, his predilection for fullness of form is best seen in his radiant female nudes. His figures are not slender maidens but mature, fertile young women with broad thighs, who have already borne children and suckled them at their generous breasts. Many of his nudes, including male ones, are modelled on those of Rubens. Although Rubens's influence fluctuates from one work to another, one can perceive the distinctive features of the two artists. Rubens's dynamism is expressed in arrested motion, while Jordaens's is static and composed. Rubens's figures are ennobled, Jordaens's down-to-earth; Rubens's psychological insight contrasts with Jordaens's indifference. Throughout his career Rubens depicted the splendour of the human body in unvarying terms; with Jordaens, on the other hand, the sturdy male figures gradually degenerate into coarse plebeians with exaggerated muscular development, while the plump country girls tend with time to resemble well-fed naked ladies rather than the nymphs of Olympus. This degeneration indeed was not confined to Jordaens's nudes or to formal aspects of his painting, but extended to the psychological field, as it became a mannerism with him to vulgarise his figures to the point of caricature.

Seventeenth-century art, which was closely bound up with the metaphysical outlook of the time, used familiar aspects of reality as symbols of the higher, invisible world. Classical antiquity, absorbed and interpreted by humanist scholars of the previous century, continued to function as a universal vehicle of allegories, sometimes in a relatively pure form but often with an admixture of contemporary allusions. Jordaens offers many examples of this mode of thought: like Rubens and Van Dyck, he used the vocabulary of pagan mythology to express the Christian ideas of his time, especially those concerning good and evil and the impermanence of human life. Allegory plays an important part in his many biblical scenes and not least in his genre scenes illustrating fables, proverbs and sayings: in these, the most personal part of his work, he illustrates the weaknesses of human nature under the disguise of everyday events. Here is seen to what extent his art rests on an 'emblematic' foundation and how he transposes traditional verities from the realm of abstraction to that of direct, tangible reality. It would be naive, however, to suppose that he was attracted to mythology and the Bible simply on grounds of religion and virtue, or that his genre pieces were intended merely as moral lessons. On the contrary, he was an artist first and foremost, and when he had the choice he preferred subjects that gave him the best opportunity to display his artistic talents. He had good reason for painting so many *Allegories of fruitfulness* (*Homage to Pomona, Ceres* etc) or themes like *Susanna and the elders*. Both mythology and the Bible appealed to him not only as sources of edification but also for the lively narratives they contained, especially those with figures that could be represented as well-formed nudes; while in genre scenes with their feasting and singing and loving couples he was able to express his joy in life to the full.

Landscapes and townscapes do not occur as such in his work. There are a number of narrative paintings in which the action takes place in an idyllic setting of rolling meadows bathed in warm sunlight, but the fields and woods are uninhabited and reveal nothing of everyday country life. Jordaens did not paint mournful autumn landscapes or winter snows; during the cold and dark days he probably retreated to a warm parlour where he could enjoy the pleasures of life

in the form of noisy conviviality and bounteous feasts. While the religious and bourgeois-moralistic aspect should not be overlooked, Jordaens's art is primarily a hymn in praise of the joys of living, by a man who had no material cares and exulted in the beauty of a world created for those who were healthy in soul and body.

Jordaens's natural talent was to portray the common people; but his environment and circumstances were such that for much of his career he worked for a church whose tenets he rejected and for an aristocracy that was alien to him. He produced masterly works which, all too often, were not masterpieces: many of them show great artistry but lack the all-important attribute of clear, harmonious organisation. It was not altogether unfairly that A. Stubbe described him as 'the master of the perfect fragment'.[13] None the less, hybrid and uneven though his achievement is, many of his works display a riot of sensuality, light and colour which is entirely his own and which added a fresh element to the wealth of seventeenth-century Flemish painting.

Jordaens did not found any school, and in general it can be said that his work was not much imitated. No more is heard of his pupils whose names are in the Register, and it may be assumed that they did not become masters. According to Cornelis de Bie[14] one of those trained by Jordaens was Jan Boeckhorst, but this master's refined style is clearly in the manner of Van Dyck, so that very possibly De Bie was mistaken. Jan Boeckhorst is not mentioned in the Register, nor is Jacob Jordaens the Younger, who was certainly taught by his father and probably became his assistant; but only one work of his is known for certain,[15] and it is far from being of such quality as to make its author famous (*see* Chapter II). Still less is known about the contribution of Jordaens's other assistants, who clearly had not enough personality to make an imprint on the many works they produced under the master's direction. Nothing whatever can be said about any followers Jordaens may have had outside the studio: whatever their skill or lack of it, they are unknown and will probably always remain so.

Jordaens is often compared with the Dutch painter Jan Steen (1626–79), and there are certainly many points of resemblance. As Max Rooses wrote, both of them 'contemplate what is beautiful and good from a material standpoint', and the mirth and happiness they depict is 'always natural, infectious, irresistible'.[16] Steen not only borrowed from Jordaens such themes as *Satyr and peasant*, *The king drinks* and *As the old sang, so the young pipe*, but was inspired by him in the treatment of certain motifs. Nevertheless, the two masters are divided by the essential difference between Flemish Baroque and the Dutch manner of depicting everyday life with unadorned veracity. Steen's art reduces that of Jordaens to normal proportions: this applies both to the heroic treatment of the latter's models and the clamorous expression of their vital energy. Steen's forms and colours are more subdued, and any lack of distinction in one or other of his works is due to the subject rather than the way in which it is treated. As Stubbe concisely puts it:[17] 'The Dutch must have realised that their way led in quite a different direction from that of Jordaens. Their firmly held views on life and art placed them in the vanguard of their time, whereas the most realistic of Flemish Baroque painters was still the prisoner of a mental outlook that was moving towards exhaustion along with the absolutist world from which it sprang'.

Bibliographical abbreviations

A.C.L.
'Archives centrales et laboratoires, Institut royal du Patrimoine artistique', Brussels

A.G.R.B.
Archives générales du Royaume, Brussels

Antwerp (1905)
Exh. cat. *Jacob Jordaens*, Koninklijk Museum voor Schone Kunsten, Antwerp, 1905

Antwerp–Rotterdam (1966–67)
R.-A. d'Hulst, exh. cat. *Tekeningen van Jacob Jordaens*, Rubenshuis, Antwerp, and Museum Boymans–van Beuningen, Rotterdam, 1966–67

Antwerp (1978A)
Marc Vandenven, exh. cat. *Jordaens in Belgisch bezit*, Koninklijk Museum voor Schone Kunsten, Antwerp, 24 June–24 September 1978

Antwerp (1978B)
R.-A. d'Hulst, exh. cat. *Jacob Jordaens, tekeningen en grafiek*, Plantin-Moretus Museum, Antwerp, 17 June–17 September 1978

Burchard
L. Burchard, 'Jugendwerke von Jakob Jordaens', *Jahrbuch der preussischen Kunstsammlungen* XLIX (1928), pp 207–18

Buschmann
P. Buschmann Jr, *Jacob Jordaens. Eene studie naar aanleiding van de tentoonstelling zijner werken ingericht te Antwerpen in MCMV* (Brussels, 1905)

Crick-Kuntziger (1938)
Marthe Crick-Kuntziger, 'Les cartons de Jordaens au Musée du Louvre et leurs traductions en tapisseries', *Annales de la Société royale d'Archéologie de Bruxelles* LXII (1938), pp 135–46

Descamps (1769)
J. B. Descamps, *Voyage pittoresque de la Flandre et du Brabant* (Paris, 1769)

d'Hulst (1952)
R.-A. d'Hulst, 'Jacob Jordaens en de "Allegorie van de Vruchtbaarheid"', *Bulletin Musées royaux des Beaux-Arts de Belgique* I (1952), pp 19–31

d'Hulst (1953A)
R.-A. d'Hulst, 'Jacob Jordaens. Schets van een chronologie zijner werken ontstaan vóór 1618', *Gentse Bijdragen tot de Kunstgeschiedenis* XIV (1953), pp 89–138

d'Hulst (1956)
R.-A. d'Hulst, *De tekeningen van Jacob Jordaens* (Brussels, 1956)

d'Hulst, Jordaens, Tapestry
R.-A. d'Hulst, 'Jordaens and his early Activities in the Field of Tapestry', *Art Quarterly* XIX (1956), pp 236–54

d'Hulst (1957–58)
R.-A. d'Hulst, 'Nieuwe gegevens omtrent enkele tekeningen van Jacob Jordaens', *Gentse Bijdragen tot de Kunstgeschiedenis en de Oudheidkunde* XVII (1957–58), pp 135–55

d'Hulst (1958B)
R.-A. d'Hulst, 'A Portrait by Jordaens', *Bulletin John Herron Art Institute* XLV (Indianapolis, 1958), no 1, pp 3–4

d'Hulst (1961)
R.-A. d'Hulst, 'Jacob Jordaens—Apollo beurtelings in strijd met Marsyas en Pan', *Bulletin Musées royaux des Beaux-Arts de Belgique* X (1961), pp 28–36

d'Hulst (1966)
R.-A. d'Hulst, 'Enkele onbekende schilderijen van Jacob Jordaens', *Gentse Bijdragen tot de Kunstgeschiedenis en de Oudheidkunde* XIX (1961–66), pp 81–94

d'Hulst (1967A)
R.-A. d'Hulst, 'Drie vroege schilderijen van Jakob Jordaens', *Gentse Bijdragen tot de Kunstgeschiedenis en de Oudheidkunde* XX (1967), pp 71–86

d'Hulst (1967B)
R.-A. d'Hulst, 'Jacob Jordaens en de Schilderskamer van de Antwerpse Academie', *Jaarboek Koninklijk Museum voor Schone Kunsten* (Antwerp, 1967), pp 131–50

BIBLIOGRAPHICAL
ABBREVIATIONS

d'Hulst (1969B)
R.-A. d'Hulst, 'Jordaens' (review of Ottawa exhibition, 1968–69), *Art Bulletin* LI (1969), pp 378–88

Duverger
J. Duverger, 'De Rijschool of Grote en Kleine Paarden in de XVIIe eeuwse tapijtkunst', *Het herfsttij van de Vlaamse tapijtkunst* (Brussels, 1959), pp 121–76

Génard (1852)
P. Génard, *Notice sur Jacques Jordaens, Extrait du Messager des sciences historiques, des arts et de la bibliographie de Belgique* (Ghent, 1852)

Génard (1869–76)
[P. Génard], 'Intrede van den Prins-Kardinaal Ferdinand van Spanje te Antwerpen op 17 April 1635', *Antwerpsch Archievenblad* VI (1869), pp 400–72; VII (1870), pp 1–113; XIII (1876), pp 215–345

Held (1933)
J. S. Held, 'Nachträglich veränderte Kompositionen bei Jacob Jordaens', *Revue belge d'Archéologie et d'Histoire de l'Art* III (1933), pp 214–23

Held (1939)
J. S. Held, 'Malerier og Tegninger af Jacob Jordaens i Kunstmuseet', *Kunstmuseets Aarsskrift* XXVI (Copenhagen, 1939), pp 1–43

Held (1940A)
J. S. Held, 'Unknown Paintings by Jordaens in America', *Parnassus* XII, 3 (1940), pp 26–29

Held (1940B)
J. S. Held, 'Jordaens' Portraits of his Family', *Art Bulletin* XXII (1940), pp 70–82

Held (1941)
J. S. Held, 'Achelous' Banquet', *Art Quarterly* IV (1941), pp 122–33

Held (1949)
J. S. Held, 'Jordaens and the Equestrian Astrology', *Miscellanea Leo van Puyvelde* (Brussels, 1949), pp 153–56

Held (1965)
J. S. Held, 'Notes on Jacob Jordaens', *Oud Holland* LXXX (1965), pp 112–22

Held (1969)
J. S. Held, 'Jordaens at Ottawa', *The Burlington Magazine* CXI (1969), pp 265–72

Hollstein
F. W. H. Hollstein, *Dutch and Flemish Etchings, Engravings and Woodcuts, c. 1450–1700* (Amsterdam [1949ff])

Hymans
H. Hymans, 'Jacques Jordaens', *Biographie nationale* X (Brussels, 1888–89), cols 523–27

Jaffé (1969)
M. Jaffé, 'Reflections on the Jordaens Exhibition', *Bulletin National Gallery of Canada* XIII (Ottawa, 1969, published 1971), pp 1–40

Jordaens Drawings
R.-A. d'Hulst, *Jordaens Drawings* (Brussels–London–New York, 1974)

Kauffmann
H. Kauffmann, 'Die Wandlung des Jacob Jordaens', *Festschrift Max-J. Friedländer* (Leipzig, 1927), pp 191–208

K.d.K., Rubens
R. Oldenbourg, *P. P. Rubens (Klassiker der Kunst* V), 4th edn (Berlin–Leipzig [1921])

K.d.K., Van Dyck
G. Glück, *A. Van Dyck (Klassiker der Kunst* XIII), 2nd edn (Stuttgart–Berlin, 1931)

Liggeren
P. Rombouts and T. van Lerius, *De Liggeren en andere historische archieven der Antwerpsche Sint-Lucasgilde* I–II (Antwerp–The Hague [1864–72])

Ottawa (1968–69)
M. Jaffé, exh. cat. *Jacob Jordaens*, National Gallery of Canada (Ottawa, 1968–69)

Rooses
M. Rooses, *Jordaens' leven en werken* (Amsterdam–Antwerp, 1906). References in the present work are to the English translation: *Jacob Jordaens. His Life and Work* (London–New York, 1908)

S.A.A.
Stadsarchief (Municipal Archives), Antwerp

Schlugleit
D. Schlugleit, 'L'Abbé de Scaglia, Jordaens et l' "Histoire de Psyché" de Greenwich-House (1639–42)', *Revue belge d'Archéologie et d'Histoire de l'Art* VII (1937), pp 139–66

Stubbe
A. Stubbe, *Jacob Jordaens en de Barok* (Antwerp–Brussels–Ghent–Louvain, 1948)

Van den Branden (1883)
F. J. Van den Branden, *Geschiedenis der Antwerpsche Schilderschool* (Antwerp, 1883)

Van Mander
Carel van Mander, *Uytleggingh op den Metamorphosis Pub. Ovidij Nasonis. Alles streckende tot voordering des vromen en eerlycken borgherlycken wandels* (Haarlem, 1604)

Van Puyvelde
L. van Puyvelde, *Jordaens* (Paris–Brussels, 1953)

Von Sandrart
J. von Sandrart, *Teutsche Akademie der edlen Bau-, Bild- und Malereikünste* (1675), ed. A. R. Peltzer (Munich, 1925)

Notes

CHAPTER I

1 H. A. L. Fisher, *A History of Europe* I (Glasgow, 1976), pp 586–90 (from which the quoted passages are taken)

2 L. Voet, exh. cat. *Antwerp's Golden Age* (1973–75), pp 13–15

3 L. Voet, *De Gouden Eeuw van Antwerpen* (Antwerp, 1973), pp 236–40, 246, 247

CHAPTER II

1 S.A.A., *Par. reg. 11, Dopen Lievevrouwekerk, 1592–1606*, p 25; Van den Branden (1883), p 814; Rooses, p 2

2 Génard (1852), pp 8–13; Rooses, pp 1–3

3 S.A.A., *Par. reg. 195, Huwelijken Lievevrouwekerk, 1589–1612*, p 963; Van den Branden (1883), p 814; Rooses, p 2

4 Génard (1852), pp 10–12

5 Liggeren I, p 443. For further data on the life and work of Adam van Noort, *see* Gerda Vansteenkiste, *Adam van Noort, een 16de–17de-eeuwse Antwerpse schilder*, unpublished thesis for H.I.K.O. (Hoger Instituut voor Kunstgeschiedenis en Oudheidkunde) (Ghent, 1975)

6 Van den Branden (1883), pp 394–95. To these thirty-five pupils should be added the name of Rubens, which does not appear in the Liggeren

7 Van den Branden (1883), pp 389–90

8 P. Génard, 'De nalatenschap van Adam van Noort', *De Vlaamsche School* (Antwerp, 1869), (pp 50–53), pp 51, 52 (doc. II); Van den Branden (1883), p 399

9 S.A.A., *SR 399, Schepenbrieven, 1589*, IV, Kieffelt, Boge (K.B.II), *f* 85r

10 S.A.A., *SR 418, Schepenbrieven, 1589*, III, Kieffelt, Boge (K.B.I.), *ff* 386v and 387r

11 S.A.A., *Collegiaal aktenboek, 1597–79, f* 38v

12 P. Génard, 'De nalatenschap van Adam van Noort', *De Vlaamsche School* (Antwerp, 1869), (pp 50–53), pp 51–53 (doc. III)

13 Liggeren I, pp 513, 514

14 *Archief Academie*, Antwerp, no 243, Bussenboek, *f* 58

15 S.A.A., *Scabinale protocollen, 1598*, sub Moy & Neesen, II, *f* 29; Van den Branden (1883), p 400

16 Van den Branden (1883), p 399

17 S.A.A., *Par. reg. 196, Huwelijken Lievevrouwekerk, 1612–15*, p 51; Van den Branden (1883), p 816; Rooses, p 6

18 Jordaens Drawings, no A 144, fig 137

19 Archives of the Plantin-Moretus Museum, Antwerp, Begrafenisrol Jan Moerentorff; Rooses, p 6

20 S.A.A., *Schepenreg. 528, 1618 Del-RI, f* 6–6v; J. van Roey, 'Het huis van Jordaens', *Natuur- en Stedeschoon* XXII (1949) (pp 27–31), pp 27, 38

21 S.A.A., *Schepenreg. 528, 1618 Del-RI, f* 15v–16; Van den Branden (1883), p 816; Rooses, p 6

22 Archives of the Plantin-Moretus Museum, Antwerp, Begrafenisrol Melchior Moretus (4 June 1634)

23 S.A.A., *Par. reg. 13, Dopen Lievevrouwekerk Zuid, 1615–24*, p 9: Van den Branden (1883), p 816; Rooses, p 6

24 Liggeren I, p 444 *(see Rekeningen Lievevrouwekerk, 1617–18)*; *Verzameling der graf- en gedenkschriften van de provincie Antwerpen* I (Antwerp, 1856), p 240 (date wrongly given as 1613); Rooses, p 2 (wrongly as 1613)

25 Liggeren I, p 566; Van den Branden (1883), p 817; Rooses, p 35

26 Liggeren I, p 272; Van den Branden (1883), p 817; Rooses, p 35

27 Liggeren I, p 596; Van den Branden (1883), p 817; Rooses, p 121

28 S.A.A., *Pk. 573, Collegiale Akten, 1621–23, f* 40v; Van den Branden (1883), p 830; Rooses, pp 36–37

29 S.A.A., *Pk. 573, Collegiale Akten, 1621–23, f* 41; Rooses, p 37

30 S.A.A., *Pk. 716, Rekwestboek, 1621–22, f* 145 r and v; Rooses, p 37

31 S.A.A., *Pk. 573, Collegiale Akten, 1621–23, f* 153v

32 S.A.A., *Par. reg. 14, Dopen Lievevrouwekerk Zuid, 1624–35, f* 14; Van den Branden (1883), p 815; Rooses, p 6

33 S.A.A., *Par. reg. 14, Dopen Lievevrouwekerk Zuid,*

1624–35, f 54; Van den Branden (1883), p 816;
Rooses, p 6

34 Liggeren I, p 444 (date wrongly given as 1655);
*Verzameling der graf- en gedenkschriften van de
provincie Antwerpen* I (Antwerp, 1856), p 240
(wrongly as 1655); Rooses, p 2 (wrongly as 1655)

35 S.A.A., *Schepenreg. 621, 1633 VI, f* 317–319*v*; Van
den Branden (1883), p 831; Rooses, p 122

36 S.A.A., *Schepenreg. 627, 1634 VI, f* 8b–9*v*; Van den
Branden (1883), p 831; Rooses, p 3

37 S.A.A., *Schepenreg. 632, 1635 V, f* 35*v*–36*v* and
f 77–78*v*

38 Génard (1869–76), VI, p 410; Rooses, pp 113–14

39 Svetlana Alpers, *The Decoration of the Torre de la
Parada, Corpus Rubenianum Ludwig Burchard* IX
(Brussels–London–New York, 1971), pp 34,
200–202, 228, 276

40 Liggeren II, p. 53; Rooses, p 121

41 *Ibid*, p 86; Rooses, p 121

42 *Ibid*, p 123; Rooses, p 121

43 *Ibid*, p 164; Rooses, p 121

44 *Ibid*, p 181; Rooses, p 122

45 *Ibid*, p 240; Rooses, p 122

46 *Ibid*, p 373; Rooses, p 122

47 S.A.A., *Not. 3828, Jan van der Donck, 1623–45* (not
foliated); *ibid, Proceszakje J 8415*; Van den Branden
(1883), p 817 (date wrongly given as 11 August 1641);
Rooses, p 121; Schlugleit, pp 156, 158

48 S.A.A., *Schepenreg. 656, 1639 V, f* 373–375*v*; A.
Thijs, *Historiek der straten van Antwerpen* (Antwerp,
1879), p 564; Van den Branden (1883), p 831; Rooses,
p 122

49 18 May 1641 (S.A.A., *Pk. 743, Rekwestboek,
1641–42, f* 47*v*); 28 October 1641 (S.A.A., *Pk. 743,
Rekwestboek, 1641–42, f* 163*v*); 12 December 1646
(S.A.A., *Pk. 747, Rekwestboek, 1645–46, f* 231*v*;
2 September 1647 (S.A.A., *Not. 3829, J. van der
Donck, 1646–60* (not foliated); 23 July 1649 (Van
den Branden (1883), p 837)

50 J. van Roey, 'Het huis van Jordaens', *Natuur- en
Stedeschoon* XXII (1949), (pp 27–31), pp 27–28

51 H. B. Cools, 'Het Jordaenshuis', *Antwerpen* (1975),
pp 129–37. For the history of the house after
Jordaens's death, *see* Rooses, pp 123–27

52 Rooses, pp 124–25

53 Rooses, pp 125–27

54 The following announcement appeared in the
Amsterdamsche Courant of 5 June 1687: 'The heirs of
the late talented painter Jacob Jordaens intend to sell
the best pictures from his estate at public auction to
the highest bidder on 18 June 1685 at the house of
Anthoni Schaerders on the Friday Market in
Antwerp, where printed lists may be had'. (S.A.C.
Dudok van Heel, 'Honderdvijftig advertenties van
kunstverkopingen uit veertig jaargangen van de
Amsterdamsche Courant, 1672–1711',
Amstelodamum LXVII (1975), p 156, no 11. This was
kindly brought to my notice by Professor J. G. van
Gelder

55 *Catalogus of Naamlijst van Schilderijen met derselver
prijzen Zedert een langen reeks van Jaaren zoo in
Holland als op andere Plaatzen in het Openbaar
verkogt. Benevens eene Verzameling van Lijsten van
Verscheyden nog in wesen zynde Cabinetten, uytgegeven
door Gerard Hoet. In 's Gravenhage bij Pieter
Gerard van Baalen, M.DCC.LII, vol. I, pp 400–406.*
Rooses, pp 249–50

56 For biographical details of Scaglia, *see* G. Martin,
*The Flemish School, c. 1600–c. 1900, National Gallery
Catalogues* (London, 1970), pp 50–51, nn 1–16, and
W. Couvreur, 'Daniël Seghers' inventaris van door
hem geschilderde bloemstukken', *Gentse Bijdragen
tot de kunstgeschedenis en de oudheidkunde* XX (1967),
pp 105–106, n 78

57 Schlugleit, pp 139–66

58 P. Génard, 'De nalatenschap van P.P. Rubens',
Antwerpsch Archievenblad II (1865), pp 81, 136;
M. Rooses, *L'œuvre de P.P. Rubens* III (Antwerp,
1890), pp 148–49; J. R. Martin, 'Rubens's Last
Mythological Paintings for Philip IV', *Gentse
Bijdragen tot de kunstgeschiedenis* XXIV (1976–78),
pp 113 ff

59 S.A.A., *Pk. 744, Rekwestboek, 1642, f* 144*v*, 145r;
Van den Branden (1883), pp 833–35

60 S.A.A., *Not. 3532, F. van den Berghe, 1639–57* (not
foliated); Van den Branden (1883), pp 826–27;
Rooses, pp 181–84; J. Denucé, *Antwerpsche
Tapijtkunst en Handel* (Antwerp, 1936), p 65

61 A. Berger, 'Inventar der Kunstsammlung des
Erzherzogs Leopold Wilhelm von Österreich',
Jahrbuch der kunsthistorischen Sammlungen I (Vienna,
1883), p LXXXIII

62 Cracow, Archives (E. Rostewiecki, *Dictionary of
Polish Painters* II [Warsaw, 1851], pp 269–70);
Rooses, p 246

63 M. Rooses and C. Ruelens, *Correspondance de Rubens*
II (Antwerp, 1898), pp 35–38

64 *Ibid*, pp 74–76

65 Rooses, p 139, n 1

66 *De grote schouburgh der Nederlantsche konstschilders
en schilderessen* I (Amsterdam, 1718), p 155

67 S.A.A., *Not. 3399, H. van Cantelbeck, 1647–48* (not
foliated); Van den Branden (1883), p 828; Rooses,
p 138

68 *Algemeen Rijksarchief*, The Hague, *Staten-Generaal*,
inv. no 3254, *f* 456; K. E. Steneberg, 'Le Blon,
Quellinus, Millich and the Swedish Court
"Parnassus"', *Queen Christina of Sweden. Documents
and Studies* (Stockholm, 1966), pp 345, 363

69 *Algemeen Rijksarchief*, The Hague, *Staten-Generaal*,
inv. no 3254, *f* 466; *ibid*, file on Sweden, inv.
no 7174; K. E. Steneberg, *loc cit*

70 *Algemeen Rijksarchief*, The Hague, *Staten-Generaal*,
file on Sweden, inv. no 7174

71 Van Puyvelde, p 142, n 195; K. E. Steneberg,
Kristinatidens måleri (Malmö, 1955), p 70

72 Rooses, p 250

73 Rooses, p 138

74 S.A.A., *Not. 3399, H. van Cantelbeck, 1647–48* (not foliated); Van den Branden (1883), p 829; Rooses, pp 137–38

75 E. Duverger, 'Abraham van Diepenbeeck en Gonzales Coques aan het werk voor de stadhouder Frederik Hendrik, prins van Oranje', *Jaarboek van het Museum Antwerpen* (1972), pp 185–87

76 J. G. van Gelder, 'De schilders van de Oranjezaal', *Nederlands kunsthistorisch Jaarboek* (1948–49), pp 119–64

77 Mariemont Museum, inv. no At. 1168/1; A. D. Schinkel, *Geschied- en letterkundige bijdragen* (The Hague, 1850), p 29; Rooses, p 160 and (in Dutch edition) pp 255–56

78 A. D. Schinkel, *op cit*, p 29; Rooses, pp 163–64; J. A. Worp, *Constantijn Huygens, de briefwisseling (1608–1687)* (The Hague, 1911–17), no 5132

79 British Museum, London; J. W. Unger, 'Brieven van eenige schilders aan Constantijn Huygens', *Oud-Holland* IX (1891), pp 195–96; Rooses, p 160 and (in Dutch edition) pp 256–57

80 C. H. C. A. Van Zijpestein, *De stichting der Oranjezaal* (The Hague, 1876), p 68; Van den Branden (1883), p 824; Rooses, pp 166–67 and (in Dutch edition) pp 257–58

81 Hollstein IX, p 227

82 S.A.A., *Not. 744, Pieter van Brueseghem, 1650–51*; Van den Branden (1883), p 827; Rooses, pp 7, 181

83 S.A.A., *Not. 3011, A. Sebille, 1651*; J. Duverger, 'De Rijschool of Grote en Kleine Paarden in de 17de eeuwse tapijtkunst', *Het herfsttij van de Vlaamse Tapijtkunst* (Brussels, 1959), p 172

84 Van den Branden (1883), p 827; Rooses, p 181

85 Van den Branden (1883), p 837

86 A.G.R.B., *Rekenkamer, reg. no 12.909, 'Ordinaris Rekeninghe van heer Nicolaes van Varick . . .'*; Van den Branden (1883), p 838; Rooses pp 223–24

87 M. L. Galesloot, 'Un procès pour une vente de tableaux attribués à Antoine Van Dijck', *Annales de l'Académie d'Archéologie de Belgique* XXIV (1868), pp 571, 601; Van den Branden (1883), p 838; Rooses, p 223

88 S.A.A., *Par. reg. 171*, p 107; Génard (1852), pp 21–22; Van den Branden (1883), p 841; Rooses, p 224

89 S.A.A., *Par. reg. 171*, pp 55–59, Par. reg. 172, pp 41, 43, 45–48; Rooses, p 226

90 Putte, to the north of the province of Antwerp, today overlaps the Belgian–Dutch border. The Protestant church was pulled down during the period of French rule in 1794. The tombstone is now attached to the pedestal of the monument to Jordaens erected in the Dutch part of Putte in 1877

91 Hymans, cols 523–27

92 Marian C. Donnelly, 'Calvinism in the Work of Jacob Jordaens', *The Art Quarterly* XXII (1959), pp 356–66

93 S.A.A., *Register Wijken – Burgerlijke Wacht (1585). Gilden en Ambachten, 4830, f 25v*

94 H. Vlieghe, *Gaspar de Crayer, sa vie et ses oeuvres* I (Brussels, 1972), p 56, doc. nos 73, 74

95 *Gemeente-Archief, Amsterdam, Ms. Res. Thes. Ord.,* no 2, f 66; Rooses, p 204

96 *Gemeente-Archief, Amsterdam, Ms. Res. Thes. Ord.,* no 2, f 98v; Rooses, p 208; K. Freemantle, *The Baroque Town Hall of Amsterdam* (Utrecht, 1959), p 53, n 4

97 *Ibid, f 97v*; Rooses, p 204

98 *Gemeente-Archief, Amsterdam, Ms. Resoluties regerende en oud burgemeesters, 1649–98, f 152v*; H. Van de Waal, *Drie eeuwen vaderlandsche geschied-uitbeelding, 1500–1800* I (The Hague, 1952), pp 225–26

99 H. Van de Waal, *op cit*, pp 215–38

100 *Rekeningen van het Hulster Ambacht*, 22 June and 2 July 1663; Rooses, pp 205–206

101 Van den Branden (1883), p 839; Rooses, p 208; d'Hulst (1967B), pp 131–50

102 C. Vosmaer, 'Oude aanteekeningen over Rubens, Jordaens, Rembrandt, Hals en Wouwerman', *De Nederlandsche Spectator* (1871), pp 62–63; *idem, Kunstkronijk* (1872), p 12; Rooses, pp 241–42

103 Von Sandrart, pp 215–16

104 *Journaal van Constantijn Huygens, Werken van het Historisch Genootschap Utrecht* (Utrecht), NS, no 32, p 174; Rooses, p 242

105 S.A.A., *Par. reg. 171*, p 122; Van den Branden (1883), p 841; Rooses, p 242

106 *Archief Openbaar centrum voor Maatschappelijk Welzijn van Antwerpen, K.H. r. 56, ff 53, 64–G.H. r. 136, p (108)r*; E. Geudens, *Les tableaux des Hospices Civils d'Anvers. Annexe* (Antwerp, 1904), pp 25–26

CHAPTER III

1 F. Baudouin, *Rubens en zijn eeuw* (Antwerp, 1972), p 13

2 J. Müller Hofstede, 'Abraham Janssens', *Jahrbuch der Berliner Museen* XIII (1971), pp 208–303

3 F. Baudouin, *P. P. Rubens* (Antwerp, 1977), chap. 2, pp 47–63

4 *Piqueur seated amid a pack of hounds* at Lille is inscribed with a date, but the third figure is obscure, so that some authors read *1635* and others *1625*

5 Held (1940B), pp 77–78; d'Hulst (1956), pp 22–23

6 H. Jantzen, 'Tradition und Stil in der abendländischen Kunst', *Über den gotischen Kirchenraum. Gesammelte Aufsätze* (Berlin, 1951), p 79 f; K. Bauch, *Die Kunst des jungen Rembrandt* (Heidelberg, 1933), p 7 f

7 D'Hulst (1967A), pp 71–74, fig 1

8 Museum of Art, Rhode Island School of Design. Burchard, p 216, fig 9; d'Hulst (1956), p 21; Ottawa (1968–69), no 5. Another version of this picture, without the angels, is in the Dahlem Museum, Berlin (panel, 63 × 50 cm). It shows a touch of Caravaggio's influence and must have been painted shortly after the Providence version. (*See* R.

Klessmann, 'Jacob Jordaens: Die Heimkehr der Hl. Familie aus Ägypten', *Berliner Museen* VIII (1958), pp 40–44; *idem*, 'Nachtrag zu Jacob Jordaens', *Berliner Museen* X (1961), pp 18–21; *idem*, 'The Return of the Holy Family from Egypt by Jacob Jordaens', *Bulletin of the Rhode Island School of Design* (Dec. 1961), pp 1–8)

9 A photograph of this painting is in the Rubenianum, Antwerp, as Hendrik van Balen. I am much obliged to Dr Carl Van de Velde for drawing my attention to this

10 Ingrid Jost, 'Hendrik van Balen d. Ä.', *Nederlands Kunsthistorisch Jaarboek* (1963), pp 83–128

11 Panel, 214 × 180 cm, signed. Photo A.C.L. no 176.117B

12 D'Hulst (1966), pp 85–89, fig 4; (Antwerp, 1978A), p 25, no 3, repr

13 Cat. Agnew, *Master Paintings* (London, 29 May–4 July 1975), no 19, fig IX. M. Jaffé was the first to establish that this work was by Jordaens

14 In the collection of Karl Louis Richter, Stockholm, in 1958; sold at Christie's, London, 26 March 1971, lot 47; d'Hulst (1966), pp 81–84, figs 1, 2

15 Formerly in the collection of Mr Zoltan de Boèr, Malmö (d'Hulst (1967A), pp 84–85, fig 5; d'Hulst (1969B), p 381, no 13), and in 1979 in the collection of Mr Rune Manacke, Malmö. A copy after this early composition was executed later, probably in the studio, and is now in the Brunswick Museum [63 × 88 cm; d'Hulst (1956), pp 33–34, fig 5, as by Jordaens]. This cannot have been made before the 1630s, since, in accordance with the evolution of Jordaens's style, it depicts the scene in a more open space where the figures have greater freedom of movement

16 Jean Seznec, 'La survivance des dieux antiques', *Studies of the Warburg Institute* XI (London, 1940)

17 Van Mander, II, *f* 21a

18 Sale of Nardus Collection, Hôtel Drouot, Paris, 9 Feb. 1953; now lost. d'Hulst (1953A), pp 121–22, fig 17; d'Hulst (1956), pp 46, 101, 109, 323, fig 14

19 Formerly at Oldenburg, but now lost. Attributed to Rubens in K.d.K. Rubens (p 60), showing how thoroughly Jordaens made use of Rubens's creative power and knowledge of the fable

20 The picture is badly damaged and it is hard to judge its quality. M. Jaffé, who first published it (Ottawa (1968–69), sub no 6; (1969), p 8, no 6), mentions two other versions, both on panel. A fourth, on canvas, is at Kaluga near Moscow

21 *See* L. Scheler, 'La persistance du motif dans l'illustration flamande des fables d'Ésope du seizième au dix-huitième siècle', *Studia Bibliographica in honorem Herman de la Fontaine Verwey* (Amsterdam, 1966), pp 350–55, repr

22 Burchard, pp 209–13, fig 1; d'Hulst (1953A), pp 96, 100, 102, fig 3; Van Puyvelde, pp 86–87, 89, 94, fig 64; d'Hulst (1956), pp 29–31, fig 3

23 J. Müller Hofstede ('Abraham Janssens', *Jahrbuch*

der Berliner Museen XIII (1971), pp 280–81) first suggested the possible connection with Frans Floris

24 D'Hulst (1953A), pp 125–26, fig 21; d'Hulst (1956), p 52, fig 19

25 D'Hulst (1953A), pp 102–104, fig 5; Van Puyvelde, p 89, fig 63; d'Hulst (1956), pp 31–33, fig 4

26 Burchard, pp 217–18, repr; d'Hulst (1953A), p 108, fig 10; Van Puyvelde, p 90; d'Hulst (1956), p 53, fig 21

27 Burchard, p 213, fig 4; d'Hulst (1953A), pp 108, 110, fig 11; Van Puyvelde, p 89, fig 62; d'Hulst (1956), pp 38–39, fig 8

28 D'Hulst (1967A), pp 74–84, fig 3

29 Burchard, p 212, fig 3; d'Hulst (1953A), pp 106–107, fig 9; Van Puyvelde, pp 88–89, 117, fig 61; d'Hulst (1956), pp 20, 38, 54, 79, fig 7; Antwerp (1978A), p 23, no 2, repr. The inventory of the estate of the tapestry dealer Michiel Wauters, who died on 26 August 1679 in his house on the Brabantse Korenmarkt at Antwerp, includes a 'Vischerye van Sinte Peeter, origineel, van Jourdaens', which hung over the living-room mantelpiece (*Antwerpsch Archievenblad* XXII, p 26)

30 Held (1940A), pp 26, 29, repr; d'Hulst (1953A), pp 114, 116, fig 13; Van Puyvelde, pp 27, 68, 91, fig 13; d'Hulst (1956), pp 40–41, fig 9; Ottawa (1968–69), no 10, fig 10; J. Müller Hofstede, 'Abraham Janssens', *Jahrbuch der Berliner Museen* XIII (1971), pp 286, 288, fig 37

31 Von Sandrart, p 214 f

32 The catalogue of paintings from Jordaens's estate sold at The Hague in 1734 includes only Flemish and Dutch masters. The best works were sold by auction at Antwerp in 1685, but no catalogue of these is known

33 Panel, 62 × 50 cm. Burchard, p 216; d'Hulst (1953A), p 125, fig 20; Van Puyvelde, p 92; d'Hulst (1956), pp 50–51. Another version (panel, 66 × 49 cm) was stated by Burchard (p 216, fig 8) to have been in a private collection at Reval (Tallinn) in 1927

34 Detroit Institute of Arts. Panel, 112 × 94 cm. Burchard, pp 214–16, fig 7; d'Hulst (1953A), p 110, fig 12; Van Puyvelde, p 92, fig 65; d'Hulst (1956), p 50, fig 18; Ottawa (1968–69), no 8, fig 8

35 North Carolina Museum of Art. Canvas, 115 × 143 cm; signed *J. Jordaens*. Ottawa (1968–69), no 9, fig 9

36 Burchard, p 213, fig 6; d'Hulst (1953A), pp 124–25, fig 19; Van Puyvelde, p 90; Jordaens Drawings, sub no A 38

37 Purchased in 1979 from Countess Camille Aprosio, Monte Carlo

38 L. Réau, *Iconographie de l'art chrétien* II (Paris, 1957), 2, p 287

39 E. Mâle, *L'art religieux après le concile de Trente* (Paris, 1932), pp 258–59

40 Rooses, pp 197–98; d'Hulst (1953A), pp 116, 118, fig 14; Van Puyvelde, pp 29–30; d'Hulst (1956), pp 41–42, fig 10; Ottawa (1968–69), no 11, fig 11; d'Hulst (1969B), p 381, n 11; Jordaens Drawings, sub no A 31

41 No painting is known to which this sketch of *circa* 1615–17 might relate

42 This triptych, with *The adoration of the Magi* as its central panel, was commissioned on 27 December 1616 and placed in the church in September 1617. The *predella* is now in Marseilles (K.d.K., Rubens, p 166)

43 D'Hulst (1953A), pp 119–20, fig 15; Van Puyvelde, p 85, fig 59; d'Hulst (1956), pp 43–44, fig 12

44 D'Hulst (1953A), pp 120–22, fig 16; Van Puyvelde, pp 28–29, 113, fig 16; d'Hulst (1956), pp 45–47, fig 13; Ottawa (1968–69), no 12, fig 12

45 D'Hulst (1953A), pp 105–106, fig 8; d'Hulst (1956), pp 34–35, fig 6

46 D'Hulst (1953A), pp 123–24, fig 18; Van Puyvelde, pp 27–28, 69, 85, fig 15; d'Hulst (1956), pp 49–50, fig 16; Ottawa (1968–69), no 14, fig 14; J. S. Held, 'Zwei Rubensprobleme (Die Kekropstöchter)', *Zeitschrift für Kunstgeschichte* 39 (1976), pp 34–35, fig 5; Antwerp (1978A), pp 19–20, no 1, repr

47 Rooses, pp 34, 187, repr facing p 34; d'Hulst (1953A), pp 132, 134, fig 23; Van Puyvelde, pp 89, 97; d'Hulst (1956), pp 55–56, fig 22; Antwerp (1978A), p 27, no 4, repr. An oil sketch for this work, enlarged by Jordaens himself at the top and sides *circa* 1660, belonged to the collection of Dr H. Wetzlar, Amsterdam and is now in the possession of the Prince of Liechtenstein, Schloss Vaduz (panel, with enlargement, 75 × 100 cm; *see* Jordaens Drawings, sub nos A 62 and C 4)

48 Metropolitan Museum of Art. J.-A. Goris and J. S. Held, *Rubens in America* (New York, 1947), no 74, figs 61–63, 65, 68

49 Canvas, 143 × 168 cm (including enlargement). The dating 1620–23 in Jordaens Drawings, sub no A 60, is too late. The Museo Civico at Vicenza (inv. no 291) has a small *Adoration of the shepherds* (panel, 66 × 50 cm) showing the same original composition with slight variations, *eg* Joseph's head is altered

50 Canvas, 118 × 113 cm. Sold at Sotheby's, London, on 8 April 1970, lot 16, and again on 12 July 1978, lot 43; now in a private collection in the U.S.A.

51 One of these copies was in a South German private collection in 1928; another belongs to Baron Axel Reedtz-Thott, Gaunø, Denmark (*see* Jordaens Drawings, sub no A 42)

52 Rooses, pp 10–13, repr facing p 10; Buschmann, pp 61–62; d'Hulst (1953A), pp 129–30, fig 22; Van Puyvelde, pp 14, 101–102, figs 70, 71; d'Hulst (1956), pp 53–54, fig 20; Jordaens Drawings, sub no 41

53 Archives of St Paul's church, Antwerp, register I (1243–1794), doc. nos 8, 9. Rooses, pp 10–13, repr facing p 10

54 Not in first-class condition. Known to me only from photographs; here attributed to Jordaens

55 Rooses, pp 15–18, 19–20, 28–29, 196, 228, repr facing p 14; Buschmann, pp 62–63, pl 13; d'Hulst (1953A), p 136, fig 25; Van Puyvelde, pp 30, 91, 110, 117, 123, fig 21; d'Hulst (1956), pp 19, 56–58, fig 24. Other versions, with variants, are in the Mauritshuis,

The Hague (panel, 125 × 96 cm) and the Herzog Anton Ulrich Museum, Brunswick (panel, 125 × 97 cm)

56 A. von Schneider, *Caravaggio und die Niederländer* (Marburg an der Lahn, 1933), pp 15, 98–99

57 D'Hulst (1953A), pp 134, 136, fig 24; Van Puyvelde, p 98; d'Hulst (1956), pp 56–58, fig 23; Ottawa (1968–69), sub no 7

CHAPTER IV

1 An undated portrait, identified by J. S. Held as Catharina van Noort, is in the collection of A. Colle at Ghent (Antwerp (1978A), p 35, no 8, repr)

2 Held (1940B), pp 70–82; d'Hulst (1956), pp 77–78

3 Rooses, p 194, fig p 232; Van Puyvelde, n 202. A copy (57 × 71 cm) is at Besançon

4 Panel, 51 × 65 cm. Rooses, p 267; Van Puyvelde, p 84; Ottawa (1968–69), no 24, fig 24

5 Strictly speaking an *Adoration of the shepherds* at Mainz (canvas, 153 × 118 cm. Ottawa (1968–69), no 23, fig 23; d'Hulst (1969B), p 381, no 23) should be added to this group. However, it has been ruined by unskilful restoration and it is therefore difficult to form an opinion of it

6 Rooses, pp 30–32, repr p 32; Buschmann, pp 64–65; Van Puyvelde, p 101, fig 69; d'Hulst (1956), pp 78–79, fig 39; Jordaens Drawings, sub no A 43

7 Rooses, pp 239–40, repr p 241; Buschmann, p 65; Held (1933), pp 216–17, fig 1; Van Puyvelde, pp 77, 103–104; d'Hulst (1956), pp 82–83, fig 43; Antwerp (1978A), p 31, no 6, repr

8 Panel, 170 × 151 cm. Van Puyvelde, p 93; d'Hulst (1956), p 84, fig 44. J. S. Held (1940B), pp 79–80, figs 11, 12) recognised Catharina van Noort in an oil sketch (canvas, 41 × 33 cm), now in the collection of A. Colle at Ghent, which he believed to have been used for the figure of Mary in the New York painting. On grounds of style and of the woman's age he dated both painting and sketch *circa* 1625. *See also* exh. cat. *Weltkunst aus Privatbesitz*, Kunsthalle, Cologne (1968), no F 19

9 Rooses, pp 32–33, repr p 33; Buschmann, pp 63–64; Held (1933), p 215; Van Puyvelde, p 89; d'Hulst (1956), p 92, fig 54; Jordaens Drawings, sub no B 11

10 Descamps (1769), p 199; Ch. Piot, *Rapport . . . sur les tableaux enlevés à la Belgique en 1794 et restitués en 1815* (Brussels, 1883), p 28, no 70; Rooses, pp 13–14; Buschmann pp 65–66; Van Puyvelde, p 103; d'Hulst (1956), pp 91, 93, fig 53. A variant in the museum of the Teirninck Foundation at Antwerp seems at first sight to be a studio product of inferior quality, but it is hard to judge as it has been spoilt by unskilful restoration

11 Ruth Saunders Magurn, *The Letters of Peter Paul Rubens* (Harvard University Press, 1955), pp 59–61, letter no 28

12 Descamps (1769), p 5

13 Rooses, p 127

14 Descamps (1769), p 129

15 Panel, 65 × 50 cm. Held (1940A), pp 26–29; J.-A. Goris and J. S. Held, *Rubens in America* (New York, 1947), p 52, no A 71

16 Canvas, 62 × 53 cm

17 Panel, 63 × 48 cm. Ottawa (1968–69), no 19, fig 19

18 Columbus Gallery of Fine Arts. Panel, 64 × 47 cm (later enlarged by another hand to 88 × 58 cm). Ottawa (1968–69), no 21, fig 21

19 Panel, 70 × 61 cm. A partial copy is in the Musée Magnin, Dijon (panel, 63.5 × 49.5 cm)

20 Panel, 70 × 61 cm

21 Panel, 64.5 × 50 cm. Wrongly as *St Philip* in Ottawa (1968–69), no 20

22 Among these anonymous half-length figures of the 1620s are: *Old man meditating, his head resting on his hand,* collection of Jules Renoite, Igny, S. et O., France (1961) (panel, 65 × 50 cm. A less good example in the Museo de Arte de Ponce, Puerto Rico); *Old man with his hands before his breast,* Amiens (panel, 64 × 49 cm). A later version as *St Paul,* holding a sword, in Huis Osterrieth, Antwerp (canvas, 70 × 60 cm); *Old man, with hand on his breast,* Akademie, Vienna (panel, 64 × 48 cm); *Old man with raised finger,* Dorotheum sale, Vienna, 27 May 1974, no 65, repr (panel, 64.5 × 47 cm; with later enlargement, 68 × 52 cm); *Old man with raised finger, reading a book,* sold at Christie's, London, 14 May 1971, lot 67 (panel, 63.5 × 48 cm. Not of the best quality)

23 Cat. no 101. Rooses, pp 21–23, repr p 24; Buschmann, pp 71–73, fig VI; Van Puyvelde, p 95, fig 5; d'Hulst (1956), pp 79, 80, fig 40

24 Canvas, 190 × 160 cm. Rooses, pp 18–20, repr facing p 19; Van Puyvelde, p 96; d'Hulst (1956), pp 80–81, 324, fig 41; Jordaens Drawings, pp 145–46, sub no A 51

25 Cat. 1959, no 1044. Van Puyvelde, p 96, fig 6; d'Hulst (1956), pp 80–81, 324

26 The same old man, probably painted from life, is seen in a *Satyr playing the flute* (half-length) at Warsaw [64]; *see also* the figure of Argus in *Mercury and Argus* at Lyons [74]. At Stockholm there is a half-length *Satyr about to play the flute* (panel, 60 × 49 cm), of about the same date but after a different model

27 Rooses, pp 20–21, repr p 21; Buschmann, pp 73–74, pl VII; Van Puyvelde, p 97, fig 4; d'Hulst (1956), pp 89–90, fig 50

28 Cat. 1975, no 1546. Rooses, p 34, repr p 36; Buschmann, p 92; Van Puyvelde, p 98; d'Hulst (1956), pp 84–85, fig 45; Jordaens Drawings, pp 154–56, sub no A 62

29 Van Mander, *f* 72r

30 Rooses, pp 143, 176, repr p 143; Buschmann, pp 74–75, pl VIII; Held (1939), p 12; Van Puyvelde, p 116, fig 55; d'Hulst (1956), pp 146–47, 216

31 Van Mander, *f* 9r

32 Rooses, pp 142–45

33 Dr Gachet made a dry-point etching after this study, which in turn was copied by Vincent van Gogh at Auvers-sur-Oise in 1890 (J. B. de la Faille, *The Works of Vincent van Gogh* (Amsterdam, 1970), p 308, no F 822, repr). Jordaens's sketch, an example of the etching, and Van Gogh's copy can be seen together at Lille

34 Jordaens Drawings, nos A 121, A 122, C 23, C 74, C 75

35 Cat. 1959, no 240. Rooses, pp 47, 201, repr p 53. Buschmann, pp 70–71; Held (1939), p 9, fig 4; Van Puyvelde, p 108, figs 75, 76; d'Hulst (1956), pp 89–90, fig 51; Ottawa (1968–69), no 17, fig 17

36 This torch throws a vivid light, producing sharp contrasts of light and dark in the lower half of the picture. In the Brussels version these are toned down as the result of restoration in 1938 by J. van der Veken under the direction of L. van Puyvelde. They are conspicuous, however, in a work in a private collection in Paris, which reproduces the Brussels version in its original state: Ottawa (1968–69), no 18, fig 18

37 Ingrid Jost, 'Hendrick van Balen d. Ä.', *Nederlands Kunsthistorisch Jaarboek* 14 (1963), pp 115–16, fig 13

38 Von Sandrart, p 215, n 136

39 L. van Puyvelde, exh. cat. *De eeuw van Rubens* (Brussels, 1965), p 114, no 121; *see* E. Dilis, *De rekeningen der Rederijkkamer De Olijftak, 1615–29* (Antwerp–The Hague, 1910), pp 89–91, 94. Both Rubens and Abraham Janssens also painted a *Pan and Syrinx* about this time

40 D'Hulst (1961), pp 29–34, fig 1; Jordaens Drawings, pp 158–59, sub no A 65; Antwerp (1978A), p 39, no 10, repr

41 Van Mander, *f* 54v

42 Cat. 1959, no 235. Rooses, pp 43–46, 59, 213, repr facing p 44; Buschmann, pp 75–79, pl IX; Held (1939), pp 9, 18, fig 5; d'Hulst (1952), pp 19–31, fig 1; Van Puyvelde, pp 31–32, 91, 113, repr frontispiece 24, 25; d'Hulst (1956), pp 85–88, fig 46; Jordaens Drawings, pp 156–57, sub no A 63

43 W. Drost, 'Motivübernahme bei Jacob Jordaens und Adriaen Brouwer', *Königsberger kunstgeschichtliche Forschungen* (Königsberg, 1928), p 12; d'Hulst (1956), pp 115–20, figs 69–71; Jordaens Drawings, pp 156–57, sub no A 63

44 L. Burchard in Gustav Glück, *Gesammelte Aufsätze, I, Rubens, Van Dyck und ihr Kreis* (Vienna, 1933), p 410; Held (1939), pp 11–12; d'Hulst (1956), p 86, n 1

45 Museum, Antwerp, cat. 1959, no 88

46 Museum, Antwerp, cat. 1959, no 104

47 No 1899 B. Antwerp (1978A), p 33, no 7, repr

48 Cat. 1959, no 245, as Van Dyck. Canvas, 59 × 48 cm

49 Detroit Institute of Arts

50 Národní Galerie v Praze, inv. no 0.2814. Panel, 68.5 × 51.5 cm

51 Cat. 1913, no 103. Panel, 65 × 50 cm

52 Held (1969, p 272) thinks that the model for the painting at Ghent was not Grapheus but a man of whom Jordaens made another study, now at Montauban (Held (1969), fig 12)

53 Held (1965), p 115, figs 10, 11

54 Rooses, pp 33–34, repr p 35; Buschmann, pp 69–70, pl V; Held (1939), p 41, n 9; Van Puyvelde, pp 113–14, 116, fig 68; d'Hulst (1952), pp 19–31, fig 2; d'Hulst (1956), pp 86, 88, fig 47; Jordaens Drawings, pp 160–62, sub no A 67

55 Cat. 1945, no 419

56 Panel, transferred to canvas, 43 × 56.5 cm. Mr John Nieuwenhuys at Brussels possesses a study (panel, 36 × 29 cm) of the same child, who is most probably Jacob Jordaens the Younger [90]

57 Rooses, p 194, repr p 193; Held (1939), pp 10–11, fig 10; Van Puyvelde, p 117; d'Hulst (1956), pp 87, 120, 175, 344; Ottawa (1968–69), no 27, fig 27

58 Rooses, pp 103–104, repr p 105; Buschmann, pp 67–69; Held (1939), pp 1–14, figs 1–3, 8, 9, 11, 15, 37; Van Puyvelde, pp 39, 63, 116–17; d'Hulst (1956), pp 87–88, fig 48. The Rijksmuseum, Amsterdam, has a later and smaller version (canvas, 119 × 197.5 cm) with the same composition. It consists of two parts painted at different periods: Held (1933), pp 221–22, fig 6; Held (1939), p 10

59 Von Sandrart, p 215

60 Originally the hand raised for protection against the sun seems also to have appeared in the study; Jordaens apparently painted over it the woman who is seen full-face

61 No 82. Panel, 70.5 × 54.5 cm

62 Was in the sale at Lepke's, Berlin, 30 April 1929, no 49, repr

63 Cat. Dorotheum, Vienna, sale 27 May 1974, no 65, repr. A copy of this picture is in the Douai museum (panel, 65 × 50 cm; cat. 1937, no 199)

64 Jordaens Drawings, no A 60, fig 68

65 F. J. van den Branden, 'Verzamelingen van schilderijen te Antwerpen', *Antwerpsch Archievenblad* XXI [1864], pp 326–27; J. Denucé, *Kunstuitvoer in de 17de eeuw te Antwerpen. De firma Forchoudt* I (Antwerp, 1930), pp 40–41

66 Exh. cat. *Weltkunst aus Privatbesitz*, Kunsthalle, Cologne (1968), no F 18, fig 9; Jaffé (1969), p 12 (no 34). A copy in the Thyssen-Bornemisza Collection, Castagnola, shows that the painting at Wesseling was cut down on all four sides; there is another, weaker copy at Kassel. A modified and enlarged version in the Young Memorial Museum, San Francisco (Ottawa (1968–69), no 33, fig 33), although signed, was probably painted with studio assistance

67 Inv. no MNG/GD/331/M. Held identified the child with Jacob Jordaens the Younger on the basis of a different version of this study (canvas, 38 × 28 cm) in the collection of José Vigeveno, Amsterdam (Held (1940B), pp 81–82, fig 15)

68 Cat. 1945, no 1545. Rooses, p 253

69 D'Hulst (1956), pp 89–90, fig 49; J. Müller Hofstede, 'Abraham Janssens', *Jahrbuch der Berliner Museen* XIII (1971), pp 291–92, fig 40, dates the picture about 1616. A weaker version with an additional female figure (panel, 120 × 90 cm) was in the M. van Gelder Collection, Brussels (Van Puyvelde, p 93, fig 67)

70 Panel, 123 × 94 cm. G. Martin, *The National Gallery Catalogues, The Flemish School, c. 1600–c. 1900* (London, 1970), pp 87–89, no 164

71 Canvas, 118.5 × 131 cm. I have not seen the painting myself and must therefore reserve the question of its authenticity and dating. It may be the reproduction of a lost original

72 Panel, 104 × 74 cm. There are other, less good versions of this painting (Held (1940B), p 82; Ottawa (1968–69), pp 92–93, sub no 39)

73 Held (1940B), pp 81–82, fig 16; Ottawa (1968–69), p 93, no 40; Antwerp (1978A), p 43, no 12, repr

74 A. Bredius and N. de Roever, 'Pieter Lastman en François Venant', *Oud Holland* IV (1886), (pp 1–23), pp 15–16

75 E. Michel and Hélène de Vallée, 'Jordaens, les quatre évangélistes', *Monographies des peintures du Musée du Louvre* (Paris, 1938), where a number of copies are listed. It may be added that another copy (canvas, 130 × 103 cm), recovered from Germany, was sold on 30–31 January 1950 as lot 67 at the Palais des Beaux-Arts, Brussels. No 5 in Michel and de Vallée's list is a modified version with an angel, later (1963) offered for sale by Duits & Co., London; a better example of this (canvas, 123 × 151 cm), formerly in the museum at Lodz, was removed by the Germans at the end of the Second World War and is now lost

76 This head resembles that of the satyr with the boy on his shoulders in *Homage to Pomona* [79], but in *The four evangelists* Grapheus appears older

CHAPTER V

1 Rooses, pp 38–40, repr facing p 40; Buschmann, pp 89–90; Kauffmann, p 198, n 11; Van Puyvelde, pp 34–35, fig 26; d'Hulst (1956), pp 130–33, fig 74; Jordaens Drawings, sub no A 73; C. Van de Velde, 'Archivalia betreffende Rubens' Madonna met Heiligen voor de kerk der Antwerpse Augustijnen', *Jaarboek Koninklijk Museum voor Schone Kunsten* (Antwerp, 1977), pp 221–34; Antwerp (1978A), p 41, no 11, repr

2 K.d.K., Rubens, p 242

3 Antwerp–Rotterdam (1966–67), sub no 30; Ottawa (1968–69), no 42, fig 42. Jordaens later used the same study for *Odysseus threatening Circe*, formerly in the collection of the late Mrs Ruth K. Palitz, New York

4 Line engraving, 65.2 × 46.3 cm. Antwerp (1978B), no 88, fig 88

5 Inv. no 947. Oil on paper, 64 × 42.5 cm

6 Inv. no 31. Oil on paper (mounted on panel), 43 × 36 cm; Ottawa (1968–69), no 59, fig 59

7 Line engraving, 43.9 × 33.3 cm; Ottawa (1968–69), no 306, fig 306

8 Rooses, pp 40–42, 105–106, 109, 180, 192–93, 213, 217, repr p 44; Buschmann, p 90, pl XVII; Kauffmann, p 198, n 11; Van Puyvelde, pp 14,

35–36, 123, fig 28; Jordaens (1956), pp 133–34, fig 75; Jordaens Drawings, sub no A 74

9 K.d.K., Rubens, p 204. Now at Vienna

10 Jordaens Drawings, nos A 74–A 76, figs 83–85

11 Ottawa (1968–69), no 69, fig 69

12 J. Denucé, *De Antwerpsche 'konstkamers', inventarissen van kunstverzamelingen te Antwerpen in de 16e en 17e eeuwen* II (Antwerp, 1932), p 107

13 Ottawa (1968–69), sub no 69

14 Rooses, pp 191–92, repr p 191; Van Puyvelde, p 124, fig 83; d'Hulst (1956), p 144, fig 85; Ottawa (1968–69), no 45, fig 45; Jordaens Drawings, sub no A 98

15 Cat. 1950, no 199. Rooses, p 215; Van Puyvelde, p 107; Ottawa (1968–69), no 22, fig 22; Jordaens Drawings, sub no A 286. An oil study corresponding to the head of Abraham is at Brunswick (n 115; canvas, 50 × 38 cm)

16 The Nelson Gallery and Atkins Museum, nos 66–63

17 Ottawa (1968–69), no 30, fig 30. The *Head of a bearded man by candle-light*, Mr and Mrs Lawrence A. Fleishman, New York (Ottawa (1968–69), no 29, fig 29) is a study for St Christopher

18 L. Réau, *Iconographie de l'Art Chrétien* III (Paris, 1958), pp 305–306. Rubens's triptych of *The descent from the cross* was commissioned by the Arquebusiers' guild, whose patron was St Christopher, so he naturally appears in the altarpiece; it may be wondered, however, why Rubens did not place him in the centre panel as he did in other similar cases (St Bavo, St Livinus, St Ildefonsus etc.). The explanation probably lies in the popular devotion to St Christopher. As the wings of the retable were only opened out on exceptional occasions, the huge image of the saint was practically always exposed to the general view

19 Cat. 1959, no 241. Rooses, pp 198–200, repr p 200; Buschmann, pp 90–91, pl XVIII; Van Puyvelde, p 128, fig 81; d'Hulst (1956), pp 144, 385; Jordaens Drawings, sub no A 389

20 M. Rooses, *L'oeuvre de P. P. Rubens* I (Antwerp, 1886), no 133, pl 42; cat. *Äldre Utländska Målningar och Skulpturer*, Nationalmuseum, Stockholm (Stockholm, 1958), p 175, no 603

21 G. P. Mensaert, *Le peintre amateur et curieux* II (Brussels, 1763), p 77

22 Canvas, 258 × 251 cm (a strip was later added at the top). Kauffmann, p 206, n 22; L. van Puyvelde, 'An Unpublished Jordaens', *Burlington Magazine* LXII (1933), pp 217, 222, fig I; Van Puyvelde, pp 105–106, 116, fig 74; Ottawa (1968–69), no 57, fig 57; d'Hulst (1956), pp 196–97, fig 89

23 Oil on paper, 37 × 29 cm. Ottawa (1968–69), no 56, fig 56

24 For less good versions, *see* Jordaens Drawings, sub no A 169

25 Canvas, 100 × 188 cm; signed *J. JOR. Fe 1641*. Rooses, p 106–107, 178–79; Held (1965), p 112, n 5. An example in the Walters Art Gallery, Baltimore,

signed *I. IOR fe 1647*, was painted with studio help (Ottawa (1968–69), no 91, fig 91)

26 Canvas, 132 × 199 cm. Ottawa (1968–69), sub no 91, fig XXV

27 Paper on canvas, 50 × 75 cm

28 Paper on canvas, 92 × 196 cm. Sold at the Hôtel Drouot, Paris, on 23–24 April 1909, lot 39, repr, and again on 14 December 1912, lot 69, repr

29 Canvas, 108 × 152 cm. Antwerp (1905), no 45, repr in Album

30 Inv. no 2552. D'Hulst (1956), pp 134, 335 (sub no 39); Held (1965), p 115, fig 13; Ottawa (1968–69), no 53, fig 53

31 Held (1941), p 122; d'Hulst (1956), pp 107–108, 326; Held (1965), pp 115–16, fig 14; Ottawa (1968–69), no 51, fig 51

32 Paper on canvas, 55 × 78 cm. D'Hulst, Jordaens, Tapestry, p 240; d'Hulst (1956), p 335 (sub no 39); Held (1965), pp 115–16, fig 15; Ottawa (1968–69), no 52, fig 52

33 W. Noël Sainsbury, *Original Unpublished Papers Illustrative of the Life of Sir Peter Paul Rubens* (London, 1859), p 243, n 265

34 D'Hulst, Jordaens, Tapestry, p 240, fig 6; d'Hulst (1956), pp 134, 138, 335 (sub no 39), fig 76; Held (1965), pp 115–16; Ottawa (1968–69), no 54, fig 54. Sold by Sotheby Parke Bernet, New York, from the collection of the late Mrs Ruth K. Palitz, 6–7 March 1975, lot 25, repr

35 Canvas, 133 × 204 cm. Rooses, p 105, repr p 107; Van Puyvelde, p 181, n 167; d'Hulst, Jordaens, Tapestry, p 240; d'Hulst (1956), pp 134, 335 (sub no 39), fig 77; Held (1965), pp 115–16; Ottawa (1968–69), no 58, fig 58

36 81 × 114 cm. *Burlington Magazine* LXL (December 1932), repr p III

37 Cat. 1900, p 349, no 363. Canvas, 117 × 225 cm. D'Hulst, Jordaens, Tapestry, p 240; d'Hulst (1956), pp 134, 138, 161, 335 (sub no 39)

38 Photo A.C.L., no 119.946 B

39 Cat. 1923, no 611. Panel, 59 × 78 cm

40 Cat. 1959, no 819. Rooses, p 194; Van Puyvelde, pp 84–85; d'Hulst (1956), pp 172–73, 342 (sub no 54); Ottawa (1968–69), no 26, fig 26; Antwerp (1978A), p 37, no 9, repr

41 Cat. 1935, no 84. Canvas, 116 × 156 cm. Rooses, pp 82, 86, 187, repr facing p 190; Van Puyvelde, pp 119–20; d'Hulst (1956), pp 142, 168, 340 (sub no 48); Ottawa (1968–69), no 48, fig 48; Jordaens Drawings, sub no A 91

42 Cat. 1893, no 425. The date, indistinct owing to damage, was read as *1625* by earlier authors such as Rooses (p 49) and Van Puyvelde (p 31). Held (1939, p 20) read it as *1635*, which has since been generally accepted as correct

43 Cat. 1922, no 2013. Rooses, pp 85–86, 176, 177, 192, repr p 96; Buschmann, pp 111, 137, pl XXXV; Van Puyvelde, pp 110–11; d'Hulst (1956), pp 144, 353

(sub no 82); Ottawa (1968–69), no 49, fig 49;
Jordaens Drawings, sub nos A 137, A 138

44 *Quid mirum natura Jovis si cedat Amori | Et vaga per
thalamos ambulet illicitos. | Ecce inter Satyros nutritur
lacte caprino, | Naturam capreae suxerat et sequitur.*
An ivory relief by Ignaz Elhafen in the Victoria and
Albert Museum, London, is based on this engraving
(18.7 cm wide; initialled *I.E.* Repr in *Burlington
Magazine* XCVI (April 1954), p 127, fig 33)

45 Cat. 1934, no 1315. D'Hulst (1956), pp 144, 321
(sub no 12); Jordaens Drawings, sub no A 38

46 *Pan sedet et viridi ridens sub tegmine fagi | Depromit
lepidos gutture dulce sonos. | Festiuo quatiens terram
pede, gaudia fingit | Grex tener, et placido gramina
dente legit.*

47 Cat. 1929, no 103. Rooses, pp 86–87, repr facing
p 86; Buschmann, pp 110–11, pl. XXXIV; Van
Puyvelde, pp 30, 108; d'Hulst (1956), pp 147, 199,
201, 353 (sub no 82), 406 (sub no 207); Jordaens
Drawings, sub nos A 137, A 138. A second version
at Kassel (cat. 1929, no 104; canvas, 147 × 173 cm) is
a copy of a lost work of which only a fragment (the
infant Jupiter) survives; this was formerly in the
possession of S. Nystad, The Hague (panel,
133 × 70.5 cm)

48 D'Hulst (1956), pp 145, 147, 149–51, fig 86;
H. Vlieghe, 'Jacob Jordaens' Activity for the Torre
de la Parada', *Burlington Magazine* CX (1968),
pp 262–65

49 Canvas, 200 × 270 cm; signed and dated *1638*

50 Cat. 1975, no 1634. Canvas, 181 × 288 cm; signed
I.R. fecit and dated *A° 16.*

51 Cat. 1975, no 1551. Canvas, 181 × 267 cm; signed
J. JOR. fec. A copy of this painting by Juan Bautista
Martinez del Maso (Cat. Prado (1945), no 1712)
appears in the background of Velázquez' *Las Meniñas*

52 Cat. 1975, no 1539. Canvas, 171 × 285 cm

53 Cat. 1975, no 1713. Canvas, 181 × 300 cm

54 A composition drawing for this picture is at
Besançon, inscribed in Jordaens's own hand
1639.6.Augusty JJ (*see* Jordaens Drawings, no A
145)

55 Cat. 1928, no 1087a. D'Hulst (1956), p 147; J. S.
Held 'Zwei Rubensprobleme (Die Kekropstöchter)',
Zeitschrift für Kunstgeschichte (1976), vol 39,
pp 34–35, fig 10

56 Sold at Sotheby's, London, 12 December 1973, lot
23. Rooses, p 152, repr p 154; Ottawa (1968–69),
no 77, fig 77; d'Hulst (1956), pp 150, 201, 355;
Jordaens Drawings, sub no A 254. A smaller version
(panel, 53 × 74.5 cm) is in a private collection at
Courtrai (d'Hulst (1966), p 90, fig 8)

57 Cat. 1908, no 999. D'Hulst (1966), pp 89–93, fig 10

58 D'Hulst (1961), pp 34–36, fig 6; exh. cat.*Weltkunst
aus Privatbesitz*, Kunsthalle, Cologne (1968), no
F 20, fig 13; Jordaens Drawings, sub no A 140. The
Christian moral of the story of Apollo and Pan is,
according to Carel van Mander (*f* 54v), that we
should not be tempted by pride to oppose the will
of God

59 Cat. 1934, no 1317. Rooses, p 153; Van Puyvelde,
pp 114–15; d'Hulst (1956), pp 150, 201, 355, fig 91;
d'Hulst (1961), pp 34, 36, fig 4; Ottawa (1968–69),
no 78, fig 78; Jordaens Drawings, sub no A 140

60 Cat. 1936, no 1044. Rooses, pp 94–95, repr p 100;
Kauffmann, p 196, n 9. An oil sketch on paper
(44 × 37 cm) for this painting is in the possession of
Mr R. Despiegelaere, Ghent (Ottawa (1968–69),
no 82, fig 82; Antwerp (1978A), p 57, no 19, repr)

61 C. Dempsey, 'Euanthes redivivus: Rubens's
Prometheus Bound', *Journal of the Warburg and
Courtauld Institutes* XXX (London, 1967), pp 420–25

62 Cat. 1959, no 677. Engraved by Schelte à Bolswert
and others. Rooses, pp 74–75, repr facing p 74;
Buschmann, pp 93–95, pl XIX; Van Puyvelde,
pp 37–38, repr facing p 28; d'Hulst (1956), p 145,
fig 87; Antwerp (1978A), p 51, no 16, repr

63 No 1407. Rooses, pp 76–78, repr p 80; Van Puyvelde,
p 135; d'Hulst (1956), pp 214, 435 (sub no 298);
Ottawa (1968–69), no 65, fig 65

64 No G.K.I. 3849. Canvas, 121 × 187 cm. Ottawa
(1968–69), no 66, fig 66

65 Rooses, p 78; Van Puyvelde, p 205; Ottawa
(1968–69), no 67, fig 67

66 I am much obliged to Mr Lode De Clercq for
pointing out that this song was published in *Annalen
van den Oudheidkundigen kring van het land van Waas*
(St Niklaas, 1938), vol 50, fascicle 1, pp 55, 58–59,
64

67 Rooses, pp 61–66

68 Cat. 1958, no 108. Rooses, pp 66–67, repr p 151;
Buschmann, p 109; Van Puyvelde, pp 139–40;
d'Hulst (1956), pp 144, 215, 303, 407 (sub no 208)

69 D'Hulst (1957–58), pp 138–43, figs 3, 4; Jordaens
Drawings, sub no C 93

70 Cat. 1922, no 2014. Rooses, pp 68–70; Buschmann,
p 107; Held (1940B), pp 80–81, fig 13; Van Puyvelde,
p 136; d'Hulst (1956), pp 147, 192, 195, 350 (sub no
75), 351 (sub no 76); Ottawa (1968–69), no 64, fig 64

71 Cat. 1959, no 664. Buschmann, pp 95–96, pl XX;
Rooses, pp 70–73, repr p 68; Van Puyvelde, p 137,
fig 7, colour plate facing p 148; d'Hulst (1956),
pp 146–47, 191, 196, 350 (sub no 74), 351 (sub
no 77), 412 (sub no 225), fig 88; Jordaens Drawings,
sub nos A 134, A 156, A 158

72 Cat. 1958, no 3760. Canvas, 160 × 213 cm. Rooses,
pp 73–74, repr p 69; Van Puyvelde, p 136, fig 8;
d'Hulst (1956), pp 242, 351 (sub no 77), 370 (sub no
117), 406 (sub no 206); Jordaens Drawings sub nos
A 135, A 156, A 163, A 235

73 Cat. 1963, no 225. Rooses, pp 61–62, 73, 148–49,
repr facing p 150; Buschmann, pp 96–97,
frontispiece; Van Puyvelde, p 140, fig 90; d'Hulst
(1956), pp 215–16, 414 (sub no 233); Jordaens
Drawings, sub nos A 163, A 164, A 235

74 Cat. 1936, no 806 (as *As the old sang, so the young
pipe*). Canvas, 239 × 322 cm; signed *J JOR FE. 1646.*
Rooses, pp 81, 137, 140; Buschmann, pp 106–107,
pl XXXII; Van Puyvelde, pp 42, 137–38, 140, 143;
Jordaens Drawings, sub nos A 127, A 136, C 48

75 Canvas, 165 × 235 cm. Formerly in the collection of the Duke of Devonshire, Chatsworth; Buschmann, p 108, pl XXXIII; Rooses, p 148, repr p 150; Van Puyvelde, pp 138–39; Jordaens Drawings, sub nos A 127, A 163, A 164

76 Cat. 1959, no 242. Canvas, 262 × 285 cm. On loan to Tournai. Buschmann, p 108; Jordaens Drawings, sub nos A 127, A 163, A 164, A 167, C 45; Antwerp (1978A), pp 73–74, no 27, repr

77 Jordaens Drawings, no A 201, fig 216

78 Rooses, pp 81–82, 86, 109, 188, repr on title-page and p 88

79 Antwerp (1978A), p 55, no 18, repr

80 Cat. 1959, no 476. Canvas, 200 × 300 cm; bears the monogram of A. van Utrecht (b Antwerp 1599, d there 1652) and the date 1637. Wrongly entitled Sea-fish, as the still life consists mostly of meat, game, fruit and vegetables. Rooses, pp 95–96, repr p 101 (mentioning other works in which Jordaens is said to have collaborated); Van Puyvelde, pp 34, 77, 130; d'Hulst (1956), pp 145, 190, 349 (sub no 71), 432 (sub no 287); Jordaens Drawings, sub nos A 119, A 125, A 147

81 Cat. 1962, no 93. Rooses, pp 96–97; Jordaens Drawings, sub no A 126 (where the picture is dated somewhat too early)

82 Cat. 1959, no 237. Canvas, 141 × 199 cm. Pieter Boel was born in Antwerp in 1622 and died in Paris in 1674. Rooses, p 235, repr p 239

CHAPTER VI

1 Cf the lawsuit brought against Jordaens by Martinus van Langenhoven in regard to five pictures delivered in 1646 (Rooses, pp 137–38)

2 Cat., undated, no 130. Rooses, pp 128–30, repr p 128; Van Puyvelde, pp 39–40; d'Hulst (1956), pp 207–208; Jordaens Drawings, pp 75, 77

3 The painting bears a closer resemblance to the engraving by Pieter II de Jode (M. Rooses, L'oeuvre de P. P. Rubens I (Antwerp, 1886), pl 49) than to The visitation in Antwerp cathedral (K.d.K., Rubens, p 52)

4 Rooses, pp 130–31, repr facing p 132; Buschmann, pp 102–103, 105, pl XXVI; Van Puyvelde, pp 41, 128; d'Hulst (1956), pp 208–209, fig 136; Jordaens Drawings, p 78, sub nos A 186, A 187, A 290, C 33

5 Rooses, pp 130–31

6 K.d.K., Rubens, p 277. Now in the Antwerp museum

7 Cat., undated, no 131. Canvas, 245 × 205 cm. Rooses, pp 196, 252, repr p 196; Van Puyvelde, p 39; d'Hulst (1956), pp 213–14; Jordaens Drawings, sub no A 322

8 Inv. no S.93. Kauffmann, p 196; d'Hulst (1956), p 214; Jordaens Drawings, sub no A 99

9 Cat. 1959, no 243. Rooses, pp 134–35, 183, repr p 136; Buschmann, p 105, pl XXXI; Van Puyvelde, pp 41–42, 68, 128, fig 34; d'Hulst (1956), pp 209, 214, fig 137; Jordaens Drawings, p 80, sub nos A 97, A 215, A 216, A 417

10 Cat. 1900, no 663. Rooses, pp 132–34, repr p 132; Buschmann, p 104, pl XXVIII; Kauffmann, p 193; Van Puyvelde, p 41, fig 32; d'Hulst (1956), pp 209, 264, 292, 310, 409 (sub nos 215, 216), 410 (sub no 217), 433 (sub no 293); Jordaens Drawings, p 80, sub nos A 185, A 308, B 13, C 41, C 110. An unsigned variant of this painting, known to me only from a reproduction, is in the museum at Perm, U.S.S.R. (cat. 1963, no 18. Canvas, 153 × 231 cm)

11 Inv. no 830. Canvas, 193 × 225 cm. Rooses, p 201, repr p 201; Van Puyvelde, pp 100–101; d'Hulst (1956), p 154; Ottawa (1968–69), sub no 200, fig XXVIII; Jordaens Drawings, sub nos A 217, A 389

12 The composition is preserved in an engraving by Vorsterman (M. Rooses, L'œuvre de P. P. Rubens I (Antwerp, 1886), pp 165–67 (no 132), pl 41)

13 Teresio Pignati, Veronese (Venice, 1976), no 239, figs 553–55

14 Cat. 1922, no 2011. Buschmann, pp 104–105, pl XXIX; Rooses, pp 172–74, 193, 229, repr facing p 176; d'Hulst (1956), pp 264–65, fig 174; Jordaens Drawings, sub nos A 30, A 185, A 270–A 272, C 47

15 Von Sandrart, p 214

16 This subject was treated several times by the Bassano (Da Ponte) family of painters, and many versions, some of them small in size, found their way to various places, eg one by Leandro Bassano in the Lille museum (cat. 1893, no 609); it is quite possible that Jordaens saw one of these

17 Cat. 1968, no 5551. Canvas, 184.5 × 221 cm (enlarged by 12 cm on the right). Van Puyvelde, pp 115, 124, fig 85

18 F. Waltman van Spilbeeck, 'De voormalige abdijkerk van Tongerloo en hare kunstschatten', De Vlaamsche School XXIX (Antwerp, 1883), p 30; Rooses, p 145; d'Hulst (1956), pp 217, 373 (sub no 128); Jordaens Drawings, sub no A 238

19 Cat. 1956, no 383. Rooses, pp 136–37, repr p 139; Kauffmann, pp 193–98, fig 1; Van Puyvelde, p 105; d'Hulst (1956), p 220; Jordaens Drawings, sub nos A 274, A 275, A 277, A 278

20 K.d.K., Rubens, p 91

21 Canvas, 210 × 165 cm. Rooses, p 175, repr p 237; Van Puyvelde, pp 104–105; d'Hulst (1956), pp 220–21, fig 140; Jordaens Drawings, sub nos A 274–A 276; Antwerp (1978A), p 71, no 26, repr

22 Cat. 1958, no 5592. Canvas, 198 × 168 cm. The painting is high on the wall and I have not been able to see it close to

23 Inv. no S 92. Canvas, 282 × 156 cm. Jordaens Drawings, sub nos A 275, A 277, A 280

24 Inv. no 76. Van Puyvelde, p 41; d'Hulst (1956), pp 151–52, 208, fig 90

25 Cat. 1975, no 1548. Canvas, 131 × 127 cm (a strip measuring about 12 cm at the top, and putti depicted in the air have been added by an unknown hand)

26 Canvas, 83 × 142 cm. Rooses, p 94, repr p 99; Buschmann, pp 114–15; Van Puyvelde, p 116, fig 88. There is a less good replica at Brunswick

27 K.d.K., Rubens, p 324. Rubens's work was inspired by Titian's *Homage to Venus* in the Prado (cat. 1945, no 419), which he copied during his second stay in Madrid

28 W. Noël Sainsbury, *Original Unpublished Papers Illustrative of the Life of Sir Peter Paul Rubens* (London, 1859), pp 214–15; M. Rooses and C. Ruelens, *Correspondance de Rubens* VI (Antwerp, 1909), pp 251–52

29 Cat. 1929, no 109. Rooses, pp 88–89, repr facing p 90; Buschmann, p 116; d'Hulst (1956), pp 219, 253, 376; Ottawa (1968–69), no 96, fig 96; Jordaens Drawings, pp 312–13

30 Rooses, p 93; Buschmann, p 111; d'Hulst (1956), pp 219, 253, 375 (sub no 133), 413 (sub no 243), 434 (sub no 294); Jordaens Drawings, sub nos A 251, C 49, C 51

31 Cat. 1925, no 988. Canvas, 123 × 158 cm. Rooses, pp 93–94; Jordaens Drawings, sub no A 251

32 Cat. 1959, no 5023. Rooses, p 91; Van Puyvelde, p 146; d'Hulst (1956), pp 219–20, 374 (sub no 130), fig 139; Ottawa (1968–69), no 98, fig 98; Jordaens Drawings, sub no A 262; Antwerp (1978A), p 69, no 25, repr

33 K.d.K., Rubens, p 133

34 Cat. 1931, no 204. Canvas, 167 × 161 cm. Jordaens Drawings, sub no A 262

35 Inv. no 54.134. Rooses, pp 92–93; Van Puyvelde, p 196; d'Hulst (1956), p 219; Ottawa (1968–69), no 97, fig 97

36 Cat. 1901, no 528. D'Hulst (1956), pp 219–20, 249, 374; Ottawa (1968–69), no 99, fig 99; Jordaens Drawings, sub no A 262

37 Cat. 1951, no 351. Canvas, 240 × 311 cm; signed *J. Jor. fec. 1649*. Rooses, p 145, repr p 147; K. Erasmus, 'Eine Studie zum Gemälde "Der Überfluss" von Jakob Jordaens im Klg. Museum in Kopenhagen', *Monatsheft für Kunstwissenschaft* (Leipzig, 1908), pp 708–709, repr; d'Hulst (1956), pp 218–19; Jordaens Drawings, sub nos A 242–A 245

38 Van Mander, *f 73v*

39 Inv. no 1009. Rooses, p 94, repr p 98; Jordaens Drawings, sub no A 149

40 Cat. 1959, no 691. Canvas, 161 × 260 cm. Rooses, pp 152, 216–17, repr p 216; Jordaens Drawings, sub nos A 150, C 70, C 76

41 Rooses, pp 142–43, repr p 143; Jordaens Drawings, sub nos A 121, A 148; Antwerp (1978A), p 65, no 23, repr

42 Canvas, 119 × 108 cm. Rooses, p 257; Van Puyvelde, p 196; Ottawa (1968–69), no 95, fig 95

43 Canvas, 111 × 88.5 cm. Sold at Sotheby's, London 8 July 1981, lot 48 (repr). The painting was in the Latinie sale, Antwerp, 1905. Rooses, pp 153–54. A drawing of *Atalanta and Hippomenes* by Maarten de Vos is in the Witt Collection, London. Rubens made an oil sketch of this subject for the decoration of the Torre de la Parada (Svetlana Alpers, *The Decoration of the Torre de la Parada, Corpus Rubenianum Ludwig Burchard* IX (Brussels–London–New York, 1971), pp 180–81, no 4a)

44 J. Van Vloten, *Alle de wercken van Jacob Cats* (Zwolle, 1862), p 84

45 Rooses, pp 137–38, 140–45; Jordaens Drawings, pp 81–82

46 G. F. Waagen, *Treasures of Art in Great Britain* III (London, 1854), pp 291–92 (as in the possession of Sir Archibald Campbell of Succoth, Bart., Garscube, Dumbartonshire); Antwerp (1978A), p 59, no 20, repr. This painting is shown in Watteau's *Enseigne de Gersaint*

47 Cat. 1912, no 914. Rooses, p 259; Van Puyvelde, p 124; d'Hulst (1956), p 127; Ottawa (1968–69), no 81, fig 81; Jordaens Drawings, sub no A 217

48 Inv. no S3.94. Van Puyvelde, pp 39–40; d'Hulst (1956), pp 217, 415; Ottawa (1968–69), no 80, fig 80; Jordaens Drawings, pp 83, 302, 522; Antwerp (1978A), p 63, no 22, repr

49 Canvas, 231 × 349 cm. Rooses, pp 48–49, repr p 58; Van Puyvelde, p 40; d'Hulst (1956), p 217

50 Atheneum. Canvas, 89.7 × 116 cm. Rooses, p 181; d'Hulst (1956), pp 260, 380; Ottawa (1968–69), sub nos 87, 303; Jordaens Drawings, sub nos A 264–A 267

51 North Carolina Museum of Art. Inv. no 52.9.99. Canvas, 109.5 × 140 cm. Ottawa (1968–69), no 87, fig 87; Jordaens Drawings, sub nos A 264, A 268

52 Van Mander, *f 72v*

53 Cat. 1930, no 1010. Rooses, pp 100–103, 193, repr facing p 102; Kauffmann, p 196; Van Puyvelde, p 40; Jordaens Drawings, sub nos A 182, B 26, C 29

54 Jordaens Drawings, nos A 182, A 183

55 Génard (1852), pp 17, 34; A. Hustin, 'Les Jordaens du Sénat. Les signes du Zodiaque', *L'Art* LXIII (Paris, 1904), pp 35–42; Rooses, pp 125–27; Van Puyvelde, pp 47–48, n 72; d'Hulst (1956), pp 212–13; Ottawa (1968–69), sub no 194; Jordaens Drawings, sub nos A 152, A 293, A 361

56 F. Hartt, *Giulio Romano* (New Haven, Yale University Press, 1958), figs 238, 240

57 Rooses, p 137

58 Cat. 1941, no 1159. Rooses, pp 140–41; Kauffmann, p 197; d'Hulst (1956), pp 214, 216. In a *Kunstkammer* at Schloss Schleissheim, generally ascribed to W. Schubert von Ehrenberg, to which various artists each contributed one of their works, there is a *King Candaules* by Jordaens which broadly corresponds in reverse image to the version at Stockholm (d'Hulst (1967B), p 147)

59 Cat. 1929, no 106. Rooses, pp 134–35, 183, repr facing p 136; Held (1949), p 153, fig 1; Van Puyvelde, pp 44–45, fig 35; d'Hulst (1956), pp 214, 231–32, 363 (sub no 102), fig 138; Ottawa (1968–69), no 90, fig 90; Jordaens Drawings, sub nos A 58, A 84, A 85, A 416

60 Cat. 1959, no 238. Canvas, 130 × 172 cm. Rooses, pp 57–58, 184, repr p 60; Van Puyvelde, p 133; d'Hulst (1956), pp 213, 236, 365 (sub no 105)

61 Cat. 1958, no 105. Canvas, 191.5 × 212 cm. Rooses, pp 59–60, repr facing p 60; d'Hulst (1956), p 213; Ottawa (1968–69), sub no 220

62 Canvas, 99 × 175 cm. Jordaens Drawings, sub no A 84

63 Canvas, 99 × 175 cm. Ottawa (1968–69), sub no 181

64 Inv. no 14810. Held (1949), p 153, fig 3; d'Hulst, Jordaens, Tapestry, p 250; Ottawa (1968–69), no 88, fig 88

65 Springfield Museum of Fine Arts. D'Hulst (1956), p 342 (sub no 52); d'Hulst, Jordaens, Tapestry, p 250, fig 19; Ottawa (1968–69), no 89, fig 89; Jordaens Drawings, sub no A 86

CHAPTER VII

1 Canvas, 850 × 820 cm. Rooses, pp 157–71, repr facing p 170; Buschmann, pp 116–19, pl XXXVII; Kauffmann, p 200; Van Puyvelde, pp 45–47, figs 37–38; d'Hulst (1956), pp 261–63, 384 (sub nos 153, 154); Jordaens Drawings, p 372 sub no A 295, pp 538–539 sub no C 69

2 Cat. 1959, no 799. Canvas, 116 × 126 cm. Rooses, pp 164–66; Van Puyvelde, p 46; d'Hulst (1956), p 263; Ottawa (1968–69), no 100, fig 100; Antwerp (1978A), pp 77–78, no 28, repr

3 Cat. 1959, no 236. Rooses, pp 164–66; Van Puyvelde, pp 46–47; d'Hulst (1956), p 263; Ottawa (1968–69), no 101, fig 101

4 Cat. 1938, no 146. Canvas, 119.5 × 117.5 cm. Rooses, pp 164–66, repr p 165; Van Puyvelde, p 46, fig 39; d'Hulst (1956), p 263; Ottawa (1968–69), no 102, fig 102

5 Buschmann, pp 119–20; Rooses, pp 168–69, repr p 169; d'Hulst (1956), pp 262–63; Jordaens Drawings, p 83. In a letter of 14 October 1649 to Constantijn Huygens (Mariemont museum, inv. no At.1168/I) [7] Jordaens calls this piece 'How death, by the revolution of time, brings all to ruin'

6 Hanna Peter, *Die Ikonographie des Oranjezaal*, typed thesis (Bonn, 1978), pp 161–62

7 Buschmann, pp 36, 38, 120–21; Rooses, pp 118–19, 125–27, repr pp 126, 127

8 Ottawa (1968–69), sub no 185

9 Their dimensions are respectively: *circa* 310 × 250 cm; *circa* 230 × 130 cm; unknown; *circa* 130 × 210 cm; *circa* 250 × 300 cm; *circa* 300 × 250 cm, dated *1652*; *circa* 240 × 135 cm; *circa* 240 × 135 cm

10 Canvas, 67 × 82 cm

11 Hecquet, nos 5, 6, 11, 16, 17, 19, 31; Buschmann, pp 136–37; Rooses, pp 88, 175 ff; d'Hulst (1956), pp 265–66, 353 (sub no 82), 376 (sub no 135), 378 (sub no 139), 383 (sub no 151); Ottawa (1968–69), pp 239–40, nos 286–91, figs 286–91; Jordaens Drawings, p 85, sub nos A 30, A 138, A 139, A 257, C 78; Antwerp (1978B), pp 149–51, nos 103–109, repr

12 Ottawa (1968–69), p 239

13 Jordaens Drawings, no A 257

14 Jordaens Drawings, no A 274

15 Inv. no 896.1.115. Canvas, 61 × 82 cm

16 Van Puyvelde, p 50; d'Hulst (1956), pp 268, 279, 384 (sub no 156); Ottawa (1968–69), no 105, fig 105; Jordaens Drawings, p 85, sub nos A 287, C 66

17 Cat. 1951, no 352. Buschmann, p 123; Rooses, pp 198–99, repr p 199; Held (1939), pp 31–33, fig 33; Van Puyvelde, p 50; d'Hulst (1956), pp 268, 279; Jordaens Drawings, p 86, sub no A 389

18 *Susanna and the elders*, Munich (K.d.K., Rubens, p 411)

19 *Susanna and the elders*, Vienna (Inv. no 1530)

20 No GK.I.5194. Canvas, 225 × 164 cm; signed *J.JOR fec 1657*. Held (1939), pp 31–33, fig 32; Van Puyvelde, p 54; d'Hulst (1956), p 268, n 1; Ottawa (1968–69), no 109, fig 109; Jordaens Drawings, p 87, sub no A 389

21 Cat. 1893, no 424. Canvas, 177 × 135 cm. Held (1939), p 31; d'Hulst (1956), p 268, n 1; Jordaens Drawings, sub no A 389

22 Louvre, cat. 1922, no 2011 A. Canvas, 391 × 300 cm; signed and dated *J.JOR fec 1653*. Buschmann, p 123; Van Puyvelde, pp 53–54, 146, n 90; d'Hulst (1956), p 270; Ottawa (1968–69), sub no 229; Jordaens Drawings, p 86

23 K.d.K., Rubens, pp 118, 195, 241 respectively

24 Cat. 1959, no 221. Canvas, 243 × 202 cm. From the chapel of the former episcopal palace at Antwerp. Rooses, pp 192, 196–97, repr facing p 200; Van Puyvelde, p 123; d'Hulst (1956), pp 213–14, 228, 256, 360 (sub no 97), 433 (sub no 289); Jordaens Drawings, sub no A 322; Antwerp (1978A), p 91, no 33, repr

25 Cat. 1957, no K.1098. Van Puyvelde, p 94; d'Hulst (1956), pp 221, 257, 379 (sub no 141), 433 (sub no 289), fig 141; Jordaens Drawings, sub nos A 95, A 261

26 In a private collection at Munich in 1938, and photographed by the museum there (no 38/906)

27 Inv. no 143. Canvas, 72.5 × 93 cm; signed and dated *J.JOR.fec.1653*. Rooses, pp 195–96, repr p 195; Van Puyvelde, pp 50–51; d'Hulst (1956), p 269; Jordaens Drawings, p 86

28 J. Denucé, *De Antwerpsche 'Konstkamers', inventarissen van kunstverzamelingen te Antwerpen in de 16de en 17de eeuwen* (Antwerp, 1932), p 260

29 Cat. 1958, no 917. D'Hulst (1956), p 392 (sub no 173); d'Hulst (1957–58), pp 150–53, fig 13; Ottawa (1968–69), no 107, fig 107; Jordaens Drawings, p 86, sub nos A 302, A 304

30 Inv. no 8536. Canvas, 156 × 147 cm. D'Hulst (1969B), p 387 (sub no 241); Jordaens Drawings, sub no A 302

31 Inv. no 266. Van Puyvelde, p 51; d'Hulst (1956), p 269, fig 175; Ottawa (1968–69), no 108, fig 108; Held (1969), p 266

32 Canvas, *circa* 300 × 300 cm. Rooses, pp 233–34, 254–55; d'Hulst (1956), p 269; Jordaens Drawings, p 86. Together with a *Christ on the cross* by Erasmus II Quellinus, also now in St Catherine's church at

Honfleur, and a *Christ on the cross* by Gilles Backereel, this picture was in the possession of J. P. Le Chanteur, a French naval official stationed in Antwerp about 1800. Descamps (1769, pp 173–74) mentions all three works in his description of the Augustinian church at Antwerp

33 Cat. 1959, no 215. Canvas, 296 × 366 cm. Buschmann, p 126, pl XLI; Rooses, pp 115, 232–33, repr facing p 238; Van Puyvelde, p 146; Jordaens Drawings, pp 86–87; Antwerp (1978A), p 87, no 31, repr

34 *The Last Supper* in the Brera, Milan (K.d.K., Rubens, p 203)

35 Descamps (1769), p 173

36 Panel, 64.5 × 45 cm

37 Canvas, 170 × 225 cm. Van Puyvelde, p 190; d'Hulst (1956), p 269

38 Canvas, 285 × 185 cm. Théodore Van Lerius, *Notice des oeuvres d'art de l'église . . . St Jacques à Anvers* (Borgerhout, 1855), pp 125–26; Buschmann, pp 124–25, n 1; Rooses, pp 201–203, repr p 202; d'Hulst (1956), pp 268–69, 281, 388 (sub no 164), 420 (sub no 253); Jordaens Drawings, p 87, sub no A 319; Antwerp (1978A), p 89, no 32 repr

39 Jordaens Drawings, sub no A 319

40 Cat. 1881, no 126. Rooses, pp 105–106, repr p 109; Walther Koch, 'Jordaens Wunder des hl. Dominikus', *Weltkunst* XXVIII (no 2, 1968), p 44, repr p 44; Jordaens Drawings, sub nos A 273, A 365

41 Rubens originally painted this picture for S. Maria in Vallicella, Rome, but as it did not answer the required purpose he took it back with him to the Netherlands, having tried unsuccessfully to sell it to the duke of Mantua (K.d.K., Rubens, p 23)

42 Canvas, 280 × 178 cm. Van Puyvelde, p 147; d'Hulst (1956), p 269; Ottawa (1968–69), no 103, fig 103; Jordaens Drawings, sub nos A 292, C 68. An oil sketch (81 × 59 cm) for this picture belongs to the Artistic Patrimony of the Province of Brabant, Brussels (Antwerp (1978A), p 85, no 30, repr)

43 K.d.K., Rubens, p 301

44 Canvas, 289 × 180 cm. Buschmann, p 129; Rooses, pp 227, 239; Van Puyvelde, pp 146–47; d'Hulst (1956), pp 269, 421 (sub no 254); Jordaens Drawings, sub nos A 292, C 68

45 Canvas, 170 × 132 cm. Jordaens Drawings, sub nos A 272, C 72, pl VIII

46 Canvas, 85 × 57 cm. In composition this closely resembles Rubens's *Martyrdom of St Lawrence*, Munich (K.d.K., Rubens, p 109)

47 Cat. 1959, no 117. Canvas, 74 × 51 cm. Rooses, p 206

48 Cat. 1951, no 353. Rooses, p 213; Kauffmann, p 202; Van Puyvelde, p 149; Held (1939), pp 33–37, fig 34; d'Hulst (1956), pp 269, 282, 283, 389 (sub no 166); Jordaens Drawings, sub nos A 299, A 307

49 North Carolina Museum of Art, inv. no G.55.7.1. Van Puyvelde, p 53, fig 43; d'Hulst (1956), pp 270, 360 (sub no 97); Ottawa (1968–69), no 110, fig 110; Jordaens Drawings, p 87, sub no A 322

50 Cat. 1931, no 879. Canvas, 163 × 235 cm; signed and dated *I.Ior.fec. 1658*. D'Hulst (1956), p 270

51 At the Leger Galleries, London, in 1975. Rooses, p 255; Erik Burg Berger, 'An Unknown Work by Jacob Jordaens', *Burlington Magazine* LXVIII (1936), pp 139–40; Van Puyvelde, p 147; d'Hulst (1956), p 398 (sub no 187); Ottawa (1968–69), no 111, sub nos 255–56, fig 111; Jordaens Drawings, sub nos A 356–A360, C 81

52 Cat. 1893, no 426. Canvas, 137 × 155 cm. Inspired by Adam van Noort's picture of the same subject (canvas, 116 × 148.5 cm) sold by Giroux, Brussels, 11 March 1928, lot 8. Van Puyvelde, p 55; Jordaens Drawings, sub nos A 378, A379, C 109, C 110

53 Cat. 1964, no 6288. Buschmann, pp 129–30; Rooses, p 229

54 North Carolina Museum of Art, cat. 1956, no 119. Canvas, 84.5 × 140 cm. Marian C. Donnelly, 'Calvinism in the Work of Jacob Jordaens', *The Art Quarterly* XXII (1959), pp 363–66, fig 5; Jordaens Drawings, sub no A 351

55 No 292. Canvas, 158 × 239 cm. Rooses, pp 214, 230; Jordaens Drawings, sub no A 351. A copy is in St Waltruda's church at Herentals (canvas, 150 × 224 cm)

56 Cat. 1937, no S 5. Canvas, 167 × 242 cm. Descamps (1769), p 238; Buschmann, p 130; Rooses, pp 214, 230, repr p 214; d'Hulst (1956), pp 274–75; Jordaens Drawings, sub no A 351. Both this work and its pendant (*see* note 57) were originally in St Peter's abbey church at Ghent

57 Cat. 1937, no S 6. Canvas, 165 × 240 cm. Descamps (1769), p 238; Buschmann, p 130; Rooses, p 214; d'Hulst (1956), pp 274, 300, 403 (sub no 198); Jordaens Drawings, sub no A 351. *See* note 56

58 Descamps (1769), p 134; Buschmann, p 129; Rooses, pp 15, 227, 235–38; Van Puyvelde, pp 125–26; Ottawa (1968–69), sub no 104; Hertha Leemans, *De Sint-Gummaruskerk te Lier* (Antwerp–Utrecht, 1972), pp 292–93, fig 290

59 Canvas, *circa* 400 × 270 cm. Descamps (1769), p 29; C. Piot, *Tableaux enlevés à la Belgique en 1794 et restitués en 1815* (Brussels, 1883), pp 54–55, no 230, n 1; Buschmann, p 129; Rooses, pp 15, 238; Van Puyvelde, p 126

60 Oil on paper (transferred to canvas), 66 × 48 cm. Ottawa (1968–69), no 104, fig 104

61 No 1921-A. Canvas, 72 × 55 cm. Van Puyvelde, p 193; Ottawa (1968–69), no 113, fig 113

62 Cat. 1933, no 2045. Destroyed in 1945

63 K.d.K., Rubens, p 49

64 Cat. 1930, no 1012. Buschmann, p 128; Rooses, pp 192, 212–13, 230, repr facing p 216; d'Hulst (1956), pp 273, 430 (sub nos 281–82); Jordaens Drawings, sub nos A 99, C 95, C 96

65 M. Rooses, *L'oeuvre de P. P. Rubens* I (Antwerp, 1886), pl 60

66 Bob Jones University Gallery. Canvas, 116 × 105 cm. Ottawa (1968–69), no 74, fig 74; Jordaens Drawings, sub nos A 99, B 29

67 Formerly in the collection of Baron Van Zuylen, Brussels. Jordaens Drawings, sub no A 363, pl VII

68 Cat. 1890, no 275. Buschmann, p 128; Rooses, pp 174, 208–10, 227, 228–29, repr facing p 212 and on pp 210, 211; d'Hulst (1956), pp 272–73, fig 176; Jordaens Drawings, p 90, sub nos A 281, A 395–A397

69 Cat. 1936, no 1909. Canvas, 238 × 296 cm. Rooses, pp 209–10; Jordaens Drawings, sub no A 395

70 Buschmann, pp 44–45, 127; Rooses, p 204; Van Puyvelde, pp 55–56; d'Hulst (1956), pp 271, 299, 400 (sub no 192); Jordaens Drawings, p 89, sub nos A 390, C 107

71 Buschmann, pp 44–45, 127; Rooses, p 204; Van Puyvelde, pp 55–56; d'Hulst (1956), pp 271, 299, 400 (sub no 192); Jordaens Drawings, p 89, sub no A 390

72 Buschmann, pp 44–45, 127; Rooses, pp 204–205; H. van de Waal, *Drie eeuwen vaderlandse geschied-uitbeelding, 1500–1800* I (The Hague, 1952), p 228; Van Puyvelde, pp 55–56; d'Hulst (1956), pp 271, 299, 400 (sub no 192); Jordaens Drawings, p 89, sub nos A 181, A 390–A 393

73 Van Puyvelde, pp 55–56; Jordaens Drawings, pp 90–91, sub no A 390

74 Centre canvas, 155 × 225 cm; signed and dated *J. Jord. fe. A° 1663*. Buschmann, p 128; Rooses, pp 192, 205–206, 230; Van Puyvelde, p 56; d'Hulst (1956), pp 271–72; Jordaens Drawings, p 89, sub no C 112

75 Canvas, 176 × 242.5 cm; signed and dated *J Jōr fëc et Inve 1663*. Van Puyvelde, p 57; d'Hulst (1956), p 272; Jordaens Drawings, p 90

76 Cat. 1948, no 220. Canvas, 230 × 230 cm; inscribed *ARTI PICTORIAE IACOBUS IORDAENS DONABAT*. Buschmann, p 130; Rooses, pp 206–207, 230; d'Hulst (1956), pp 273–74, fig 177; d'Hulst (1967B), pp 131–50; Jordaens Drawings, pp 90–91, sub nos C 115–C 116; Antwerp (1978A), p 109, no 42, repr

77 Cat. 1959, nos 218 (canvas, 263 × 274 cm) and 219 (canvas, 184 × 486 cm). Buschmann, p 45; Rooses, pp 207–208, d'Hulst (1956), p 274; d'Hulst (1967B), pp 131–50, figs 1, 2; Jordaens Drawings, pp 90–91, sub no A 366; Antwerp (1978A), pp 105, 107, nos 40–41, repr

78 Museum, Antwerp, cat. 1959, no 23

79 Canvas, *circa* 150 × 200 cm. Rooses, p 230; Van Puyvelde, pp 58–59; d'Hulst (1956), p 274; Jordaens Drawings, p 91, sub no A 186

80 Canvas, *circa* 150 × 200 cm. Rooses, p 231; Van Puyvelde, pp 58–59, n 61; d'Hulst (1956), p 274; Jordaens Drawings, p 91, sub nos A 186, A 187

CHAPTER VIII

1 E. Panofsky, *Early Netherlandish Painting* (Harvard University Press, 1964), pp 194–95

2 Hermitage museum, no 484. Hymans, col. 517; Buschmann, p 84, pl XII; Rooses, p 266; Held (1940B), pp 70–82, fig 1; Van Puyvelde, pp 25–26, fig 11; d'Hulst (1956), pp 22–23, 27, 31, 54, 63, 77, 194, fig 1; Ottawa (1968–69), no 3, fig 3

3 Held (1940B), pp 70–76

4 Cat. 1958, no 107. Hymans, col. 517; Buschmann, pp 82–83, pl XI; Rooses, pp 154–56, repr facing p 156; Held (1940B), pp 70–82; d'Hulst (1953A), pp 96–100, fig 2; Van Puyvelde, pp 26–27, fig 12; d'Hulst (1956), pp 22, 27–29, 54, 63, 77, 194, 351 (sub no 77), fig 2; Ottawa (1968–69), no 4, fig 4; Jordaens Drawings, p 64, sub no A 134

5 Prado museum, cat. 1975, no 1549. Hymans, col. 517; Buschmann, pp 85–86, pl XIII; Rooses, pp 53–54, repr p 54; Held (1940B), pp 78–79, fig 8; Van Puyvelde, pp 117–18, fig 3; d'Hulst (1956), pp 77–78, 81–82, fig 42

6 A. P. de Mirimonde, 'Les sujets de musique chez Jacob Jordaens', *Jaarboek Koninklijk Museum voor Schone Kunsten* (Antwerp, 1969), pp 201–206. Musical instruments also figure in seventeenth-century portraits merely as status symbols: *cf* Richard D. Leppert, 'David Teniers the Younger and the Image of Music', *Jaarboek Koninklijk Museum voor Schone Kunsten* (Antwerp, 1978), p 109: 'In fact, being a musician was considered so *de rigueur* that, even when they did not play instruments, the bourgeois were wont to hold one as a "prop" for their portrait'

7 Museum of Fine Arts, Robert Dawson Evans Collection, no 17.3232. J.-A. Goris and J. S. Held, *Rubens in America* (New York, 1947), no A 23; d'Hulst (1956), p 82; Ottawa (1968–69), no 35, fig 35

8 Canvas, 99 × 69 cm. Buschmann, pp 86–87, pl XIV; Rooses, pp 111–12, repr p 119; Burchard, pp 216–17; d'Hulst (1956), p 21

9 Rooses, pp 50–51; Van Puyvelde, pp 36–37; Held (1965), pp 112–14, figs 1, 2, 5; Ottawa (1968–69), sub no 178; Jordaens Drawings, p 73, sub nos A 117, A 118, A 173; Antwerp (1978A), pp 47, 49, nos 14, 15, repr

10 *Openbaar Centrum voor Maatschappelijk Welzijn van Antwerpen*, K.H.R. 171, *f 103v, Ontvangsten 1619–35 van de kamer van de huisarmen*

11 *Graf- en gedenkschriften van de provincie Antwerpen, I, Antwerpen Cathedrale kerk* (Antwerp, 1856), pp 426–27

12 *Ibid*, p 387

13 *Ibid*, p 387

14 K.d.K., Rubens, p 27

15 Frick Collection, New York. K.d.K., Van Dyck, pp 98–99

16 Jordaens Drawings, no A 117

17 Jordaens Drawings, no A 118

18 *Katalog der niederländischen Gemälde von 1550 bis 1800 im Wallraf-Richartz-Museum und im öffentlichen Besitz der Stadt Köln* (Cologne, 1967), pp 61–62, nos 1045, 1047, figs 7, 9, 80

19 Schlugleit, p 161

20 Rooses, pp 108–109

21 Rooses, p 109

22 Canvas, 117×113 cm. Sold at Sotheby's, London, 4 November 1970, lot 150

23 G. Waagen, *Treasures of Art in Great Britain* II (1854), p 94; Hymans, col. 530; Buschmann, p 101, pl XXIV; Rooses, pp 54–55, repr facing p 54; Van Puyvelde, pp 126–27; Ottawa (1968–69), no 44, fig 44; G. Martin, *National Gallery Catalogues, The Flemish School, c. 1600–c. 1900* (London, 1970), pp 91–94; Jordaens Drawings, sub no C 11

24 S. Slive, *Frans Hals* (London, 1970), 1–2, p 136, figs 125, 127

25 For the sake of accuracy it should be mentioned that Jordaens probably painted this double portrait in two stages. Technical examination has shown that the sitters were originally painted in three-quarter length; this is confirmed by a drawing showing the first state of the composition, in the Bernard Houthakker Gallery at Amsterdam in 1969 (Jordaens Drawings, no C 11, fig 488)

26 Buschmann, pp 92–93

27 C. Norris, 'The Disaster at Flakturm Friedrichshain: a Chronicle and List of Paintings', *Burlington Magazine* XCIV (December 1952), p 343

28 Daniel Papebrochius, *Annales Antverpienses* IV, ed. F. H. Mertens and E. Buschmann (Antwerp, 1847), p 436

29 No 640. Rooses, p 156, repr facing p 158; Van Puyvelde, p 122; Ottawa (1968–69), no 61, fig 61

30 Jordaens Drawings, nos A 173 (fig 184) and A 174 (fig 185)

31 Cat. 1958, no 486. Canvas, 155.5 × 120 cm. Buschmann, pp 99–100; Rooses, p 108; Van Puyvelde, p 131; d'Hulst (1956), pp 146, 349 (sub no 72); Ottawa (1968–69), sub no 72; Jordaens Drawings, sub no A 173

32 Cat. 1949, no 121. Canvas, 146 × 112 cm; inscribed *AETATIS 73 A° 1641*. Buschmann, pp 99–100; Rooses, p 108; Van Puyvelde, p 131; d'Hulst (1956), pp 146, 190, 349 (sub no 72); Ottawa (1968–69), no 72, fig 72; Held (1969), p 271; Jordaens Drawings, sub no A 173

33 National Trust. Inscribed [AE]T. 66. Van Puyvelde, p 132; d'Hulst (1956), pp 146, 190, 349 (sub no 73); Ottawa (1968–69), sub no 72; Jordaens Drawings, sub no A 174

34 Cat. 1959, no 244. Canvas, 137 × 113 cm; inscribed *66 [AETA]TS 1641*. Buschmann, pp 99–100; Rooses, p 108; Van Puyvelde, p 132; d'Hulst (1956), pp 146, 349 (sub no 73); Ottawa (1968–69), sub no 72; Jordaens Drawings, sub no A 174

35 Cat. 1959, no 222. Canvas, 68 × 54 cm. Held (1940B), p 78, fig 6; Antwerp (1978A), p 53, no 17, repr

36 Rooses, p 109; Held (1969), p 267, fig 1

37 W. Pinder, Rembrandts Selbstbildnisse, *Die blauen Bücher* (1950), pp 10, 12

38 Van Puyvelde, fig 1; Ottawa (1968–69), sub no 189; Jordaens Drawings, sub no A 159

39 Von Sandrart, p 291; Antwerp (1978B), p 148, no 102, repr

40 Jordaens Drawings, no A 159, fig 171a

41 Held (1940B), p 74, n 23; exh. cat. *De schilder en zijn wereld* (Delft–Antwerp, 1964–65), no 66; exh. cat. *Le siècle de Rubens dans les collections publiques françaises* (Paris, 1977–78), no 74, fig 74; J. ooucart, 'Postface à l'exposition "Le siècle de Rubens dans les collections publiques françaises" ', *Revue du Louvre et des Musées de France* (1979/2), p 154

42 Mariette Fransolet, 'François du Quesnoy', *Mémoires, Académie royale de Belgique, Classe des Beaux-Arts* IX (Brussels, 1941), no 1, p 199

43 Canvas, 76 × 60 cm. Van Puyvelde, p 25, fig 2; Ottawa (1968–69), sub no 189

44 Ottawa (1968–69), no 106, fig 106

45 G. de Tervarent, *Attributs et symboles dans l'art profane, 1450–1600* (Geneva, 1959), cols 288–89

46 No 2016. Buschmann, p 101, pl XXV; Rooses, p 240, repr p 244

47 Exh. cat. *De eeuw van Rubens* (*Le siècle de Rubens*) (Brussels, 1965), no 132, repr

48 No. 56.73. Canvas, 122.5 × 89 cm. Van Puyvelde, p 208; d'Hulst (1958B), pp 3–4, fig 3; Ottawa (1968–69), no 93, fig 93

49 Wallraf-Richartz Museum, no 2158. Canvas, 97 × 72 cm

50 Cat. 1968, no 722. Canvas, 98 × 74 cm. Buschmann, p 129; Rooses, pp 240–41, repr facing p 248; Van Puyvelde, p 208; A. Pigler, 'Notices sur quelques portraits néerlandais', *Bulletin du Musée hongrois des Beaux-Arts* (Budapest, 1962), no 21, pp 68–69, 137, fig 49

CHAPTER IX

1 J. Duverger, 'Geschiedenis van de Vlaamse tapijtkunst', in R.-A. d'Hulst, *Vlaamse wandtapijten* (Brussels, 1960), pp IX–XVI

2 R.-A. d'Hulst, *Vlaamse wandtapijten* (Brussels, 1960), pp 271, 274

3 Jordaens Drawings, nos A 413–A 423

4 Nora de Poorter, *The Eucharist Series* I, *Corpus Rubenianum Ludwig Burchard* II (Brussels, 1978), pp 136–49

5 Van Puyvelde, p 157; J. Duverger, 'Aantekeningen betreffende tapijten naar cartons van Jacob Jordaens', *Artes Textiles* V (Ghent, 1959–60), p 48

6 D'Hulst, Jordaens, Tapestry, pp 237–43, figs 1–9; d'Hulst (1956), pp 134, 136–38, 161–62, 164, 307–308, 335 (sub no 39), 336 (sub nos 40–41), 337 (sub nos 42–43), figs 76–77

7 Exh. cat. *Tekeningen van P. P. Rubens* (*Rubens Drawings*) (L. Burchard and R.-A. d'Hulst) (Antwerp, 1956), sub nos 111–12

8 Exh. cat. *L'Ecole de Fontainbleau* (Paris, 1972), no 428

9 E. Duverger, 'Une tenture de l'histoire d'Ulysse livrée par Jacques Geubels le jeune au Prince de Pologne', *Artes Textiles* VII (1971), pp 74–98. Duverger suggests that this set may have been woven

to Jordaens's designs. If so, the cartoons must have
dated from 1624 or shortly after. We should then
have to assign *The history of Alexander the Great* and
Scenes from country life to an earlier date, and
consider whether the date on the Lille painting,
Piqueur seated amid a pack of hounds, should not after
all be read as *1625*, as Van Puyvelde thought, instead
of *1635*

10 Mercedes Ferrero-Viale, 'Essai de reconstitution
idéale des collections de tapisseries ayant appartenu à
la Maison de Savoie au XVIIe et XVIIIe siècle', *Het
herfsttij van de Vlaamse tapijtkunst* (Brussels, 1959),
pp 281–82, 295

11 Crick-Kuntziger (1938), pp 137–38

12 Jordaens Drawings, no A 80, fig 89

13 Jordaens Drawings, nos A 78–A 81, A 413

14 Jordaens Drawings, no A 78, fig 87

15 Jordaens Drawings, no A 79, fig 88

16 Jordaens Drawings, no A 81, fig 90

17 R.-A. d'Hulst, *Vlaamse wandtapijten* (Brussels,
1960), pp 52–56

18 D'Hulst, Jordaens, Tapestry, pp 245–46, figs 14–18;
d'Hulst (1956), pp 137, 142, 172, 307–308, 342 (sub
nos 53–54), 343 (sub no 55), fig 84

19 On the strength of the identification of a certain mark
as being that of Catharina van den Eynde, widow of
Jacob I Geubels, some authors have supposed that
The history of Alexander and *Scenes from country life*
were woven in her workshop, and have taken the date
of her death (before 15 March 1629) as a *terminus
ante quem* for the execution of these two series. But,
as Nora De Poorter has pointed out ('Over de
weduwe Geubels en de datering van Jordaens'
tapijten "De taferelen uit de landleven", een voetnoot
bij de Jordaens-studie', in *Libellus Discipulorum*,
presented to R.-A. d'Hulst in 1977, pp 53–69, figs 1,
2), the identification of the mark rests on too slender
evidence to permit conclusions to be drawn from it.
It has also not been proved that Jacob II Geubels,
whose signature appears in full on certain tapestries
in the two series, died in 1628 or 1629, as Duverger
maintained ('Aantekeningen betreffende tapijten naar
cartons van Jacob Jordaens', *Artes Textiles* V
(1959–60), p 49)

20 Jordaens Drawings, no A 414, fig 441

21 Jordaens Drawings, no A 82, fig 91

22 Jordaens Drawings, no A 83, fig 92

23 Cat. 1923, no 611. Panel, 59 × 78 cm

24 Cat. 1959, no 819. Antwerp (1978A), p 37, no 9, repr

25 D'Hulst, Jordaens, Tapestry, pp 243–45, figs 10–13;
d'Hulst (1956), pp 137–38, 142, 164, 167–68, 172,
307–308, 337 (sub no 44), 338 (sub no 45), 339 (sub
nos 46–48), 340 (sub no 49), figs 81–83

26 P. J. Harrebomée, *Spreekwoordenboek der
Nederlandsche taal* I (Utrecht, 1858), p 159

27 Jordaens Drawings, no A 87, fig 96

28 Jordaens Drawings, no A 88, fig 97

29 Jordaens Drawings, no A 89, fig 98

30 Jordaens Drawings, no A 90, fig 99

31 Jordaens Drawings, no A 91, fig 100

32 E. Duverger, 'Tapijten naar Rubens en Jordaens in
het bezit van het Antwerps handelsvennootschap
Fourment-Van Hecke', *Artes Textiles* VII (1971),
pp 139–48, fig 19

33 D'Hulst (1956), pp 136–38, 172, 181, 183, 187, 211,
229, 233, 236–38, 266, 308, 341 (sub nos 50–51), 344
(sub no 60), 361–69 (sub nos 100–15)

34 J. Denucé, *Antwerpsche tapijtkunst en handel.
Bronnen voor de geschiedenis van de Vlaamsche kunst*
IV (Antwerp, 1936), p 65

35 J. Grauls, 'Uit de Spreekwoorden van Jacob
Jordaens', *Bulletin Koninklijke Musea voor Schone
Kunsten* (Brussels, 1959), pp 90–95

36 Jordaens Drawings, nos A 189, A 191, A 192,
A 195–A 197, A 202–A 203, A 205, A 207–A 212

37 Jordaens Drawings, nos A 193–A 194, A 215

38 Margaret, Duchess of Newcastle, *The Lives of
William Cavendish, Duke of Newcastle, and of his wife
Margaret, Duchess of Newcastle*, ed. M. A. Lower
(London, 1872), pp 79–111

39 Duverger, pp 127–28

40 D'Hulst, Jordaens, Tapestry, pp 249–50, figs 19–23;
Jordaens Drawings, nos A 84–A 86, figs 93–95

41 Duverger, pp 133, 171

42 Duverger, pp 134–35, 172

43 Van den Branden (1883), p 827

44 The inventory of the estate of the Antwerp dealer
Michiel Wauters, who died on 26 August 1679,
included the cartoons for a series of 'horses,
comprising eight pieces'; he also left 'a chamber
tapestry, horses, coarse, four ells and a half deep,
consisting of the following pieces, to wit, one piece
eight ells long, item a piece seven ells long, item a
piece six ells long, item a piece five ells long, and two
pieces each four ells long' (F. J. Van den Branden,
'Verzamelingen van schilderijen te Antwerpen',
Antwerpsch Archievenblad XXII (Antwerp, n.d.),
pp 27, 31). The author of the cartoons and tapestries
is not mentioned, but we know that Wauters, less
than a year before his death, had bought thirty
designs from Jordaens's estate (F. J. Van den
Branden, *op cit*, p 32). This bears witness to his
interest in Jordaens's work and makes it quite likely
that the cartoons and tapestries of horses were by
Jordaens also

45 E. Ritter von Birk, 'Inventar der im Besitz des
allerhöchsten Kaiserhauses befindlichen
Niederländer Tapeten und Gobelins', *Jahrbuch der
kunsthistorischen Sammlungen des allerhöchsten
Kaiserhauses* I (Vienna, 1883), pp 245–46

46 Held (1949), pp 153–56

47 Duverger, pp 142–43

48 Jordaens Drawings, no A 217, fig 232

49 Duverger, pp 145–46, 172

50 Ottawa (1968–69), sub no 279; E. Duverger,
'Tapijten naar Rubens en Jordaens in het bezit van
het Antwerps handelsvennootschap Fourment-van
Hecke', *Artes Textiles* VII (1971), pp 150–54

51 Jordaens Drawings, no A 141, sub no 142a

52 W. Stechow, 'A Modello by Jordaens', *Allen Memorial Museum Bulletin* XXIII (1965), pp 1–16, fig 1

53 Marthe Crick-Kuntziger, 'La tenture d'Achille d'après Rubens et les tapissiers Jean et François Raes', *Bulletin des Musées royaux d'art et d'histoire* VI (Brussels, 1934), p 2 ff; *idem*, 'La tenture et l'histoire d'Achille, note complémentaire', *ibid*, p 70 ff

54 Exh. cat. *Jacob Jordaens* (Antwerp, 1905), no 33, repr in Album, no 33

55 E. Duverger, 'Tapijten naar Rubens en Jordaens', *Artes Textiles* VII (1971), pp 139–48, fig 19

56 Crick-Kuntziger (1938), pp 145–46, figs 11–13; J. Duverger, 'Aantekeningen betreffende tapijten naar cartons van Jacob Jordaens', *Artes Textiles* V (1959–60), pp 57–62

57 R.-A. d'Hulst, *Vlaamse Wandtapijten* (Brussels, 1960), pp 53, 56

58 Crick-Kuntziger (1938), pp 144–46, figs 11–13; J. Duverger, 'Aantekeningen betreffende tapijten naar cartons van Jacob Jordaens', *Artes Textiles* V (1959–60), pp 57–62

59 Crick-Kuntziger (1938), pp 139–40, fig 8. Two examplars of *Queen Olympias and a lady of her suite (?)* are known, both woven at Brussels

60 Antwerp (1978A), p 101, no 38, repr

61 Jordaens Drawings, no A 418, fig 438

62 Crick-Kuntziger (1938), pp 141–42; Jordaens Drawings, sub no A 415

63 F. J. Van den Branden, 'Verzamelingen van schilderijen te Antwerpen', *Antwerpsch Archievenblad* XXII (Antwerp, n.d.), p 32

64 Jordaens Drawings, nos A 369–A 373, figs 388–92

65 H. Göbel, *Wandteppiche, I, Die Niederlande* (Leipzig, 1923), pp 315–16, 442, fig 275

66 Jordaens Drawings, no A 334, fig 351

67 Jordaens Drawings, no C 83, figs 561–62

68 F. J. Van den Branden, 'Verzamelingen van schilderijen te Antwerpen', *Antwerpsch Archievenblad* XXII (Antwerp, n.d.), pp 30–31

69 Rooses, pp 190–91

70 Jordaens Drawings, nos A 308–A 314, figs 325–31

71 Jordaens Drawings, nos A 325–A 326, figs 342–43

72 Jordaens Drawings, nos A 374–A 376, figs 393–95

73 Jordaens Drawings, nos A 225–A 228, figs 240–43

74 Jordaens Drawings, no A 99, fig 110

75 Jordaens Drawings, no A 286, fig 302

76 Jordaens Drawings, no A 361, fig 379

77 340 × 252 cm. Rooses, p 192

78 Jordaens Drawings, no A 328, fig 345

CHAPTER X

1 For a full account of Jordaens's work in this sphere, *see* Jordaens Drawings

CHAPTER XI

1 Stubbe, p 70

2 C. Vosmaer, 'Oude aanteekeningen over Rubens, Jordaens, Rembrandt, Hals en Wouwerman', *De Nederlandsche Spectator* (1871), pp 62–63; *idem*, *Kunstkronijk* (1872), p 12; Rooses, pp 241–42; Jordaens Drawings, p 91

3 Von Sandrart, pp 215–16; Jordaens Drawings, p 92

4 *Journaal van Constantijn Huygens, Werken van het Historisch Genootschap Utrecht* (Utrecht), N.S., no 32, p 174; Rooses, p 242; Jordaens Drawings, p 93

5 A. D. Schinkel, *Geschied- en letterkundige bijdragen* (The Hague, 1850), p 29; Rooses, pp 163–64; J. A. Worp, *Constantijn Huygens, de briefwisseling (1608–1687)* (The Hague, 1911–17), no 5132; Jordaens Drawings, p 83

6 Rooses, pp 36–37; Jordaens Drawings, pp 69–70

7 Van den Branden (1883), p 187; Rooses, pp 115–19; Schlugleit, pp 156, 158; Jordaens Drawings, pp 76–77

8 Van den Branden (1883), p 837; Jordaens Drawings, pp 75–76, 80, 82

9 Jordaens Drawings, p 79

10 Jordaens Drawings, pp 79–80

11 Van den Branden (1883), p 829; Rooses, pp 137–38; Jordaens Drawings, pp 81–82

12 W. Noël Sainsbury, *Original Unpublished Papers Illustrative of the Life of Sir Peter Paul Rubens* (London, 1859), p 221; Rooses, p 117

13 Stubbe, p 75

14 *Het Gulden Cabinet* (Lier, 1661), p 254

15 *Noli me tangere*, Musée de Picardie, Amiens

16 Rooses, p 247

17 Stubbe, p 133

Acknowledgements

The author and publishers acknowledge with thanks
the following for their permission to reproduce the works illustrated in this book

AUSTRIA
Salzburg
Salzburger Landessammlungen-Residenzgalerie [167]
Vienna
Gemäldegalerie der Akademie der bildenden Künste
[168, 243]
Graphische Sammlung Albertina [142]
Kunsthistorisches Museum [124, 127, 128, 143, 158,
185, 191]

BELGIUM
Antwerp
Educatieve Dienst van de Musea [36]
Koninklijk Museum voor Schone Kunsten [1, 9, 10,
40, 49, 51, 112, 137, 192]
Huis Osterrieth [76]
Rockoxhuis [231]
Photogravure de Schutter [231]
St James's Church [36]
Stad Antwerpen [178]
Stedelijk Prentenkabinet [2, 48, 52, 93, 96, 117,
134, 173]
Van der Linden Collection [204, 205, 206, 213]
Brussels
Archives Centrales Iconographiques d'Art National
[8, 10, 11, 17, 18, 42, 45, 48, 49, 57, 77, 93, 97, 110,
166, 170, 178, 198, 218, 223]
Bibliothèque Royale Albert 1er (Cabinet des
Estampes) [200]
G. Dulière Collection [195]
Musées royaux des Beaux-Arts de Belgique [11, 17,
18, 19, 60, 62, 77, 79, 97, 131, 140, 169, 203, 218, 223]
John Nieuwenhuys Collection [90]
Ghent
Museum voor Schone Kunsten [67]

CANADA
Ottawa
National Gallery of Canada [152, 184]

DENMARK
Copenhagen
Statens Museum for Kunst [44, 70, 78, 82, 208, 214]

FRANCE
Angers
Musée des Beaux-Arts [248]
Bayonne
Musée Bonnat [34]
Besançon
Musée des Beaux-Arts [163]
Dijon
Musée des Beaux-Arts [72]
Douai
Musée des Beaux-Arts [69]
Musée de la Chartreuse [69]
Grenoble
La Maison Ifot [41]
Musée des Beaux-Arts [41]
Musée de Grenoble [194]
Lille
Musée des Beaux-Arts [46, 54, 75, 95, 118, 157]
Paris
Ecole Nationale Supérieure des Beaux-Arts [65, 113,
125, 180]
Musée du Louvre [39, 91, 119, 138, 139, 160, 163,
170, 172, 197, 230, 252]

GERMANY
Berlin-Dahlem
Staatliche Museen [247]
Bremen
Kunsthalle [226]
Cologne
Wallraf-Richartz Museum [149, 241, 242]
Dresden
Staatliche Gemäldegalerie [85, 146, 161, 196, 224]
Hamburg
Kunsthalle [199]
Karlsruhe
Staatliche Kunsthalle [53, 103]
Kassel
Staatliche Gemäldegalerie [27, 59, 121, 132, 175,
181, 209, 233]
Mainz
Mittelrheinisches Landesmuseum [229]

Munich
 Kunst-Dias Blauel [44, 63, 250]
 Schloss Schleissheim Alte Pinakothek [44, 63, 250]
Oldenburg
 Landesmuseum [164]
Stuttgart
 Staatsgalerie [92]
IRELAND
Dublin
 National Gallery, Ireland [99]
ITALY
Florence
 Pitti Palace [183]
Milan
 Commune di Milano Collection [114]
 Palazzo Marino [114]
 Pinacoteca de Brera [100]
Rome
 Palazzo del Quirinale [107]
JAPAN
Tokyo
 The National Museum of Western Art [13]
LIECHTENSTEIN
Vaduz
 Collections of the Ruling Prince of Liechtenstein [50]
NORWAY
Oslo
 Nasjonalgalleriet [212]
THE NETHERLANDS
Amsterdam
 Rijksmuseum [120, 135, 147]
 Stedelijk Museum [106]
 Stichting Lichtbeelden Instituut [217]
The Hague
 Huis ten Bosch, Rÿksdienst v/d Monumentenzorg [202]
Rotterdam
 Collection of the Museum Boymans-van Beuningen [115, 136, 190, 201]
POLAND
Gdańsk
 Pomeranian Museum [87]
Warsaw
 National Museum [37, 64]
SPAIN
Madrid
 Museo de Prado [71, 73, 84, 88, 234]
Tarragona
 Museo Diocesano [174, 176]
SWEDEN
Skokloster
 State Museum [207]
Stockholm
 Nationalmuseum [55, 89, 111, 189]
SWITZERLAND
Winterthur
 Oskar Reinhart Collection, 'Am Römerholz' [245]

UNITED KINGDOM
ENGLAND
Blackburn
 Stonyhurst College [98]
Bristol
 City of Bristol Museum and Art Gallery [210]
Cambridge
 Fitzwilliam Museum [141]
London
 Trustees of the British Museum [123, 129]
 Trustees of the National Gallery [240]
 Victoria and Albert Museum [122]
Northampton
 Collection of the Marquess of Northampton [130]
Oxfordshire
 Buscot Park, National Trust [249]
NORTHERN IRELAND & ULSTER
Belfast
 Ulster Museum Art Gallery [101]
SCOTLAND
Edinburgh
 National Gallery of Scotland [151]
Glasgow
 Glasgow Museums and Art Galleries [28, 126]
U.S.S.R.
Leningrad
 Hermitage [32, 162, 232, 251]
Moscow
 Pushkin State Museum of Fine Arts [102, 150]
U.S.A.
Boston, Mass.
 Museum of Fine Arts [193, 235]
Chicago, Ill.
 Art Institute of Chicago [56]
Detroit, Mich.
 Detroit Institute of Arts [68]
Hartford, Conn.
 Wadsworth Atheneum, The Ella Gallup Sumner and Mary Catlin Sumner Collection [25]
New Haven, Conn.
 Yale University Art Gallery, Everett V. Meeks Fund [215]
New York
 The Metropolitan Museum of Art [38, 116]
 John D. Schiff [144]
Providence, R.I.
 Museum of Art, Rhode Island School of Design [24]
Raleigh, N.C.
 North Carolina Museum of Art [216]
Sacramento, Calif.
 E. B. Crocker Art Gallery [66]
St Louis, Miss.
 St Louis Art Museum [23]
Springfield, Mass.
 Museum of Fine Arts, The Gilbert H. Montague Collection [186]
Washington, DC
 National Gallery of Art, Rosenwald Collection [182]

Indices

The following abbreviations are used throughout the three indices:
(c) cartoon, (D) drawing, (E) engraving, (P) painting, (S) oil sketch, (T) tapestry,
(numbers) footnote references, [numbers] illustration references

Collections

This index lists all the paintings, oil sketches, drawings and tapestries
by Jordaens mentioned in the text. The works are listed alphabetically according
to place and then by importance of collection

Two studies of a crouching female nude (D) 304,
313 [182]

WESSELING NEAR BONN
August Carl von Joest
The Holy Family with an angel (P) 123 [86]

WINTERTHUR
Oskar Reinhart
Portrait of a lady (P) 285 [245]

DESTROYED
Formerly Berlin, Kaiser Friedrich Museum
The vision of St Bruno (P) 262 [225]
Family concert (P) 252
Portrait of Adam van Noort (P) 283 [244]

Formerly Dixmude, St Nicholas's church
The adoration of the Magi (P) 199, 262

Formerly The Hague
Justice (P) 263

WHEREABOUTS UNKNOWN
Formerly Amsterdam, St Francis Xavier's church
Christ carrying the cross (P) 252 [217]

Formerly Antwerp, Augustinian church
The martyrdom of Sts Felicitas and Perpetua (P) 250

1905 Antwerp, P. van der Ouderaa
Odysseus and Nausicaa (P) 142

Formerly Antwerp, M. Rooses
Paul and Barnabas at Lystra (D) 308

Formerly Asch, Adler
Study of an old man (P) 114 [81]

1930 Belgium, Baron Cassel
Gentleman playing the lute and lady with a fan
(Scenes from country life) (T) 300

1931 Berlin, Van Diemen
Allegory of knowledge (P) 74 [42]

1935 sold Berlin, Graupe
Alexander and Parmenion (The history of Alexander
the Great) (T) 298

Formerly Blaschkow, Bohemia, G. von Mallmann
The young Achilles and Pan (The young Jupiter and
Pan?) (P) 305

Formerly Brussels, Duke of Arenberg
The abduction of Amphitrite (P) 220

Formerly Uccle, Brussels, M. van Gelder 1974; sold
Vienna, Dorotheum
Old man with raised finger (P) 114, 126, 332 (22), 333
(63) [83]

1954 sold Brussels, Giroux
Gentleman playing the lute, and lady with a fan
(Scenes from country life) (T) 300

Formerly Duke of Devonshire and Brussels, Meeus
The king drinks (P) 181

1803 Brussels, Frans Pauwels sale
Astronomy (C) 308

Formerly Brussels, J. Wouters
Telemachus leading Theoclymenus before Penelope (P)
144

1960 Dutch art trade
Christ in the garden of olives (S) 245

Formerly The Hague, S. Nystad
The infant Jupiter fed by the goat Amalthea (P)
(fragment) 335 (47)

Formerly Hereford, Allensmore Court,
Col. H. E. Pateshall
The rape of Europa (P) 49, 106, 220 [16]

Formerly Hluboká, Bohemia, Schwarzenburg Palace
Proverbs (T) (eight pieces) 301

Formerly Leningrad, Hermitage
Jeroboam I receiving part of the garment of the
prophet Ahijah (D) 307
Elijah awakened by the angel (D) 308

1965 London, Brod Gallery
Paul, Silas and Timothy before
the city-gate of Philippi (D) 308

Formerly London, L. Burchard
The Holy Family (P) 66

1971 sold London, Christie's
Old man with raised finger, reading a book (P)
332 (22)

1932 London, Leger and Sons' Gallery
Odysseus taking leave of Alcinous (P) 144

Formerly London, Russell
Head of a woman (D) 313 [198]

1970 sold London, Sotheby's
Portrait of a man in an armchair (P) 280

Formerly Malmö, Zoltan de Boër; 1980 sold London,
Sotheby's
The rape of Europa (P) 52, 54, 106, 220 [20]

1981 sold London, Sotheby's
Atalanta and Hippomenes (P) 220

Formerly London, G. W. Wrangham
Veritas Dei (D) 308

Formerly Madrid, Sr Iriarte
Satyr with a nymph and two children (P) 176

Formerly New York, W. Guggenheim
Alexander presented with arms and adored as a god by
his people (The history of Alexander the Great) (T)
298

1968 New York, Mayorkas Bros
The history of Alexander the Great (T) (two pieces)
298

Formerly New York, Mrs Ruth K. Palitz
Diana and Callisto (P) 176, 335 (56) [144]
Odysseus threatening Circe (P) 144, 333 (3),
334 (34) [105]

1944 sold New York, Parke-Bernet
The history of Charlemagne (T) (two pieces) 306

Formerly Oldenburg, Museum
Nymphs and satyrs (Allegory of fruitfulness) (P) 55,
75, 107 [22]

Formerly Paris, Braquenié; later sold in the U.S.A.
Scenes from country life (T) (six pieces) 300

Formerly Desfossés; 1929 sold Paris
Scenes from country life (T) (seven pieces) 300

Formerly Paris, T. Dreyfus
Diana resting with nymphs, satyrs and booty (P)
216 [179]

1912 sold Paris, Drouot
Odysseus and Nausicaa (C) 142, 297

Subjects

This index lists all subjects mentioned in the text.
The biblical ones are listed in chronological order and the others
by the characters involved or the themes portrayed

General index

This index lists names of artists, authors, collectors, owners, historical persons, antique models and places of importance. In order to avoid duplication, no reference is made to works by Jordaens

259889

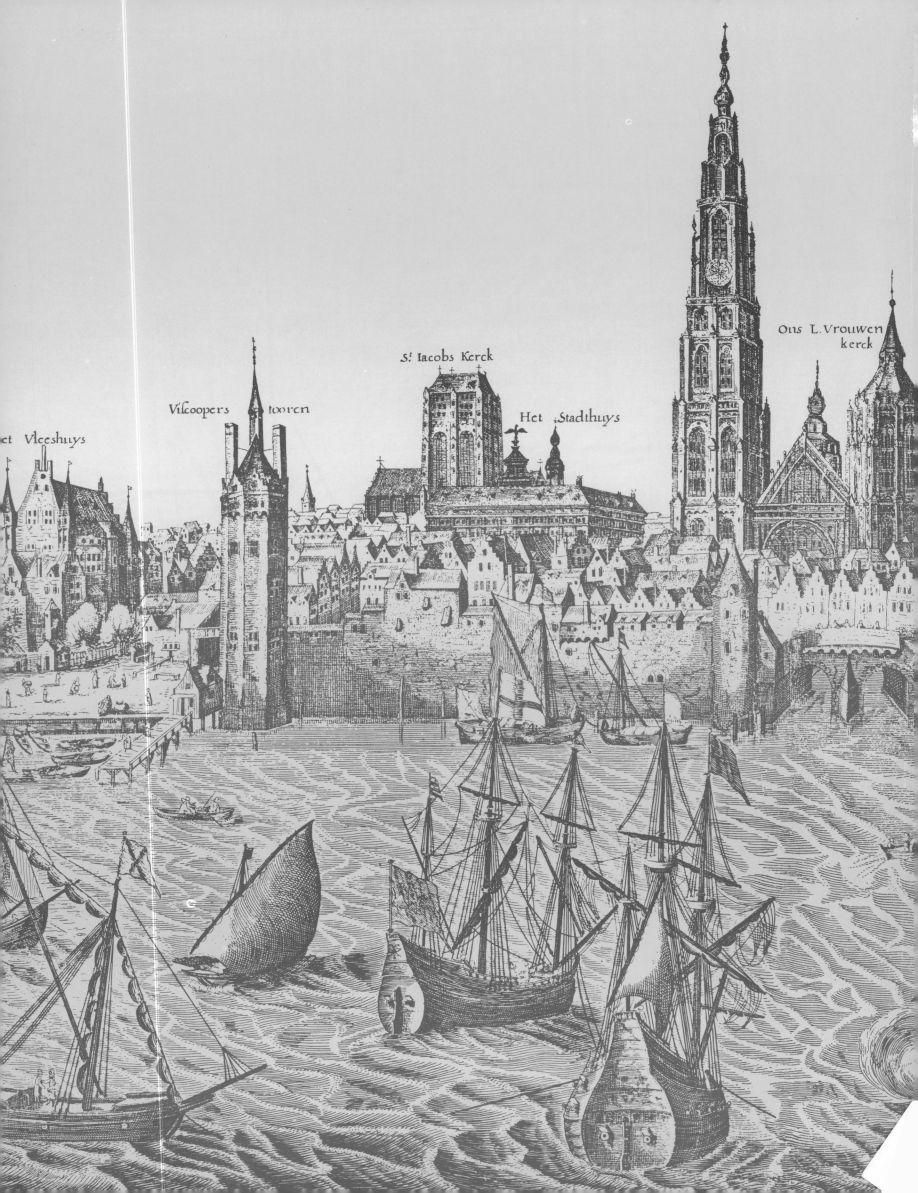

ct Vleeshuys

Vilcoopers tooren

S.^t Iacobs Kerck

Het Stadthuys

Ons L. Vrouwen kerck